INNUMERABLE
INSECTS

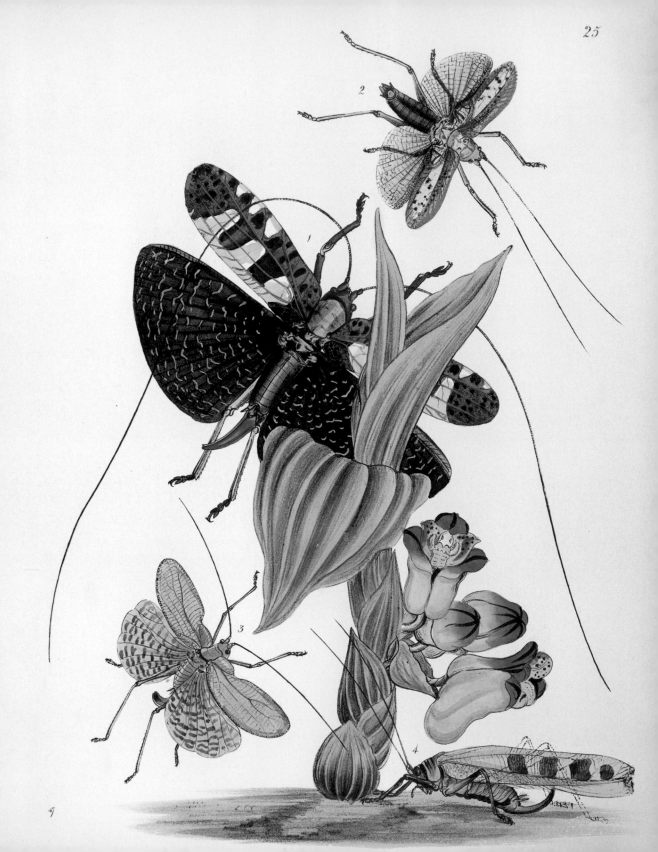

AMERICAN MUSEUM ᵒ͟ꜰ NATURAL HISTORY

NATURAL HISTORIES

INNUMERABLE INSECTS

The Story of the Most Diverse and Myriad Animals on Earth

MICHAEL S. ENGEL

FOREWORD BY TOM BAIONE

FEATURING ILLUSTRATIONS FROM ONE OF THE WORLD'S
GREAT RARE BOOK COLLECTIONS

STERLING
New York

AMERICAN MUSEUM
of NATURAL HISTORY

STERLING
New York

An Imprint of Sterling Publishing Co., Inc.
1166 Avenue of the Americas
New York, NY 10036

ISBN 978-1-4549-2323-7

Distributed in Canada by Sterling Publishing Co., Inc.
c/o Canadian Manda Group, 664 Annette Street
Toronto, Ontario M6S 2C8, Canada
Distributed in the United Kingdom by GMC Distribution Services
Castle Place, 166 High Street, Lewes, East Sussex BN7 1XU, England
Distributed in Australia by NewSouth Books
45 Beach Street, Coogee, NSW 2034, Australia

For information about custom editions, special sales, and premium and corporate purchases,
please contact Sterling Special Sales at 800-805-5489 or specialsales@sterlingpublishing.com.

Manufactured in China

2 4 6 8 10 9 7 5 3 1

sterlingpublishing.com

Cover design by Scott Russo
Interior design by Ashley Prine, Tandem Books

Picture Credits – see page 207

The **American Museum of Natural History** is one of the world's preeminent scientific, educational, and cultural institutions. Since its founding in 1869, the Museum has pursued its mission—to discover, interpret, and share information about human cultures, the natural world, and the universe—through a broad program of scientific research, education, and exhibition.

Each year, millions of visitors experience the Museum's 45 permanent exhibition halls, which include world-famous diorama halls and fossil halls as well as the Rose Center for Earth and Space and the Hayden Planetarium. The Museum's scientific collections, only a tiny fraction of which are on view, contain more than 34 million specimens and artifacts. These collections are an invaluable resource for the Museum's scientists, for graduate students in the Museum's Richard Gilder Graduate School, and for researchers around the world.

Visit amnh.org for more information.

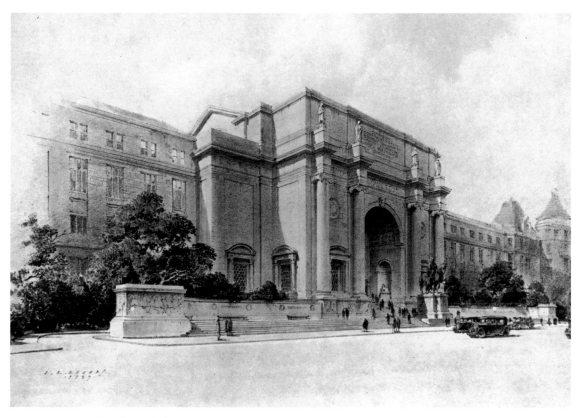

Drawing of the Museum, 1926, by John Russell Pope, from a hand-colored lantern slide.

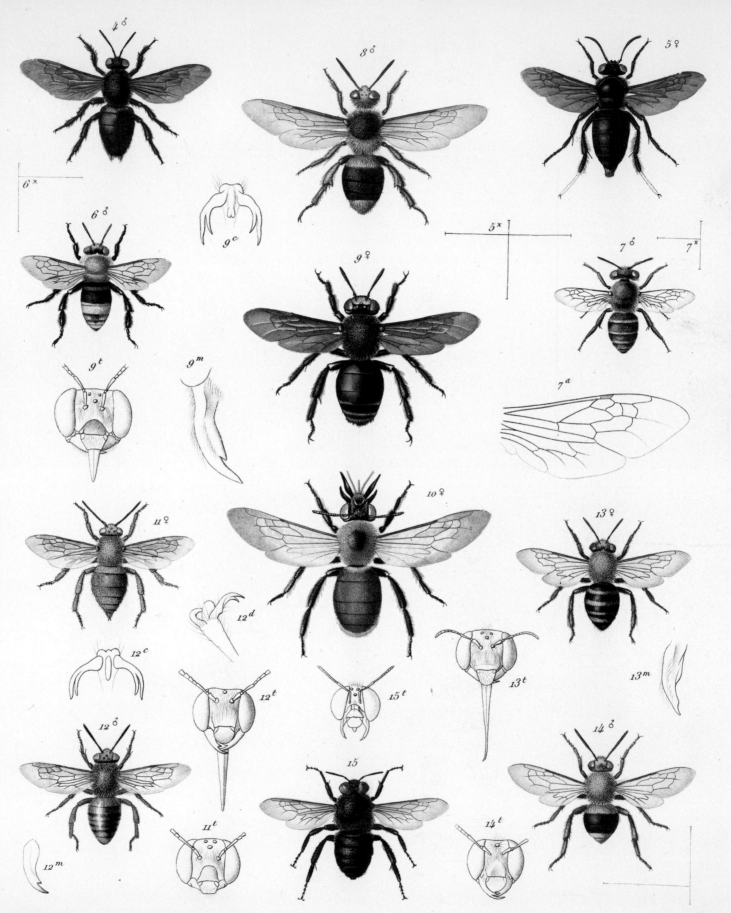

Mexger et Penjade pinx.

Lebrun sc.

"The chiefest cause, to read good books,
That moves each studious minde
Is hope, some pleasure sweet therein,
Or profit good to finde.
Now what delight can greater be
Than secrets for to knowe
Of Sacred Bees, the Muses' Birds,
All which this booke doth showe."

—Charles Butler, *The Feminine Monarchie,*
or the Historie of Bees, 1609

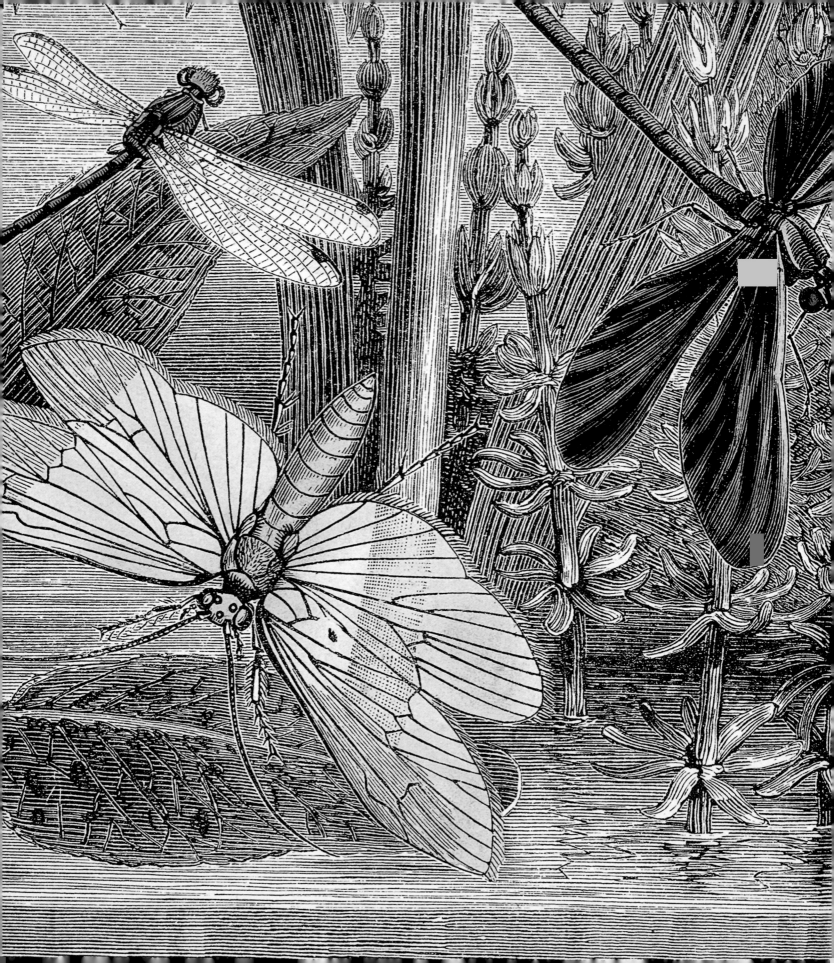

CONTENTS

Foreword xi

Introduction: Inordinate Insects xiii

1 Entomology: The Science of Insects 1

2 Grappling with Diversity 11

3 Earliest of the Six-Legged27

4 Insects Take to the Skies43

5 Complete Metamorphosis77

6 Pests, Parasites, and Plagues105

7 It Takes a Village 125

8 The Language of Insects143

9 Hiding in Plain Sight167

10 The World Abloom181

Acknowledgments 199

Suggested Reading 201

Works Featured 202

Picture Credits 207

Index 208

EUROPEAN BUTTERFLIES AND MOTHS

by

W. F. KIRBY.

FOREWORD

❦

When the American Museum of Natural History's Library began building its collection 150 years ago, our mission was to create a repository of recorded natural science thought and observation throughout the centuries. Much has changed since 1869, but the Library's original commitment has not. What has changed is our understanding of the important role played by each of the organisms that share our fragile planet, regardless of their size. While most of us larger mammals and more-apparent creatures are well known, a scientist seeking to make discoveries of new animals today need only look to the insects, where most species are yet to be described and named. When they do join the ranks of the known, a record of their existence will join the many others that came before them in the Library.

It's been said that natural science literature has a longer memory than other sciences, and this is true in the sense that published descriptions of species and localities are valuable for the snapshots in time they provide. This still-vital information—in images and text—retains its relevance and beauty today. Among our collections are thousands of marvelously illustrated books containing hundreds of thousands of illustrations of all manner of insects. And the insects reproduced in the following pages are beguiling beyond words. With a few exceptions, the images in this volume are from books in the Museum Library's collection. That this up-to-date, scientific work could be nearly entirely illustrated with images from older volumes in our collection is a testament to the timelessness of these works.

The collection has grown over the years through purchases and many gifts. Book collectors are often characterized as obsessive, and one particularly generous collector was no exception. When the Museum learned that it had been named in the will of an important and idiosyncratic collector of natural history insect books and insect specimens, we were thrilled to retrieve the rich trove of thousands of rare volumes and specimens from the collector's home. Interestingly, the collections lovingly comingled throughout the house, so that it seemed as if they were feeding the collector's curiosity to the end.

Innumerable Insects is a delight not only for the eyes, but for the curious mind, ready to ponder the fables and facts laid out by its articulate and erudite scientist-scholar-author Michael Engel. We humans are lucky insects are so small. They outnumber all the other species combined. Equipped with nothing short of superpowers, if insects were a few orders of magnitude larger in scale, they would certainly dominate our planet. As it is believed that only a fifth of insect species are known to science, revelations of more surprising powers certainly await. If *Innumerable Insects* is a primer on what's known . . . we can only imagine what we can expect.

Tom Baione, Harold Boeschenstein Director,
Department of Library Services, March 2018

OPPOSITE: The ornate cover of W. F. Kirby's *European Butterflies and Moths* (1889 [1882]), one of the stunningly illustrated entomological volumes from the American Museum of Natural History Rare Book Collection.

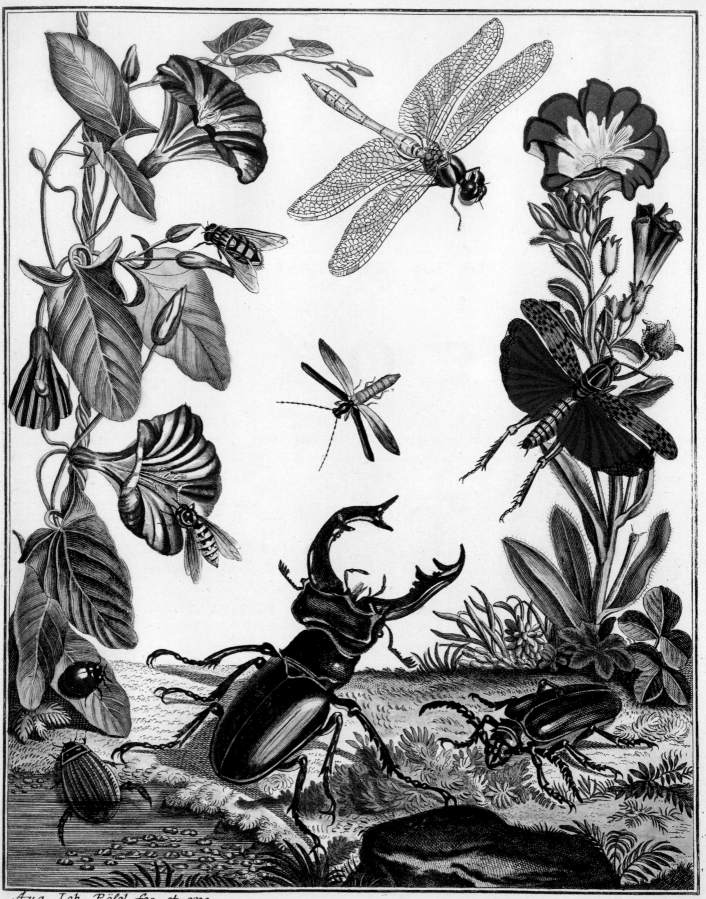

Aug. Ioh. Röfel fec. et exc.

INORDINATE INSECTS

———— ✦ ————

There is a possibly apocryphal tale in which the prominent British evolutionary biologist J. B. S. Haldane (1892–1964), while seated at a formal dinner next to the archbishop of Canterbury, was asked by the estimable cleric as to what he had divined of the Creator from the study of His creation. Haldane's irreverent reply: "An inordinate fondness for beetles."

While the veracity of this conversation having occurred may be questioned, it is an undeniable truth that insects are truly inordinate. In fact, if one were to make a cursory observation of all life on our Earth, then the inescapable conclusion would be that nature has a perverse preference for the six-legged. To date, we have discovered, described, and named around two million species in our world, slightly more than half of which are insects. Thousands of new insect species are added to the ranks every year, and while the discovery of a new bird or mammal is rightly heralded in the press, the flood of new insects being uncovered is typically overlooked. Yet, insects are as intimately entwined into our lives as any other collection of species, and in many ways they are more intricately linked and vital to our daily existence than most other groups. Insects are so commonplace that we scarcely pay them notice in the same way we are rarely conscious of our breathing. Whether we are cognizant of it or not, we intermingle with insects every day as we go about our lives. They are always underfoot, overhead, in our homes, where we play and work, and, although we might not wish to think about it, in our food and waste.

Insects are both familiar and foreign to us, and it is their often-diminutive size and widely perceived cultural stigma that prevents most of them from becoming more endeared to us. From the dawn of humanity, our successes and our failures have been tied to insects. Civilizations have risen and fallen as a result of entomological interventions, with the directions of wars and territorial expansions reshaped by mostly unseen, six-legged foes. Our mythologies and religions abound with references to insects,

OPPOSITE: A snippet of insect diversity and their associated flora, complete with aquatic bugs, a large stag beetle, a dragonfly aloft, a leaping grasshopper, a small wasp, a fly, and a ladybug. The stag beetle at center clearly pays homage to the work of Dutch miniaturist Jacob Hoefnagel, over a century prior. From August Johann Rösel von Rosenhof, *De natuurlyke historie der insecten* (1764–1768).

LEFT: Detail of an engraved portrait of Cardinal Antonio Barberini (1607–1671) showing the Barberini family coat of arms with three bees.

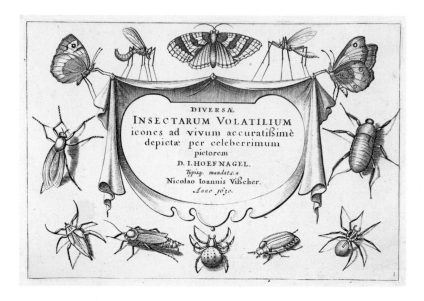

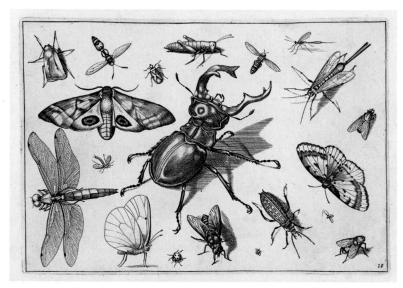

TOP: The introductory engraving to the theater of insect diversity as presented by Jacob Hoefnagel in his *Diversae Insectarum Volatilium Icones* (1630). Jacob engraved images of insects drawn by his father, Joris—also an artist—and arranged them with beautiful symmetry and precision that would be duplicated by later artists.

BOTTOM: Another of Hoefnagel's finely etched plates from *Diversae Insectarum*, reflecting the dazzling and seemingly infinite variety of insects—which has long attracted the attention of naturalists and artists alike.

either as plagues sent from wrathful gods or through allegories of insectoid industriousness, such as the counsel in Proverbs 6:6 to "Go to the ant, thou sluggard; consider her ways and be wise." They also have represented nobility in heraldry, from the three bees on the coat of arms of the seventeenth-century Barberinis of Rome (see previous page) to the golden bees of the Frankish king Childeric I that were later so prominent on the robes and regalia of Emperor Napoléon (1808–1873).

Whether as a flight of butterflies, a hum of bees, a concerto of crickets, or a cloud of flies, insects in one form or another fill us with fear, revulsion, comfort, admiration, and even delight. We have a love-hate relationship with insects, as we compete with them for our crops, yet they are critical as pollinators of the same fields as well as of our forests; they recycle our wastes and till our soils, but they also invade and damage our homes; they are infamous for spreading pestilence and plagues, yet they may also cure disease. Further, insects are used to dye our fabrics and foods, alter our atmosphere and landscapes, inform our engineering and architectural efforts, inspire great works of art, and even rid of us other pests. They outnumber all other species combined and many individual insect species dwarf humans in terms of abundance. From this perspective, Earth belongs more to the insects than to us. Our evolution, physical and cultural, is inseparably connected with insects as both pests and benefactors. Were humans to disappear tomorrow, our planet would thrive. If insects packed up and left, Earth would quickly whither, become toxic, and die. With all of this in mind, it is a wonder that we don't show greater appreciation for our multitudinous neighbors.

Estimates of the total current diversity of insects range from 1.5 to 30 million species. A conservative and likely realistic value is somewhere around 5 million species. At 5 million, it means we are still far short of understanding the variety of insect life surrounding us, as thus far entomologists have only described one-fifth of this diversity. This overwhelming task is made all the more daunting when we consider that insects are also one of the most ancient lineages of terrestrial life, with a history extending back more than 400 million years. Through the vastness of time and vicissitudes of cataclysms, insects have persisted and perished, but most often flourished. If it seems incredible to conceive of 5 million insect species today, the potentially hundreds of millions that cumulatively existed throughout the history of insects is staggering. Most species that have ever existed throughout the history of life are now extinct, and perhaps 95 percent or more of all species that ever existed are now gone. Nonetheless, they are part of an uninterrupted chain of descent extending from the first ancestral insect species to the millions that surround us today. In between, there have been innumerable performers on evolution's stage, and while the curtain has closed on the acts of many, their collective triumph is unprecedented in the nearly 4-billion-year history of life on Earth.

As humans, we boast of our many achievements (and we do have many!), but we are fragile—perhaps among the least adaptable of species. We have occupied the whole of the world, but not through succeeding in each of those environs. Instead, we shape habitats to our needs. We live in the polar regions of our planet, but in domiciles that create a microclimate in which we can thrive. We live in deserts,

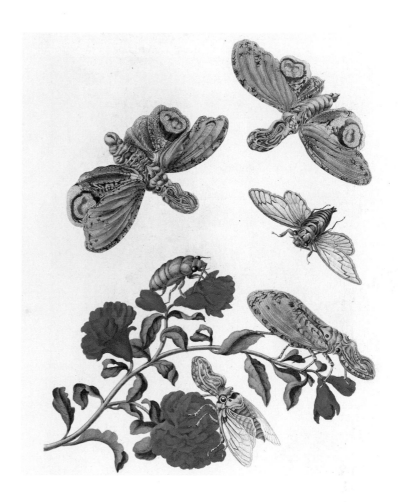

but often in air-conditioned structures that similarly mimic our comparatively narrow range of tolerance. True, we can consider our ability to reshape areas to our liking as one of our defining glories, but there are other ways of measuring success, and it is hubris that leads us to think that we are paramount among the lineages of Earth.

Insects are virtually everywhere, even in the most remote places. From the frozen poles to equatorial deserts and rain forests, from the peaks of the highest mountains to the depths of subterranean caves, from the shores of the seas to prairies, plains, and ponds, insects can be found in droves. The only place in which

Tropical lantern bugs (*Fulgora laternaria*) and a cicada (*Fidicina mannifera*) on pomegranate (*Punica granatum*), fruits of which were introduced to the Americas by Spanish explorers. From Maria Sibylla Merian, *Over de voortteeling en wonderbaerlyke veranderingen der Surinaemsche insecten*, a 1719 Dutch edition of her 1705 masterwork *Metamorphosis Insectorum Surinamerisium*.

TOM. *IV. Tab. V.*

Fig. 1.

Fig. 2.

Fig. 3.

A.J.Röfel a R. fecit et exc.

The breathtaking range of form among insects is encapsulated in species as utterly disparate as delicate butterflies and heavy, ponderous beetles. From Rösel von Rosenhof, *De natuurlyke historie der insecten.*

and they did all of this tens if not hundreds of millions of years before humans ever appeared to mimic these achievements. Today's insects are the various descendants of life's greatest diversification.

THIS IS THE STORY of those pervasive little things that run our world, and it is illustrated by the great works of the past through which our many entomological discoveries were illuminated. While the numerous books featured in these pages are antique, the information contained therein in many instances is as vital today as ever. It is the fallacy of present ages to assume that old is synonymous with anachronistic or, worse yet, faulty and worthless. In reality, care of observation and accuracy of representation in texts and images one hundred or more years old may surpass anything that we produce today. Knowledge obtained long ago can be highly relevant to our current world. For example, in 2015 it was discovered that a single surviving copy of a ninth-century medical text, *Medicinale anglicum* (*Bald's Leechbook*), contained a natural remedy that proved potent in treating the methicillin-resistant strain of *Staphylococcus aureus* (MRSA), a bacterial scourge that otherwise laid waste to our modern medical efforts. Similarly, an 1879 article by the French surgeon Paul F. Segond (1851–1912) on the anatomy of the human knee led contemporary doctors to rediscover in 2013 an entire ligament critical in stabilizing the rotation of this joint, proving how "old" information from even the most intensely studied biological entity on earth— namely us—remains crucial.

they have never managed to succeed is in the oceans, where they are characteristically absent.

Insects outnumber us all. Their segmented body plan is remarkably labile, and they have low levels of natural extinction with rapid species generation, leading to a history of successes eclipsing those of the more familiar ages of dinosaurs and mammals alike. Insects were among the earliest animals to transition to land, the first to fly, the first to sing, the first to disguise themselves with camouflage, the first to evolve societies, the first to develop agriculture, and the first to use an abstract language,

Sometimes the only firsthand information we may have for a species is contained in rare

A folio depicting several species of mantises from Henri de Saussure's *Études sur les myriapodes et les insects* (1870), photographed in the American Museum of Natural History's Rare Folio Room.

books, such as accounts of dodos or Steller's sea cow. Among insects, there are legions of species that we have scarcely seen again since intrepid explorers first encountered them long ago, and those descriptions of their appearances and lives are our only connection to organisms that may be driven to extinction before we happen across them again.

Great works of the past, originals of which are now difficult to find, reveal to us the evolution of information dissemination and artistic representation in science, as well as our own perceptions and interpretations of our world, while simultaneously telling us of the grandeur of insect diversity. Unlike today, publishing in the past was difficult, and not for the faint of heart. To adequately depict species, particularly as if in life, required considerable skill. To illuminate a treatise one might have to carve images into wood and use the woodcuts like stamps. Later, intaglio printing relied on images engraved into sheets of copper, and ink then filled the grooves for transfer to folio

leaves. Subsequent lithography, either in metal or on limestone, improved upon these methods, becoming the standard for embellishing texts. As one can imagine, there was little room for error, and only after the image was printed to the page would it then be colored. The total process could take years depending on the number of images and the number of copies to be made. The result of these labors were works of great scholarship and sublime artistic expression. The images herein are not mere adornments, but unique sources of scientific information. Few institutional libraries are as blessed as the American Museum of Natural History to have in a single repository such a sweeping breadth of works by a panoply of entomological luminaries. The scope of rare works on insects residing therein, like insects themselves, is inordinate, and it is fitting that we should allow their pages to inform us of insect evolution.

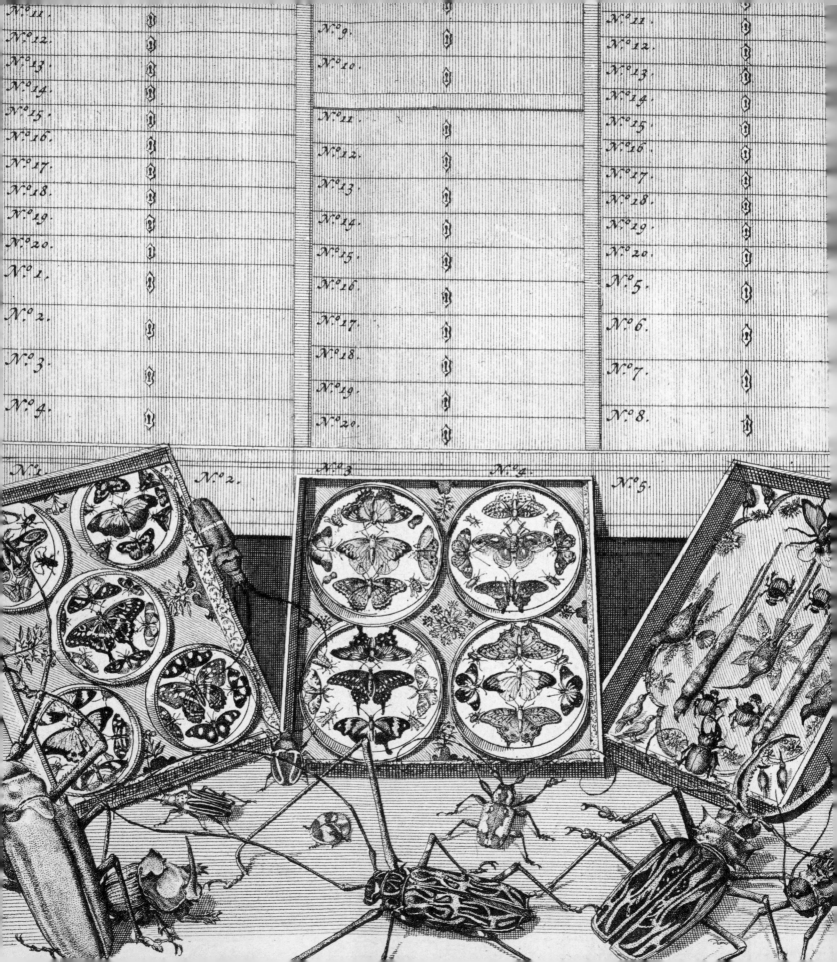

ENTOMOLOGY

1

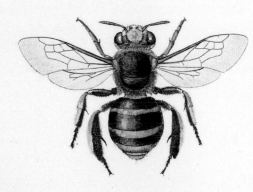 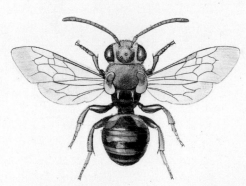

> *"It can never be too strongly impressed upon a mind anxious for the acquisition of knowledge, that the commonest things by which we are surrounded are deserving of minute and careful attention."*
>
> —James Rennie
> *Insect Architecture,* 1857

PAGE xviii: A cabinet of natural wonders from the world of insects, arrayed in their drawers, from Levinus Vincent's *Wondertooneel der nature* (1706–1715).

OPPOSITE: Although often considered insects, spiders, mites, centipedes, and millipedes belong to different lineages of the phylum Arthropoda. Spiders, ticks, mites, and their other eight-legged relatives are arachnids, while the many-legged millipedes and centipedes are myriapods. This print depicts various East African species of spiders, ticks, and millipedes. From Carl Eduard Adolph Gerstaecker, *Baron Carl Claus von der Decken's Reisen in Ost-Afrika* (1873).

Entomology is the scientific study of insects, the word deriving from the Greek *éntomon*, meaning "insect," and *lógos*, meaning "subject of study." Like many branches of biology, entomology, in one form or another, is ancient. Since before our civilizations struggled into existence, we have benefited from and been diminished by insects. Early on we focused our attention on only those elements of our world that were either harmful or beneficent, and this too was true with insects. Perhaps not surprisingly, apiculture and sericulture are the most ancient of entomological endeavors. Exploitation of honey bees for honey and wax was already widespread 8,500 years ago, and a vibrant bee-keeping industry from 3,000 years ago was discovered in 2007 in Israel, the biblical land "flowing of milk and honey" (Exodus 33:3). At least 8,000 years ago, in the Araña Caves in Valencia, Spain, early painters depicted people climbing ropes to retrieve honey from cliff-face hives, and wall paintings from the Old Kingdom of Egypt attest to beekeeping practices 4,400 years ago. By at least 5,000 years ago, the cocoons of silk moths were being unraveled by people of the Yangshao culture, in today's northern China, to produce those fine fabrics we so adore even now.

ARTHROPODA

Despite the lengthy history of our involvement with these creatures, there remains today confusion over what is and is not an insect. Insects belong to a larger group of animals called *arthropods*, formally known as the phylum Arthropoda. Arthropods are truly ancient, dating back to at least the early Cambrian, around 540 million years ago, and were among the initial diversification of major animal lineages. The arthropods encompass a huge swath of animal diversity and include everything from spiders and scorpions to millipedes and centipedes to crabs, shrimp, and lobsters. The most numerous of the arthropod groups are the insects, and sometimes subsets of those aforementioned lineages are grossly lumped with them into the field of entomology. For

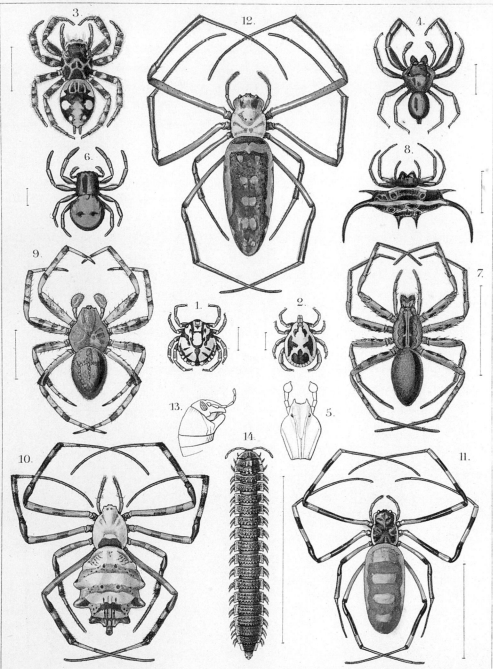

1. Amblyomma eburneum. Gerst. 2. Dermacentor pulchellus. Gerst. 3. Plexippus nummularis. Gerst.

4. Phidippus buccidentus. Gerst. 5. Deinopis cornigera. Gerst. 6. Stiphropus lugubris. Gerst.

7. Phoneutria decora. Gerst. 8. Gastracantha resupinata. Gerst. 9. Epeira haematomera. Gerst.

10. Argyope suavissima. Gerst. 11. Nephila hymenaea. Gerst. 12. Neph. sumptuosa. Gerst.

13. Spirostrepfus macrofis. Gerst. 14. Polydesmus mastophorus. Gerst.

Tieffenbach px et sc

instance, it is not uncommon for the average individual to believe that entomology covers spiders and their relatives, or even millipedes and pill "bugs" (aka, roly polies, or doodle bugs). In fact, these all belong to other subsets of Arthropoda and have their own fields of inquiry. Spiders, for example, are arachnids and like scorpions, mites, ticks, and their relatives, they are covered by arachnology. Millipedes are encompassed by myriapodology, and pill bugs, despite the misnomer "bugs," are actually crustaceans and more closely related to crabs and lobsters than they are to insects.

Arthropods are those animals with a chitinous exoskeleton, much like a suit of armor, and as a result have articulated joints wherever movement is required. The word *arthropod* literally means "jointed foot" (in Greek, *árthron*, meaning "joint," and *poús*, *podós*, meaning "foot"), in reference to these necessary joints allowing for movement of the chitinous body. Muscles attach within the exoskeleton to provide movement and support, and collectively the muscles and outer skeleton act as a scaffolding for the internal organs. Arthropods are arranged much like an upside-down vertebrate. Where we have a dorsal nerve cord and ventral heart, arthropods have a ventrally positioned nervous system and extended aorta, or open "heart," along the back of the body. In this regard, the placement of our nerve chord and our heart is an inverted arrangement relative to that in arthropods.

Since the presence of a rigid exoskeleton imposes a limitation on growth, it must therefore be periodically molted. Shedding of the old cuticle in place of a new, larger one permits arthropods to grow throughout their lives, without being hampered by the confines of their protective skeletons. Arthropods

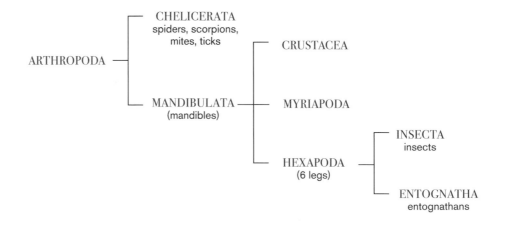

Hierarchical Organization of Arthropoda

Major groups constituting the phylum of arthropods (those animals with a jointed exoskeleton), and the placement of insects among them.

ARTHROPODA —
- CHELICERATA
 spiders, scorpions, mites, ticks
- MANDIBULATA (mandibles) —
 - CRUSTACEA
 - MYRIAPODA
 - HEXAPODA (6 legs) —
 - INSECTA
 insects
 - ENTOGNATHA
 entognathans

experience their world entirely through their exterior skeleton, and there are any number of modifications that permit different forms of perception ranging from vision and hearing to chemical and mechanical receptors. As the most diverse of all arthropods, insects include some of the best examples of arthropod senses. Some of these sensory structures are familiar to us, such as the large compound eyes of a fly or the feathered antennae of a moth, while others do not quite resemble what we might expect or seem misplaced on the body. For example, the "ear" of a cricket, while resembling a small membranous drum like our eardrum, is positioned on the legs rather than the sides of the head. Other insects can have ears in disparate places throughout the body, such as on the abdomen of certain moths, the chest of some mantises, and even on the wings of a subset of lacewings. All insects have small, slender extensions of cuticle that superficially resemble the hair of mammals. In insects, however, these are called *setae*, and they serve a plethora of purposes. Some setae have minute pores that allow for the intake of specific chemicals in the environment that are distributed either through the air or from some surface, and these permit insects to smell or taste. The "hair" of a fly or the "furry" antennae of a moth are setae.

Today's arthropod fauna includes four major groups of animals. These are formally classified as the Chelicerata, Crustacea, Myriapoda, and Hexapoda, with insects belonging to the last of these. Spiders, scorpions, mites, ticks, harvestmen, and their relatives are all arachnids, having eight legs and lacking antennae. Together with horseshoe crabs (which are not crabs at all!), they comprise the Chelicerata. Chelicerata are named after their characteristic fangs, called

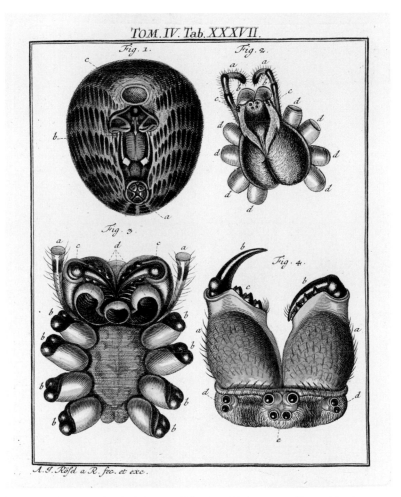

Spiders and their relatives lack the mandibles found in insects and instead feed via impressive fangs, called *chelicerae*, as seen at bottom right, with the chelicerae extended upward and the face with its eight eyes below. From top right clockwise: underside of the abdomen, top of the carapace with legs removed, chelicerae in facial view, and underside of the head and thorax with legs removed. From August Johann Rösel von Rosenhof, *De natuurlyke historie der insecten* (1764–1768).

chelicerae. The Crustacea scarcely need any introduction, as the very name brings to mind a whole host of animals that can be found at your average seafood restaurant. Crustaceans include crabs, lobsters, and shrimp as well as the less delectable krill, barnacles, copepods, and roly polies. Millipedes and centipedes, and the lesser known pauropods and symphylans, form the

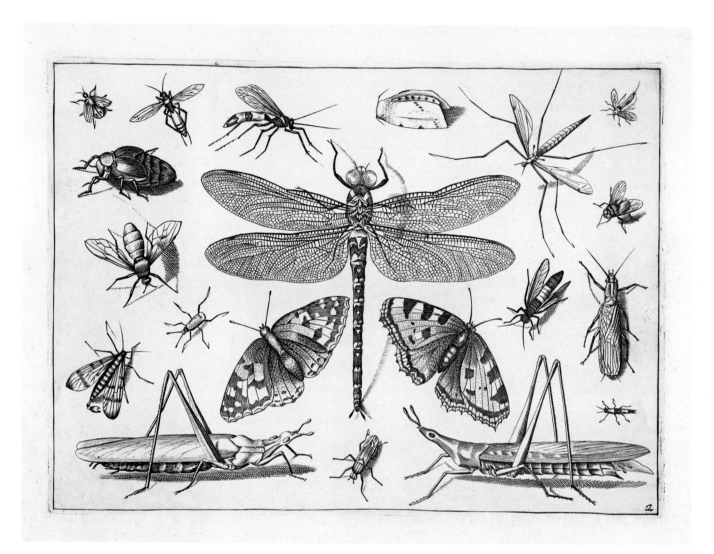

A dazzling array of the most diverse of all hexapods—the insects. From dragonflies and butterflies to wasps and beetles, the body plan of six legs dominates our terrestrial environments throughout the world. From Hoefnagel, *Diversae Insectarum*.

Myriapoda and are best known for the numerous pairs of walking legs running the length of their body. While chelicerates have chelicerae, the Crustacea, Myriapoda, and Hexapoda all have mandibles, the distinctive set of jaws used as their primary means of feeding. Myriapoda and Hexapoda share a common means of breathing, both having a network of fine tubes, called *tracheae*, formed from the exoskeleton and permitting the passive movement of oxygen through their bodies.

TRUE INSECTS

As their name indicates, the Hexapoda are those arthropods with three pairs of legs—in Greek *hexa* means "six" and *podos* means "foot." They are also distinguished from other arthropods by the familiar arrangement of the body into three major parts: head, thorax, and abdomen. Each of these units has a primary function: the head is for sensory input and gustation, the thorax for locomotion, and the

abdomen for the viscera, which covers digestion, excretion, and reproduction. It is perhaps surprising to many that the presence of six legs and the tripartite body plan do not define an insect. While insects are hexapods with these aforementioned traits, there is one other group that shares these same features. Hexapoda include the true insects, formally named *Insecta*, as well as their closest living relatives, the Entognatha. Entognatha are small, wingless animals in which the mouthparts are tucked into a pocket within the head, which gives them a puckered appearance. Their name references this internalization of the mouthparts, the Greek *entos* meaning "inside" or "within," and *gnáthos* meaning "jaw" (together, "jaws within").

So what makes an insect an insect? If it is not the number of legs, what sets true insects apart from Entognatha? In brief, it's their mouthparts, how they lay eggs, and a sensory capability hidden within their antennae. (See the illustration of an insect body plan, right). Insects' mouthparts are external, unlike the Entognatha but similar to myriapods, crustaceans, and arachnids. Thus, we can usually see with ease the mandibles, followed by two other sets of mouthpart appendages called the *maxillae* and *labium*. While mandibles are unjointed, immediately behind them are the maxillae, jointed structures that can easily manipulate a food item. Posterior to this are what on the surface appear to be a second set of maxillae, but along their midline they are fused to form a composite structure, the labium, which acts as a back wall of sorts for the space created by the mouthpart appendages, and again aiding an insect to hold and manipulate an object with its mouth.

Aside from the externally visible mouthparts, true insects also have a structure at the

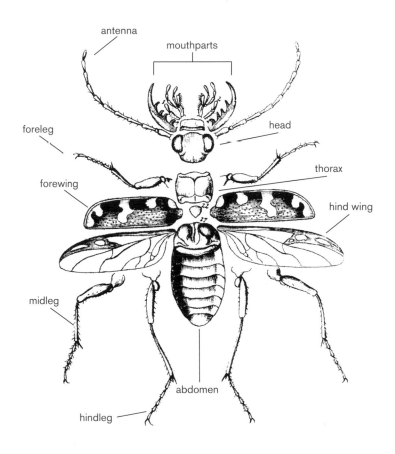

back of the body called an *ovipositor*. As its name implies, this structure is used to deposit eggs and is therefore present only in females. In most insects the ovipositor resembles a long tube, and its presence is a major feature influencing insect evolution. An ovipositor allows for the careful placement of eggs, including into concealed locations that may lead to improvements in survival, and is perhaps one of those features that has helped lead to the overall success of insects.

Another defining feature of insects, albeit less noticeable, is the presence of a specialized

The insect body plan, exemplified here by a tiger beetle (family Cicindelidae), consists of three primary elements: head, thorax, and abdomen. From Georg Wolfgang Franz Panzer, *Deutschlands Insectenfaune* (1795).

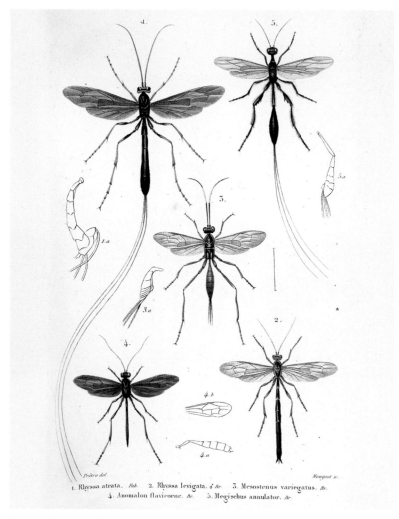

In some insects, such as particular parasitic wasps, the egg-laying ovipositor can be prominent—even longer than the rest of the body. Shown here, parasitic wasps of the families Ichneumonidae and Stephanidae; the ovipositors of the female ichneumonid (*Megarhyssa atrata*, top left) and stephanid (*Megischus annulator*, top right), trail behind them from the tip of their abdomens. From Amédée Louis Michel Lepeletier, comte de Saint Fargeau, *Histoire naturelle des insects* (1836–1846).

Johnston (1822–1891), a professor of surgery at the University of Maryland. As the antenna moves, the Johnston's organ is able to detect whether such movement is the result of gravity or deflection by physical or acoustic vibrations. This seemingly trivial feat has broad implications for insects because the organ expands the insect's general awareness. The subtle detection and discrimination of these movements by the Johnston's organ is used for an array of functions, from assisting flight stability to detecting nearby pressure-induced vibrations in the air. For example, some flies can detect the wingbeat frequency of a nearby insect using their Johnston's organ, going so far as to determine whether the vibrations are those of a courting mate. There are other traits that serve to define insects relative to other arthropods, but these are vastly more obscure.

ONE OF THE GREATEST challenges in entomology is the seemingly simple task of documenting those species that exist, learning where they may be found, and determining how they are interrelated and what we might discover of their biology. This is no small feat when you consider that the numbers are so great. There may be 4 million species or more still waiting to be recovered from our world's varied habitats, and each informs us of the greater tapestry of insectan evolution. Indeed, entomology suffers from a scaling problem. While a population of 1,000 ornithologists means each expert need only cover 10 species of birds, 1,000 entomologists would be responsible individually for thousands of species. The sheer number of insect species is often not appreciated unless compared to other

chordotonal organ within the antenna. This structure is formed of a bowl-shaped cluster of sensory cells within the second segment of an insect's antenna and is highly sensitive to the movement of the remainder of the antenna. It is called the *Johnston's organ*, named after its discoverer, Christopher

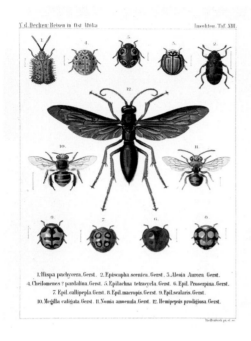

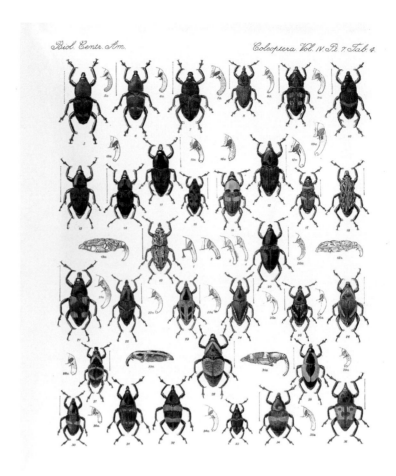

ABOVE: Various African beetles (above and below) and two bees—*Amegilla circulata*, at left, and *Pseudapis amoenula*, at right—surround a giant spider wasp (*Hemipepsis prodigiosa*). From Gerstaecker, *Reisen in Ost-Afrika*.

RIGHT: A panoply of tropical weevils of the family Dryophthoridae. From *Biologia Centrali-Americana. Insecta. Coleoptera.* (1909–1910).

animals. Consider, for example, that there are over 60,000 species of weevils, over 20,000 species of bees, and approximately 18,700 species of butterflies worldwide. Meanwhile, there are 30,000 species of fishes, almost 10,000 species of birds, and about 5,400 species of mammals. As presently known, weevils alone are 6 times the diversity of all birds, and unlike birds, new species of weevils are discovered at such a high rate that some entomologists estimate there may be over 200,000 species of this one insect group alone. Termites are one of the smaller insect lineages, and yet at over 3,100 species, they come close to rivaling all mammalian diversity. And this merely touches on the tip of an incomprehensibly large mountain of species among the other insects, and the countless more waiting to be discovered in our forests, deserts, plains, and streams. Inordinate indeed!

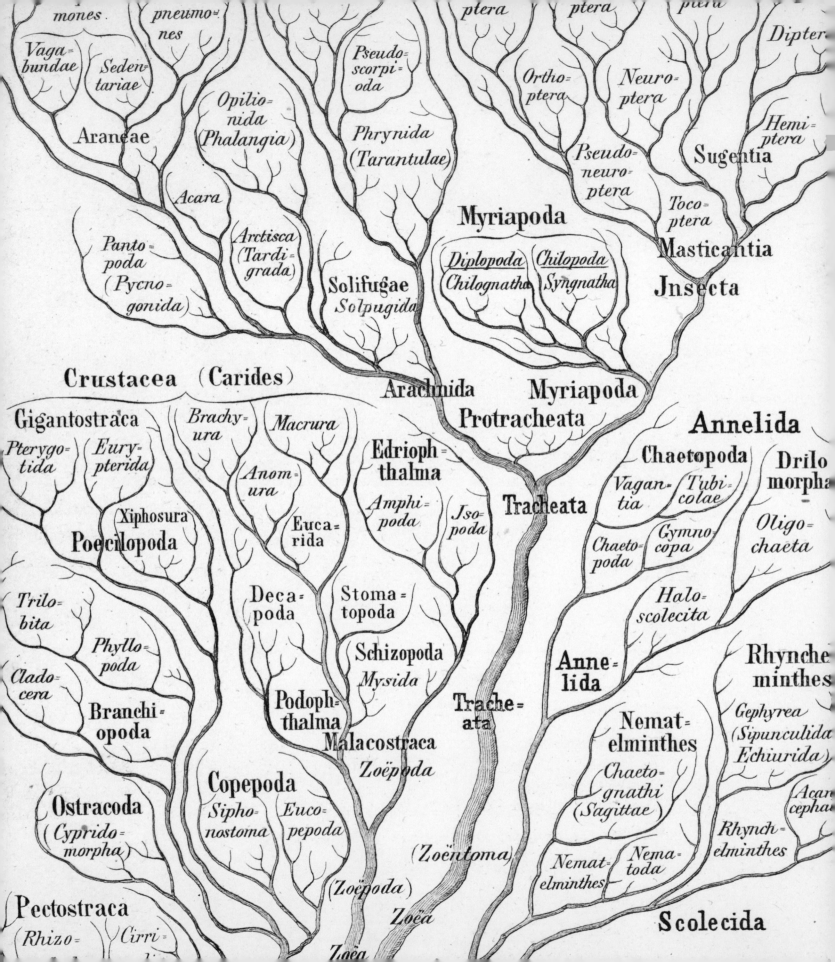

2

Grappling with
DIVERSITY

> *"I have heard it stated upon good authority that 40,000 species of insects are already known, as preserved in collections. How great, then, must be the number existing in this whole globe!"*

—William Kirby and William Spence
An Introduction to Entomology, 1826

PAGE 10: Detail from *Generelle Morphologie der Organismen* (1866) by noted German naturalist Ernst Haeckel (1834–1919) (also see page 23).

OPPOSITE: Frontispiece to Maria Sibylla Merian's *Over de voortteeling wonderbaerlyke veranderingen der Surinaemsche insecten* (1719 Dutch edition of *Metamorphosis Insectorum Surinamensium*, 1705, see pages 94–95). While a woman and cherublike children look over (or even fight over, as two of them are doing) a collection of specimens, the wild nature of Suriname can be seen through a massive window framed in neoclassic architectural elements.

One of the first things we do in life is classify the world around us. We learn to recognize and label the persons and objects that are most vital to our well-being, and this process of classification continues throughout our lives. Inevitably, our first words are an act of nomenclature and classification—*mommy* or *daddy*. In the same way, humankind has, since its infancy, sought to label and arrange the objects in our world, giving each a unique name so that we might communicate effectively with others. Names give meaning to our universe, and it is true to say that classification is fundamental to the human condition. Our classifications can be artificial, of mere convenience, or natural, reflecting historical or physical processes occurring in nature. We group stars into constellations, although these patterns do not exist in nature and instead reflect regional and cultural influences on our perceptions of the night sky. By contrast, we classify galaxies by the physical laws impacting their forms, spiral versus elliptical for example, or arrange elements by their molecular weight and associated properties. Our natural classifications organize and synthesize knowledge, facilitate effective communication, and, in their ultimate form, permit the formulation of testable predictions.

When one peers into the natural world, the rich variety of life can often become overwhelming and seem chaotic. Nonetheless, there is an order to be found. The process of evolution naturally produces a hierarchical arrangement of biological traits, such that one can distinguish groups nested within groups. Closely related species can be grouped into a genus, all of which stem from a most recent common ancestor. Closely related genera can be grouped into a family, families into an order, orders into a class, classes into a phylum, and phyla into a kingdom. These are the canonical ranks of the famous Linnaean hierarchy put forward by the great father of biological nomenclature, Carl Linnaeus (1707–1778), and which each of us learns, and frequently forgets, in elementary school.

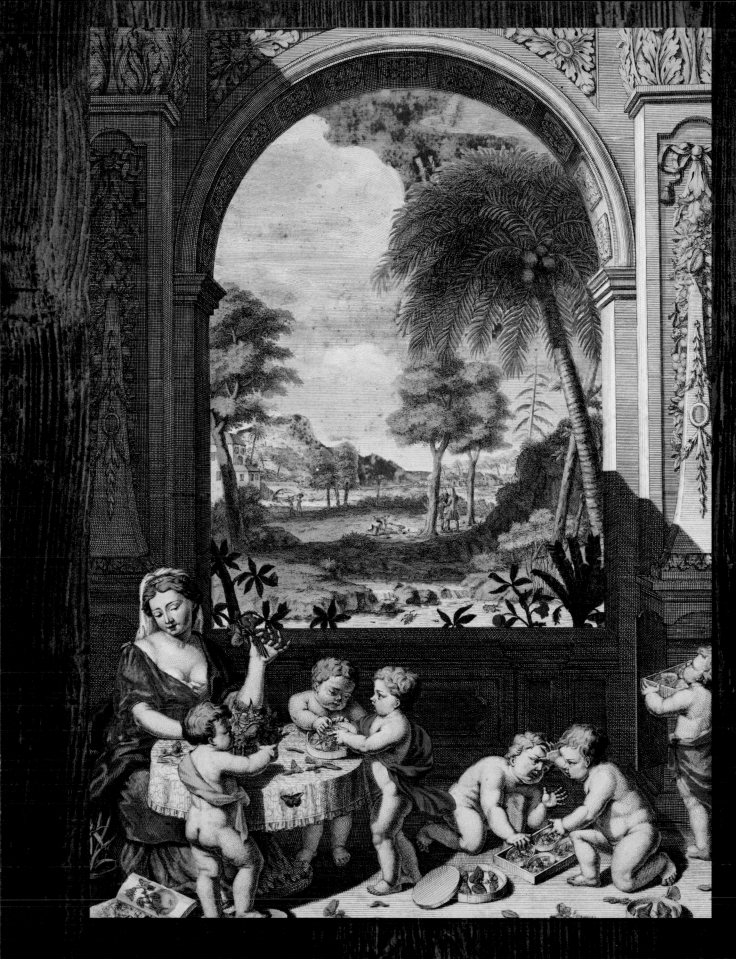

The title page of a 1758 edition of Carl Linnaeus's *Systema Naturae* (1735), wherein he stabilized the method by which we hierarchically classify the world's species.

Linnaeus, a Swedish botanist and physician, was not the first to work toward a grand organization of all species, but he was the first to provide a uniform and structured method by which the diversity of traits among species could be arranged into a natural system. He simplified the names of organisms, with each receiving a binomial indicating its genus and species, such as *Homo sapiens* for ourselves. Together, the application of binomial nomenclature and the arrangement of species into the Linnaean hierarchy provided a standardized means of communicating about the natural world, with each species in its designated place. Where previously it was challenging to know whether two authors were discussing the same species or not, Linnaeus's system made this transfer of information far more rigorous. This may seem trivial, but when faced with the difference between a poisonous or edible species, one that may cure disease or one that may pose a threat, it can quickly become a matter of life or death. The first step is agreeing on what we are discussing and establishing an agreed-upon name. As famously stated by Linnaeus, "If you know not the names, then the knowledge of things is lost." Linnaeus relied considerably on entomological observations recorded by his intellectual forbearers, and it took millennia of steady advances, hampered by false starts and reversals along the way, before intellectual evolution arrived at its own paradigm.

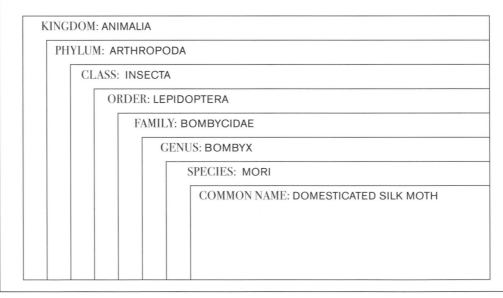

Linnaean Hierarchical Classification

The classification of the domesticated silk moth, *Bombyx mori*, is shown below, using the canonical ranks of the Linnaean system, with each group subordinate to the one above it.

KINGDOM: ANIMALIA
PHYLUM: ARTHROPODA
CLASS: INSECTA
ORDER: LEPIDOPTERA
FAMILY: BOMBYCIDAE
GENUS: BOMBYX
SPECIES: MORI
COMMON NAME: DOMESTICATED SILK MOTH

ENTOMOLOGY IN ANTIQUITY

Entomological observation extends deep into antiquity, and well before any written record. Our mythologies and religions are rife with references to insects, and tales of their lives filter into proverbs and parables. We are all familiar with Aesop's fable of the ant and the grasshopper, and the story of the plagues of biting insects and locusts brought down upon Egypt as related in Exodus. The earliest surviving account of an attempt to arrange, classify, and understand insects is that of Aristotle (384–322 BCE), the famed Greek scholar who mentored a young Alexander the Great, set forth the principles of formal logic, and is widely credited as the father of many lines of philosophical inquiry. Aristotle's *Historia animalium*, along with other works of antiquity, rightly recognized many of the groups we still know today, distinguishing bees from wasps, butterflies from moths, locusts from crickets. Although modified through the ages, Aristotle's writings would remain influential in one form or another for the next two thousand years. After him, entomological endeavors continued, but writers focused their discussions on strictly practical matters, covering only the most obvious species as they related to humans, or sought insects as moral allegories.

Dioscorides (40–90 CE), a Greek botanist and physician from Cilicia (modern-day Turkey) who worked in Rome during the rule of the infamous Nero (r. 54–68 CE), wrote an interesting pharmacological text, outlining the use of insects to cure numerous ills. Individuals suffering from *quartan ague*—recurrent fevers possibly caused by influenza or malaria—were treated by mixing seven bed bugs and beans with their food, while

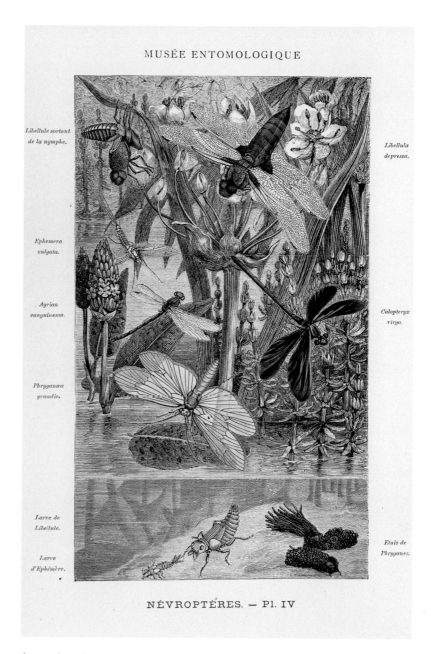

MUSÉE ENTOMOLOGIQUE

Libellule sortant de la nymphe.

Ephemera vulgata.

Agrion sanguineum.

Phryganœa grandis.

Larve de Libellule.

Larve d'Éphémère.

Libellula depressa.

Calopteryx virgo.

Etuis de Phryganes.

NÉVROPTÈRES. — Pl. IV

A snapshot of aquatic insect diversity amid their environs at different stages of life. Across the top, the broad-bodied darter dragonfly (*Libellula depressa*): left, as a naiad shedding its skin while suspended from a blade of water grass; at right, the adult in flight. In the center, an adult mayfly, far left; a ruddy darter dragonfly (*Sympetrum sanguineum*), left; a beautiful blue demoiselle damselfly (*Calopteryx virgo*), right; the large caddisfly *Phryganea grandis*, bottom, flying over a pond's surface. Beneath the water are mayfly and dragonfly naiads (left) and caddisfly larvae cases (right). From *Musée entomologique illustré: histoire naturelle iconographique des insects* (1876).

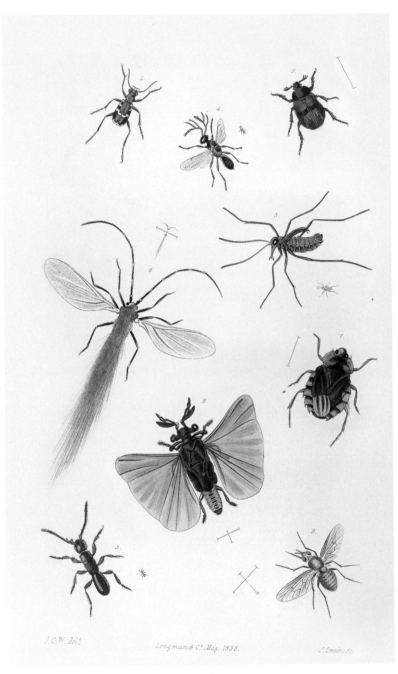

The splendid variety of insect life from the frontispiece of John O. Westwood's textbook *An Introduction to the Modern Classification of Insects* (1840), illustrated by the author. Clockwise from top left: northern dune tiger beetle (*Cicindela hybrida*), eulophine parasitoid wasp (*Dicladocerus westwoodii*), scarab beetle (*Anomala donovani*), snowflea (*Boreus hyemalis*), ancient river water bug (*Aphelocheirus aestivalis*), bee fly (*Phthiria fulva*), twisted-wing parasite (*Stylops aterrimus*), diapriid wasp (*Platymischus dilatatus*), and ensign scale insect (*Orthezia urticae*).

earaches could be eliminated with a tincture of ground cockroaches and oil. The contemporaneous Roman naval commander and naturalist, Pliny the Elder (23–79 CE)—who famously perished in Pompeii during the eruption of Mount Vesuvius—wrote an encyclopedia called the *Naturalis historia*, which, like Aristotle's volumes, would stand as one of the definitive sources for all things natural for more than a millennium. Pliny's arrangement of insects was effectively that of Aristotle's, but the individual biological information on each species did differ considerably at times. Roman authors, ever so practical as they were, wrote more extensively on the agricultural impact of insects, and Roman remedies for the control of pests may be found amid writings on farming and viticulture. Nonetheless, humanity had yet to appreciate the full diversity of the insects around them or the fact that conspicuousness does not always equate with importance.

Entomology, and in fact virtually all scholarly endeavors in Europe, suffered greatly when the Western Roman Empire came to a crashing end in the late fifth century. Scholastic endeavors retreated to monasteries and lost the broad support once enjoyed under the imperial structure of Roman society. Monks and scribes did what they could to copy existing elements of knowledge, but owing to a focus on revealed truth over empiricism, mystical interpretations were growingly pervasive. Perhaps the most influential and enduring entomological work coming out of the latter phase of imperial disintegration was the *Etymologiae* of Isidore of Seville (ca. 560–636 CE). Isidore's *Etymologiae* was an encyclopedic tome and therefore covered insects in his chapter on animals, but his take, characteristic of the time and indicated by the title, was to use the derivation of the names

themselves as the explanation of an insect's biology. The book was hugely influential, and it has been estimated that it was one of the most copied texts in late antiquity.

Isidore classified his insects in disparate sections. *De verminibus* (vermin) included beetles, silkworms, termites, and lice, while *De minutis volatibus* (tiny flying animals) covered bees, roaches, butterflies, cicadas, locusts, and flies. The knowledge conveyed was riddled with errors, with notions of spontaneous generation as a common recourse. For example, "The hornet is named from *cabo*, that is, from the packhorse, because it is created from them" and "*Bibiones drosophilae* [a name Isidore gave to what were perhaps fruit flies] are creatures that are generated in wine." Such insights could be found alongside the practical biology of basilisks—mythical crested serpents—and the belief that birds are born twice during their life. Many medieval writers continued along similar lines, although with each century came more departures from the traditions of antiquity. As in many things, however, the Renaissance brought a great flourishing in entomology.

RENAISSANCE CLASSIFICATION AND INSECTS

The first book dedicated strictly to insects, and particularly their classification, was *De Animalibus Insectis Libri Septem* (*On Insects, Seven Books*) (1602) by Ulisse Aldrovandi (1522–1605), a professor of natural science at the University of Bologna (see pages 20–21). Aldrovandi provided the first dichotomous key for the determination of insect groups, configuring the arrangement as he saw it

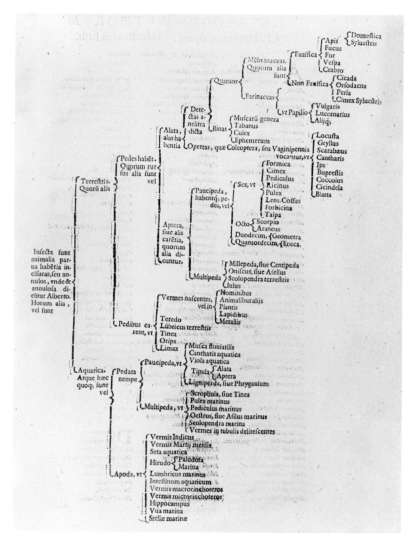

Although it was only meant to reflect a dichotomous means of identifying and organizing information about insects and related invertebrates, this hierarchical classification by Ulisse Aldrovandi (from *De Animalibus Insectis Libri Septem* [1638 edition, 1602]) was prescient and in several respects accurately reflects evolutionary relationships.

graphically and in an iconography that, to the modern viewer, resembles a depiction of evolutionary relationships.

While he most certainly did not operate with a concept of evolution in mind, several of his pairings would be considered accurate by today's analytical methods, attesting to

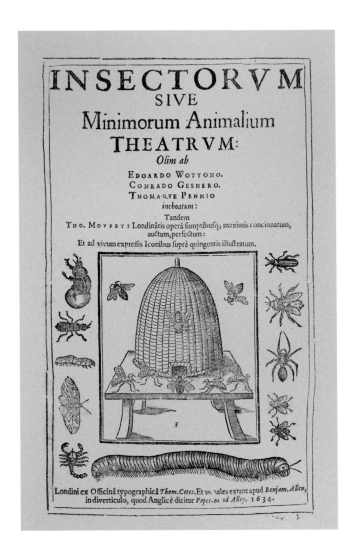

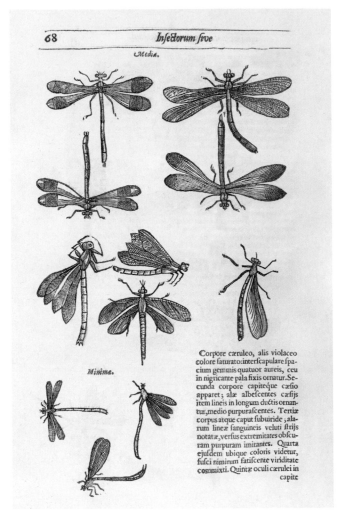

ABOVE LEFT: The title page of Thomas Moffet's *Insectorum sive Minimorum Animalium Theatrum* (1634), which summarized the contributions of many scholars and attempted to classify and describe the biology of insects and other arthropods then known. The work was prohibitively expensive to publish at the time and only appeared posthumously; his original illustrations were replaced with the fine woodcuts for which the book is known.

ABOVE RIGHT: Woodcuts of various dragonflies and damselflies (order Odonata) from Moffet's *Insectorum*.

Aldrovandi's skill as an observer. His book was made all the more accessible by the numerous woodcuts. For each species placed in his system, he provided whatever biological data could be obtained either through direct observation or through a comprehensive compilation of all prior literature, some of which had been less than thoroughly vetted before being repeated. The English doctor Thomas Moffet (1553–1604) made a similar attempt at compiling entomological knowledge. Moffet's *Insectorum sive Minimorum Animalium Theatrum* (*The Theater of Insects, or Smaller Animals*) (1634) was far less accurate or

comprehensive, although some of the wood-cuts are remarkable for their accuracy and were improvements over those of Aldrovandi, while others were simply unfortunate.

OPTICS AND INSECTS

Neither Ulisse Aldrovandi nor Thomas Moffet had the advantage of examining their subjects with the aid of a microscope. Around the turn of the century, perhaps in 1599, the first optical microscope was invented in Middelburg, in the Dutch province of Zeeland by either Zacharias Janssen (1585–ca. 1632) or Cornelis Drebbel (1572–1633)—although who should rightly hold credit is controversial. As the world of insects is often beyond the limited reach of our eyes, this revolution in optics opened new vistas into entomological minutiae. While Antonie van Leeuwenhoek (1632–1723) is famed for being the first to publish illustrations of microorganisms using the new technological advances, he was not the first to publish observations made with a microscope. In 1609, Galileo Galilei (1564–1642) developed his own simple microscope, and by 1611 he had been recruited into a relatively new scientific society, the famous Accademia dei Lincei, founded in Rome by naturalist and scientist Frederico A. Cesi (1585–1630). The Lincei published some of Galileo's early astronomical observations, including his treatise on scientific methodology, *Il Saggiatore* (*The Assayer*) (1623), and would later help defend him against the Church during his inquisition.

Using Galileo's microscope, Cesi and fellow Lincean Francesco Stelluti (1577–1652), a mathematician and doctor, studied and illustrated three bees, the famous triumvirate of bees from the Barberini family's coat of arms. The detailed images of the bees and their anatomy were printed as a broadsheet in 1625, titled as *Melissographia*, and presented as a Christmas gift to Pope Urban VIII (1568–1644), born Maffeo Barberini, from the Lincei as a symbol of *perpetuae devotionis* (perpetual devotion). These were the first printed images of organisms as viewed through a microscope, and quite appropriately, they were of an insect.

Cesi began expanding upon this for a book, the *Apiarium*, but died in 1630. Stelluti further developed the anatomical study, and incorporated the *Apiarium* into his *Persio tradotto in werso sciolto e dichiarato* (*[Works of Aulus] Persius [Flaccus] Translated into Light Verse and Annotated*) (1630), a text on the satires of Perseus meant to

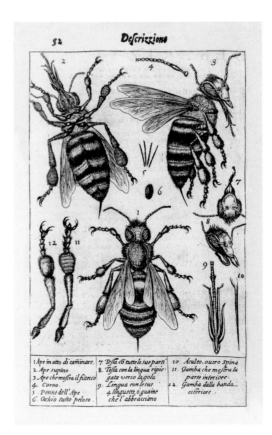

The first images produced with the aid of a microscope, one developed by Galileo, were a triumvirate of honey bees (*Apis mellifera*). Francisco Stelluti illustrated a worker bee from (from top left clockwise) underneath, the side, and the top, as well as finer anatomical details of the legs (bottom left), mouthparts and sting (bottom right), head (center right), and antenna (top center). From Stelluti's *Persio tradotto in verso sciolto e dichiarato da Francesco Stelluti* (1630). The illustration was originally printed in 1625 in a broadsheet titled *Melissographia*, and presented to Pope Urban VIII as a Christmas gift.

THE POPE'S DRAGON-SLAYER

Ulisse Aldrovandi was born into a noble family in Bologna, then part of the Papal States. His parents named him after Odysseus (*Ulixes* being the Latin variation of that name), one of Homer's heroes from the *Odyssey* and *Iliad*, while they named his brother for Achilles. Aldrovandi was inspired by the burgeoning sciences and humanities that were developing dramatically in sixteenth-century Italy. He studied logic, philosophy, mathematics, and law at the University of Bologna—the first university in Europe, founded in 1088—and completed a degree in medicine and philosophy in 1553. The following year he began teaching logic and philosophy, but he was more driven toward natural history. He began developing a collection of specimens and instructing students in natural science, eventually becoming the university's first professor of natural sciences, in 1561. Collecting obsessively, Aldrovandi developed an extensive "cabinet"—as collections were then known—of natural curiosities, and, in 1568, founded the city's botanical garden, a public garden, that is still in operation today.

Aldrovandi was never lacking in self-assurance, even boasting that he was the sixteenth century's Aristotle, and perhaps not surprisingly, he often found himself at odds with others. For

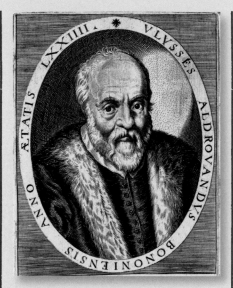

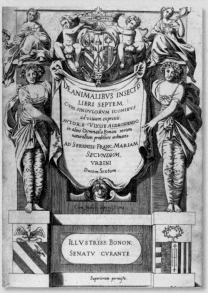

TOP: Portrait of Aldrovandi from his *Ornithologiae* (1599).

BOTTOM: Title page of Aldrovandi's *De Animalibus Insectis Libri Septem*, the first textbook dedicated exclusively to insects.

instance, in 1549 he was arrested for heresy, before being pardoned by Pope Julius III (1487–1555) in 1550. Then in 1575, Aldrovandi's quarrels with doctors in Bologna resulted in his suspension from the university. His mother was a cousin of Pope Gregory XIII (1502–1585), who is remembered by the eponymous calendar, among other reforms, that he commissioned to replace the Julian system of dates. Despite Aldrovandi's prior run-ins with the pontifical seat, Gregory intervened on his behalf in 1577 and he was allowed to resume his positions.

Aldrovandi's collection ultimately grew to become one of the largest assortments of natural objects of the sixteenth-century Renaissance. He wrote thousands of pages for an encyclopedic treatment of natural history, although most of his work was not published until after his death in 1605.

While Aldrovandi did much to advance natural history as a science, he was a creature of his time and many medieval notions permeated his writings, particularly as evidenced in his *Monstrorum Historia* (*The History of Monsters*) (1642) and *Serpentum, et Draconum Historiae* (*The History of Serpents and Dragons*) (1640). In fact, Aldrovandi was considered the dragon expert of the day, such that when Gregory was made pope, Aldrovandi was called upon to inspect a purported dragon that had appeared in

the countryside; he declared it a positive omen for the new pontiff.

One work that did appear during his lifetime was his *De Animalibus Insectis Libri Septem* (*On Insects, Seven Books*) (1602), an encyclopedia of everything to do with insects. Aldrovandi did not restrict his writing to mere practical applications, but attempted to consider all insect diversity as he understood it. This was a departure from previous generations and the reason why many regard him as the founder of modern natural history. Aldrovandi's book can be considered the first textbook of entomology, and it even includes a dichotomous arrangement for his classification, the iconography of which is strikingly similar to that of an evolutionary tree. While advocating empirical evidence, Aldrovandi was, however, susceptible to questionable observations and rather incredible leaps in logical reasoning. In support of the ancient belief that bees were generated from the carcasses of oxen, he purportedly opened five drones, discovering within each of them the tiny heads of oxen—clearly irrefutable support for the hypothesis. Fortunately, it would not be long before the mysteries of metamorphosis would be revealed to all.

Aldrovandi's woodcuts of crickets, katydids, and grasshoppers from *De Animalibus*.

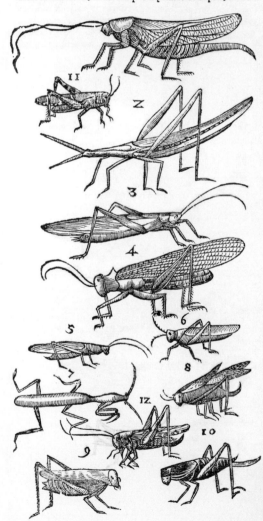

Liber Quartus de Insectis. 413

A verò viridi, & subalbido variat. Tibia, ac pediculi instar serræ dentati, dilutè punicei suat. Alæ media sui parte vltra extremam aluum in longum protenduntur, quaternæ. Harum binæ superiores fusco, & balio maculosæ. Inferiores ex fusco argenti splendore micant, ac à volatus officio cessante insecto, minimè vt illæ simplices sunt, sed decuplo rugarū ordine in se complicatæ, quomodo mantilia extergendis manibus dicata, & puerorum illæ ex charta laternæ viæ duces, multiplici plicarum serie, sibi mutuo incumbentium componi solent, quas cùm ad volatum explicat, in trium digitorum latitudinem distensas est intueri.

Secunda Tabula duodecim habet Locustarum diuersas species. Prima è maiorum genere dorsū habet colore ochræ nigris minutis pūctis, siue guttulis consperso. Alarū tegmen viridescit, & eiusdē coloris, & magnitudinis punctulis notatur. Caput, pectus, & aluus, it è pedes viridi, ochroqᵢ variāt. Aluus in aduncū aculeū orhræcolore desinit; capite Perlis similis est. Antēnas habet mirę lōgitudinis, & tenuitatis, rubicūdas subrutilas. Nu. 2 Locusta capite, & antennis Cochleā, siue Domiportā æmulatur. Capite, nisi oculi id proderēt, carere videretur.

Antēnę crassæ sunt, & crassa quoqᵢ admodum femora posteriorum pedūm. Alas habet corpore protensiores. Vndiqᵢ, concolor sibi. Color est cinereo flauescēs. Num. 3. Locusta est è genere vulgarium, vnicolor, viridis, præter antēna s, quæ lutescunt. Quarta tricolor Locusta vocari potest. Vulgo Frate hoc est monachus nominatur, nō ob colorū diuersitatem, sed quòd cucullata est. Caput collum cucullatum, pectus, & femora posteriorum pedū sunt viridia. Tibiæ verò eorundē pedum sanguinei planè coloris: cætera omnia cinerea. Antennæ exiles, sursū erectę. Quinta ex aculeatarū, siue caudatarum genere, vbiqᵢ; vnicolor, viridis. Num. 6. ex atro cinerea, vndiqᵢ sibi concolor est. Septima ἄπτερος, Bruchus dici potest, fœtū illius maximæ, quæ primo loco in prima tabula spectatur, esse puto: nam etiā gibbosa est, & priores pedes, è pectoris initio è gibbi, seu tuberculi regione, producit, & viridis est tota. Num. 8. ea videtur, cuius descriptionem supra dedimus ex authore de natura rerum: nam aculeum habet pro cauda, vt ille loquitur, & tota viridis est, caput equino capiti simile. Tales Hollandi, vt audio Corenmesen vocāt. Tales ego propriè legitimas

Mm 3 Lo-

The title page of John Ray's *Historia Insectorum* (1710), a work that laid out observations on the biology of numerous insect species and greatly influenced the classificatory efforts of scholars who followed Ray, such as Linnaeus.

obscure the scientific observations being published, as Urban VIII remained less than favorable toward such inquiry. Insects would remain a subject of great fascination to early microscopists, and many were featured in English polymath Robert Hooke's (1635–1703) famous treatise, *Micrographia* (1665), prepared with a significantly improved instrument relative to that of the Linceans.

LATER CLASSIFICATION: SPECIES, HIERARCHY, AND EVOLUTION

While numerous other tracts on insects were produced, one of the more transformative efforts at classifying entomological diversity was the posthumously published *Historia Insectorum* (1710), by John Ray (1627–1705). Ray was an English naturalist and theologian who expressed a particular interest in botany and entomology. Quite amazing for the time in which he lived, Ray is credited with providing the first biologically based concept for what constituted a "species." In brief, Ray considered species to be all those individuals who derived from a common progenitor, a notion so modern in form and analogous to the biological species concept—which would not be codified until 1942—as to be astounding. This prescient and succinct definition of species is a virtual blueprint, if writ over a larger scale, for evolution itself.

Ultimately, this lengthy tradition led to Linnaeus and his own revolution in biological classification. In fact, authors such as Moffet and Ray so influenced Linnaeus's thinking that he adopted many of the names they had employed for particular groups or species of insects. Linnaeus, like the authors before him, did not conceive of the classifications of insects in terms of evolutionary descent, yet they were unknowingly identifying enduring patterns reflecting the underlying evolution that had occurred. The process and mechanism of evolution, whereby changes in populations of an ancestral species diverge to give rise to novel descendant species, produces a hierarchy as a natural byproduct. So, at its simplest, we find that all arthropod species have an external exoskeleton, all mandibulate arthropods have mandibles as their primary feeding appendages, all insects have six legs and three body sections, all butterflies and moths have scales on their wings, and so forth; each sharing the suite of particular traits with their most recent common ancestor and its many descendants.

Authors prior to the advent of evolutionary thinking struggled over explanations for this observed phenomenon, that nature should appear to be so hierarchically arranged. It took the work of a somewhat reclusive beetle collector to bring it all together, uniting the millennia of observations of biological traits along with population and developmental biology, patterns of geographical distribution, behaviors, and geological history to arrive at the unifying notion that species come from extinct, ancestral species through the isolation of naturally occurring variations, differential survivorship (that is, not all individuals have an equal chance of surviving), and specialization in the face of climatic change, predation, or other influences impacting reproductive success. Those variants that survived the change in the local environment would pass their traits on to the next species, and so on. The remainder would perish, relegated to the annals of extinction. So it was that Charles R. Darwin (1809–1882)

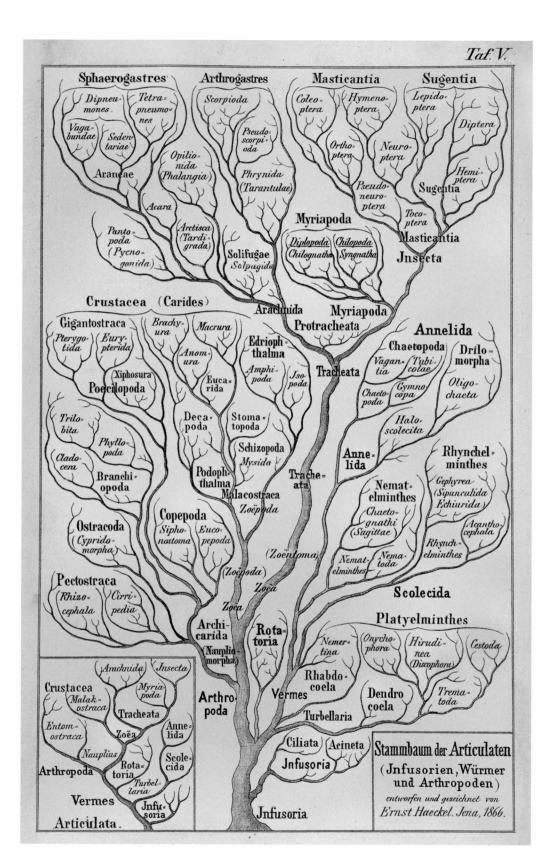

The earliest iconography of genealogical relationships among articulated invertebrates after the Darwinian revolution. The arthropods form the large branch along the left and top of the tree, with the insects nested beyond myriapods in the upper right corner. From Haeckel, *Generelle Morphologie der Organismen*.

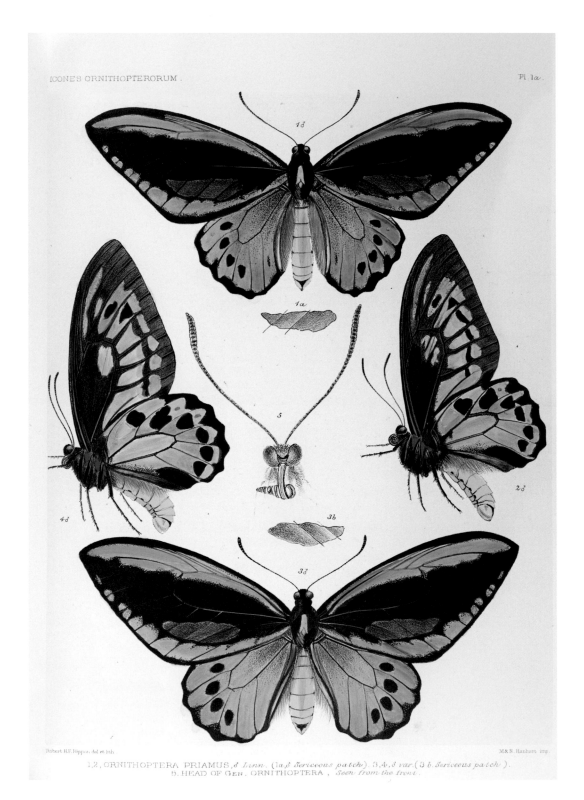

Pl. 1 a.

1,2, ORNITHOPTERA PRIAMUS, ♂ *Linn*. (1a,♂ *Sericeous patch*), 3,4,♂ *var*.(3 b. *Sericeous patch*).
5. HEAD OF GEN. ORNITHOPTERA , *Seen from the front*.

Robert H.F. Rippon. del et lith.

M.& N. Hanhart. imp.

The common green birdwing butterfly (*Ornithoptera priamus*), with its dramatically marked wings, is one of the millions of insect species alive today that collectively attest to the considerable success and ancient history of insects. From Robert H. F. Rippon, *Icones Ornithopterorum* (1898).

articulated a viable mechanism by which evolution would take place. This forever transformed our understanding of the world around us. Darwin helped us realize that natural classifications were those that accurately reflected the underlying relationships established by evolution, and that with this new appreciation there was "grandeur in this view of life."

Classifying and understanding the evolutionary relationships among insects is no simple task, partly owing to the aforementioned vastness of their numbers. The clues to their extensive past and interconnected lines is written in their anatomy and underlying genome, and today entomologists bring together these disparate forms of data in order to recover a holistic view of insect history. Today's evolutionary classification of insects is deeply rooted in the history of their study. While new discoveries refine our understanding, it is phenomenal the degree to which many early researchers, working with quaint tools, were able to correctly discern such important distinctions. In some instances, we have been unable to perfect any further those revelations arrived at a century or more ago.

When we think of major groups of insects such as roaches, grasshoppers, beetles, wasps, or flies, these are distinctions among what scientists consider taxonomic orders, the Linnaean rank below the class Insecta but above the various families. Examples of families would be the Drosophilidae (fruit flies), Bombyliidae (bee flies), Syrphidae (flower flies), and Muscidae (stable flies), all belonging to the order Diptera (true flies). Long before any of these insects existed, however, their earliest progenitors were among the first animals on land, living more

than 410 million years ago and on an Earth so different from our own as to seem alien.

At the start of the Devonian period, around 420 million years ago, land animals were dominated by arthropods. Originally living in the oceans, particular groups of ancient Arthropoda evolved into terrestrial species, appearing after some early plants had already departed the water and begun colonizing the land. The world had no forests, fields, or meadows. The primitive land plants at this time remained comparatively simple, lacking structures like leaves, which we find so indicative of our present-day flora. Instead, early land plants were short, much like floral beds in home gardens today, lacking roots and never venturing far from water. Vertebrates, specifically amphibians, would not join the insects on land until much later during the period and after terrestrial floras became more developed.

By the close of the Devonian period, some sixty million years after its start, organically rich soils would appear, supporting forests of giant ancestors of ferns, along with a vibrant insect life—most of which would move about on two pairs of membranous wings. But before all of this, before wings and flight, before arborescence, before our planet's landscapes greened, there were already insects. The story of the six-legged was already underway, and anyone peering into that ancient Earth would scarcely dream that those animals, of all of life's variety, would come to rule the world.

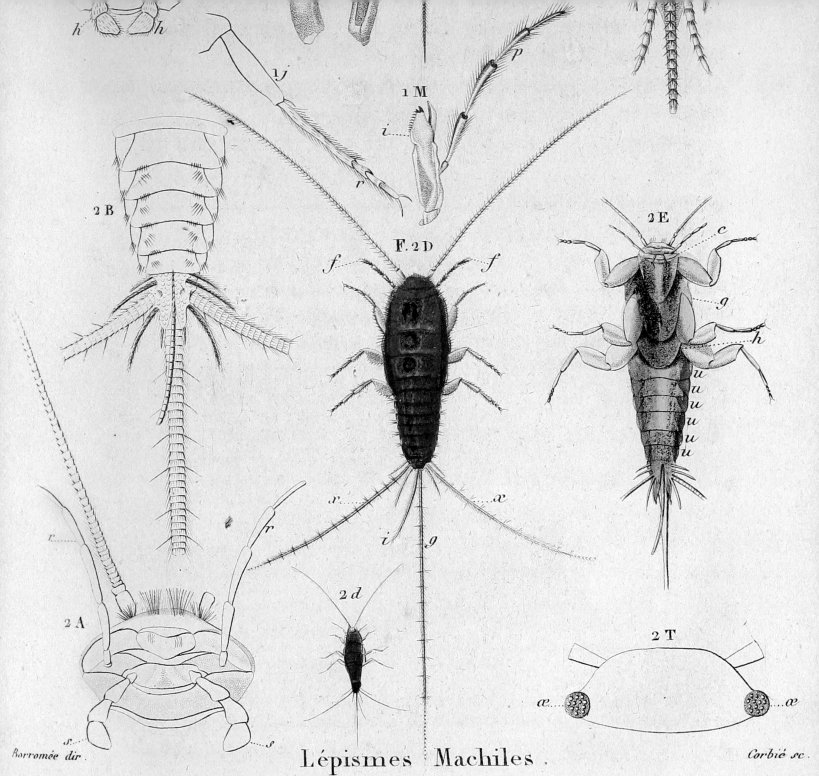

Lépismes Machiles.

Lépisme Ablette F. 1 D *un individu grossi.* x-x *et* g *soies articulées.* i *le plus long des appendices mobiles.* 1 d *le mé-*
me individu de grandeur naturelle. 1 t *levre supérieure ou chaperon.* 1 T *la levre inférieure.* s-s *les palpes labiaux.* 1
M *une machoire séparée.* i *l'extremité de la machoire.* p *le palpe maxillaire.* 1 m *les mandibules séparées.* a *une*
mandibule ou du côté extérieur. b *une mandibule vue du côté intérieur.* 1 j *la jambe.* r *le tarse.* 1 l *la langue.*
Lépisme aphie F. 2 D *un individu grossi.* x-x *les soies articulées latérales.* g *la soie articulée du milieu.* i *le*
plus long des appendices mobiles. f-f *les palpes maxillaires.* 2 d *le même de grandeur naturelle.* 2 E *le même vu*
en dessous grossi. c *le prothorax.* g *mésothorax.* h *le métathorax.* u-u *segmens.* 2 T *la tête.* x-x *les yeux.*
2 A *la tête vue en dessous.* s-s *les palpes labiaux.* r-r *palpes maxillaires.* 2 B *extremités du corps.* Machile gra

3

Earliest of the
SIX-LEGGED

"'What sort of insects do you rejoice in, where you come from?' the Gnat inquired.
'I don't rejoice in insects at all,' Alice explained, 'because I'm rather afraid of them—
at least the large kinds. But I can tell you the names of some of them.'
'Of course they answer to their names?' the Gnat remarked carelessly.
'I never knew them to do it.'
'What's the use of their having names,' the Gnat said, 'if they won't answer to them?'
'No use to them,' said Alice; 'but it's useful to the people who name them, I suppose.
If not, why do things have names at all?'"

—Lewis Carroll
Through the Looking-Glass, 1871

In Lewis Carroll's *Through the Looking-Glass*, Alice finds herself reduced to the size of an average insect and chats about entomological nomenclature with a gentlemanly gnat while sitting beneath a tree. Alice politely names those insects she is most familiar with, such as a butterfly and a dragonfly. Although Alice could rattle off familiar names for some insects, among those most primitive of the six-legged there are species so infrequently encountered by the average person as to have scarcely more than their Linnaean scientific names—names Alice might never have imagined. In fact, all of Alice's examples were of insects who could fly, but there was once a time in the distant past—before birds, before dinosaurs, before vertebrates left the oceans to walk on land—when insects had not yet evolved their gossamer wings. Few descendants remain today of those earliest wingless hexapods who had already developed their own way of life, confined to the land before other insects evolved an ability to fly. Unfortunately, most of us are unfamiliar with their names or they've never been given common names at all.

Only five groups today represent the descendants of those ancient six-legged animals that could never fly. Three belong to the pucker-faced Entognatha (see page 7); while they have six legs and are sister to true insects, or class Insecta, the Entognatha are not true insects themselves. The three orders comprising the Entognatha are the Collembola, called springtails, and the Diplura and Protura—neither of which has a common name. (Although some people have recently proposed potential names for each, these candidate names are not widely known, even among entomologists). Rounding out the five groups are two belonging to the true insects. These are the bristletails and silverfish, which are orders Archaeognatha and Zygentoma, respectively. While all of these animals can scurry, climb, or even jump, none can, or ever could, fly. While we, like Alice, often recall the names of insects, we are biased toward those with wings.

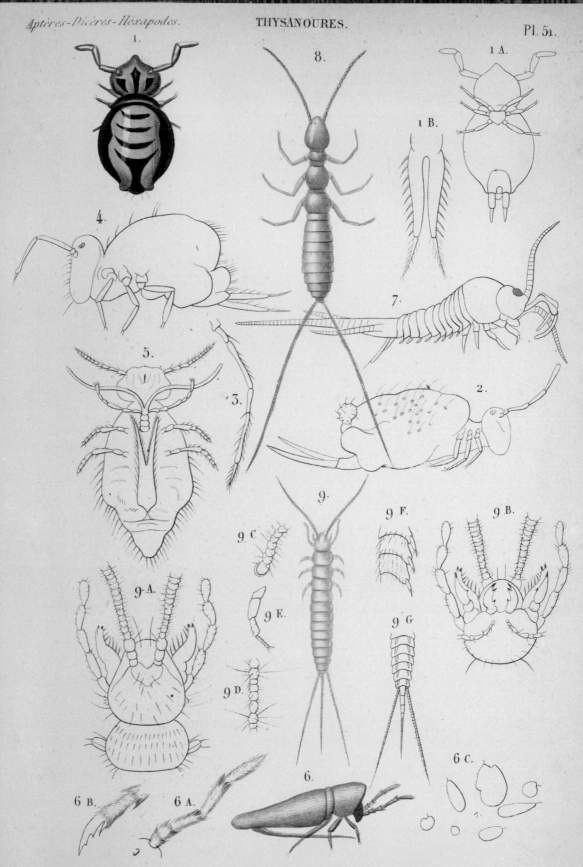

Smynthures, &c.

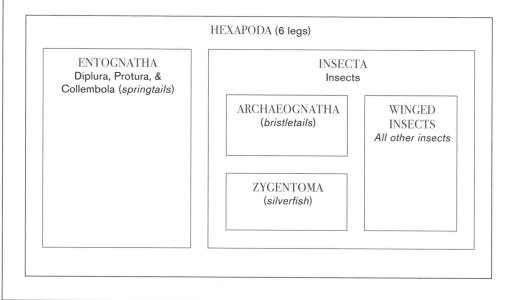

Hierarchical Organization of Hexapoda

Hexapod diversity is organized into a series of hierarchically arranged groups, the most familiar of which are the insects, and particularly the winged insects.

HEXAPODA (6 legs)

ENTOGNATHA
Diplura, Protura, &
Collembola (*springtails*)

INSECTA
Insects

ARCHAEOGNATHA
(*bristletails*)

WINGED
INSECTS
All other insects

ZYGENTOMA
(*silverfish*)

There are certainly other flightless insects, such as worker ants, fleas, and myriad more, but in the case of these species, each is the result of the *loss* of wings from ancestors who were fully flight capable. The entognathans, bristletails, and silverfish, and all of their progenitors, however, never had wings at all, and so can be considered as the truly wingless. By the time other insects took to the air on their membranous wings, the originally wingless subset of hexapods had already been around for generations, and would have looked upon the flying insects as young newcomers.

Early naturalists, such as Ulisse Aldrovandi (see pages 20–21), often failed to make notice of these Lilliputian hexapods, or generally grouped them all together as mere vermin of no practical use or harm. Naturalists after Aldrovandi were eager to make sense of all insects, not just those that were obviously of some benefit or nuisance, yet found it challenging to discern the finer details of anatomy that distinguish some types of insect from others. This difficulty was partly the result of their small sizes, most of these wingless hexapods being less than a centimeter in length and often much smaller. Linnaeus, who placed a great emphasis on the various forms of insect wings as a means of defining the orders he categorized in his *Systema Naturae* (*System of Nature*) (1758), lumped all wingless insects into a catch-all group he named Aptera, from the Greek for "those without wings." Unfortunately, in doing this he threw together not only

the originally wingless hexapods, but also any other arthropods that lacked wings. The result was a meaningless group of creatures as disparate and clearly unrelated as termites, lice, fleas, and even arachnids and crustaceans, collectively defined not by anything that truly united them but instead by the mere fact that they were not flying insects. Mesmerized by wings, Linnaeus failed to realize the significance of the difference in body plans between the wingless hexapods, arachnids, and crustaceans, and it would remain for later taxonomists to bring to the forefront the evolutionary distinctiveness of these latter groups.

Originally wingless insects are found throughout the world, although some are more abundant and frequently encountered in temperate or tropical habitats. Most have small structures called *eversible vesicles* present on the undersurface of the abdomen. These are tiny, fleshy lobes that can be extruded by internal blood pressure and are used to absorb water. Not surprisingly, then, most originally wingless hexapods live in moist habitats, alongside sources of water, and some even live on the water's surface. Bristletails and silverfish are the best exemplars for what the ancestor of all insects might have looked like, and they retain many traits that are considered primitive relative to the remainder of the class Insecta. For instance, bristletails and silverfish, as well as most entognathans, molt continuously throughout their life, including after sexual maturity. By contrast, all other insects stop molting after reaching maturity, with one notable exception to be highlighted later on. In addition, entognathans, bristletails, and silverfish do not copulate, unlike other true insects, but instead males transfer sperm indirectly via a structure they produce called a *spermatophore*, which is a packet that contains the sperm within an environment suitable for the sperm's survival outside of the body. The female then collects the spermatophore and fertilization is completed internally as she pulls the spermatophore within her. The spermatophore frequently contains various nutrients that nourish the female and the eggs.

THE ENTOGNATHA: DIPLURA, PROTURA, AND COLLEMBOLA

The Entognatha are so infrequently encountered by anyone other than entomologists that most lack common names. These species generally live on the soil surface or under vegetation or rotting bark, frequently near a source of water such as along rivers or ponds. As the

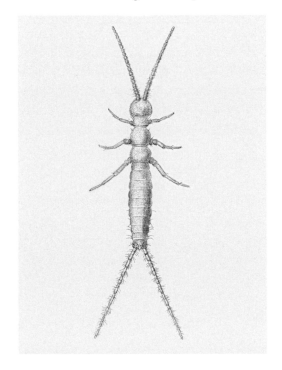

The small and herbivorous diplurans such as *Campodea staphylinus* are rarely observed, with scarcely more than two hundred known species. Illustration from John Lubbock's *Monograph of the Collembola and Thysansura* (1873).

LORD OF THE FLIGHTLESS

Precisely one year prior to her death, Queen Victoria (1819–1901) directed the passage of letters patent raising Sir John Lubbock (1834–1913) to the peerage as 1st Baron, Lord Avebury. The title honored Lubbock's role in conserving Britain's greatest Neolithic site, Avebury. In order to prevent the land from being disturbed, Lubbock bought the area outright and then, in his parliamentary role, pushed legislation forward that conserved many prehistoric sites. It was the first law of its kind within the United Kingdom.

Lubbock was quite a Renaissance man, and although a banker and politician by trade, his real passion was science, particularly archeology and entomology. In fact, his contributions to both archeology and entomology are so considerable that one would scarcely believe he had time to do much else. Our concepts of Paleolithic and Neolithic periods among Stone Age peoples were first articulated in Lubbock's works, and—quite shockingly for the age in which he wrote—applied the notions of Darwinian evolution to humans and their civilizations in *The Origin of Civilisation and the Primitive Condition of Man* (1870). Lubbock was even so bold as to mimic the title of Darwin's landmark 1859 book in one of his, titling it *On the Origin and the Metamorphoses of Insects* (1872). In fact, Lubbock regularly corresponded with Darwin, who lived not far away, and served as a pallbearer at Darwin's funeral in Westminster Abbey in 1882.

Lubbock wrote a particularly delightful book on the biology of ants, bees, and wasps in 1882, among many other subjects. Most remarkable among his

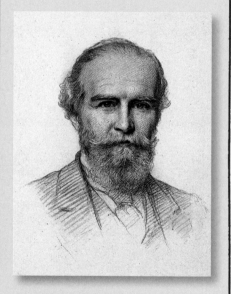

Sir John Lubbock, 1st Baron, Lord Avebury. Reproduction after a pencil drawing by H. T. Wells (1896).

many entomological achievements was a beautifully illustrated monograph on the primitive wingless hexapods, which prior to this work were collectively lumped into an artificial grouping known as the Thysanura. The name comes from the Greek *thysanos*, meaning "tassel" or "fringe" and *ourā* for "tail," and refers to the filament-like tails of silverfish and bristletails (see pages 38–41). Lubbock was the first to clarify the many distinctions among these early hexapods, not a simple task given their minute sizes and the relatively crude scientific optics of the day. In fact, many times researchers relied on candlelight reflected off mirrors to illuminate their microscopes, or they had nothing more than a hand lens through which to peer at the tiny arthropods.

Nonetheless, using these simple tools, Lubbock came to the realization that the primitive hexapods were not a natural group, that is to say that they were not all each other's closest relatives. He formalized two taxonomic groups—the Collembola for the springtails (the entognathan orders Protura and Diplura were not yet known at the time of his work) and a more narrowly circumscribed Thysanura—to include the wingless true insects of the orders, Archaeognatha and Zygentoma. Lubbock created the name *Collembola* and was the first to acknowledge that they lacked the filament-like tails of silverfish and bristletails.

In his work *Monograph of the Collembola and Thysanura* (1871), Lubbock described many new species, discussing their evolution and elaborating as no one before on the morphology and

anatomy of these animals in relation to their natural history. While Lubbock prepared the original sketches of anatomical details, the many beautiful illustrations in the book were the work of another. The lithographs were executed, and some painted by hand, by a Mr. A. T. Hollick, who Lubbock remarked as being, "a gentleman who is unfortunately deaf and dumb, but in whom these terrible disadvantages have been overcome by natural genius." Lubbock thanked Hollick effusively for the "beauty and accuracy of his work." Whereas many sumptuously illuminated volumes were produced throughout the nineteenth century that reveled in gaudy butterflies and showy beetles, this singular text delighted in the hidden wonder of springtails, silverfish, and their kin. One might truly say that the systematization of the primitively flightless hexapods was founded by Lubbock, making him the first "Lord of the Flightless" in the peerage of entomological evolutionary biology.

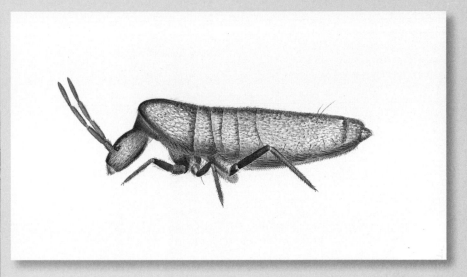

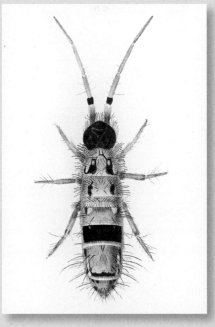

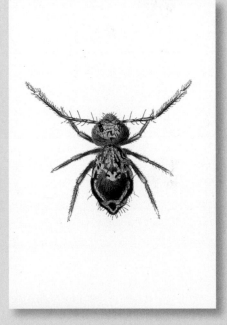

TOP: The subtle silvery blue and gray colors of the hunched and elongate springtail *Lepidocyrtus curvicollis*, as rendered by Hollick for Lubbock's *Monograph*.

ABOVE RIGHT: Lubbock was one of the few nineteenth-century scholars to appreciate the primitively wingless hexapods for their subtle beauty, such as seen in this miniscule globular springtail (*Ptenothrix atra*), as well as the intricacies of their biology and anatomy.

ABOVE LEFT: The many magnificent illustrations of springtails (such as this *Orchesella cincta*, diplurans, silverfish, and bristletails in Lubbock's *Monograph* were executed by A. T. Hollick, a deaf and mute artist.

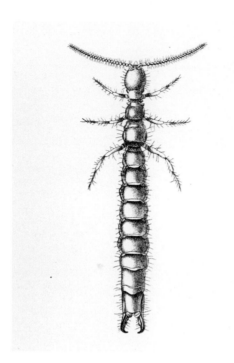

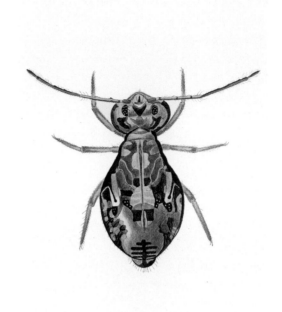

name *Entognatha* implies—*ento*, "inside," and ancient Greek *gnáthos*, "jaw"—the mouthparts are tucked up within a pocket, known as a *gnathal pouch*, in the head capsule.

Among the approximately one thousand known species of Diplura—most of which are 2 to 5 millimeters in length (although a minor few can be almost ten times this size)—there are two basic types: herbivores with long, multi-segmented appendages called *cerci* at the back of the body resembling antennae or paired tails, and predators with cerci shortened into a pair of stout pincers, used for grasping their prey. Dipluran mothers will guard their eggs and the young after they have hatched. Being a dipluran mother, however, can be a dangerous calling, as some hatchlings can turn cannibalistic and devour their parent.

The similarly obscure Protura comprise about five hundred species of truly minute (less than 2 millimeters in length) and wholly bizarre animals, which were not discovered until 1907. Nonetheless, they inspired the late Swedish entomologist Søren L. Tuxen (1908–1983) to devote the majority of his career to their study, producing what remains the definitive monograph on them in 1964. Species appear to be specialized herbivores that feed on fungi and are distinctive for the loss of their antennae, and instead use their front legs as sensory organs. Holding their forelegs up and in front of them, proturans walk using only four legs, despite being hexapods.

Last but certainly not least among the Entognatha are the Collembola, the most diverse of them all, with around nine thousand species and the only entognathans to have a common name, the springtails. Springtails are putatively related to the Protura, although evidence for this has been conflicting. Species of springtails are found throughout the world, even in the seemingly uninhabitable polar

regions, on the tops of the highest mountains, and in the deepest of caves. Some individuals can grow to more than 20 millimeters in size, but most are far smaller, even less than a third of a millimeter in length. They are generally scavengers of decomposing matter and fungi, but a few will prey on a variety of microorganisms such as minute worms or other tiny arthropods. The antennae of springtails are rather reduced and squat, and the bodies are either globular in form or somewhat cylindrical, and are frequently marked with patterns or color. For instance, the largest springtails, which belong to the genus *Tetrodontophora*, are usually a bright, velvety purple or blue. They are often found in aggregations in caves or along the edges of ponds and streams.

Some springtails don't just live near freshwater, they actually live on its surface and are therefore effectively fairly aquatic. In general, Collembola have fairly hydrophobic (water-repellent) exoskeletons, which make it easier for them to come into contact with water without being engulfed and drowned. The semi-aquatic species of Collembola have further specializations among their setae as well as structures on their feet that collectively permit them to avoid breaking the surface tension of the water. Indeed, other modifications allow them to control their movement over the water, and the males of these species produce peculiar spermatophores that rest on the water for retrieval by receptive females. Not only are Collembola the most diverse of entognathans in numbers of species, but they are also the most abundant. Often, when conditions are ripe, they form aggregations with several million individuals clustered together. The purpose of these swarms is not entirely understood but appears to be the result of particularly suitable reproductive circumstances and episodes of dispersal to new localities.

The name *springtail* references the order's singular mechanism of rapid movement. Aside from their three pairs of legs, springtails have a true spring on the underside of their abdomen which, when released, literally hurls the

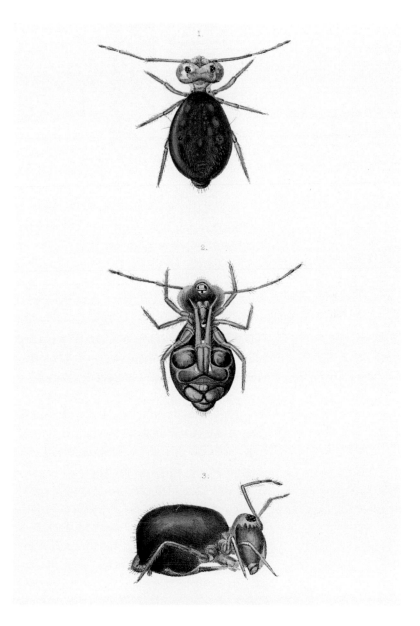

The globular springtail *Dicyrtoma fusca* viewed from above, below, and the side. The paired arms of the spring, which permits these animals to leap, can be seen folded beneath. From Lubbock's *Monograph*.

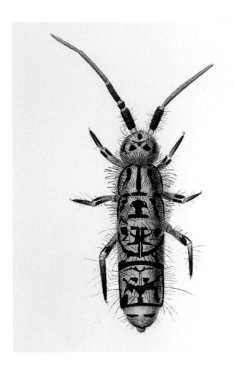

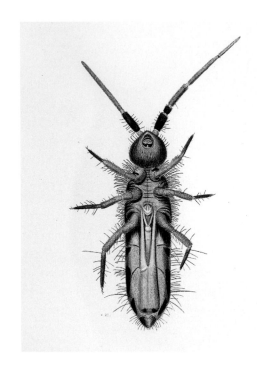

animal through the air, often to considerable distance. Some springtails can fling themselves up to eighty times their body length. Today, the world's record for a running long jump by a human is slightly over 29.3 feet (8.95 meters), or about five times an average man's height. Imagine leaping nearly 465 feet (142 meters), and without a running start—that approximates the achievement of these springtails!

On the underside of the abdomen toward the back, a springtail has a structure formed from the fusion of paired abdominal appendages that is the actual moving component of the spring; this is called the *furculum*. The furculum is folded forward and held tightly in place by a small lock, or *retinaculum*, positioned more anteriorly on the abdomen's center. The furculum is held in place with considerable potential energy until the animal is disturbed, at which point it is quickly released and the force propels the springtail

aloft. This method of dispersion is not flight, and they cannot be considered flying animals. Springtails have no control over their movement in the air, nor can they glide or direct their descent back to earth, so they can just as easily end up in a worse place whence they started. However, the jumps are sufficiently quick and lengthy, particularly the combination of repeated leaps, to remove the animal from any precarious situation or to aid dispersal to new habitats. Since springtails are tiny and of minimal weight, they are often captured in air currents during their leaps, and by riding the winds they may be deposited on distant islands, mountain peaks, or elsewhere. By becoming "aerial plankton," springtails have managed to colonize the world as diminutive and often unseen conquerors.

This means of spring-loaded movement is truly ancient, and the remains of a species of springtail are among the earliest of fossil

be exchanged at the store in accordance with the applicable warranty.

Returns or exchanges will not be permitted (i) after 14 days or without receipt or (ii) for product not carried by Barnes & Noble or Barnes & Noble.com.

Policy on receipt may appear in two sections.

Return Policy

With a sales receipt or Barnes & Noble.com packing slip, a full refund in the original form of payment will be issued from any Barnes & Noble Booksellers store for returns of undamaged NOOKs, new and unread books, and unopened and undamaged music CDs, DVDs, vinyl records, toys/games and audio books made within 14 days of purchase from a Barnes & Noble Booksellers store or Barnes & Noble.com with the below exceptions:

A store credit for the purchase price will be issued (i) for purchases made by check less than 7 days prior to the date of return, (ii) when a gift receipt is presented within 60 days of purchase, (iii) for textbooks, (iv) when the original tender is PayPal, or (v) for products purchased at Barnes & Noble College bookstores that are listed for sale in the Barnes & Noble Booksellers inventory management system.

Opened music CDs, DVDs, vinyl records, audio books may not be returned, and can be exchanged only for the same title and only if defective. NOOKs purchased from other retailers or sellers are returnable only to the retailer or seller from which they are purchased, pursuant to such retailer's or seller's return policy. Magazines, newspapers, eBooks, digital downloads, and used books are not returnable or exchangeable. Defective NOOKs may be exchanged at the store in accordance with the applicable warranty.

Returns or exchanges will not be permitted (i) after 14 days or without receipt or (ii) for product not carried by Barnes & Noble or Barnes & Noble.com.

Policy on receipt may appear in two sections.

Valid through 12/29/2018

Buy 1
Fresh Baked Cookie
Get 1 FREE

USE ON YOUR NEXT VISIT

To redeem: Present this coupon in the Cafe

M7P7L8Y

Buy 1 Fresh Baked Cookie Get 1 Free:
1 redemption per coupon, while supplies last.
Valid on Fresh Baked cookies only.
Ask Cafe cashier for full Terms & Conditions

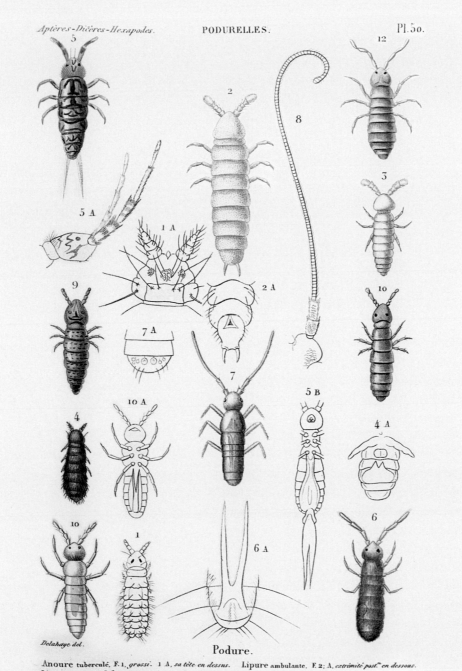

Delahaye del.

Podure.

Anoure tuberculé, F. 1, *grossi*. 1 A, *sa tête en dessus*. Lipure ambulante, F. 2; A, *extrémité post.ⁿ en dessous*.
Lip. volvaire, F 3. Ochorute aquatique, F. 4. A, *abdomen en dessous*. Orchesellé histrion, F. 5; A, *ses antennes*; B, *corps vu en dessous*. Heterotome vert, F. 6; Macrotome agile, F. 7; A, *extrémité de l'abdomen montrant quelques écailles*.
Tête du Macr. longicorne, F. 8. Isotome spilosome, F. 9. Isot. puce F. 10. Isot. Desmarest, F. 11. Isot. Nicolet, F. 12.

A splendid array of colorful springtails (order Collembola). From Walckenaer, *Histoire naturelle des insectes. Aptères.*

evidence for hexapods. *Rhyniella praecursor* was a tiny springtail from the early Devonian, approximately 410 million years ago, and preserved complete with its spring and lock. One can imagine these early hexapods leaping about the seemingly alien world of long ago—a period in which forests had not yet evolved across our world, where the tallest plants were comparatively simple, leafless, vascular organisms living near water, and in which animals had only recently colonized land.

THE FIRST
TRUE INSECTS:
ARCHAEOGNATHA
AND ZYGENTOMA

All other hexapods belong to the true insects, or class Insecta. The earliest divergence among insects, which predates the origin of wings and flight, are the bristletails and silverfish, each recognized as their own taxonomic order. The Archaeognatha include the bristletails, sometimes called jumping bristletails, while the Zygentoma are widely known as silverfish or firebrats. The name *firebrat* is usually given to those species preferring high temperatures, with their presence near furnaces or ovens in homes leading to this nom de plume. Like the entognathans, these wingless insects are widespread and typically ignored, even by the majority of entomologists. Neither are especially diverse today, with only around five hundred species of each.

Both groups consist of rather slender animals with long antennae and three elongate filaments at the tail end—two of which are the cerci, like those of diplurans, and at the middle there is a similar prolongation of the last abdominal segment. The bodies are rather

Jumping bristletails (order Archaeognatha) such as *Machilis maritima* are the most primitive of living insects, scraping lichens and algae with their simple mandibles. From Lubbock, *Monograph*.

low to the ground and frequently there may be scales scattered about. As in the entognathans, bristletails and silverfish do not copulate and instead mate via a spermatophore, produced by the male and then retrieved by the female. As true insects, females have an ovipositor, which guides the deposition of eggs and permits her to place them in secluded crevices or in holes that she prepares for their protection. By the time they hatch, the mother is gone and the young must fend for themselves.

Archaeognatha are usually nocturnal, spending the daylight hours under stones or

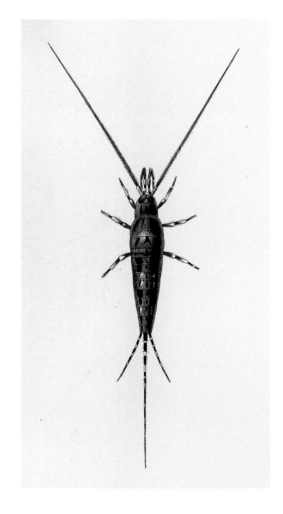

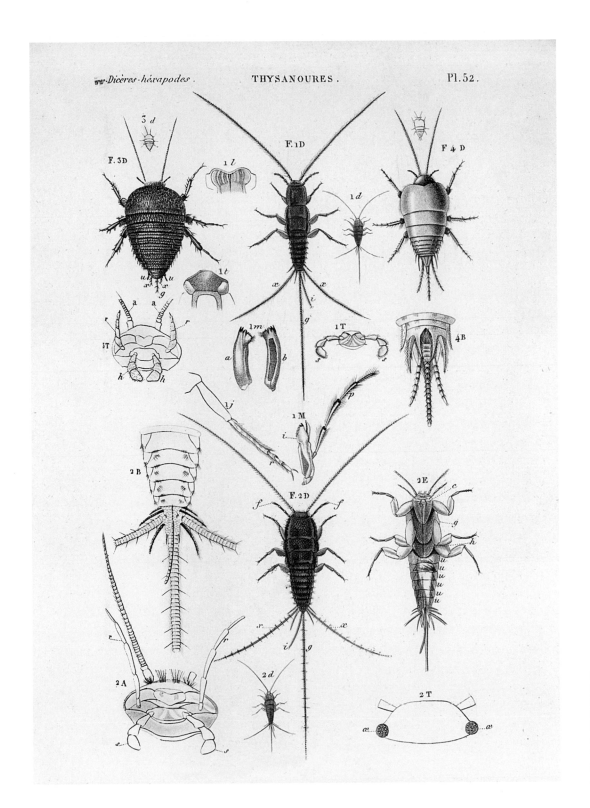

Although resembling each other superficially, bristletails and silverfish—the primitively wingless insects—are not all closely related. From Walckenaer, *Histoire naturelle des insectes. Aptères.*

within the crevices of bark. During the night they emerge to feed and mate. Their diet consists of lichens and algae, although they will also scavenge exoskeletal fragments of other arthropods. Bristletails have large compound eyes as well as three smaller, simple eyes called *ocelli*, at the top of the head. Ocelli are found in a variety of insect groups; while ocelli do not perceive images, they are sensitive to variations in light levels and may be used in navigation and orientation, particularly at night. The thorax is hunched, and by flexing considerable muscles in the abdomen, the bristletail can jump as a means of evading a predator.

The biology of silverfish is largely the same, although they are more generally omnivorous, squatter, and cannot jump. They also have smaller compound eyes and lack ocelli, with the exceptions of a peculiar relict species surviving in northern California and an extinct species that was found in Baltic amber from forty-five million years ago. Although they cannot jump, silverfish are quite agile and have no difficulty darting away when danger looms

Superficially, these two groups seem quite similar, and yet from an evolutionary perspective they are utterly distinct. The most fascinating aspect of their story is hidden within seemingly inconsequential details of their anatomy. Bristletails have mandibles that are attached to the head via a single ball-in-socket joint and that can rotate like an auger. They use these to scrape at surfaces to remove the lichens and algae upon which they feed. This kind of original joint is also present among the entognathans, where it consists of a thumblike knob (called a *condyle*) on the mandible that inserts into a cuplike impression (the socket, or *acetabulum*) on the head capsule. The scientific name of bristletails, Archaeognatha—*archaîos*,

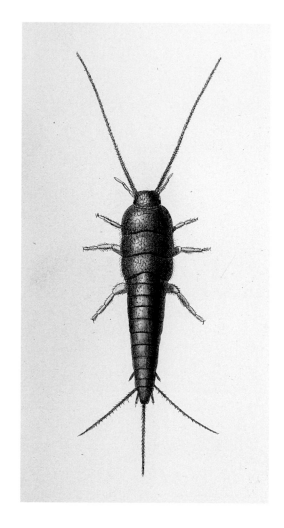

"ancient" or "primeval," and *gnáthos*, "jaw"— references this primitive form of mandible with its single attachment.

The mandibles of silverfish, however, are articulated to the head at two points, rather than merely one. The first point of attachment is like that of bristletails, in that the mandible has a thumblike knob in a socket on the head capsule. This attachment is at the tail end of the silverfish mandible. The second point of attachment, at the forward end of the mandible, evolved separately. It also consists of a knob in a socket, but this is reversed, with

INNUMERABLE INSECTS

the knob on the head and the socket on the mandible. This two-jointed, or dicondylic (two condyles), mandible is found in silverfish, and most notably, all other insects. These mandibles cannot rotate but instead move in scissorlike fashion, enabling greater force. Silverfish also share with all other insects, to the exclusion of the bristletails, a unique modification at the base of the ovipositor that gives it greater control. These traits, among others, and the sequence of DNA in their genomes, demonstrate the remarkable reality that silverfish are the closest living relatives of the winged insects—despite their primitive resemblance to bristletails. In fact, the ordinal name for silverfish references this genealogical relationship: *Zygentoma* combines the Ancient Greek *zygón*, meaning "yoke," which is a wooden harness used for joining together two oxen, and *éntoma*, for "insect." The Zygentoma are therefore the "yoke" or harness that joins the primitively wingless with the winged insects.

The lowly silverfish therefore holds a distinguished position as sister to life's most spectacular diversification: the winged insects that comprise over 99 percent of all insectan diversity, and over half of all life we know today. You might consider this astounding fact next time you watch a silverfish scurry out from under your refrigerator or oven during a late-night foray into the kitchen.

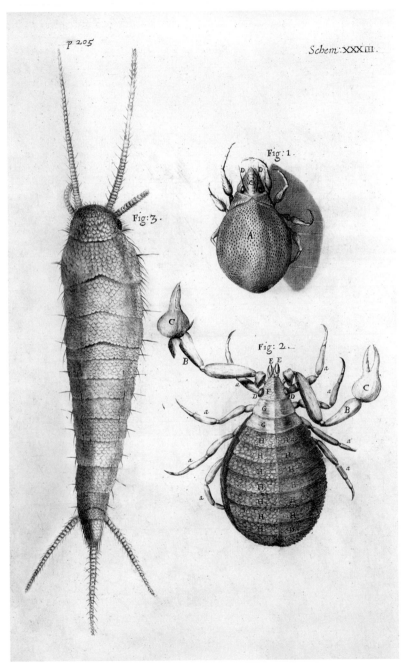

Despite the reduced attention received by silverfish relative to their winged relatives, a common silverfish was among the select few observed by Robert Hooke with his newly developed microscope, alongside two arachnids (a mite above, a pseudoscorpion below). From Hooke's *Micrographia* (1667 edition).

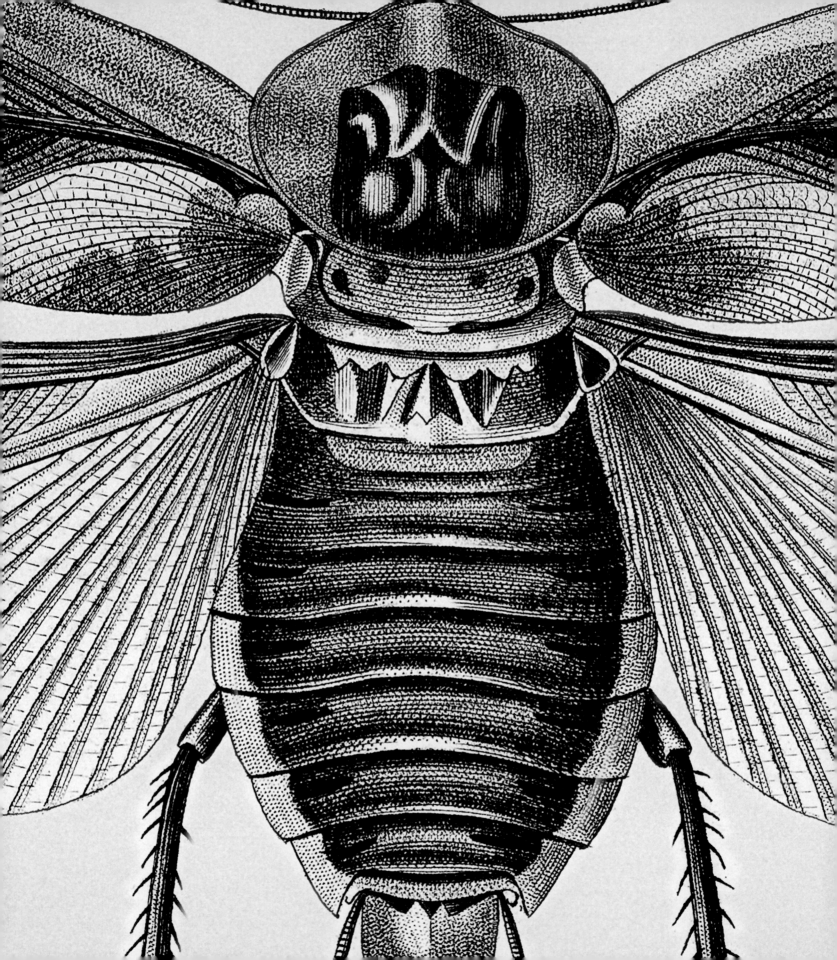

4
INSECTS
Take to the Skies

> *"A power of Butterfly must be—*
> *The Aptitude to fly*
> *Meadows of majesty concedes*
> *And easy Sweeps of Sky."*
>
> —Emily Dickinson
> *Complete Poems*, 1924

———✦———

PAGE 42: Detail of a giant cave cockroach from Jean Victor Audouin, *Histoire naturelle des insects* (1834) (also see page 70).

OPPOSITE: The hind wings of the southern African common milkweed locust (*Phymateus morbillosus*) are spectacularly crimson and contrast dramatically with the bluish forewings and yellow abdomen. From Edward Donovan, *Natural History of the Insects of China* (1838).

When we marvel at insects, it is usually their wings that pique our interest. We are dazzled by the variety of patterns on the wings of butterflies and moths, by the metallic sheen or spots on those of beetles, and the fine veins running through the wings of dragonflies and lacewings. Most insects fly, using a pair of wings to generate the lift and thrust necessary to sustain and control movement through the air. So numerous and pervasive are flying insects that if one is asked to quickly picture an entomologist in their mind's eye, inevitably what is envisaged is that of a person on the hunt with a net in hand, ready to swipe their catch from the air. Any number of Gary Larson's *Far Side* cartoons may come to mind with just such a depiction!

Aside from the aforementioned orders in the preceding chapter, all living insects belong to a hefty subclass called the Pterygota, obviously so named owing to the presence of wings—in Greek, *pteryx* means "wing." It is precisely this ability to fly that makes the word *fly* so ubiquitous in many insect common names, including mayfly, dragonfly, stonefly, owlfly, black fly, and butterfly, to name a few. For the keen-sighted, one sobriquet stands out among this sampling of common monikers. Among all of those named, only the black fly is a *true fly*; that is, a species of the order Diptera, the taxonomic group comprising those insects we call *flies* and which have but a single pair of wings (versus the two pairs in others orders, see pages 98–99). The remainder of those insects listed above, despite having *fly* in their common name, belong to different orders that are as distinct from and distantly related to the true flies as the latter are from and to beetles or roaches. Long ago, when names of convenience were initially formed and our optics on these diminutive animals were limited, any minute arthropod flying about was simply dubbed a fly. Only centuries later did we come to understand that these were disparate lineages of insects. So, how does one keep it all straight when the word *fly* is appended to the common name of so many unrelated kinds of insects? In entomology there is a general rule of thumb, best articulated by the distinguished entomological anatomist Robert E. Snodgrass (1875–1962): "If the insect is what the name implies, write the two

Pl. 13.

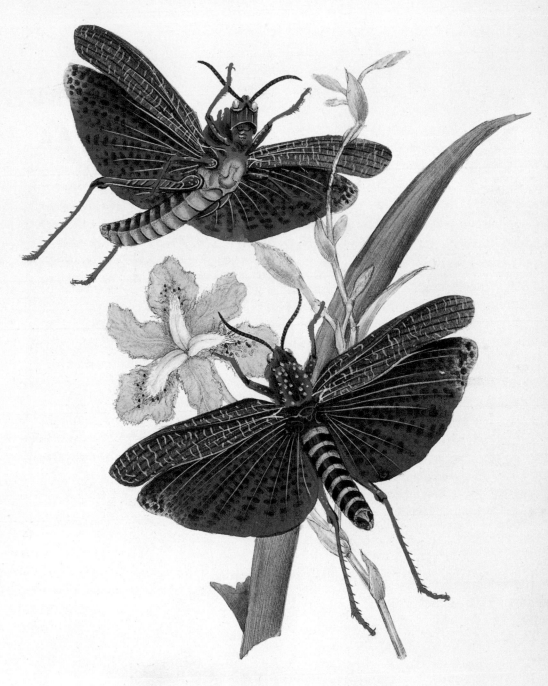

Locusta morbillosa.

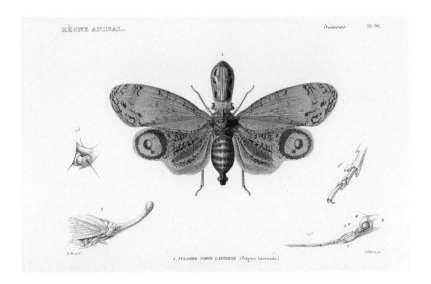

words separately; otherwise run them together." A silverfish is not a fish, and neither a dragonfly nor a butterfly are flies (for that matter, nor are they dragons or made of dairy products). Flies are those insects in the order Diptera, or, the *true flies*. A horse fly bites horses and is decidedly a fly, and this is reflected in its appellation. And, of course, it can certainly fly.

We tend not to think much about the remarkable nature of flight in insects. Mosquitoes buzz in our ears, dragonflies dart over ponds, and butterflies flit through our gardens, and we scarcely give them notice—the mosquito being perhaps an exception. This flight is not a mere matter of gliding safely from a precipice, as is done by many animals, but it is instead an active process allowing for takeoff from any location and control over the speed and direction in which the individual wishes to move. Flight permits new avenues in which an organism may experience life—invading new habitats as they disperse, allowing quick escape from danger, and providing a novel means for locating shelter, food, or a mate. To actively defy the grip of gravity, to slip "the surly bonds

of Earth" as said by the Anglo-American poet John G. Magee (1922–1941), is an incredible achievement, and not easily accomplished. The British satirist Douglas Adams (1952–2001) summed up the evolution of flight most succinctly in his book *Life, the Universe and Everything* (1982), writing that there, "is an art to flying, or rather a knack. The knack lies in learning how to throw yourself at the ground and miss." Today, perhaps as many as 5 million species casually "miss" the ground on a regular basis, and maybe 100 million more did so as well during the intervening 410 million years since the progenitor of them all first hurled itself at the ground and got the knack of it.

Only four lineages of animals have successfully invaded our Earth's skies in this way: insects, birds, bats, and the long-extinct flying reptiles known as *pterosaurs*. Among all of these, insects were nature's first flyers. Insects were the first of all life to take to the skies with powered flight, and today there are over a million known species among the winged insects. In fact, insects were the only flying animals for perhaps 170 million years before they were eventually joined

by pterosaurs, and much later by birds and eventually bats. By the time any other animals soared into the air, insects had been perfecting their aerial acrobatics for an expanse of time two and half times greater than that since dinosaurs died out over 65 million years ago. When one looks at the ease with which a bee hovers gently before a flower, it is the summation of evolution's refinement of insect flight over a period of at least 410 million years. Insects gave the world flight, and flight gave insects the world.

WING EVOLUTION AND MECHANICS

In birds, bats, and pterosaurs, the evolution of the wing is straightforward. In each of these, the wing is a modified form of the foreleg, with the same arrangement of bones as observed in their relatives, but augmented for flight. By contrast, the origin of the insect wing has been one of the more abominable riddles in evolutionary biology. An insect wing is not merely a modified leg; all flying insects retain their original six legs and still bear two pairs of prominent wings. Wings are not legs. So, what then is a wing? This pernicious problem has vexed the brightest entomologists for generations. Over the last 150 years, hypotheses have abounded, and only recently have comparative anatomy and modern developmental genetics come together to provide a unified answer. The bulk of a wing is formed of a thin extension from the upper wall of the thoracic exoskeleton, which is then hinged at its base. The genetic architecture for forming a

Diagrammatic Segment of Insect Thorax Showing Point of Wing Articulation

The base of an insect wing sits between the exoskeletal elements forming the top and side of the thorax, with the wing sitting above a dorsal knob in the side of the thorax, which acts as the fulcrum for the wing. Small exoskeletal pieces anterior (basalare, sometimes divided into two components as shown here) and posterior (subalare) to the fulcrum attach to muscles which, when contracted, result in either forward or reverse tilting of the wing. Adapted from an original diagram from Robert Evans Snodgrass, *The Thorax of Insects and the Articulation of the Wings*, 1909.

hinged joint already exists in the development of the articulated legs, and it was this suite of genes that were copied and coopted to permit movement at the base of the wing.

While the wings of vertebrates can be actively augmented during flight through any number of muscles within the limb, the insect wing is a passive structure. The only muscles that operate the wing are located in the thorax itself, and they do not extend beyond and into the flight foil. At their simplest, insect wings operate somewhat like a long lever. Muscles within the thorax attach from top to bottom and from back to front, and it is the contraction of these that distorts the overall shape of the thoracic exoskeleton itself. The side of the thorax acts like a fulcrum over which the top of the thorax and wing sit. As the muscles extending from top to bottom contract, they pull down on the upper side of the thorax, while the wing, on the end of the fulcrum, is sent upward. Relaxation of these muscles and contraction of the alternate pair bring the wing down. Additional sets of musculature pull on small portions of the integument anterior and posterior to the wing base, which cause the wing to tilt forward or backward, thereby enriching the range of possible motions. In fact, most insect wings do not simply flap up and down, but instead move in a figure-eight fashion, and the aerodynamics of insect flight is far more complicated than it appears.

Flight in the smallest insects is different altogether, as for these animals air itself is a viscous environment, and as a result their movement is like swimming through a thick fluid. This is the result of a scaling effect in the relationship of inertial and viscous forces acting on a wing moving through a fluid, such as air. At its most simplistic, a larger wing passing quickly through air experiences mostly inertial forces and minimal disruption—ideally none if one is in an airplane—between the individual layers of the air it is displacing as it moves (this is called *laminar flow*). As a wing scales down in size, the relative role of viscous forces increases, with significant disruption between the layers as the flyer pushes against the air, resulting in what is called *turbulent flow*. This increased dominance in viscous forces is why the mechanics of the smallest of insects is so different from that of a large dragonfly or locust. The same effect can be achieved by slowing down a large wing, such that at slower speeds turbulence can have a greater impact. Accordingly, there is a complex boundary line between the relative importance of these and other forces, all relating to wing size and shape as well as the corresponding size and form of the insect's body.

Although the foil of the wing is a passive structure, it does change shape during flight. Running through the wing are a series of minute tubes that are extensions of the insect's tracheal breathing system, and these form the pattern of veins we observe. The veins help give shape to the wing, providing support to the thin membrane formed of exoskeleton. The veins have defined points of weakness within them, and these allow areas of the membrane to give way during certain wing movements, permitting certain folds to form and control the dynamics of flight particular to that group of insects. In addition, several insects have veins more closely clustered along the forward edge of the wing, or even thickened into a block toward the wing's tip. These lend weight and strength during the powerful downstroke of flight, preventing fluttering that would otherwise defeat the forces generated.

The wings of insects come in a seemingly infinite variety, and they have been coopted by evolution for many purposes well beyond a mere means of getting about. Wings, properly adapted, are used to warm the body by catching the early rays of the sun after the rigor of cold nights, to startle and confuse potential predators, to display and communicate with mates, to cover and protect the body, and even to be shed such that they do not interfere with other functions of life. Simply put, wings are not always just wings.

The immature stages—prior to sexual maturation—of winged insects do not fly; they either lack wings altogether or the wings are represented merely by undeveloped pads. Fully formed and functional wings appear only during the final molt to adulthood. The wingless bristletails and silverfish molt throughout life, including after reaching sexual maturity, but molting stops at maturity for flying insects. The one exception to this rule is the mayfly, in which functional wings appear in the next-to-last molt, and these insects shed their exoskeleton a final time after becoming capable of flight.

The great majority of insects have wings, and it is the variety of these appendages that most loudly speaks to the diversity of insect life: mayflies, dragonflies, crickets, grasshoppers, roaches, mantises, termites, aphids, water bugs, and so many more, each with their unique adaptations and myriad life histories. Winged insects do much more than fly, and during their evolution some invaded freshwater streams and lakes, some built elaborate homes and societies, and yet others shed their wings to become parasites. Like the primitively wingless insects (see chapter 3), the winged insects are classified into taxonomic

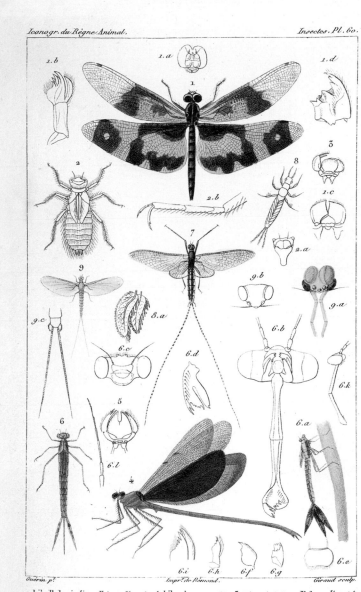

Primitive winged insects: from top to bottom, a dragonfly with luxuriously patterned wings, *Rhyothemis variegata*; the mayfly *Hexagenia limbata*; and the metallic green damselfly, *Neurobasis chinensis*. From Félix-Edouard Guérin-Méneville, *Iconographie du règne animal de G. Cuvier* (1829–1844).

A NEW HOPE FOR ENTOMOLOGY

In early nineteenth-century London, the favored place to meet and discuss all things entomological was in the residence and personal "museum" of the Rev. Frederick W. Hope (1797–1862) and his wife, Ellen Meredith (1801–1879). Ellen had previously been courted by Benjamin Disraeli (1804–1881), who would later serve two terms as the United Kingdom's prime minister, but she declined in favor of Hope. Both Hope and Ellen were from families of considerable means, and they put their fortunes to the task of developing a first-class natural history collection from throughout the world, complete with an extensive library and tens of thousands of engravings. Hope had a strong penchant for beetles, but he did not shy away from the other insects, nor did he forget the other branches of natural science. He was a close friend of the young Charles Darwin, the latter referring to Hope as his "Father in Entomology"; they spent June of 1829 together collecting beetles in Wales.

Hope and his wife were exceedingly generous, opening their collections for study to suitable individuals; the Hopes even went so far as to provide money and materials necessary for others to carry out their studies. For much of his adult life, Hope suffered from poor health. During his late forties, he began retiring

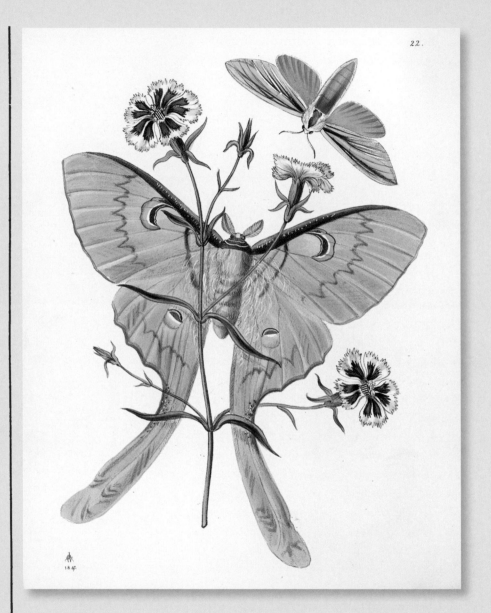

The monographs of John O. Westwood greatly benefited from his considerable artistic talents, and his illustrations were greatly sought out by contemporary naturalists. Displayed here are a large Malaysian moon moth (*Actias maenas*) alongside a large candy-striped hawkmoth (*Leucophlebia lineata*) from Westwood's *The Cabinet of Oriental Entomology* (1848).

from many societal offices and activities in which he was heavily involved—particularly his beloved Entomological Society of London (today known as the Royal Entomological Society), of which he was a founding member in 1833. (In 1835, Ellen was the first woman fellow admitted to the learned society.) Hope notified his alma mater, Oxford University, of his desire to see his collections transferred to their care and for the establishment of a curatorship to oversee his specimens. In 1855, Oxford laid the foundation stone for its new Museum of Natural History, and sizable endowments from Hope ensured that the Hope Entomological Collection—inclusive of his vast holdings of books and ancillary materials—would be well cared for. Hope's selection for the custodian of his collections was John O. Westwood (1805–1893), for he trusted no one else with the task, and in 1858 Westwood was so appointed.

Westwood had originally studied law but detested it. He was more passionate for natural history, archeology, heraldry, and medieval art, and, by 1820, he was vigorously collecting insects and corresponding and exchanging material with fellow entomologists. In March 1824, Westwood met Hope and the two became fast friends. A decade later, Hope appointed the junior man as conservator of his insects, except for the beetles. Eventually Hope established a professorship, the Hope Professor of Zoology (Entomology), of which Westwood took the inaugural chair in 1861 and remained in that capacity until his death.

Westwood was truly an ideal candidate, for his expertise was extensive, and many have considered him the last of the great polyhistors of entomology. He was also a talented artist, making his work all the more valued for the accuracy and subtle beauty of the subjects depicted, and he generously illustrated works for friends and colleagues. Westwood expanded considerably upon Hope's collection, and with the resources pro-

Varied species of stag beetles (family Lucanidae) as arranged by Westwood for his *Cabinet of Oriental Entomology.*

vided was able to purchase important specimens, engravings, paintings, and virtually anything entomological. Westwood wrote extensively, publishing the leading entomological textbooks of the day—for which he received the Royal

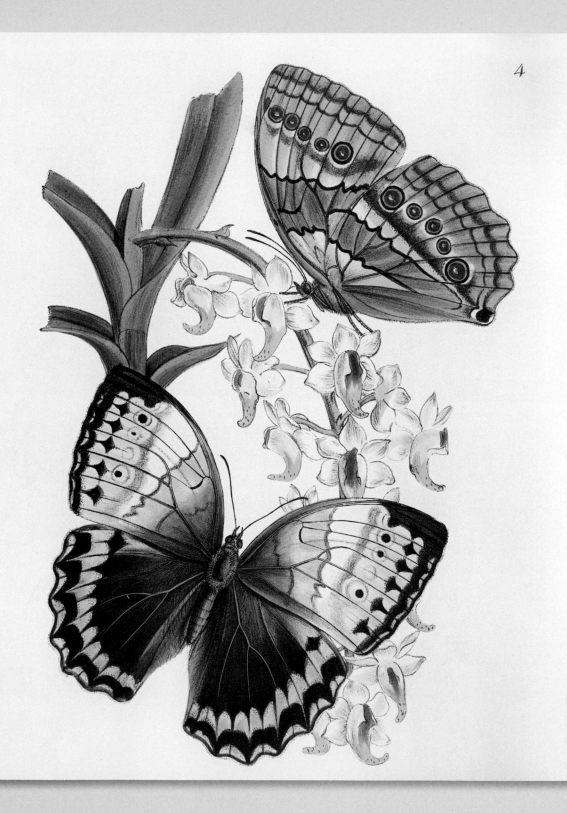

4

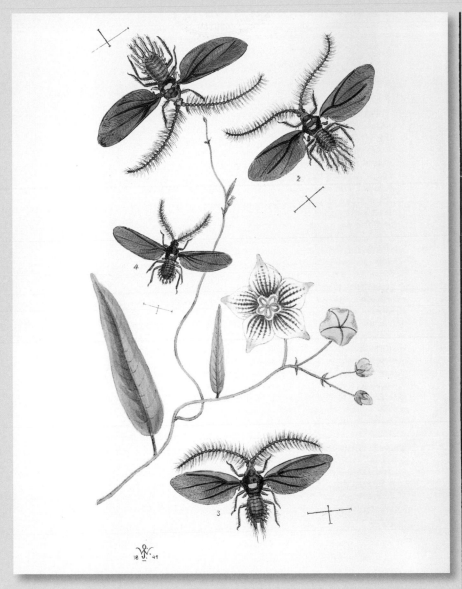

OPPOSITE: The different sides of the wings of the northern jungle queen butterfly (*Stichophthalma camadeva*) from Myanmar, Thailand, and northeastern India, as depicted in Westwood's *Cabinet of Oriental Entomology.*

ABOVE: The peculiar males of scale insects (family Coccidae) are often difficult to associate with their corresponding females, whose bodies evolutionarily reduced to flattened, soft ovals often covered with wax. From Westwood, *Arcana Entomologica; or, Illustrations of New, Rare, and Interesting Insects* (1845).

Society's gold medal in 1855—as well as monographs and articles on every group of insects then known, all gorgeously illustrated.

Much like other learned gentlemen of this era, Westwood's expertise was not confined to one subject, and he was a regular contributor to the journal *Archaeologia Cambrensis* as well as a published authority on antique ivories and paleography. Never wishing to see entomological information lost, Westwood would reissue older works, expanding and improving upon them, such as Edward Donovan's (1768–1837) *Natural History of the Insects of China* and *Natural History of the Insects of India* (reissued in 1842), or purchase abandoned projects, seeing them through to completion on behalf of their original authors. The man seemed to be electric with energy, and he drew many to the study of insects. He made himself open to all, all that is, except for Darwin, because Westwood remained a staunch anti-evolutionist. Quite ironically, though, many of his discoveries corroborated Darwin's interpretations.

The Hope chair continues today, and there have been five successors to Westwood, each building entomological science in their own way. Through Westwood, the collections he developed, and the endowment he provided, Hope inspired and gave considerable life to entomology, a legacy that continues to benefit the science even now.

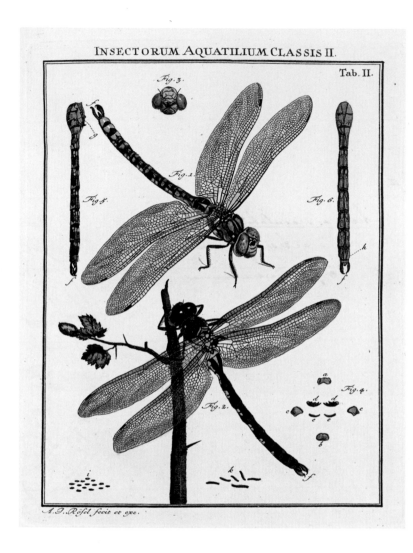

INSECTORUM AQUATILIUM CLASSIS II.

Tab. II.

A. J. Rösel fecit et exc.

Adult dragonflies (order Odonata) as illustrated by August Johann Rösel von Rosenhof for his *De natuurlyke historie der insecten* (1764–1768).

orders, many of which were first recognized by Linnaeus. He gave them names referring to the particular forms of their wings, so that most names for orders (ordinal names) end in *ptera*, from the Greek *pterón*, another term for "wing." This pattern of naming was largely followed by later entomologists, either when new orders were discovered or when scientific advances revealed that Linnaeus had initially cast too wide a net, grouping unrelated insects into one order. These orders come in such variety that it is impossible to summarize them as a whole,

and only by proceeding group by group can one appreciate what makes each so unique.

EPHEMEROPTERA AND ODONATA

The earliest flyers had outstretched wings but lacked the specializations that permitted them to be folded flat over the back of the abdomen. When at rest, their wings either extend out to the sides or straight up above the body. This form of wing is called *paleopterous*. During the Paleozoic era, which ended 252 million years ago, insects with these kinds of wings were varied, abundant, and dominant, while today only two lineages of paleopterous insects—a mere fraction of their former glory—persist: the mayflies, order Ephemeroptera, and the order Odonata, consisting of the dragonflies and damselflies. Mayflies, dragonflies, and damselflies are found near ponds and streams, as their immatures live in freshwater, although the Ephemeroptera and Odonata each independently evolved this mode of aquatic life. The aquatic and wingless immatures of mayflies, dragonflies, and damselflies are called *naiads*. The term *naiad* is a nod to Greek mythology, where the Naiads were female spirits who presided over bodies of fresh water such as lakes and streams. The naiads must emerge from the water for their molt into adults, at which time their wings unfurl from within the naiad exoskeleton. These wings gradually stiffen and dry, and the insect can then take flight. Since naiads are so dependent on the water in which they live, the health of their populations is usually an excellent indicator of water quality.

Mayflies are generally slender insects with broad forewings, while the hind wings are

reduced or sometimes entirely lacking. Mayfly naiads must be tasty, as they are a major food source for many fish and other aquatic predators, and they are treasured by fishing enthusiasts, who work tirelessly to mimic them as lures. An entire industry on fly tying exists, and troves of books have been written—and will continue to be written—on how to tie the perfect "hatch" (a naiad emerging as an adult) and the subtle ways in which to tug upon the line such that the lure parodies the movement of a particular mayfly species in the water column.

Adult mayflies are peculiar in that they retain vestigial mouthparts but they do not feed.

Mayflies, such as these from Central America, are the most primitive of flying insects: colored, at top, *Lachlania lucida*; below (left to right): *Euthyplocia hecuba*, *Homoeoneuria salviniae*, and *Hexagenia mexicana*. From *Biologia Centrali-Americana. Insecta. Neuroptera. Ephemeridae.* (1892–1908).

This means that the adults survive solely on the nourishment stored up during their juvenile stage. Juveniles of some species are carnivores, while others scrape algae. The lives of adult mayflies are accordingly brief, with many living only a few days or even hours, and their singular purpose is to find a mate. This ephemeral nature is reflected in their ordinal name, Ephemeroptera: in Greek, *ephémeros* means "for the day." Since their lives are so brief, there is no time to dawdle or waste while trying to locate a suitable mate, and for this reason the emergence of adult males and females is highly synchronized. Adults appear in mass emergences, and on particular spring or summer evenings, it is not uncommon to find a cloud of mayflies swarming about lights, the largest emergences numbering into the tens of millions of individuals. Swarms have been known to be numerous and dense enough to shut down traffic, obscuring drivers' views and clogging radiators.

While these swarms increase the opportunity for a male and female to meet, they also attract hosts of opportunistic predators eager to make a hearty meal of mayflies. Birds, spiders, dragonflies, and many other predators avail themselves of the feast. Mayflies are ancient, and one can imagine a mass emergence of some primitive species of mayflies being dined upon by the earliest birds, mammals, or even smaller dinosaurs. Males and females couple in flight, and the latter then typically drops eggs into the water, though some species may land to insert their abdomen into the water to deposit the eggs. Their tasks complete—mating and laying eggs—the male and female soon die, bringing to quick close to the ephemeral life of the adult mayfly.

DRAGONFLIES AND DAMSELFLIES ARE popular with amateur entomologists, as they are large, often spectacularly colored, and are usually about during daylight hours, darting over ponds and streams. The six thousand or so species are adept flyers, capable of rapid maneuvers and coming to a swift stop to hover and survey their territory. They are great aerial predators with acute vision and are capable of snatching their prey in flight. Their method of mating is unusual in that the male first transfers sperm to a set of organs on the underside of his abdomen. He then uses claspers at the end of his abdomen to grasp the female by the neck and stabilize her. She then bends her abdomen out to receive the sperm from his secondary abdominal organs. The rather contorted formation they assume quite appropriately resembles that of a heart.

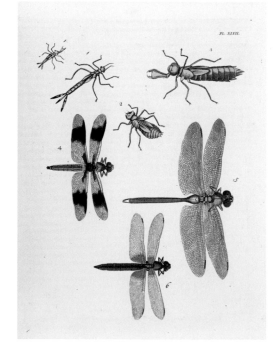

RIGHT: Various colored dragonflies (order Odonata) with their aquatic naiads, including one (upper right) with its fierce labial mask—used to capture prey—extended. From Drury, *Illustrations of Exotic Entomology.*

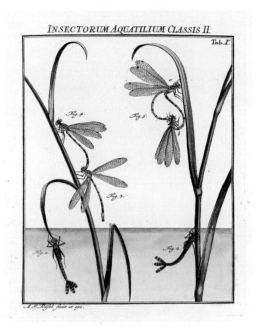

INSECTORUM AQUATILIUM CLASSIS II.

Tab. I.

Damselflies (order Odonata) as aquatic naiads, and above as mating pairs, with the male grasping the female by the neck and then together forming an inverted shape reminiscent of a heart. From Rösel von Rosenhof, *De natuurlyke historie der insecten*.

While our jet engines are considerable engineering achievements, dragonflies invented jet propulsion long before any human or primate stumbled onto the scene. Most dragonfly naiads are capable of darting through the water, moved by a jet propulsion system. The animal draws water into the rectum as it breathes, and then expels it with considerable force, shooting the naiad away from a foe or toward its prey, which, in the case of the latter, is then snagged by a fierce "mask." The mask is an elongate form of the labium—the posterior set of mouthpart appendages—which extends forward to cover the lower face, including the other mouthpart structures. The mask can pull prey—which for larger naiads may include small fish—toward the fierce mandibles lurking underneath.

PLECOPTERA

Unlike the mayflies, dragonflies, and damselflies, almost all other flying insects have wings that can be folded backward to lie flat over the abdomen when not in use, a condition called *neopterous*. This modification serves to protect the wings when not in use and aids in the cooption of the wings for purposes other than flight. The first of those orders with such wings are the stoneflies, who, like the mayflies, dragonflies, and damselflies, live in freshwater as naiads during their juvenile stages and are excellent indicators of water quality, perishing quickly with the introduction of pollutants. Their scientific ordinal name, Plecoptera (from the Greek *plékō*, meaning "plait") refers to the pleating of their broad hind wings—a feature actually shared by several other groups—which are folded when at rest. Males and females communicate by drumming their abdomens on a surface, locating each other via Morse code–like signals that are unique to each species. The adults of the nearly thirty-five hundred species feed little, spending their time on locating a mate and courtship. Many stonefly mothers lay their eggs while flying, dropping eggs en masse as they fly low over the surface of the water, much like a bomber, while others skim the surface of the water and use the action to "wash" the eggs from her abdomen.

Stonefly naiads generally feed on algae and aquatic plants, although some groups have become omnivorous scavengers or even carnivores, and nearly all can be found pressed against the undersurface of stones in the water, hence the common name, where they avoid predators. The long-bodied naiads are active swimmers and have a series of unique muscles in the abdomen that allow them to undulate

Diverse winged insects: three castes of the termite *Reticulitermes lucifugus* (worker at upper left, winged queen at top center, soldier at upper right); the webspinner *Embia mauritanica* between the worker and solider termites; the stoneflies *Brachyptera risi* and *Perla marginata* at middle; and the book louse, *Psocus bipunctatus*, at bottom. From Cuvier, *Le règne animal distribué d'après son organisation.*

the body side to side while swimming, much like a fish. They are the only such aquatic insects able to produce such movements.

EMBIODEA AND ZORAPTERA

There are two likely related orders of insects that include minute, rarely seen species living in small, gregarious colonies. The first order comprises the webspinners. While the name *webspinner* might bring to mind spiders and orb webs hanging near porch lights, here it refers to the taxonomic order Embiodea, a name that signifies the insects' liveliness: from the Greek *embios*, "lively, " and *eîdos*, "appearance" or "form." These tiny insects live in silken galleries spread out over tree trunks or rocks, the silk spun from large glands in their forelegs. The webspinners, which are typically between 7 to 20 millimeters in size, live in colonies of usually fewer than thirty individuals all residing within the silken confines of their galleries. Females watch over their eggs within the gallery and take care of the young nymphs. Typically, females may shed their wings after establishing a new gallery, but when the wings are present they are unusual among flying insects. The veins are diaphanous and form sinuses between the membranes that make up the wing, but they are flexible and collapse easily, a necessary detail so that they do not become entangled when moving backward through the silken tunnels. Even though such a flimsy structure would seem ineffective for flight, webspinners are quite lively flyers when in the air. This is achieved by pumping blood into the sinuses of the wing, the pressure stiffening it to support flight.

Similarly gregarious, although living under bark of rotting logs rather than nestled amid silk, are the tiny Zoraptera. These insects, which are usually less than 3 millimeters in length, were discovered only about a century ago, in 1913, and are so infrequently met with that they lack a common name—although some have tried to promote the idea of calling them *angel insects*. They usually look like chestnut-brown termites but are wholly unrelated. The logs in which they live must be soft, such that the bark easily crumbles in one's hand. Zoraptera live in small groups of usually less than one hundred individuals. Within a colony, females lay a few eggs at a time, watching over and constantly grooming them to remove pathogens like bacteria or fungi.

Perhaps what most distinguishes Zoraptera are that they come in two different forms, which occur during different phases of a colony's life. Most of the time they are blind and wingless, feeding on fungi, nematodes, and sometimes mites. The wingless forms were the first Zoraptera discovered by the Italian entomologist Filippo Silvestri (1873–1949), whose university office looked out toward nearby Mount Vesuvius. Believing them to be utterly incapable of flight, he gave them a name that means "purely without wings" (in Greek, *zoros*, "pure," with the prefix *a-*, called the *alpha privative* and expressing negation). It was not long, however, before the error of this name was revealed. These insects do have wings, but only when it is time to disperse. As the logs in which they live decay away to nothing or the colony becomes overcrowded, some of the eggs laid produce individuals that have large eyes and paddle-shaped wings with faint marks where once were veins. Fully capable of flight, these individuals disperse to

find new logs, and upon establishing a new home, resume laying eggs that hatch into the flightless and sightless.

NOTOPTERA

Another recently discovered group, first classified as an order in 1915, are the wingless ice crawlers of the Northern Hemisphere and the heel walkers, or rock crawlers, of sub-Saharan Africa, both relicts of animals that were once widespread and previously winged, and that today are represented by about fifty species. Together they are known as the *Notoptera*, a name referring to the back of their thorax (*nōton*, Greek for "back"); the man who named them, Guy C. Crampton (1881–1951), originally believed that the absence of wings was due to their having been superseded by a small extension of the back. The ice crawler—which looks a bit like a cross between a cricket and a wingless roach—darts about snow packs scavenging or capturing small arthropods that are moving sluggishly due to the cold. Although they avoid warmer temperatures, ice crawlers are not impervious to the cold and will die if the temperature falls much below freezing. By contrast, their southern sisters in Africa, the heel walkers, thrive in warm, dry climates, where they are nocturnal in rocky or grassy habitats. Heel walkers hold the tips of their feet up as they move, hence their unique name. Resembling a squat mantis combined with a stick insect, the heel walkers were only described in 2000, although specimens had sat in research collections for nearly one hundred years before that.

DERMAPTERA

A more familiar group of flyers, the earwigs have been plagued with a bad reputation for centuries and still evoke fear and revulsion. Their common name originates from the Old English *ēarwicga* ("ear insect"—*ēare*, "ear," and *wicga*, "insect") inspired by the myth that they burrow through the human ear into the brain to lay their eggs, bringing on pain and insanity. In reality, these insects do nothing of the sort, and while it is true they prefer to live in dark, warm, and often damp crevices, they are typically found under bark or stones, or amid the litter of leaves on a forest floor. On an extremely rare occasion, an earwig has been known to crawl within the opening of a human ear or nostril, but only for warmth during a cold night, and such exceedingly rare occurrences can just as likely occur with a beetle or other insect. Quite contrary to their nasty reputation, some earwigs are used to control the population of agricultural pests, particularly on kiwifruit and some citrus crops. The approximately two thousand species are principally found in tropical and warm temperate regions where they are largely nocturnal omnivores, although some may be strictly herbivorous or even carnivorous.

Perhaps what makes earwigs most recognizable are their characteristic forceps at the tip of the abdomen, used for capturing prey, holding their mates, and folding their distinctive fanlike hind wings. Their scientific ordinal name, Dermaptera, however, refers to the form of their reduced forewings—small, hardened plates that often have a texture resembling leather—*dérma* means "hide," as in a

leathery animal pelt. These forewing plates do not function for flight and instead are covers for the hind wings when not in use, although some earwigs are entirely wingless. Earwigs are doting mothers, and while they do not live in social colonies with other individuals, they exhibit great care for their own eggs and young nymphs. In fact, we know from the fossil record that this trait of extensive brood care is ancient among earwigs, with clusters of nymphs from the ancient roosts of extinct species dating back over one hundred million years. After a couple of molts, the nymphs are ready to fend for themselves and by this time must do so, as otherwise the once-caring mother may suddenly turn on them!

Two groups of earwigs have departed from this general pattern of life, each becoming parasitic on mammals, but as the result of quite independent evolutionary events. While the groups of parasitic earwigs specialize on different hosts, both became wingless, lost their forceps, and became blind with only vestigial eyes. They both give birth to live young rather than lay eggs. Each is rather flattened and suited for moving about undetected amid their host's fur. They often do not live entirely on the host and will retreat to the mammal's roost when not feeding. Those occurring in Africa live in the nests of rats native to the region, where they scrape dead skin and fungus from the host, and constitute the family Hemimeridae. The others, forming the family Arixeniidae, are found in Southeast Asia where they function similarly as parasites on bats. Like their many nonparasitic relatives they most certainly do not burrow into ears, nor do they drive rats and bats insane.

Despite the myth that earwigs burrow into the ear canal and induce madness, species such as the common European earwig (*Forficula auricularia*) are quite benign and the females are actually doting mothers to their young. From John Curtis, *British Entomology* (1823–1840).

Pattern *4*

Copy to be returned to Mr. Lopen

An original plate pattern (used by a colorist to hand-paint the plates in each book) from E. F. Staveley's *British Insects* (1871). It depicts varied winged insects: at top, the common European earwig (*Forficula auricularia*); at middle (left to right), the house cricket (*Acheta domesticus*), katydid (*Tettigonia viridissima*), and large marsh grasshopper (*Stethophyma grossum*); at bottom (left to right), the dusky roach (*Ectobius lapponicus*) and a minute thrips (perhaps a species of *Phlaeothrips*).

ORTHOPTERA AND PHASMATODEA

The grasshoppers, crickets, and katydids are the opera stars of the Insecta. Along with their many relatives, including locusts, the twenty thousand known species comprise the order Orthoptera (*orthós*, Greek for "straight" or "proper," refers to their elongate, generally straight forewings). Although famed for their sounds, the calls of Orthoptera are not vocalizations at all; instead they are the product of the wings rubbing together or the legs rubbing against the wings. Of course, if one is singing, then there must be an audience and a means by which to hear. The "ears" of the insects, called *tympana*, are formed of small chambers outwardly bordered by a thin membrane, acting much like our own eardrums. However, the tympana are not positioned on the sides of the head but instead are on the forelegs. The fattened hind legs, used to give Orthoptera their forceful leaps, are another distinction. Nearly all species are insatiable herbivores and familiar sights among the leaves of our gardens and crops. Most are solitary, although some can become gregarious, and at their most nightmarish can darken the skies with swarms of locusts—the very stuff of biblical plagues. Not all are easily seen, and many of us have been up at night trying to pinpoint a pesky cricket whose nightly song is preventing slumber. But the real way in which species avoid detection is through coloration that often resembles their environment, such as many of the katydids whose wings are so leaflike in appearance as to make them virtually invisible amid foliage.

The real champions of disguise, however, are the stick and leaf insects, together belonging to the order Phasmatodea, so named for

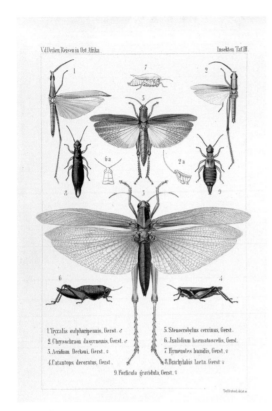

ABOVE: Sundry grasshoppers (order Orthoptera) and two earwigs (order Dermaptera). From Carl Eduard Adolph Gerstaecker, *Baron Carl Claus von der Decken's Reisen in Ost-Afrika in den Jahren 1859 bis 1865* (1873).

RIGHT: Gaudy katydids—*Parasanaa donovani*, *Sanaa imperialis*, *Scambophyllum sanguinolentum*, and *Calopsyra octomaculata*—leap lively in Westwood's *Cabinet of Oriental Entomology.*

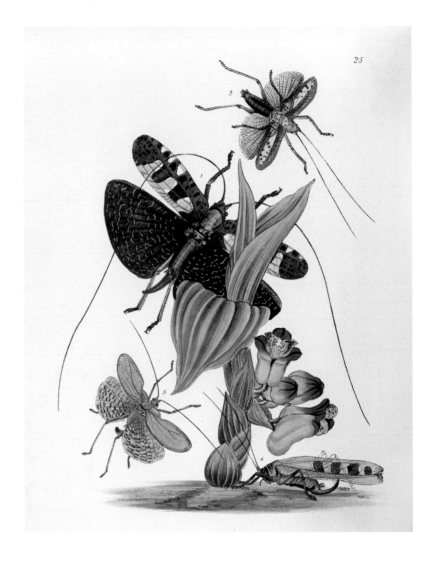

their ability to disappear from view. Their name literally means "form of a phantom"—in Greek, *phásma*, "phantom," and *eîdos*, "appearance" or "form"—and for this reason they are sometimes called *ghost insects*. All stick and leaf insects are herbivores and live out their lives on foliage, in shrubs, or on the trunks of those trees that they mimic. There are over three thousand species, and most of these are active at night, moving relatively little during the day and blending into their surroundings.

Many stick insects are wingless, as they have little need of flight. What is remarkable is that wings have been lost and regained among stick insects many times throughout their evolution, disappearing and reappearing like someone repeatedly turning on and off a light. This is achieved by a simple switching on and off of the genetic mechanism signaling for the development of wings, and while wingless stick insects may not exhibit wings, they fully retain the genetic code to produce wings.

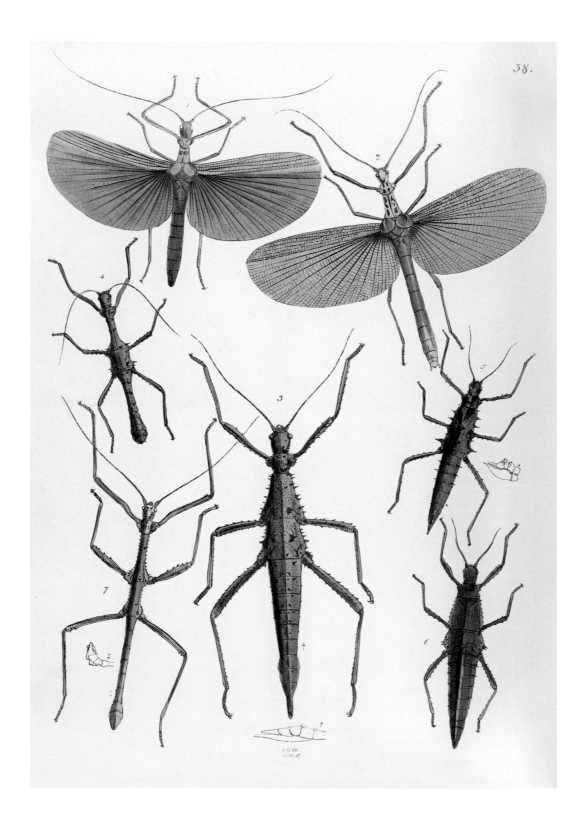

There are over three thousand species of stick and leaf insects worldwide, and while the wings of many have become vestigial or been completely lost, there are many who retain the ability to fly. They tightly fold their wings along their elongate bodies when not in use. From Westwood, *Cabinet of Oriental Entomology*.

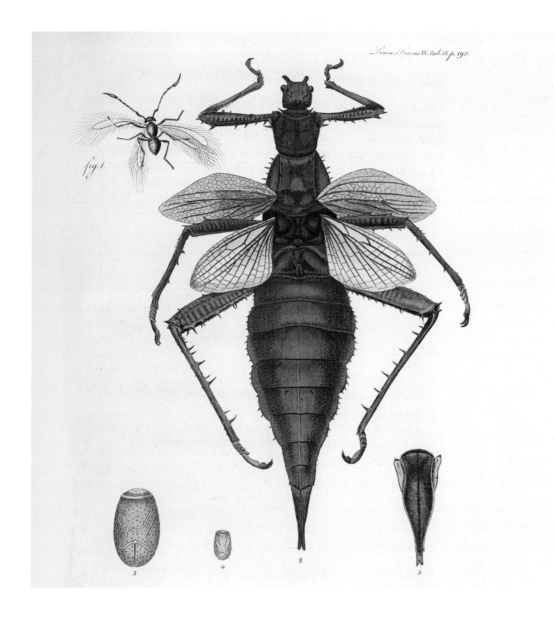

Linn. Trans. V. tab. 18. p. 192.

fig. 1.

The massive Malayan jungle nymph (*Heteropteryx dilatata*) is among the heaviest of Phasmatodea at up to 2.3 ounces (65.2 grams), and also holds the record for the largest eggs among insects, at about one-half inch (12.7 millimeters) in length. This illustration appeared in John Parkinson's account of the species in *Transactions of the Linnean Society* (1798).

Stick insects include the world's longest living insect, *Phryganistria chinensis* from southern China, whose slender body extends to over 24.5 inches (62.2 centimeters)—just over 2 feet (.6 meters)! Some species are hefty, and the broader and more leaflike females of *Heteropteryx dilatata* from Malaysia are beasts, weighing in at about 2.3 ounces (65.2 grams), or nearly

four times the weight of your average hamster. One of the scarcest insects on Earth is also a stick insect. The Lord Howe Island stick insect, *Dryococelus australis*, is a large, spiny, and wingless species that was eradicated by rats arriving on a cargo ship that ran aground on the eponymous island in the Tasman Sea in 1918. Within two years the stick insects were gone; that is until

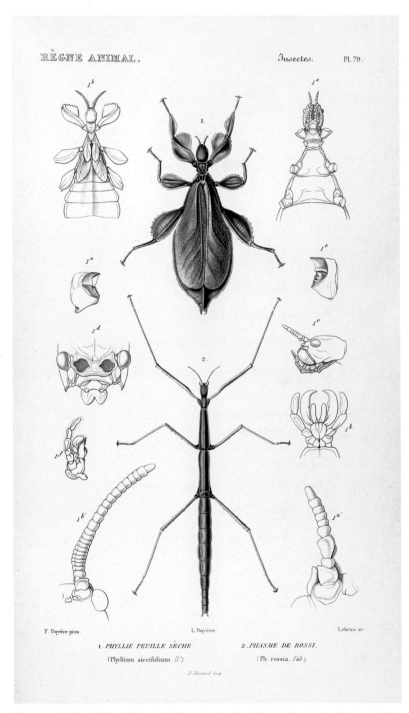

F. Doyère pinx.　L. Doyère.　Lebrun sc.

1. *PHYLLIE FEUILLE SÈCHE.*　2. *PHASME DE ROSSI.*
(Phyllium siccifolium. *Il.*)　(Ph. rossia. *Fab.*)

F. Réaumud imp.

The remarkable mimics of the order Phasmatodea include species evolved to resemble leaves, such as the Southeast Asian walking-leaf (*Phyllium siccifolium*), top, as well as to camouflage themselves as twigs or sticks, like the European stick insect (*Bacillus rossius*, bottom). From Cuvier, *Le règne animal distribué d'après son organisation.*

a tiny population of no more than twenty-four individuals was found living on an isolated rocky peak no more than 980 feet (299 meters) wide and towering out of the Pacific, 12 miles (19 kilometers) south of Lord Howe Island.

In many species of Phasmatodea the males are particularly rare and difficult to find, but this has nothing to do with their mimicry. Instead, the scarcity of males results from rampant parthenogenesis, whereby females do not require a mate to produce fertile eggs, effectively cloning themselves generation after generation. One might jokingly say that the males made themselves so well hidden that they became inconsequential!

MANTODEA, BLATTARIA, AND ISOPTERA

Three closely related groups are the mantises, roaches, and termites, or the orders Mantodea, Blattaria, and Isoptera. In fact, the last of these, the termites, are essentially specialized, social roaches.

The praying mantises, who perhaps should more properly be called "preying" mantises, encompass about twenty-five hundred species of truly spectacular predators. They have large eyes situated on a highly mobile head that is thrust forward on an extended neck, giving them a wide range of view. Not surprisingly, they have excellent visual perception and will readily interact with you by following a finger. Mantises have large, grasping forelegs, usually beset with spines, for grasping their prey. When the forelegs are folded, this gives mantises their characteristic "praying" appearance, to which their name, Mantodea, refers (the Greek *mantis*

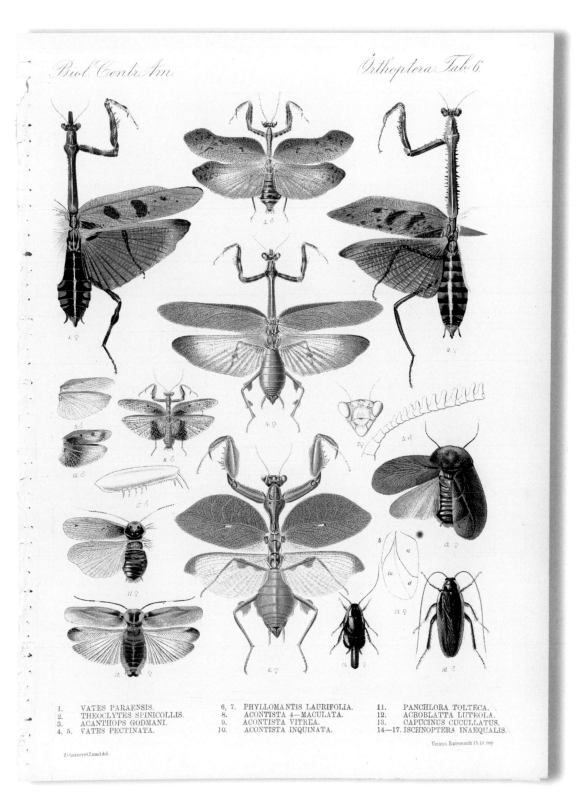

1.	VATES PARAENSIS.	6, 7.	PHYLLOMANTIS LAURIFOLIA.	11.	PANCHLORA TOLTECA.
2.	THEOCLYTES SPINICOLLIS.	8.	ACONTISTA 4—MACULATA.	12.	ACROBLATTA LUTEOLA.
3.	ACANTHOPS GODMANI.	9.	ACONTISTA VITREA.	13.	CAPUCINUS CUCULLATUS.
4, 5.	VATES PECTINATA.	10.	ACONTISTA INQUINATA.	14—17.	ISCHNOPTERA INAEQUALIS.

Zehntner et Lunel del.

Vienna, Bannwarth Th. lit. imp.

While mantises and roaches are seemingly quite different, such as these Central American species of both, they are actually close relatives; both groups lay eggs in hardened cases called *oothecae*. From *Biologia Centrali-Americana. Insecta. Orthoptera.* (1893–1909).

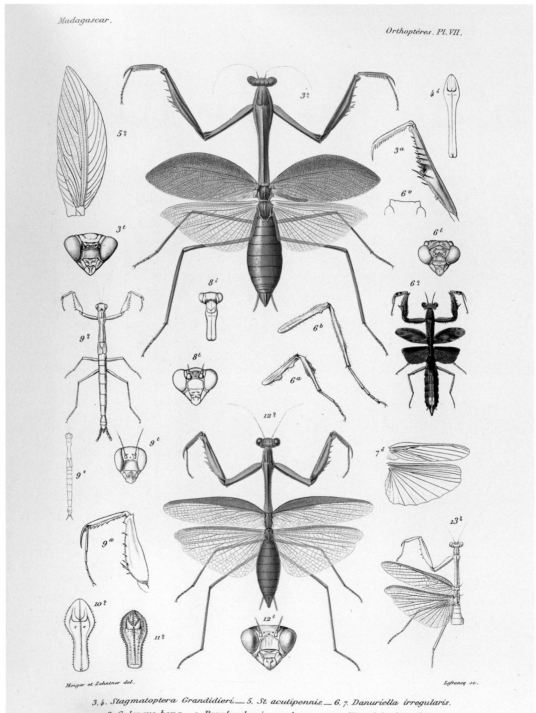

Menger et Zehntner del.

Lefran00 sc.

3.4. *Stagmatoptera Grandidieri.*— 5. *St. acutipennis.*— 6.7. *Danuriella irregularis.*
8. *Galepsus hova.*— 9. *Paralygdamia madecassa.*— 10. *Hierodula bioculata.*
11. *H. Kersteni.*— 12, 13. *H. hova.*

Predatory mantises (order Mantodea), with their raptorial forelegs, such as these lustrous species from Madagascar, have long been a favorite among naturalists. From Henri de Saussure, *Histoire physique, naturelle et politique de Madagascar, Orthoptères* (1895).

means "soothsayer"). Individuals are quick enough to snag a fly from the air, and if you've ever attempted to grab a fly in flight, then you know how difficult this can be. The largest of mantises can be up to almost 8 inches (20.3 centimeters) in length, and some giant species can take down frogs, small lizards, or fledgling birds. As predators, mantises often have coloration that allows them to lurk amid foliage undetected. At their most extreme, some mantises mimic flowers, assuming bizarre shapes in order to blend into their floral surroundings. Mantises are infamous for their sex lives, in which females typically consume the males after—or even during—mating. Mantises lay groups of eggs in hardened, protective cases, called *oothecae*, a trait shared with the roaches.

Unlike mantises, which tend to fascinate us, roaches are maligned and looked upon with disgust. There are over forty-five hundred species of roaches, collected under the order Blattaria, one of the few insect ordinal names of Latin origin—*blatta* being Latin for "light-shunning insect," while *-āria* is a suffix used to modify nouns into abstract groups, with the name effectively meaning "the group for roaches." Most species prefer warm, natural environments but a few species are quite amenable to moving about in urban settings. Sadly, these few have made roaches the poster child of pests and mistakenly synonymous with filth and disease, while the majority of wild species are really quite clean animals and do not spread infection.

Most roaches are nocturnal and are usually found amid detritus on forest floors. They are generally scavengers, although many exceptions exist. There are species who can emit light as a form of communication, much like a firefly, or that rub portions of their body together

to make stridulating calls. Species of the genus *Cryptocercus*, commonly known as wood roaches, are gregarious; they live within rotting logs and feed on wood, just like termites. In fact, the wood roaches are the closest-known relatives of termites, and, like the latter, have symbiotic microorganisms in their guts that permit them to digest wood.

Termites, or Isoptera (from the Greek *ísos*, meaning "equal" and referring to their largely identical fore and hind wings), were the first insects to become truly social—they evolved their societies over 140 million years ago. All

Early entomologists and artists often attempted to depict the complete life cycle of a species within a figure. Here, the life history and biology of the European praying mantis (*Mantis religiosa*) is outlined, from the hardened ootheca encapsulating the eggs, to the emerging nymphs, and eventually to the predatory adult. From Rösel von Rosenhof, *De natuurlyke historie der insecten* (1893–1909).

M.^{me} Pillot pinxit et direx.^t Victor Sculp.^t

The finely etched lines produced by lithography beautifully capture the intricate details of the lovely wings of the Central American giant cave cockroach (*Blaberus giganteus*), females of which can reach 4 inches (10 centimeters) in length. From Jean Victor Audouin, *Histoire naturelle des insectes* (1834).

of the nearly 3,150 species of termites are social. Most live in large, perennial colonies, with their societies organized around a system of castes. The queens provide the reproductive output for the colony, continually laying eggs in order to keep up a steady production of new termites, while the workers are sterile and undertake all of the main chores of colony life. Some termites have a third caste, soldiers, who are similarly sterile and modified solely for defense—sometimes so dramatically that they are unable to feed themselves or care for themselves. (See illustration on page 58). Soldier termites vary widely and employ many methods

to defend their homes. Typically, soldiers have large heads accommodating powerful muscles; these control fearsome mandibles that are used to bite at and slice through invaders. The heads of soldiers may also be specialized into bulbous nozzles that spray noxious glues meant to entangle invading ants.

Like wood roaches, termites harbor symbiotic microorganisms in their guts that aid the breakdown of the tough cellulose of the plants consumed. This dietary specialization along with their efficient and sometimes large colonies—which can number upward of one million workers—have made them one of the

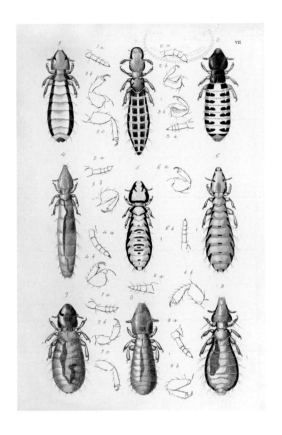

more ubiquitous of all insects—although less than 13 percent of all species are injurious to crops or structures, and less than 4 percent are considered serious pests.

PSOCODEA, THYSANOPTERA, AND HEMIPTERA

The order of lice, Psocodea (from the Greek *psokos*, meaning "rubbed" or "gnawed"), comprises two groups that were once placed in related but separate orders: the bark lice (or book lice) and the true lice. Bark lice can be found virtually everywhere—under bark or on foliage, beneath stones or in caves, and even in our very homes. In fact, they are not uncommon in libraries, where they can do considerable damage to books by chewing away on fragile pages—hence their other moniker, "book lice." In general, they feed on spores, plant tissue, algae, and lichens, but sometimes also on other insects. The nearly fifty-seven hundred species are largely solitary animals, although some can be found in abundant aggregations. Bark lice wings are fairly simple, with a reduced number of veins relative to most other winged insects and usually held over the body like a tent when not in use.

The more familiar and certainly detested members of this order are the true lice, the very paragons of parasitism. Like their nonparasitic relatives, there are approximately five thousand

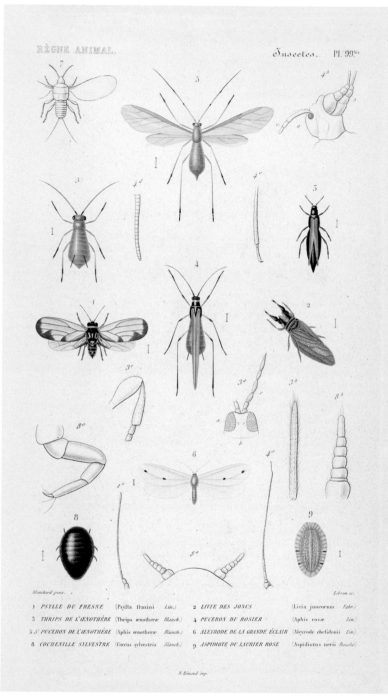

RÈGNE ANIMAL. Insectes. Pl. 99bis

1 *PSYLLE DU FRESNE* (Psylla fraxini *Lin.*) 2 *LIVIE DES JONCS* (Livia juncorum *Fabr.*)
3 *THRIPS DE L'ŒNOTHÈRE* (Thrips œnotheræ *Blanch.*) 4 *PUCERON DU ROSIER* (Aphis rosæ *Lin.*)
5 5ᵉ *PUCERON DE L'ŒNOTHÈRE* (Aphis œnotheræ *Blanch.*) 6 *ALEYRODE DE LA GRANDE ÉCLAIR* (Aleyrode chelidonii *Lin.*)
8 *COCHENILLE SYLVESTRE* (Coccus sylvestris *Blanch.*) 9 *ASPIDIOTE DU LAURIER ROSE* (Aspidiotus nerii *Bouché*)

Aphids, whiteflies, and scale insects, seemingly outliers among the insect order Hemiptera, are closely related to cicadas, planthoppers, and true bugs. Also included here is a single thrips (dark brown insect, upper right), representing the closely related order Thysanoptera. From Cuvier, *Le règne animal distribué d'après son organisation.*

species of true lice, all of which feed on the blood of bird or mammal hosts. Species usually have a high degree of specialization for feeding upon a given host and cannot survive on alternative hosts, although there are certainly several exceptions to this general rule. All true lice are wingless, having lost their wings during their evolution to parasitism, and while some retain the chewing mandibles of their bark lice relatives, one specialized group, the Anoplura (sucking lice), have a small beak used to pierce their host. Although lice are quite diverse, only three species feed on humans and these are aptly named as the head louse, body louse, and pubic louse, leaving little question as to where each might be found. Lice live out their entire lives on their hosts, cementing their eggs, called *nits*, to the feathers or hair of the host's body. In the case of human lice, this gives parents and children ample time to bond while the former carefully comb out the nits after the latter have been sent home early from school.

Related to the lice are two orders of largely plant-feeding insects, both of which have stylet-like mouthparts used to pierce and suck fluids. The thrips (a name that is both singular and plural, like *sheep*), or Thysanoptera, include fifty-eight hundred species of tiny insects specialized to feed on fungi, pollen, and plant tissue. Their wings are slender and fringed with elongate setae, and it is this feature that serves as the basis for their ordinal name, with *thysanos* meaning "fringe" or "tassel." Usually less than a millimeter in length, thrips can occur in dense populations, and some are pests of vegetable crops or ornamental flowers. Sometimes it is not so much the damage this type of thrips will do through its own feeding that makes it a pest, but the plant diseases it can unwittingly spread—such as viruses that

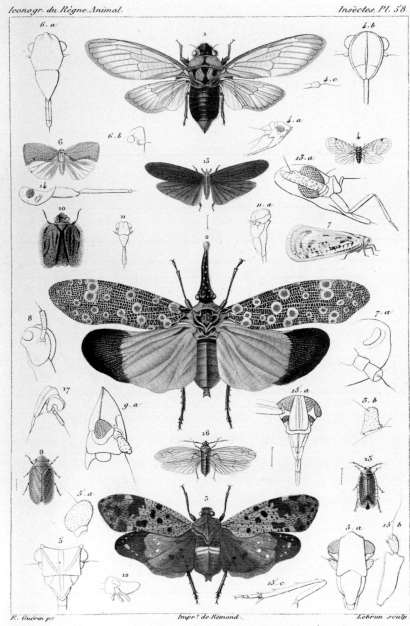

E. Guérin *pt.*　　　　　　*Impr*? *de Rémond.*　　　　　Lebrun *sculp.*

1. Cicada *Diardi, Guér.* 2. Fulgora *Lathburii, Kirby.* 3. Aphæna *variegata, Guérin.*
4. Cixius *pellucidus, Guér.* 5. Tête de Lystra *lanata, F.* 6. Ricania *marginella*
Guér. 7. Pœciloptera *maculata, Guér.* 8. Tête de Flata *floccosa, Guér.* 9. Tettigo-
metra *virescens, Lat.* 10. Issus *pectinipennis, Guér.* 11. Tête d'Iss. *coleoptratus, F.*
12. *Id.* d'Otiocerus *Coquebertii, Kirby.* 13. Anotia *coccinea, Guér.* 14. Tête de Derbe *pallida, Fab.*
15. Asiraca *clavicornis, F.* 16. Ugyops *Percheronii, Guér.* 17. Tête du Delphax *minuta, F.*

Cicadas, planthoppers, and lantern bugs together form one of the major diversifications of species among the largely herbivorous insect order Hemiptera (see next page). From Guérin-Méneville, *Iconographie du règne animal de G. Cuvier.*

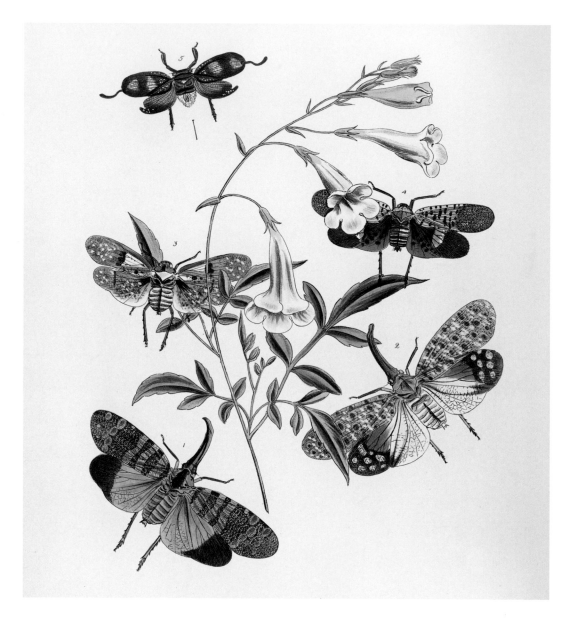

produce large necrotic areas on tomatoes or other crops. Despite this nuisance, other thrips are important pollinators and are relied upon by flowers such as those of the heath family, Ericaceae. Many thrips induce gall tissues (abnormal growths) in plants during feeding or while injecting their eggs in plants, and in one family these galls serve as the nests for small societies, complete with castes like those of termites—queens, sterile workers, and even soldiers.

The other piercing-sucking order, Hemiptera, is the first of the truly megadiverse lineages, with slightly over one hundred thousand species. These are the aphids, whiteflies, scale insects, planthoppers, cicadas, lantern

bugs, and true bugs. While *bug* is an oft-employed pejorative for any insect, it really refers to a diverse subset of Hemiptera, such as stink bugs, shield bugs, seed bugs, bed bugs, water striders, and many more. The name *Hemiptera* is derived from the Greek *hémisus*, meaning "half," due to the partially hardened forewings of the true bugs, where only the half farthest from the body is membranous. This is a lineage of seemingly disparate animals, but all share a characteristic form of rostrum (snoutlike projection) that has piercing stylets. Many Hemiptera—including the aphids, whiteflies, planthoppers, cicadas, and lantern bugs, many of which are major agricultural pests—use their piercing rostrum to access the nutritious fluids of plants. Conversely, most of the true bugs have become predators, although here and there some, such as palm bugs and the intricately beautiful lace bugs, that have reverted to a plant-feeding lifestyle. The predatory true bugs largely prey on other insects, but some have evolved to feed on bird or mammal blood. These include bed bugs and kissing bugs, the latter of which are notorious for the transmission of the tropical parasitic Chagas disease.

WINGS WERE, WITHOUT A DOUBT, one of the most significant factors in the success of insects. Flight certainly poised the many lineages to flourish and occupy diverse habitats, which along with feeding and other specializations led to the vast variety of winged insects. Wings alone, however, cannot entirely account for insect success, and it is a popular misconception that one evolutionary novelty is responsible for diversification, although such

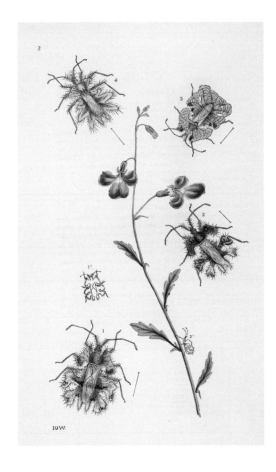

True bugs, such as these species of Coreidae, can have a spiky or lacelike appearance owing to expansions of the hardened wings and thorax. Here, golden egg bugs, so named because they carry their orange eggs on their back. From Westwood, *Arcana Entomologica*.

oversimplifications do make for good sound-bites. In reality, it is the coming together of many evolutionary factors—an interaction of several key traits in combination with the wider environment, stochastic events, and the concomitant evolution of other lineages—that breeds diversity. For insect diversity, a significant change subsequent to the origin of wings metamorphosed a large group of flying insects into evolutionary superpowers, with true hegemony over our world.

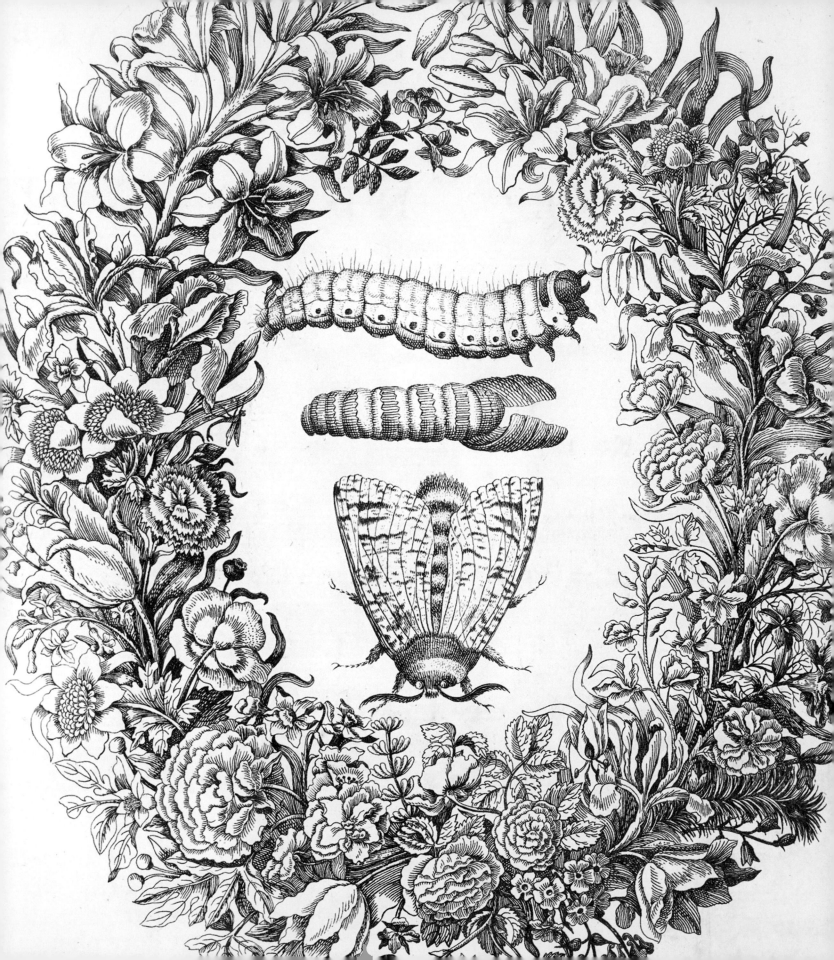

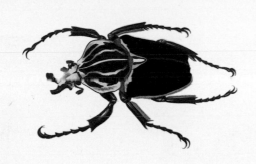

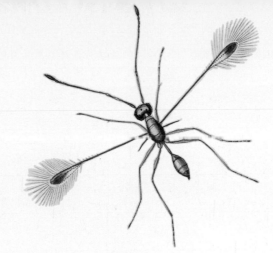

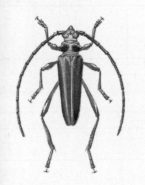

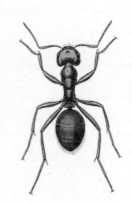

5

Complete
METAMORPHOSIS

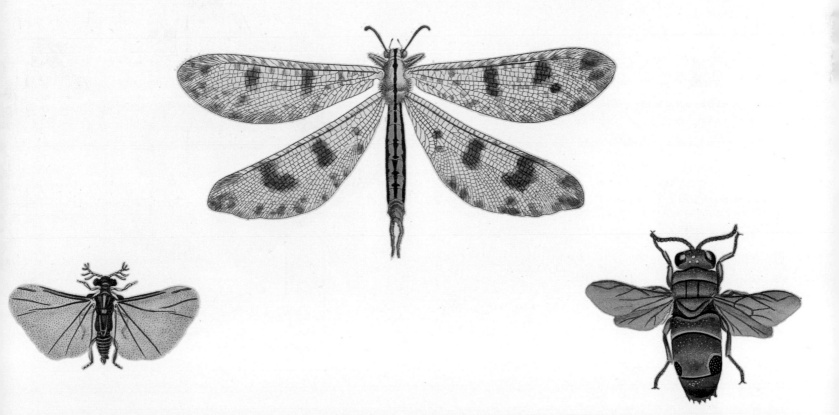

> *"Nothing in a single-frame picture of a caterpillar tells you it is going to transform into a butterfly."*
>
> —R. Buckminster Fuller
> *Cosmography*, 1992

PAGE 76: Detail of a larva, pupa, and adult moth, from Maria Sibylla Merian's *Histoire des insectes de l'Europe* (1730) (also see page 80).

RIGHT: Developmental stages of a lucanid stag beetle: eggs (bottom left), larvae (bottom right and center left), pupae (center right and bottom center), and pupal chamber (top). From August Johann Rösel von Rosenhof, *De natuurlyke historie der insecten* (1764–1768).

OPPOSITE: One of the greatest contributions to understanding insect metamorphosis came from the great illuminated folios produced by Merian during her time living in Suriname. Top to bottom: the longhorn beetle (*Macrodontia cervicornis*), the large tropical weevil (*Rhynchophorus palmarum*), and a common orchid bee (*Eulaema cingulata*). From Merian's *Surinaemsche insecten* (1719).

As children, we are essentially miniaturized versions of our later selves. The same is true for many groups of insects, and the immature forms of almost all of the orders discussed in the preceding chapters resemble their corresponding adult forms to a large degree. After hatching from the egg, nymphs become progressively larger at each molt, ultimately reaching sexual maturity and gaining their fully functional wings at the final molt to adulthood. This kind of development is termed *hemimetabolous* (from the Greek *hemi,* meaning "half," and *metabolos,* or "changeable"); it is sometimes referred to as *incomplete metamorphosis*, as the changes between molts are slight and the nymphs typically have lives similar to their mature forms. For example, the nymphs of grasshoppers have the same diet and habits as the adults, but they are smaller, have nonfunctional wing pads, and have not yet become reproductively capable. The most diverse groups of winged insects, however, have a fundamentally different mode of development, beginning life as a larva—whether as a caterpillar (moths and butterflies), grub (beetles), or maggot (flies)—and undergoing a more dramatic form of transformation from a larva into a pupa and then ultimately into an adult. By contrast, a hemimetabolous insect, such as the aforementioned grasshopper, has no larval or pupal stage prior to adulthood, only nymphal.

Complete metamorphosis, properly termed *holometabolous* (in Greek, *hólos* means "complete"

SCARABAEORUM TERRESTRIUM CLASSIS I.

Tab.IV.

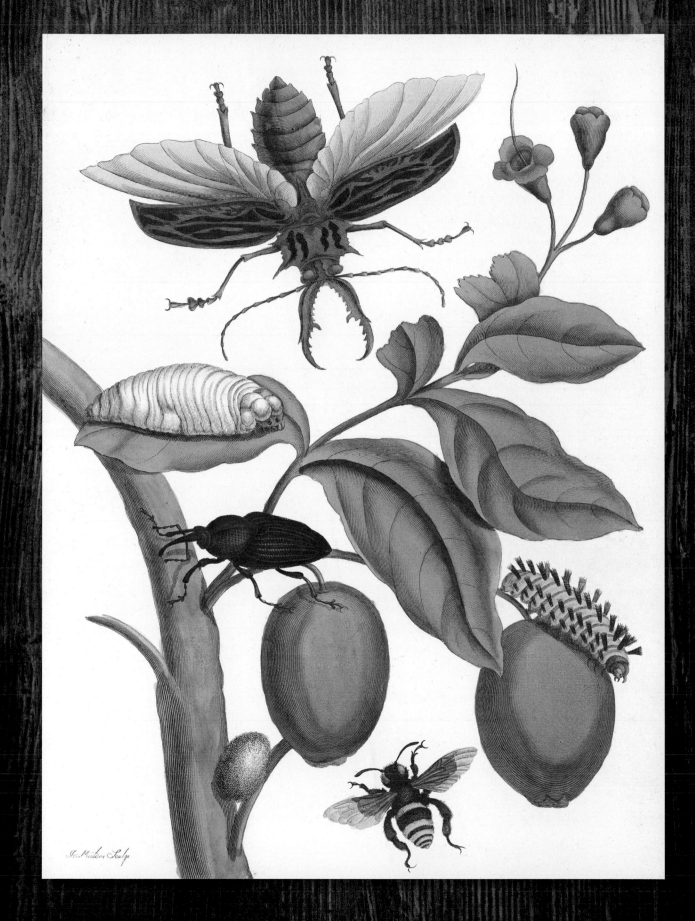

CLXXI

lived by the one individual as entirely distinct modes of existence. Larvae frequently live in different habitats from adults, feed on different foods, and require different conditions in order to succeed. So different are larvae from their adults that for the greater part of human history, it was mistakenly believed that larval and adult insects had nothing to do with one another and were completely separate animals. For centuries, observers failed to see whence adult holometabolous insects sprang, or if they did connect a larva with its associated adult, then it was supposed that some fantastical transformation had taken place such that a wholly new animal appeared.

Any number of bizarre hypotheses filtered through the ages. It was believed that most insects did not mate, but generated directly from rotting material, either flesh or vegetation. One famous hypothesis was the notion that bees were born from the rotten carcasses of oxen, a misconception that persisted for over a thousand years before it was dispelled. In his *Etymologiae,* Isidore of Seville (see pages 16–17) taught that honey bee workers were formed from rotting oxen, while hornets sprang from decomposing horses, drone bees (males) issued from decaying mules, and some wasps emanated from putrid asses. Interestingly, the details of metamorphosis as we understand it today were principally elaborated by the work of two individuals in the late seventeenth century who were both based in Amsterdam: Jan Swammerdam (1637–1680), a Dutch anatomist (see pages 82–83), and Maria Sibylla Merian (1647–1717), a native German illustrator and naturalist (see pages 94–96). Both devoted their talents to the mysteries of insect development, and each published accounts that demonstrated the continuity in

or "total"), stands in stark contrast to hemimetabolous metamorphosis. Holometabolous insects emerge from the egg as a larva, which grows through a series of molts prior to undergoing a developmental shift into a largely quiescent stage known as the *pupa*—sometimes within a cocoon, such as those made famous by silkworms—before taking the stage as an adult. The larva differs greatly from the adult, and in most instances these two stages are

life of holometabolous insects—from egg, to larva, to pupa, and finally adult.

Despite Fuller's quote at the beginning of this chapter, within developing larvae are islands of tissue that represent the primordia of those structures that will be unique to the adult, such as wings, antennae, and reproductive organs. These clusters of cells, called *imaginal discs*, were discovered by Swammerdam, who correctly interpreted their role in metamorphic development.

Holometabolous insects account for the real bulk of insect diversity, with approximately 85 percent of all insects undergoing complete metamorphosis. In fact, the ascendance of insects is partly credited to this reality by which complete metamorphosis allows larvae and adults to experience such different lives. All of the taxonomic orders discussed in the remainder of this chapter belong to this major grouping, and they are collectively known as the Holometabola, a less-than-subtle allusion to their characteristic mode of development. Despite the considerable success of the Holometabola, not all holometabolous insect orders are rich in species, at least by insectan standards. Indeed, while four particular groups number over one hundred thousand species each, the other groups include ten thousand species or less in all.

MEGALOPTERA, RAPHIDIOPTERA, AND NEUROPTERA

Three groups form a tight set of related orders among insects that undergo complete metamorphosis. Most commonly called dobsonflies, snakeflies, and lacewings—or Megaloptera,

Representative species of the closely related insect orders Megaloptera, Raphidioptera, and Neuroptera. Top to bottom: Megaloptera–the alderfly (*Sialis lutaria*) and the fishfly (*Chauliodes pectinicornis*); Raphidioptera–the snakefly (*Raphidia ophiopsis*); and Neuroptera–the mantis lacewing (*Mantispa styriaca*). From Georges Cuvier, *Le règne animal distribué d'après son organisation* (1836–1849).

Raphidioptera, and Neuroptera—these are minor groups among holometabolous insects, and they are collectively relicts of a lineage going back over 280 million years but that was dwindling by 50 million years ago. Today, these

A ZEALOT FOR CHANGE

For millennia it was assumed that larvae, pupae, and adult insects were all unrelated, representing entirely different individuals. It was also believed that many insects were the result of spontaneous generation, sometimes materializing from the putrefied flesh of other animals. Such a notion was anathema to the Dutch physiologist Jan Swammerdam, who would exorcise these ideas from entomology but whose own religious fanaticism eventually led him to cast aside his science.

Swammerdam was born in Amsterdam in 1637. He matriculated at the University of Leiden in 1661, trained to be a doctor, and graduated in 1667, after a brief leave to work in Paris. While in Paris he befriended the royal librarian of Louis XIV, Melchisédech Thévenot (ca. 1620–1692), who would later send Swammerdam a copy of *De Bombyce* (1669), a book on the dissection of the silk moth by Italian anatomist Marcello Malpighi (1628–1694). Swammerdam was already fascinated by the minute lives of insects, and his interests were further fueled by Malpighi's work—much to the consternation of Swammerdam's father, who wished his son to pursue the priesthood or practice medicine.

Swammerdam became singularly devoted to natural history. Rearing insects in his home and even nourish-

ABOVE LEFT: Swammerdam depicted in a print by Johann Peter Berghaus after Rembrandt van Rijn, ca. 1840. ABOVE RIGHT: The title page to a 1685 edition of Swammerdam's *Historia Insectorum Generalis* (1669), a work wherein he dispelled ancient misconceptions regarding metamorphosis.

ing blood-feeding species with his own blood, Swammerdam studied the habits and life cycles of mosquitos, moths, ants, and others, all under microscopic examination and with honed microdissection techniques. He constructed his own instruments and perfected a precision for working with the tiniest of insect organs. Swammerdam is credited with numerous discoveries, not all entomological, from nerve induction of muscular contraction to the lymphatic valves that today bear his name. Above all of these, he is most remembered for dispelling the idea that any insects generated spontaneously, and for demonstrating without question that larva, pupa, and adult are all different stages in the life of a single individual. He was also the one to empirically prove the gender of the queen bee by dissecting her abdomen to reveal ovaries, and he was the one to discover the drone's male organs. Swammerdam prepared all of his own illustrations, using the latest method of the age, engravings in copper.

Swammerdam's fervor for study was intense, galvanized by his awe at God's creation. His faith, however, turned to

zeal, and in 1673 he walked away from science. By 1675, he had fallen under the spell of the hysterical and persuasive French-Flemish mystic spiritualist Antoinette Bourignon (1616–1680), who led a small group of rogues around Europe, distributing pamphlets of her revelations. Not surprisingly, Swammerdam found his spiritual emptiness was not sated, and in 1677 he rather quickly left the sect, returning to Amsterdam distraught and ill. His father had passed away, and Swammerdam became embattled with his sister over the inheritance. He died in 1680, only in his early forties.

Before being overtaken by religious zeal, however, Swammerdam published his initial entomological observations in 1669 as *Historia Insectorum Generalis* (*A General History of Insects*). His most extensive and fundamental contribution, however, was compiled from loose manuscripts and translated into Latin by Herman Boerhaave (1668–1738). This collection appeared in 1737, fifty-seven years after Swammerdam's death, as the *Biblia Naturae* (*Nature Bible*). The pious Swammerdam's "bible" of nature truly glorified the multiplicity of creation through empirical science and the fact that one organism could undergo considerable change during its life, much as Swammerdam did himself.

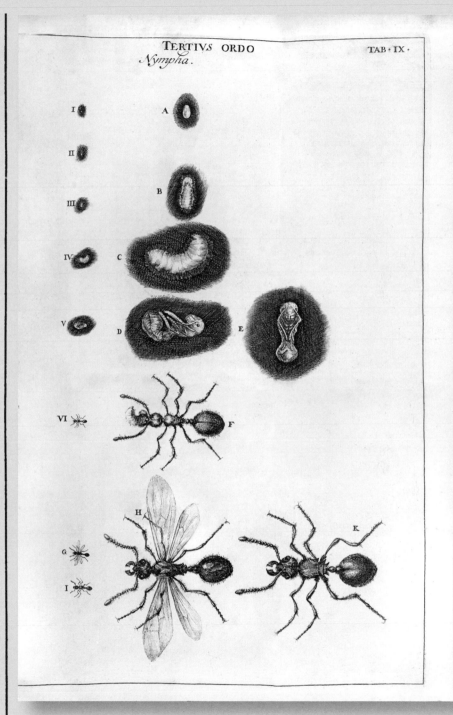

The various stages of development in an ant (family Formicidae) as worked out by Swammerdam and meticulously figured in copper engravings, from *Historia Insectorum Generalis*.

ABOVE: The predaceous larvae of giant dobsonflies, such as *Corydalus cornutus* (adult shown here), are called *hellgrammites* and are a popular bait among anglers. From Cuvier, *Le règne animal . . .*

RIGHT: Snakeflies (order Raphidioptera) take their common name from their serpentine necks that give them an archaic, almost antediluvian-like, appearance. Detail from M. Olivier, *Encyclopédie méthodique. Histoire naturelle. Insectes.* (1811).

The dobsonflies, along with the related fishflies and alderflies, have aquatic larvae, with the sizable ones familiarly known to fishermen as *hellgrammites*. These are often large, robust insects, with one monstrous species discovered in 2014 wielding an 8-inch (20-centimeter) wingspan. The derivation of the name *Megaloptera* is therefore quite apt, as the Greek words *mégas* and *pterón* mean "large wing." A dobsonfly spends most of its life as a larva, living in the water for several years before emerging to build a pupal chamber in the soil and later hatching as a short-lived adult. Male dobsonflies appear ferocious, with long tusklike jaws, but are largely harmless as these ornamentations are used to display for females during courtship and to grasp their mates, but not for hunting. Megaloptera can be found throughout the world.

Snakeflies, as their name implies, superficially resemble tiny serpents because of their long necks and slender heads, which are often positioned as though they are slightly recoiled. However, the first part of their ordinal name, *Raphidioptera*, refers to the opposite end of the body. Female snakeflies have long, needle-like ovipositors, and it is this feature that lends them their name—from the Greek *raphidos*, meaning "needle." Although distributed globally over sixty-five million years ago, today snakeflies are restricted to temperate forests of the Northern Hemisphere where they are daylight predators, usually feeding on small arthropods. The long ovipositor is used to deposit eggs underneath bark, where many larval snakeflies develop. Immature snakeflies are peculiar among holometabolous insects for two reasons. First, in order to complete their development, the late-stage larva or pupa must undergo a period of near-freezing

three groups of insects weigh in at about 380, 250, and 5,800 species respectively—meager numbers relative to the likes of beetles, moths, and flies. All three have greatly innervated, membranous wings to one degree or another, and while entomologists have debated relationships among the principal lineages of insects, the evolutionary affinity among these has almost never been in any serious doubt.

temperatures, a trait that partly explains their confinement to colder northern localities or higher elevations. Secondly, whereas pupae are generally quiescent, snakefly pupae are active and quite mobile, hunting for small prey just as do the adults.

Last are the lacewings, which also include antlions and owlflies. Their diaphanous wings are intricately laced by fine veins, much more so than dobsonflies or snakeflies. The beginning of their ordinal name, *Neuroptera*, derives from the Greek *neuron*, "nerve," referencing this very fact. Adult lacewings are usually nocturnal animals that often feed on pollen or nectar, although some consume small arthropods or don't eat at all—not living long enough as adults to require food. While the adults appear delicate and graceful, the larvae are vicious predators. All larval Neuroptera have modified jaws in which the mandibles and maxillae are united to form vampiric tubes that are used to drain the bodily fluids of their prey. The larvae of green lacewings are effective killers of aphids and often cloak themselves in elaborate camouflage by covering their bodies with pieces of lichen, plant debris, or even the

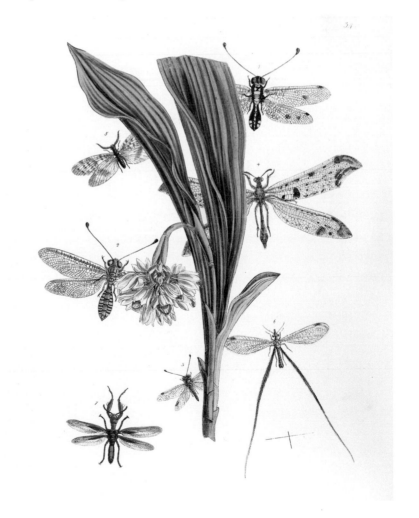

ABOVE: Antlions (family Myrmeleontidae, order Neuroptera) and fishflies (family Corydalidae, order Megaloptera) include some of the largest species of their respective orders: top to bottom, *Palpares libelluloides*, *Euptilon ornatum*, *Chauliodes pectinicornis*, and *Vella americana*. From Dru Drury, *Illustrations of Exotic Entomology* (1837).

RIGHT: The wings of lacewings (order Neuroptera) and their relatives are more richly innervated than most other holometabolous insects. Here are shown owlflies, antlions, mantis lacewings, and thread-winged lacewings, as well as a single fishfly (order Megaloptera, upper left). From John O. Westwood, *The Cabinet of Oriental Entomology* (1848).

corpses of their victims (see pages 170–171). They are so effective that one of their common names is "aphid wolf," and they are sometimes employed as biological control agents. Larval antlions burrow backward into loose soil or sand, sitting at the bottom of small pits with their stout jaws spread wide, waiting for ants or other arthropods to stumble to the bottom and meet a rather crushing demise. Perhaps most peculiar of all are the lacewings known as spongillaflies, whose larvae have evolved as predators of freshwater sponges, a form of prey that the predator need not fear will escape.

BELOW LEFT: Adults of antlions (family Myrmeleontidae, upper box) and owlflies (family Ascalaphidae, lower right) of the order Neuroptera, and scorpionflies (family Panorpidae, bottom left box) of the order Mecoptera. From Olivier, *Encyclopédie méthodique. Histoire naturelle. Insectes.*

BELOW RIGHT: The larva of a common European antlion (family Myrmeleontidae) dig characteristic funnel-like pits in soil to trap passing prey. From Rösel von Rosenhof, *De natuurlyke historie der insecten.*

COLEOPTERA

The beetles, order Coleoptera, are so wholly unlike lacewings, dobsonflies, and snakeflies in general appearance that it is usually a shock to learn that they are all closely related. Beetles are the behemoths of insect diversity, with over 360,000 described species and a steady stream of new species flowing in every year—even from the seemingly over-studied faunae of North America and Europe. There seems to be no end in sight to the growth of coleopteran

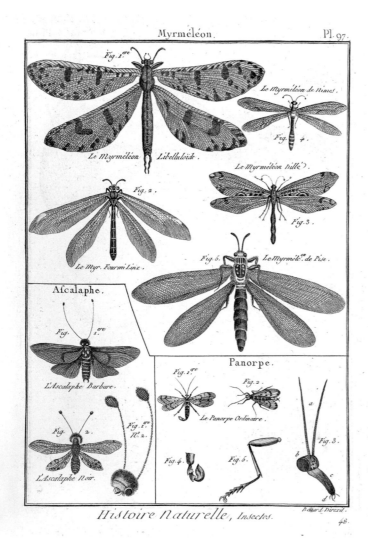

INNUMERABLE INSECTS

SCARABAEORUM TERRESTRIUM PRAEFAT. CLASSIS II.

Tab. I.

Fig. a.
Fig. b.
Fig. 1.
Fig. 2.

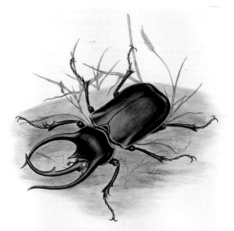

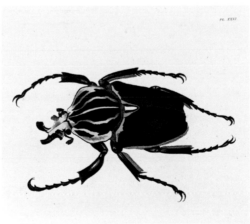

Pl. XXXI

TOP LEFT: Iconic large beetles, clockwise from top left: the harlequin beetle (*Acrocinus longimanus*); and at right, the sabertooth longhorn beetle (*Macrodontia cervicornis*). From Rösel von Rosenhof, *De natuurlyke historie der insecten.*

BOTTOM LEFT: Named for the Greek Titan who supported the heavens upon his shoulders, the massive Atlas scarab beetle (*Chalcosoma atlas*) from Southeast Asia can be over 5 inches (12.7 centimeters) in length. The males use their prominent horns in jousting matches between competitors seeking mates. From Edward Donovan, *Natural History of the Insects of India* (1838).

BOTTOM RIGHT: The goliath beetle (*Goliathus goliatus*) of eastern equatorial Africa is one of the larger species in its genus, with lengths up to 4.3 inches (11 centimeters). From Drury, *Illustrations of Exotic Entomology.*

diversity, and nearly one-fifth of all the known species on our planet are beetles. From this, one can properly appreciate J. B. S. Haldane's reported reference to God's seemingly inordinate fondness for Coleoptera.

In Greek, *coleos* means "sheath," which refers to the hardened and protective covering on the body of the beetle. This characteristic "shell" is actually composed of the front pair of wings, which are specialized forewings called *elytra*. The hind wings alone are used for flight, and when not in use, these broad wings are folded in a characteristic manner, tucked safely under the elytra and on top of the abdomen,

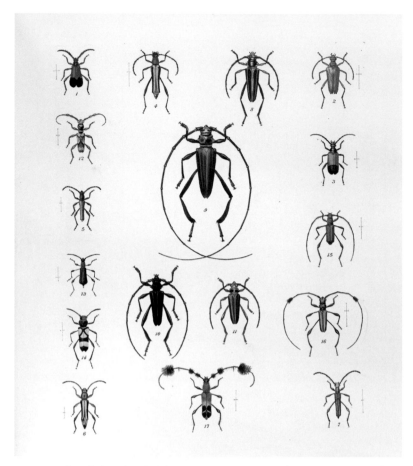

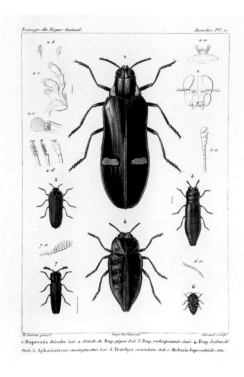

ABOVE LEFT: A profusion of tropical American longhorn beetles (family Cerambycidae). From *Biologia Centrali-Americana. Insecta. Coleoptera.* (1880–1911).

ABOVE RIGHT: The hardened forewings (called *elytra*) of beetles, often marked with patterns and colors—as well as the inordinate numbers of beetle species—have made them popular with amateur and professional entomologists alike. The elytra of large species, such as the *Megaloxantha bicolor* (at center), can vary from green to blue to red and have even been used to make jewelry. From Félix-Edouard Guérin-Méneville, *Iconographie du règne animal de G. Cuvier* (1829–1844).

with both abdomen and hind wings covered and protected by the hardened forewings.

Beetles come in every shape and size, from the aptly named Goliath beetles of Africa, which can grow to over 4 inches (10 centimeters), illustrated on page 87, to *Scydosella musawasensis*, the nearly invisible featherwing beetle of Nicaragua, which at just over one-hundredth of an inch (.25 millimeters) in length holds the current record as the smallest of all beetles. We give special names to certain groups of beetles—fireflies, ladybugs, June bugs, and weevils are nothing more than particular forms of this wide-reaching lineage. For any mode of life one can envision, there is certainly a beetle that fits the description: parasites, predators, pollinators, fungal feeders, plant pests, aquatic forms, and even species that prefer to muck about in slime and dung. Virtually everywhere you look, a beetle is to be found. The biggest groups are specialized herbivores, having diversified along with flowering plants, although beetles as a whole are much more ancient, with fossil species recognizable as early beetles dating back 280 million years ago. With their never-ending variety, they have been a favorite of collectors for hundreds of years, and many budding entomologists start as beetle aficionados, Darwin among them.

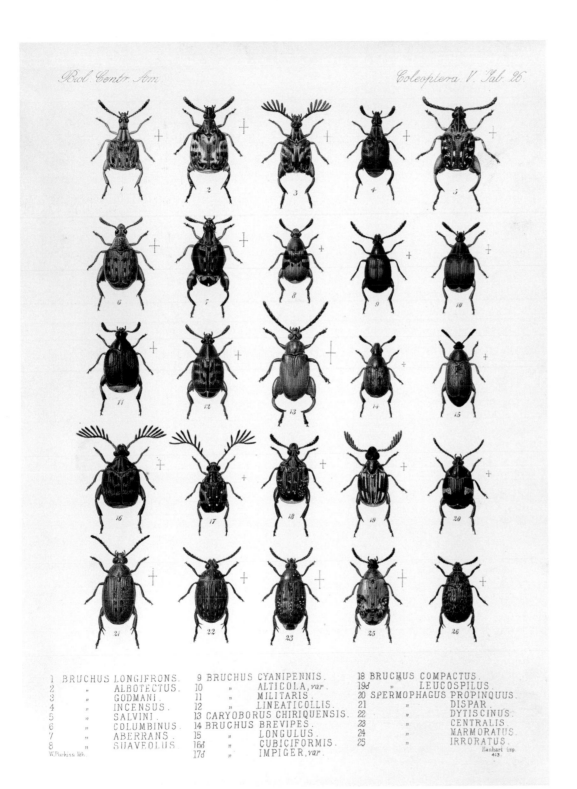

1 BRUCHUS LONGIFRONS.	9 BRUCHUS CYANIPENNIS.	18 BRUCHUS COMPACTUS.
2 " ALBOTECTUS.	10 " ALTICOLA, var.	19♂ " LEUCOSPILUS.
3 " GODMANI.	11 " MILITARIS.	20 SPERMOPHAGUS PROPINQUUS.
4 " INCENSUS.	12 " LINEATICOLLIS.	21 " DISPAR.
5 " SALVINI.	13 CARYOBORUS CHIRIQUENSIS.	22 " DYTISCINUS.
6 " COLUMBINUS.	14 BRUCHUS BREVIPES.	23 " CENTRALIS.
7 " ABERRANS.	15 " LONGULUS.	24 " MARMORATUS.
8 " SUAVEOLUS.	16♂ " CUBICIFORMIS.	25 " IRRORATUS.
	17♂ " IMPIGER, var.	

W. Purkiss lith. Hanhart imp.
413.

Seed beetles (subfamily Bruchinae) are a diverse group among the leaf beetles (family Chrysomelidae). The larvae chew their way into the seeds of various plants; these granivores can be critical pests of crops. From *Biologia Centrali-Americana. Insecta. Coleoptera.*

STREPSIPTERA

The twisted-wings (yes, that is a name), order Strepsiptera, are a group of approximately six hundred species that are exclusively parasitic, and they perhaps hold the distinction of being the most wholly bizarre of all insects. So peculiar are the twisted-wings that identifying their nearest relatives has boggled the minds of entomologists, although it appears as though they are likely relatives of the beetles. In appearance and biology, twisted-wings are unforgettable animals, and it is only their minute proportions and scarcity that prevent them from being more properly scrutinized. Adult males are certainly distinctive, with large, bulbous eyes that resemble blackberries. The forewings are reduced to small, slender stalks that do not function for flight, but rather appear to provide sensory input that aids in orientation. Conversely, the hind wings, which alone power twisted-wing flight, are broad and scarcely retain any of the veins that usually traverse the surface of insect wings. Their name is derived from these flimsy wings, as in Greek, *streptós* means "twisted." The male antennae are greatly branched, and the mandibles are vestigial, assuming sensory rather than gustatory roles.

The female twisted-wing is another matter entirely. In almost all twisted-wings, the adult females are neotenic, a term referring to the fact that although they are adults, in outward appearance they remain as if larvae. Thus, nearly all females lack eyes, antennae, wings, legs, and even some seemingly necessary organs, such as

NEAR RIGHT: The enigmatic twisted-wing parasites (order Strepsiptera) have fully winged males while females, who never leave their host, are scarcely recognizable as insects. Clockwise from upper left: *Xenos vesparum*, *Stylops dalii*, *Elenchus tenuicornis*, and *Halictophagus curtisii*. From Cuvier, *Le règne animal . . .*

FAR RIGHT: When first discovered and described, the twisted-wing parasite *Halictophagus curtisii* was presumed to victimize sweat bees of the genus *Halictus*, with this assumed biology reflected in the scientific name, which literally means "eating *Halictus*." However, it was later discovered that they instead parasitize planthoppers and thorn bugs and relatives of these groups, leaving the generic name quite a misnomer. From John Curtis, *British Entomology* (1823–1840).

a rectum. As a parasite, the female lives within the body of her host, such as a bee or a cricket, and does not emerge except to extrude a small portion of her simplified head through membranous joints in her host's exoskeleton, this being her only connection with the outside world. In another bizarre "twist," an exposed opening on her head serves as both the site with which the adult male will mate, and the canal through which she will later give birth to live young, rather than lay eggs as most other insects do. As pitchmen are so fond of saying, "But wait, there's more!" A winged male will locate a parasitized host in which the adult female's head is partially extruded; he will mate with her extruded head, and then depart. The fertilized eggs in time spill into the female's body cavity and will develop inside of her, eventually becoming first-stage larvae. These first-stage larvae are highly active and emerge through the canal in the mother's head, dispersing into the environment to look for new hosts. Once a new host is found, the twisted-wing larva uses digestive enzymes to effectively "bore" its way into the host's body where it then molts to a greatly simplified, legless, and largely quiet larval form, gradually extracting nutrients from its victim. Eventually, developing males extrude from the host to form a pupa and then later an adult, while females repeat the cycle undertaken by their mothers.

HYMENOPTERA

Ants, bees, and wasps are all members of the Hymenoptera (*hymenos* meaning "membrane" in Greek), which comprise one of the four "mega" orders of insects. Hymenoptera number over 155,000 species and are one of those groups that remain grossly underestimated in terms of their total diversity—it could double in size once a full accounting is completed. Few realize it, but ants and bees are merely modified wasps, and so one might simply say

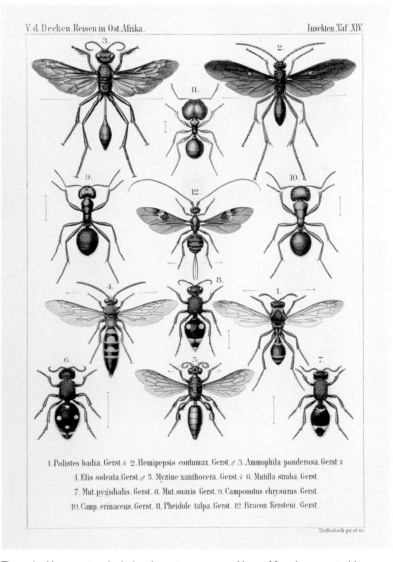

The order Hymenoptera includes the ants, wasps, and bees. Many hymenopterids are capable of stinging, such as the majority of species (from varied families) depicted here, although ironically, the one at center with the long ovipositor is actually a parasitoid wasp (*Bathyaulax kersteni*) and does not sting. From Carl Eduard Adolph Gerstaecker, *Baron Carl Claus von der Decken's Reisen in Ost-Afrika in den Jahren 1859 bis 1865* (1873).

Pl. 37.

Prêtre del.

Corbié sc.

1. Parnopes carnea. *Fab.* 2. Cleptes semiaurata. *Lep.* 3. Stilbum calens. *Fab.*
4. Euchræus purpuratus. *Fab.* 5. Hedychrum lucidulum. *Fab.* 6. Chrysis ignita. *Lin.*

1. *Chrysis imperialis.*
2. *Stilbum oculatum.* 3. *Stilbum splendidum.*

LEFT: Cuckoo wasps (family Chrysididae) such as these often display brilliant metallic colors and, much like pill bugs, can roll themselves into a tight defensive ball when attacked. From Amédée Louis Michel Lepeletier, comte de Saint Fargeau, *Histoire naturelle des insects* (1836–1846).

ABOVE: Cuckoo wasps number over three thousand species worldwide and, like the birds they were named after, many are "cuckoos" that lay their eggs in the nests of other wasps—although some are specialized parasites of stick insects or sawflies. From Donovan, *Natural History of the Insects of India.*

that this is the order of wasps. The big theme in wasp evolution is that of parasitism, with parasites comprising over 75 percent of the species. The most primitive wasps, however, feed exclusively on plants as larvae, sometimes forming large aggregations and becoming injurious forest pests. Plant-feeding species such as wood wasps and sawflies—so named because of the sawlike ovipositors they use to place eggs within stems or other plant tissues—account for only eight thousand species. These do not have the archetypical "wasp waist"; instead the abdomen is tightly adjoined to the thorax.

The more familiar-looking wasps evolved a narrow waist, allowing great movement of the abdomen, and, more importantly, the ovipositor at its end. These wasp-waisted species became parasitic, first on other wood-boring insects and then branching out to attack the full panoply

of insects and even some arachnids. Parasitism apparently kicked wasp diversification into high gear well before the origin of flowering plants. The biology of some parasitic wasps is the stuff of nightmares, even partially inspiring the themes of popular movies such as *Alien*. For example, a female ichneumonid wasp will grasp her victim, such as a caterpillar, arch her slender abdomen up high as a guide for the hypodermic ovipositor, and inject her eggs into the living host. The host then goes about its life, while the wasp larvae consume them from within, eventually killing the host and bursting from its body to form pupal cocoons. One group of these narrow-waisted wasps evolved a further modification of the ovipositor in which it is no longer used to lay eggs but instead injects venom from associated glands, this being the sting we all fear. The sting is used both to subdue prey and as a defensive weapon. Since it is a modified ovipositor, males obviously lack this structure and are incapable of inflicting such harm.

While some of these stinging wasps remained parasites, most evolved into predators that went on to hunt spiders, caterpillars, planthoppers, and many other insects. The predator species include our most familiar Hymenoptera: hornets, paper wasps, yellow jackets, ants, and bees, most of which are also social, with intricate nests and colony structures. Rather than hunt prey, bees seek out pollen and nectar and are preeminent pollinators. Yet, even among the bees, parasitism remains a driving theme. Most bees are solitary, and while there are slightly less than one thousand social species, about 5 percent of their diversity, there are several thousand species of parasitic bees. Commonly called cuckoo bees, they place their eggs within the nests of others, just like the birds of the same name.

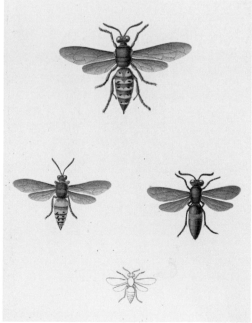

TOP LEFT: The forewings of the fairy wasp (*Mymar pulchellum*), at less than 1 millimeter in length, have an elongate stalk that expands into a paddle at their apex and bears a fringe of long, stiff setae—a characteristic form of wing for truly minute flying insects for whom flight is similar to swimming through a viscous fluid. From Curtis, *British Entomology*.

BOTTOM LEFT: The western cicada killer (*Sphecius grandis*, at top and far left) is an impressively sized wasp (2 inches [5 centimeters] in length) that hunts cicadas, while the sphecid wasp (*Stizoides unicinctus*, near left) is a cuckoo in the nests of related wasps. Despite their fearsome appearance and size, neither are aggressive. From Thomas Say, *American Entomology* (1828).

THE ART OF CHANGE

During a time when women were largely excluded from scientific circles, Maria Sibylla Merian artfully demonstrated a fine aptitude for natural history and left to the world one of the most recognizable folios on insect life. Like her contemporary Jan Swammerdam, Merian documented insect metamorphosis, helping to loosen the grip of many Aristotelian and medieval misconceptions.

Merian was born in Frankfurt in 1647 to an engraver who died when she was only three. A year later, her mother married the floral painter Jacob Marrel (1613–1681), who tutored Merian in art. As a young girl she was drawn to the beauty of insects and began sketching and painting images of caterpillars on their plants, noticing how in time they transformed to moths and butterflies. Marrel was himself a devotee of the works of Caravaggio (1571–1610), a painter famed for his naturalism. Caravaggio did not shy away from depictions of decay, such as his *Basket of Fruit* (ca. 1599), which—daring for the time—includes a worm-eaten apple and insect-damaged leaves. This appreciation for realism must have passed down to Merian, whose own works would depart from artistic conventions, often showing within one scene the complete cycle of life—including the less-than-gorgeous aspects of death.

Merian married one of her stepfather's students, Johann Andreas Graff (1636–1701), in 1665. She eventually had two daughters, and, like Marrel, taught painting. In 1675, she published a collection of floral engravings, followed in

Portrait of Maria Sibylla Merian by Jacob Joubraken after Georg Gsell, from *A Dictionary of Painters* by Matthew Pilkington (1805).

MARIA SIBILLA MERIAN
Nat. XII. Apr. MDCXLVII. Obiit XIII. Jan. MDCCXVII.

1677 and 1680 by two further sets illustrating the metamorphosis of butterflies and other insects. One set even included a painting of parasitic wasps attacking caterpillars. Her marriage was an unhappy one, and she left her husband in 1685 to join a Protestant commune in

the Dutch village of Wieuwerd, living at a residence owned by Cornelis van Aerssen van Sommelsdijck (1637–1688), the first governor of Dutch Suriname. There, Merian became intrigued by fantasies of tropical life. In 1691, she and her daughters moved to Amsterdam. The following year, Merian's husband divorced her, while their eldest daughter married a merchant based in Amsterdam who traded with Suriname. Merian was determined to explore and illustrate the natural wonders of a tropical environment, and by 1699 she began to plan a voyage to Suriname, covering her expenses through the sale of paintings and apparently with some assistance from her merchant son-in-law.

In July of that year, she and her younger daughter set sail, arriving two months later in the colony she had dreamed of seeing for more than a decade. For two years she traveled throughout the colony, keenly observing the plants and animals, principally insects and their metamorphosis, all of which were foreign to her European experiences. Tropical forests are tall and greatly stratified, with much insect life taking place high above in the canopy, well out of a human's reach and view. Merian did what she could to access the species up above, and even once had men fell a tree so that she might see what wonders lay beyond the capability of

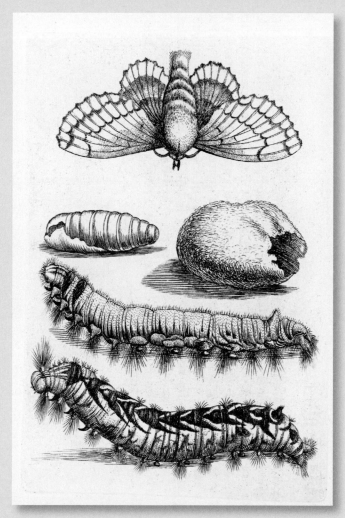

From early in her career, Merian was fascinated by the life cycles of insects and regularly depicted the various stages—such as the larva, pupal case, and adult—of moths (depicted here from *Histoire des insectes de l'Europe*) and butterflies.

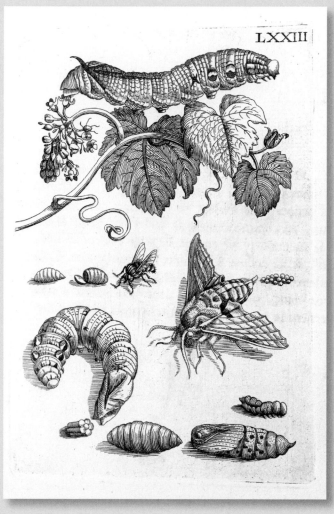

Merian characteristically showed both the beautiful as well as the less attractive aspects of life all within the same image, such as the one seen here, from *Histoire des insectes de l'Europe*, detailing the various life stages of a moth alongside the same stages of their parasitic flies.

climbers. Everywhere she cast an objective and careful eye.

In June 1701, Merian fell ill, possibly suffering from malaria, and had to return to Amsterdam. Upon her return, she sold specimens and for four years finalized her engravings and watercolors of the many tropical plants and insects she observed. These artworks were accompanied by text detailing the insects' life cycles, and—most importantly—for holometabolous species, descriptions of their complete metamorphosis. Published in 1705, her *Metamorphosis Insectorum Surinamensium* (*Transformation of the Suriname Insects*) was a tour de force of empirically derived wisdom, and while the book was a success, the finances it generated did not last for the remainder of her life. Merian preferred scientific

knowledge over wealth and comfort, and she continued to sell her paintings as a means of support. Despite the power of her opus in intellectual circles, as a woman she was largely barred from discussions, even when they concerned her own findings. In 1715, Merian suffered a stroke that left her partly paralyzed. She never recovered, passing from this world in 1717. Had she painted her own life, it certainly would have mimicked those of her beloved insects, a representation of her own metamorphosis, utterly changing the expectations of a woman at the dawn of the Enlightenment.

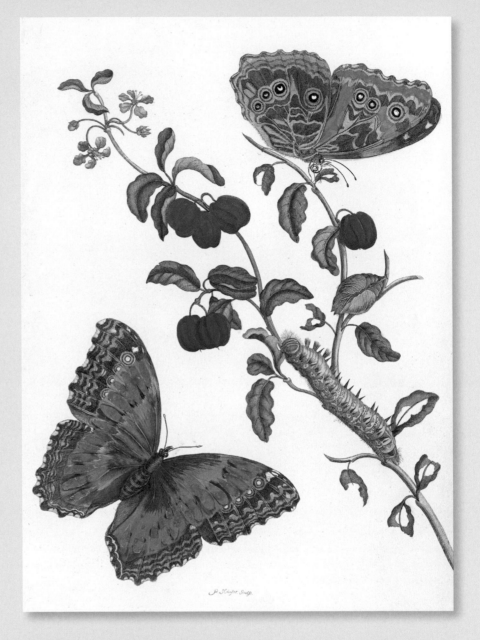

Merian's sojourn in Suriname brought her together with large tropical butterflies such as this Deidamia morpho (*Morpho deidamia*), which she shows feeding as a larva on its host plant, Barbados cherry (*Malpighia glabra*), and as adults, with both the upper and lower wing patterns replicated. From *Surinaemsche insecten* (1719).

MECOPTERA AND SIPHONAPTERA

Another minor group are the scorpionflies, which have the scientific name Mecoptera (*mêkos* in Greek means "length," a reference to the long wings of many in the order). Like the lacewings, these insects are today relict, with scarcely more than 750 species. The order consists of rather disparate groups, many of which have slender wings and elongate heads. The males of those rightly called scorpionflies have bulbous genitalia that arch back over the abdomen, much like the tail of a scorpion, but which are harmless. Yet others are gangly animals, with long legs used to hang from foliage and to grasp their food, which consists of small arthropods. These are referred to as *hangingflies* and look like crane flies, the latter of which are true flies and unrelated.

The earwigflies, also called *forcepflies*, are another peculiar family of Mecoptera, with only three surviving species. The genitalia of the males is modified into massive pincers, looking

In testament to Ulisse Aldrovandi's accurate observations, his woodcut of a common European scorpionfly (genus *Panorpa*) can be immediately recognized by the elongate head and bulbous, arching male genitalia resembling a scorpion's tail. Detail from a 1638 edition of Aldrovandi's *De Animalibus Insectis Libri Septem* (1602).

much like the tail end of an earwig. Meanwhile, the family of snow fleas, or snow scorpionflies, have either vestigial or missing wings, and they disperse over snow to mate in late winter and early spring. One last family of scorpionflies, called Nannochoristidae, are distributed across the Southern Hemisphere and are the only aquatic Mecoptera, preying on the larvae of true flies that live in freshwater. The larvae of nannochoristid scorpionflies have full compound eyes, something not found in the larvae of any other insects. Modern research into their evolutionary relationships suggests they are likely misplaced among Mecoptera and some rightly consider them as their own order, dubbed as the Nannomecoptera.

With over twenty-five hundred species, the fleas are one group of holometabolous insects many would rather live without. Fleas are exclusively blood-feeding parasites that mostly prey on mammals but also feed on several groups of birds. Unlike lice, who live out

A flea, likely the house flea (*Pulex irritans*), as exhibited for the first time in all of its glory and minute detail by Robert Hooke using his microscopic lenses for his magnum opus, *Micrographia* (1665, this edition 1667). Although fleas lack wings, they are all descended from a common ancestor that was fully capable of flight.

E. Guérin p.ᵗ Impr° de Rémond. Giraud sculp

1 Nemoptera *extensa Oliv.(halterata Fab.)* 2 Bittacus *tipularius Latr.*

3 *détails de la* Panorpa *communis Lin.* 4 Boreus *hiemalis Lin.*

Once believed to all be related, the spoon-winged lacewing at top (*Lertha extensa*), belongs to the order Neuroptera, while the snowflea (*Boreus hyemalis*, middle), with its vestigial wings, and hangingfly (*Bittacus italicus*, at bottom) are both related within the order of scorpionflies (Mecoptera). From Guérin-Méneville, *Iconographie du règne animal de G. Cuvier.*

their entire lives on the host, fleas spend considerable time off their host when not feeding, fleeing quickly should the animal upon which they are feasting die. Accordingly, while some fleas are specific to particular host species, many are not, and they will dine on a wide range of potential victims. During their evolution into a specialized form suitable for their mode of life, fleas lost their wings and the ability to fly. Their heads are compact and have piercing stylets through which blood is drawn, and the ordinal name, Siphonaptera, references this. The Greek derivation *síphōn* means "pipe," and the prefix *a-* expresses negation, thusly giving the insects a name that loosely means "siphon without wings." The hind legs are modified for jumping, giving fleas their characteristic mode of escape as well as a ready means of landing on their next host. Fleas, like lice, have had a profound influence on human civilization, acting as the carriers of bubonic plague, a bacterium responsible for pandemics such as the Black Death of the fourteenth century.

DIPTERA

The order Diptera includes the true flies as well as the mosquitos and midges. The name *Diptera* means "two wings" (*dís* is Greek for "twice"), and unlike other lineages, the hind wings are reduced to small, stalked structures called *halteres*. The halteres assist with flight stabilization, and although flies operate with only two functional wings, they are excellent fliers. Flies are incredibly successful, with over 155,000 species discovered, but this may be only a quarter or less of their global diversity. When we think of flies, most people bring to mind the common house fly, *Musca*

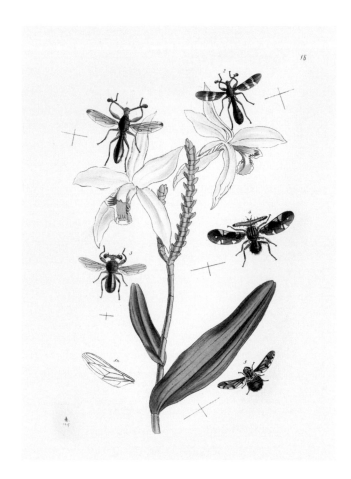

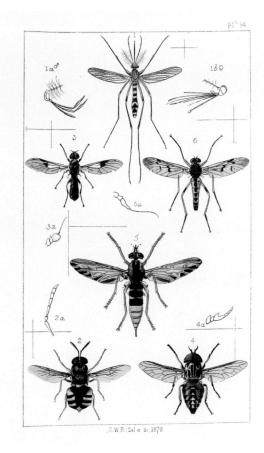

ABOVE LEFT: Flies are among the most ecologically varied of all insects, and some—such as the stalk-eyed flies (family Diopsidae), figured here among their relatives—are textbook examples of exaggerated male ornamentation resulting from preferences of females during mate selection. From Westwood, *Cabinet of Oriental Entomology*.

ABOVE RIGHT: A range of flies (order Diptera) from E. F. Staveley's *British Insects* (1871): from top, house mosquito (*Culex pipiens*), soldier fly (*Stratiomys chameleon*), another soldier fly (*Sargus cuprarius*), marsh horse fly (*Tabanus autumnalis*), hornet robber fly (*Asilus crabroniformis*), and down-looker snipe fly (*Rhagio scolopaceus*).

domestica. Flies, however, are more ecologically varied than any other group of insects, making it challenging to succinctly sum them up. Flies may be found specialized for every imaginable habitat, are global in distribution, and although solitary, can exhibit behaviors as intricate and dazzling as any other group of arthropods. Flies can be quite sensational when magnified, with resplendent colors that rival any of those among the more splashy beetles. In fact, observing the mating displays of those with patterned wings is like watching small sailors signaling with semaphore flags. Some have evolved to be wingless, living as parasites on bees and bats, while others have exaggerated head shapes, with the eyes of males widely set on long stalks and used to show off for their mates. Blood-feeding species such as many mosquitos, tsetse flies, and others are extremely hazardous to human health

Caddisflies (order Trichoptera) resemble small moths and are so named for the distinctive cases built by their aquatic larvae from sand, small pebbles, or plant debris. From Rösel von Rosenhof, *De natuurlyke historie der insecten.*

because they can transmit microorganisms that cause devastating diseases such as malaria, yellow fever, leishmaniasis, sleeping sickness, and encephalitis. Yet others, such as screwworm flies, are pests of livestock, although their larvae are also an aid to forensics, permitting investigators to pinpoint the time and even location of death of murder victims.

INSECTORUM AQUATILIUM CLASSIS II.

Tab. XVI.

Tab. XVII.

A.J. Röfel fecit et exc.

Nonetheless, the truth is that flies are largely beneficial, and the actions of a few have left the majority wrongly maligned. The most deeply researched species—apart from our own—is from the Diptera order: the laboratory fruit fly, or *Drosophila melanogaster*. The fruit fly has been a model for unlocking the fundamental principles of genetics and development, directly guiding many advances in human health over the last century. The laboratory fruit fly shares with us 75 percent of those genes that can cause disease within humans, and this close genetic relationship and the ease with which the flies can be manipulated makes them ideal tools in medicinal research.

Flies are also the second-most-critical lineage of pollinating insects, right alongside butterflies, moths, beetles, and bees. Most flies are small, but one mydas fly from Brazil, *Gauromydas heros*, can have a wingspan of up to 4 inches (10 centimeters) across. The larvae of most flies are informally referred to as maggots, and they are as variable as are their adults. Fly larvae are important recyclers, consuming decomposing plants, fungi, and even animals. While the term *maggot* brings on images of putrefaction and disease, the larvae of one species, the green bottle fly, *Lucilla sericata*, are used therapeutically to clean necrotic wounds, as the flies consume the dead tissue, which promotes healing.

TRICHOPTERA AND LEPIDOPTERA

The last two lineages are the closely related caddisflies, order Trichoptera, and the butterflies and moths, or Lepidoptera.

The caddisflies, with about fourteen thousand species, are another of those groups in which the immatures are aquatic, the larvae living in a variety of watery habitats and constructing small cases or retreats. Among the caddisflies are one of only two true marine insect lineages, the other being species of midge in the genus *Clunio*. The marine caddisflies, belonging to the family Chathamiidae, live amid intertidal algae, although one species, *Philanisus plebeius*, will oviposit its eggs into the pores of the starfish *Patiriella exigua*. There, the eggs are protected until they hatch as larvae and exit the starfish's body.

Caddisfly retreats are spun from silk secreted by the larva, and some species will spin small nets to filter food from the water or to snag prey. Others are active predators in moving water and will spin silken "safety lines," anchoring themselves to rocks while they swim about to catch small arthropods. The most impressive caddisfly constructions are cases built of a variety of materials, which, depending on the species, can range from small slivers of wood to minute stones. While some cases are affixed to the substrate, others are not, allowing the larva to relocate by sticking its short legs out of the front of the case and dragging it behind. Like the larvae, pupae will also spin small silken shelters in the water, eventually emerging as delicate adults with wings covered with fine setae, giving them their hairy appearance. The name *Trichoptera* literally means "hairy wings" in Greek (*trichos*, "hair"). As adults, they superficially resemble slender moths and survive on land on scarcely anything other than nectar, having generally vestigial mouthparts. The adults live only long enough to find a

Butterflies and moths (order Lepidoptera), perhaps the most familiar of flower-loving insects, have a fine covering of scales over their wings, often beset with spectacular patterns or washes of color, such as the Ceylon tree nymph butterfly (*Idea iasonia*, top left), or the bee robber hawk moths (*Acherontia lachesis*, right) and *Acherontia styx*, below left), all painted around the Javanese orchid (*Acanthephippium javanicum*). The species of *Acherontia* are also known as death's head hawk moths owing to the skull-like patterns of the thorax. They attack honey bee hives by mimicking the bees' scent. From Westwood, *Cabinet of Oriental Entomology*.

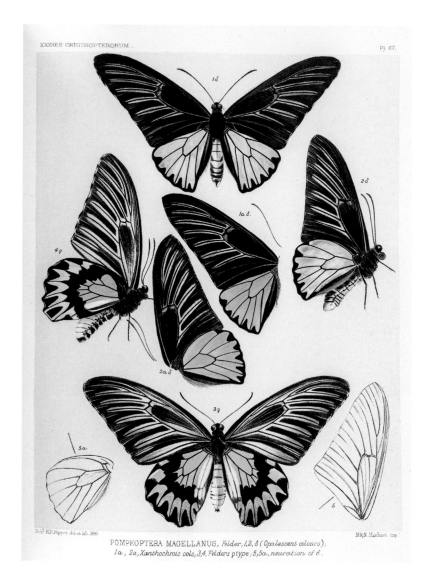

Pl. 67.

POMPEOPTERA MAGELLANUS, *Felder, 1,2, 3 (Opalescent colours);*
1a , 2a, Xanthochroic cols, 3,4, Felders p type; 5,5a, neuration of 3.

Butterflies are the general favorites among the order Lepidoptera, and perhaps none are more iconic than the great birdwings, such as the Magellan birdwing of the Philippines (*Troides magellanus*). From Robert H. F. Rippon, *Icones Ornithopterorum* (1898–[1907]).

butterflies are covered with small scales, and it for this reason that Linnaeus named their order Lepidoptera (in Greek, *lepidos* means "scale"). Aside from their lovely, scaled wings, all butterflies and all but the most primitive moths, have a coiled proboscis that is used to drink fluids such as nectar, water, or the juice of rotting fruit. In one of the more exceptional departures, species of the Southeast Asian moth genus *Calyptra* have evolved to imbibe blood from mammals.

Moth and butterfly larvae are called *caterpillars*, and almost all caterpillars are herbivores. The caterpillars of many moths are major agricultural pests, such as the tomato and tobacco hornworms, which are both caterpillars of species of the hawkmoth genus *Manduca*. Others are household nuisances, such as the clothes moth, *Tineola bisselliella*. Some moths, however, are greatly prized. The silkworm moth, *Bombyx mori*, does not occur naturally but is a domesticated form of *B. mandarina*, feeding on mulberry and having been selectively bred by humans for almost five thousand years. The silken cocoons are harvested and carefully unspun to produce treasured textiles, and in antiquity the secrets of sericulture, or silk farming, were guarded by penalty of death. These moths have been so vital to our global heritage that the ancient trade routes across Asia are known as the Silk Road, although much more than just silk was exchanged.

Many moths are tiny and go unnoticed except when they flutter about our lights at night. Species like the Atlas moth, *Attacus atlas*, and luna moth, *Actias luna*, however, are large and colorful, the former reaching up to 10 inches (25.4 centimeters) in wingspan, and many moths are as beautifully patterned as the most ornate of butterflies.

mate and breed. Females will deposit their eggs on the surface of the water or overhanging vegetation so that the newly hatched larvae can dive in and begin the process of weaving their silken masterpieces.

Dwarfing the caddisflies in number of species are the moths and butterflies; with approximately 157,000 species, they are by far the most diverse group of plant-feeding insects. Unlike caddisflies, the wings of moths and

Butterflies are nothing more than garish, day-flying moths, comprising about 18,800 species, and yet they are perhaps the most familiar and beloved of all insects. For millennia, they have been the passion of enthusiastic collectors and naturalists and the muses of countless artists, poets, and dreamers. People have expended fortunes to gather the largest and showiest species, and it is no surprise that so many eighteenth- and nineteenth-century monographs revolved around finely painted portrayals of butterflies, perhaps only surpassed by those of birds and flowers. In fact, the earliest entomological societies—perhaps one of the first of all zoological societies—was devoted to butterflies. The Aurelian Society (a precursor of the present-day Royal Entomological Society) was founded in London in the late seventeenth century. The name *Aurelian* is derived from *aurelia*, an old Latin term for a butterfly's chrysalis (the hardened pupal skin), which was itself derived from *aureus*, meaning "golden," in reference to the hue assumed by the chrysalis of some species shortly before the emergence of the butterfly. The ostentatious colors of butterflies are often warnings to predators, indicating some degree of toxicity should they be consumed. Not all is as it may seem, however, for deception evolved repeatedly, with color mimics frequently indicating to predators a degree of toxicity not truly present (see pages 177–179). For all their beauty and delicacy, the colors of butterflies are at times meant to mislead, a reality that would have offended the sensibilities of most eighteenth-century Aurelians!

FLYING INSECTS WITH COMPLETE metamorphosis achieve what the rest of us merely dream of—living two different lives, at least metaphorically. Swammerdam and Merian showed that these different lives were truly one, carefully observing what others were unable to see: larvae specialized for one set of conditions wiggling through water, scurrying over land, or burrowing through muck to later assume new skin, new habits, and a new identity as winged adults.

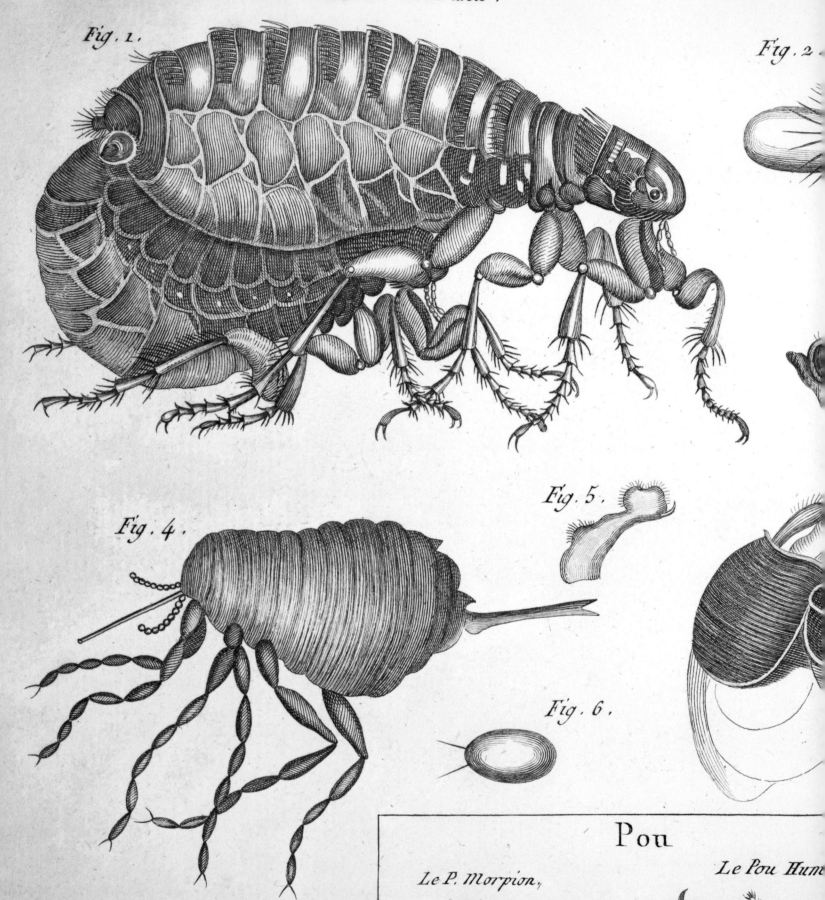

La Puce Penetrante.

Fig. 1.

Fig. 2.

Fig. 4.

Fig. 5.

Fig. 6.

Pou

Le P. Morpion,

Le Pou Hum

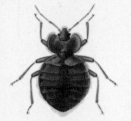

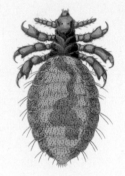

6
PESTS,
Parasites, and Plagues

> "So, Nat'ralists observe, a Flea
> Hath smaller Fleas that on him prey,
> And these have smaller Fleas to bite 'em,
> And so proceed ad infinitum."
>
> —Jonathan Swift
> *On Poetry,* "A Rhapsody," 1733

PAGE 104: Detail of various parasites, from M. Olivier, *Encyclopédie méthodique. Histoire naturelle. Insectes.* (1811) (also see page 109).

OPPOSITE: A variety of mosquitoes and their relatives. At center, the mosquitoes *Anopheles maculipennis.* Clockwise from top left, common house mosquito (*Culex pipiens*), another mosquito (*Aedes cinereus*), phantom midge (*Chaoborus crystallinus*), lake fly (*Tanypus varius*), biting midge (*Serromyia femorata*), and a chironomid midge (*Chironomus plumosus*). From Georges Cuvier, *Le règne animal distribué d'après son organisation* (1836–1849).

Most insects do not bite or sting, and yet we tend to treat them all as pests or menaces. As a natural protective mechanism, humans remember traumatic events more intensely so that we become wary of the sources of those traumas in the future. This same protective focus applies to us both culturally and as a species, and it is therefore understandable that we might recoil from insects based on an ingrained response to past bites or stings, whether inflicted on ourselves, our societies, or our distant progenitors. It is true that certain insects can pose a danger by competing with us for food, bringing ruin upon our homes, or directly threatening our health—particularly should certain allergies exacerbate whatever toxins might be presented. Nonetheless, pests and parasites of humans, despite their prominence in our collective conscience, represent the tiniest fraction of the world's insect species, and we should resist our innate urge to swat or revile them as a first response. Most insects go about their lives utterly ignored by us, doing us no harm and instead benefiting humanity in the various means by which they help our ecosystems function. That said, when insects do make themselves noxious and "bug" us, they are so very adept at doing so.

A copper engraving of a mosquito (perhaps *Culex pipiens*) prepared by Jan Swammerdam for his treatise on the natural history and development of insects, *Historia Insectorum Generalis* (1685 edition, 1669).

Blanchard pinx. Em. Bl. part. zool. del. Schmelz sc.

1 COUSIN COMMUN. (Culex pipiens. Lin.) 2. ANOPHÈLE À AILES TACHETÉES. (Anopheles maculipennis. Meig.)

3. AÈDE CENDRÉ. (Æ. des cinereus Meig.) 4. CORÈTHRE PLUMICORNE. (Corethra plumicornis. Meig.)

5. CHIRONOME PLUMEUX. (Chironomus plumosus. Lin.) 6. TANYPE BIGARRÉ. (Tanypus varius. Fabr.)

7. CÉRATOPOGON FÉMORAL. (Ceratopogon femorata. Meig.)

N. Rémond imp.

FLEAS AND LICE

Hans Zinsser (1878–1940), the American physician who isolated the typhus bacterium and developed a vaccine against it, rightly wrote in his book *Rats, Lice, and History* (1935): "Swords and lances, arrows, machine guns, and even high explosives have had far less power over the fates of the nations than the typhus louse, the plague flea, and the yellow-fever mosquito." Typhus and bubonic plague alone have brought conquering armies to their knees, reduced cities to mass graves, and spread terror through civilizations more than any atrocity.

By example, the Justinian plague, spread by rat fleas putatively from Egypt and Palestine, burst forth in Constantinople in 541 CE. Exacerbated by climatic shifts of the time, this

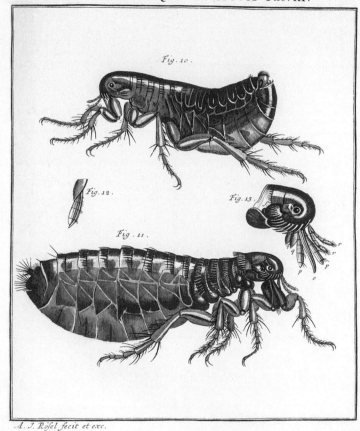

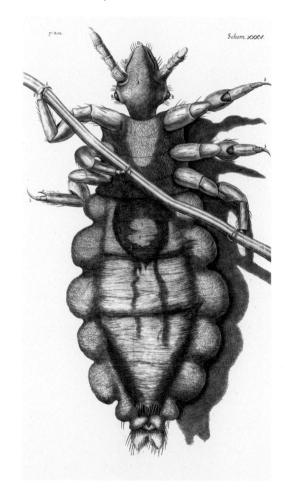

ABOVE LEFT: Fleas such as the house flea (*Pulex irritans*) can have a wide range of hosts, making it easy for them to transfer between species, such as from house pets to humans. From August Johann Rösel von Rosenhof, *De natuurlyke historie der insecten* (1764–1768).

ABOVE RIGHT: A human louse (*Pediculus humanus*) from Robert Hooke's landmark *Micrographia* (1665), the first book to illustrate minute animals and the details of plants as observed through various microscopic lenses. With the aid of his lenses, Hooke was the first to describe and name the cell, as well as the fine anatomical details of insect eyes and other structures.

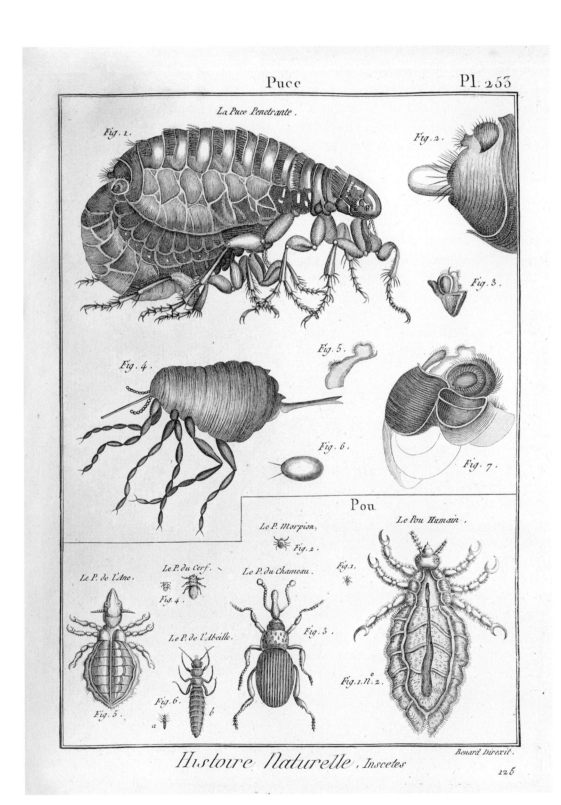

A plethora of parasites: a pair of mating fleas (order Siphonaptera, top left) and crab and body lice (*Pthirus pubis*, bottom left, and *Pediculus humanus*, bottom right) flank various other parasitic arthropods, from beetles to ticks. From Olivier, *Encyclopédie méthodique. . . . Insectes*.

severe form of bubonic plague ultimately left twenty-five million dead across Europe and the Levant, which is believed to be about 13 percent of the total human population at the time. A pandemic of proportional impact today would wipe out the current population of the United States three times over. Emperor Justinian I (r. 527–565), famed for the construction of the great Hagia Sofia cathedral, was himself beleaguered by the infection but was among the minority who survived. Unfortunately, Justinian's legacy was so marred by the plague that his name was lent to that particular outbreak. Indeed, the great English historian Edward Gibbon (1737–1794) wrote in his *History of the Decline and Fall of the Roman Empire* (1776–1788) that Justinian's reign "is disgraced by a visible decrease of the human species, which has never been repaired in some of the fairest countries of the globe."

Another emperor, Napoléon, marched on Russia in 1812 with approximately six hundred thousand troops, but he retreated after a harsh winter, malnourishment, and lice ravaged his army with typhus. A mere month into his campaign, typhus had already taken over a tenth of his men, and many more would also succumb to the illness. Six months later, after decimation by unsuccessful battles, starvation, cold, and disease, they marched back into France, numbering only around thirty thousand.

Add to these afflictions malaria, dengue fever, yellow fever, leishmaniasis, sleeping sickness, Chagas disease, and myriad more, and there is every reason to be wary of disease-carrying insects. However, there is no insect species that itself causes disease; instead, certain insects are vectors that carry and transmit pathogenic bacteria, protozoans, and viruses.

Interestingly, in the case of epidemic typhus, the disease is as fatal to the lice as it is to us. The body louse, or *Pediculus humanus humanus*, is the species known to transmit *Rickettsia prowazekii*, the bacterium that causes typhus, to humans. (The louse does not transmit *Rickettsia* through its bite but instead through its feces, which get rubbed into the wound as the bitten person scratches.) A louse becomes infected with *Rickettsia* by feeding on a human already acutely afflicted by the disease, and then it may transmit the illnessto another individual before it perishes. The bacteria proliferate inside the louse's gut, so much so that eventually the gut lining bursts and the louse dies. One might say that from the perspective of the louse, *we* are the disease-carrying agent bringing an infection to *it*.

KISSING BUGS, TSETSE FLIES, AND MOSQUITOES

Chagas disease is spread through a mode of transmission similar to epidemic typhus. The disease, which is widespread through the tropical Americas, is caused by the protozoan *Trypanosoma cruzi*. As with epidemic typhus, the protozoan is found in the feces of the insect vector, which in this case are certain species of "kissing" bugs of the subfamily Triatominae. In human habitations, the triatomines live in rafters or other peripheral locations, coming out at night to feed. The bugs defecate promptly after feeding, and it is through scratching that the parasites enter our bodies. Some historians believe Darwin, who suffered greatly throughout much of his adult life, was afflicted with Chagas disease, the result of a bite from a

triatomine during his travels through Argentina on the voyage of the HMS *Beagle*.

Sleeping sickness, or African trypanosomiasis, is also caused by a species of the protozoan genus *Trypanosoma*, but it is injected into the bloodstream when tsetse flies feed upon us. Malaria is similarly brought on by a parasitic protozoan—the genus *Plasmodium*—transmitted by mosquitos of the genus *Anopheles*. The protozoan invades the salivary gland of the mosquito, and the parasite can then be transferred to us through the mosquito's saliva when it bites us. Plague is caused by the bacterium *Yersinia pestis*, which infects rodents. In urban areas, rats are largely the carriers, but mice, squirrels, and even gerbils can be infected. The rodents are then fed upon by the Oriental rat flea, *Xenopsylla cheopis*, which can then transmit the bacteria to humans when rodents come into close proximity to people and share their fleas with us. During historical pandemics, climate-driven outbreaks in Asia—likely originating from wild gerbils—would sweep into Europe where transmission by rodents and fleas in the filthy confines of medieval cities led to disastrous results.

BED BUGS AND MAGGOTS

Not every individual louse or flea has the potential to do such harm, even if those species feed upon us. The bite of the average mosquito typically causes nothing more than an annoying, itchy welt, although some blood-feeding insects can cause pain through severe irritation or allergic responses. Bed bugs are a scourge that is making a considerable comeback in our cities, owing to increased resistance to greatly overused pesticides. There are less than one hundred species in the exclusively blood-feeding bug family that includes the common bed bug. Only three of those species feed on us, and of those three, only two are particularly troublesome. The rest of the family evolved to feed on bats, birds, or small mammals, and they pay us no heed. The common bed beg is *Cimex lectularius*, the species name taken from the Latin word for a bed or couch. Bed bugs are not known to be capable of spreading any disease agents; it is more their irritating bites and invasiveness that are of concern. So pervasive have these wingless Hemiptera been in our lives that we even wish our loved one's a pleasant night's sleep with "good night, sleep tight, don't let the bed bugs bite!" The original hosts of bed bugs were likely bats, and *C. lectularius* may still be found on bats even today, as well as on chickens or other domesticated animals.

It is believed that bed bugs first came into regular contact with humans who shared caves with bats in the Middle East, and they spread with us as we advanced our civilizations. Bed bugs do not live entirely on their hosts; they only venture onto the body during the

The common bed bug (*Cimex lectularius*) first became associated with humans when we still resided in caves of what is now the Middle East, and they have subsequently spread with us throughout the world. Detail from Cuvier, *Le règne animal . . .*

OF LICE AND MEN

It is little wonder that the most beautiful of illustrated works from the nineteenth century rarely figured ectoparasites (parasites that live on the exterior of their hosts) of humans, such as fleas or lice. How much pleasure might there be in viewing colorful displays of animals so wretchedly reviled? And yet, one of the more remarkable monographs of the period was specifically centered on lice. Henry Denny (1803–1871) was a British entomologist who was widely considered a leading authority on parasites. In 1825, Denny was appointed as the first curator for the Leeds Literary and Philosophical Society, which established the Leeds City Museum. In 1842, he published his *Monographia Anoplurorum Britannae* (*A Monograph on the British Anoplura*), a work devoted to the Anoplura, the group of sucking lice that includes the three species so pestiferous to humans. Worldwide there are about 550 species of Anoplura, the vast majority of which live on a wide range of mammals—from aardvarks and elephants to lemurs and even seals.

Denny began the project in 1827 and spent fifteen years working during his leisure hours, often being rebuked by others for undertaking a work on a group, as he wrote in the preface to his monograph, "whose very name was sufficient to create feelings of disgust." He did everything himself, including preparation of the many fine and accurate anatomical illustrations, figuring all the species, and summarizing everything known about them at the time. It is difficult to conceive of lice making for gorgeous figures, and yet Denny's "louse-y" monograph did just

It is a testament to Henry Denny's illustrative powers that lice, so reviled, should be rendered sublime. The ungulate sucking lice (family Haematopinidae) featured here—from Denny's *Monographia Anoplurorum Britanniæ* (1842)—feed on many of our domesticated animals.

that. Denny worked in an era prior to an understanding of evolutionary processes or the role that human lice play in spreading disease-causing microorganisms, and this lead to some rather quaint perspectives on the origins and purpose of such parasites in nature. Denny wrote in the preface,

As regards the period when Parasitic animals were first created, I shall not offer an opinion, the subject being one of those speculative theories which it is impossible to reduce to a demonstration. Though my venerable and esteemed friend, the father of British Entomologists, the Rev. Dr. Kirby, has conjectured, that Parasitic Insects infesting the human race, were not called into existence until after the fall of Adam. "Can we," (he says), "believe that man in his pristine state of glory, and beauty, and dignity, could be the receptacle and prey of these unclean and disgusting creatures?"

In reality, lice are quite ancient. A magnificently preserved bird louse was discovered in shale from Germany that is approximately fifty million years old. Lice species were infesting mammals for eons prior to humankind, and they most certainly plagued our many hominid ancestors long before our species appeared. Denny also noted that,

The precise use of these creatures in the economy of the universe is not very easy to define, and although I cannot go so far as with [Linnaeus] to give the louse full credit of preserving full-fed boys from coughs, epilepsy, &c. yet I do think it probable they may be conducive to health, in a certain degree, by promoting cleanliness; for were it not for the great increase which soon takes place, if a colony are allowed undisturbed possession, there are individuals, probably, who are so lost to all sense of decency, that they would never clean themselves at all. But by means of this peculiar stimulus, it becomes absolutely necessary to have a bath now and then.

Had Denny understood their role in transferring the bacteria responsible for diseases as devastating as trench fever and typhus, or similar agents that infect livestock and fowl, then he might have looked upon them with a bit more trepidation and concern. It is fair to say that the smaller bacterial foes are far greater enticements toward cleanliness than the mere itch of a louse.

Denny had intended to expand his work into the exotic species of lice, amassing specimens from colleagues, including material from Darwin taken during his voyage on the HMS *Beagle*. He spent years preparing the fine lithographs necessary to accompany his grand vision for this supplement. Unfortunately, the scope of the work envisioned was massive and left incomplete at the time of his death. John O. Westwood (see pages 50–53), the Hope professor and curator of entomology at Oxford, purchased Denny's collection and plates from his widow, intending to see the work finished, but even the indomitable Westwood was overwhelmed by its scope and projected cost. Today, the material remains in Oxford's museum.

In the end, Denny published only two works, his monograph on British lice, and an earlier (1825) and equally lovely treatment of the British pselaphine and scydmaenine beetles. Nonetheless, his contribution to the study of parasites was tremendous, and it would be nearly half a century before any real improvement would arrive in the form of the work *Les Pédiculines: Essai monographique* (*Lice: Monographic Essay*) (1880), by Swiss entomologist Édouard Piaget (1817–1910). Although Piaget's coverage of species surpassed that of his predecessor, Denny's sublime portraits remain superior, and through his artistic hand we lose some of our revulsion toward these animals, perhaps even discovering in them a subtle beauty.

The lice of humans: clockwise from top left, the body louse (*Pediculus humanus humanus*), the head louse (*P. h. capitis*), and the crab louse (*Pthirus pubis*). The body louse and head louse are subspecies of the same species, presumably having diverged from each other only about one hundred thousand years ago. From Denny, *Monographia*.

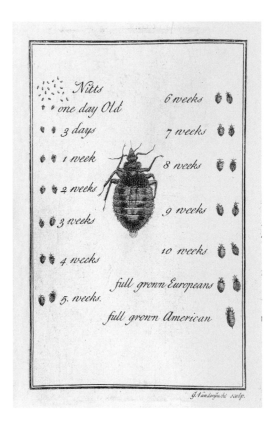

night in order to feed, retreating during the day to peripheral areas of the roost, nest, or, in our case, bedroom to rest and reproduce. Bed bugs inspired some of the first exterminator companies, which appeared in London in the 1650s. In 1730, British exterminator John Southall published a pamphlet on bed bugs, titled *A Treatise of Buggs*, in which he more thoroughly outlined their biology than had been done previously. Southall offered for sale his services in administering to furniture and homes a mysterious concoction, his "nonpareil liquor," said to be the most effective means of exterminating the vermin and taught to him by an aged African during his 1727 visit to Jamaica. Not everyone was pleased with his keeping hush the formula, and a J. Cook penned a letter to the *London Magazine* chastising him for doing so.

Of course, pests do not only feed on us—they also attack our livestock and crops. For every species of mammal or bird that we raise, including those we cherish as pets, there are a number of parasitic insects that are more than delighted to make a meal of them. At their worst, the swaths of destruction caused by some infestations can lead to famine and all of the evils that may bring.

Horses and cattle can be greatly affected by numerous insects, including blood-feeding horse flies, black flies, bot flies, screwworms, lice, fleas, and many others. These insects can directly cause injury and death or act as vectors for debilitating or fatal infectious diseases. Myiasis is the presence of a fly maggot feeding within the tissue of a mammalian host. Bot flies and screwworms (the maggots of

certain species of blow flies) are some of the more notorious culprits in cases of myiasis. For instance, the screwworm *Cochliomyia hominivorax* is particularly devastating to cattle; the maggots cause grotesque lesions in the skin as they burrow into healthy tissue and feed. Once the maggots—which resemble small screws—burrow in, the only portion that remains visible are their breathing tubes at the tail end of the body. A related species, *C. macellaria*, prefers to eat dead tissue and has become an important tool for medical examiners and detectives as the progression of the maggots' development within a body can reveal the time and location of death. This practice helped spawn the field of forensic entomology.

LOCUSTS AND OTHER HERBIVORES

Less sickening to behold than maggots in festering wounds are the varieties of caterpillars, aphids, bugs, and beetles that feed on fruits, vegetables, and grains. Perhaps the most famous of agricultural pests, however, are locusts, a species whose plagues have been written about since cuneiform and hieroglyphics were our primary scripts. Locusts are grasshoppers that may undergo swarming under specific conditions; numerous grasshopper species are subject to such influence. Usually solitary insects, overcrowding spurred by food shortages or drought can trigger a gregarious phase initiated by an increase in serotonin. This leads to a cascade of physiological and behavioral shifts, including a higher metabolism, which causes individuals to eat more voraciously, breed more readily, become more attracted to one another, and

ultimately act as a cohesive entity. In several species, individuals in the gregarious phase also take on different body colors relative to those in the solitary phase.

As they continue to compete for our crops, locusts and other grasshoppers—such as the large and colorful *Tropidacris cristata* shown here—have greatly influenced human societies, culture, and mythology over the millennia. From Rösel von Rosenhof, *De natuurlyke historie der insecten*.

Schädliche Geradflügler
(das Coloriete in natürl. Größe)

Bd. III. Taf. XIV.

Gryllus
1. stridulus . 2 . coerulescens . 3 .migratorius . 4. tuberculatus . 5. italicus .
6 .verrucivorus . 7 .viridissimus .

Leaf beetles (family Chrysomelidae) are varied in biology and form, with some appearing like miniature colorful tortoises, owing to the expansion of their hardened wing coverings. From Jules-Sébastien-César Dumont d'Urville, *Voyage au pôle Sud et dans l'Océanie sur les corvettes* l'Astrolabe *et la* Zélée (1842–1854).

The great father of forest entomology, Julius T. C. Ratzeburg, gorgeously illustrated his monographs, depicting here the appearance and biology of grasshoppers found in Germany's forests. From volume 3 of his *Die Forst-Insecten* (1844).

The largest swarms consist of billions of individual locusts that can cover vast areas. When a swarm takes flight it can easily be redirected by wind currents, so some swarms can get pushed out to sea to die or even deposited onto glaciers. Such swarms have been found in thick layers of ice thousands of years old, giving us a glimpse into ancient outbreaks. As one might imagine, billions of locusts require a great deal of food—each insect eats the equivalent of its own body weight in vegetation per day—and cultivated farmland is ripe for the reaping. It is therefore not surprising that

Egyptians and other people of antiquity were so scared when winds unexpectedly brought down from the skies thick clouds of locusts that devoured their food and so invited famine and death. Locusts still plague us today, and damage to crops can run well into the billions of dollars. The most devastating species are the desert locust, *Schistocerca gregaria*, and the migratory locust, *Locusta migratoria*.

Herbivorous insects of all varieties feed on our fields and food stores or ravage our ornamentals and hardwoods, skeletonizing and blighting leaves, boring through twigs and

Schädliche (Blatt-) Käfer nebst Fraß.
(vergröss.)

Cl. Taf. XX.

Chrysomela

Fig.1.Pini, 2.quadripunctata, 3.Tremulae, 4.Populi, 5.Capreae, 6.Alni, 7.Vitellinae, 8.oleracea,
9.10.pinicola, 11.Helxines, 12.flexuosa, 13.aenea.

Leaf beetles (family Chrysomelidae) are a diverse group with over thirty-seven thousand species, and their hungry larvae can defoliate plants. From Ratzeburg, *Die Forst-Insecten* volume 1.

stems, and producing unsightly galls. The list of such herbivore pests is extensive, but the majority is found among the larvae of beetles and moths, and the nymphs and adults of aphids, thrips, true bugs, grasshoppers, and katydids.

One of the world's major pests is the Colorado potato beetle, *Leptinotarsa decemlineata*.

Although named for their destruction of potato crops, the beetles are equally fond of other vegetable crops of the plant genus *Solanum*, which includes tomatoes. The larvae are the ones that do the damage, and populations can quickly reach levels in which nearly every plant is being nibbled away by plump, red larvae. Originally

INSECTS OF THE FORESTS

In any field of endeavor there is always progress, with new and important information steadily accumulating every year. Eventually, there can come a tipping point in which a dramatic synthesis and reshaping of the field takes place—a paradigm shift that places all past efforts in a new light and casts aside many misperceptions. The catalyst for just such an intellectual revolution in one branch of entomology was Julius T. C. Ratzeburg (1801–1871), the patron saint of forest entomologists, who may rightly be credited with having founded the field as a discrete science. Many insects live in forests, but forest entomology concerns itself with advancing forest resources as they relate to those species that promote or hinder forest management. Prior to Ratzeburg, works that one might loosely classify as covering forest entomology principally documented little more than major insect outbreaks without any attempts to really investigate the underlying biology. Johann M. Bechstein (1757–1822) and Georg L. Scharfenberg (1746–1810) had together produced the definitive work on forest insects at the time. Their three-volume *Vollständige Naturgeschichte der schädlichen Forstinsekten* (*Complete Natural History of Destructive Forest Insects*) (1804) was, however, greatly lacking as neither author wrote from much personal experience in dealing with the

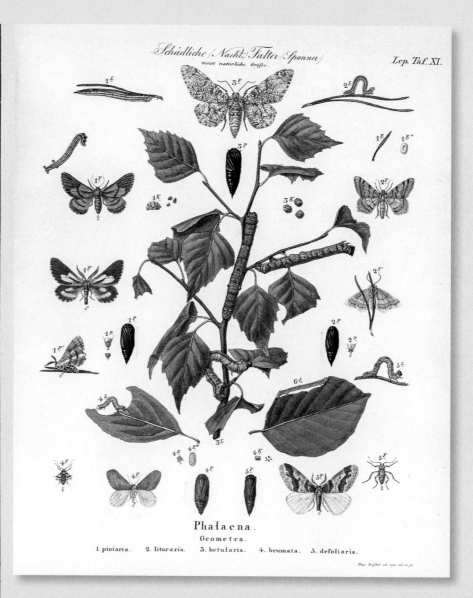

Ratzeburg's representations of forest insects on their host plants were so accurate that volumes of *Die Forst-Insecten* were distributed throughout Germany as a standard reference for identification and reference. This plate, from volume 2, depicts five different species of geometrid moths (family Geometridae), many of which can be notorious pests going by various common names, such as the peppered moth (*Biston betularia*) depicted at top center.

species covered. They instead summarized much from other, often erroneous, sources.

Ratzeburg began his career teaching in Eberswalde, not far from Berlin, and witnessed firsthand extensive damage to the surrounding forests. He immediately went for Bechstein and Scharfenberg's volumes and promptly found them to be superficial. Recognizing that something substantive and rigorous needed to be done, in 1835 he launched into a major effort to provide the much-needed synthesis. Today it is taken for granted that any scientific investigation begins with a thorough review of the available literature, yet at the time such a course of action was rare. Still, Ratzeburg pulled together and thoroughly digested all of the available literature pertinent to forest insects. He also wrote to every forester and natural history scientist and assimilated the responses to his letters. He inquired with them as to their own observations, the veracity of past findings, and what experiences they might have had in dealing with particular pests. In time, the German government instructed all of their forest officials to send information directly to Ratzeburg, and his office became the hub for all things relating to insects and forests. All of this was fine and valuable, but Ratzeburg felt that the only true means of developing a real understanding of these species was through personal observation and experience. He therefore spent large parts of nearly every day out in the

forest, making his own detailed notes on the lives of the many pertinent species, including corroborating or refuting the numerous observations sent to him by correspondents. Rearing many species back in the lab, Ratzeburg was able to experiment with conditions to see how these might impact the survival or development of each insect.

The life cycle of various species of plant-feeding wasps, colloquially known as "sawflies" (family Tenthredinidae, order Hymenoptera), as depicted in a plate from volume 3. The sawfly larvae superficially resemble caterpillars and feed on leaves, denuding entire trees if left unchecked.

In this way he was able to correct misguided notions that had persisted for decades, if not centuries.

In 1837, Ratzeburg published the first of his three volumes on forest entomology, introducing the subject and discussing beetles and weevils. This was followed in 1840 by a volume on moths, and in 1844 by a book concerning other groups such as locusts, aphids, sawflies, lacewings, and true flies. Each volume was accompanied by detailed color plates depicting particular species, and, quite importantly, Ratzeburg included illustrations of the immature stages of many species with examples of the plant injuries they inflicted. These illustrations are exceptionally accurate, and most of them were drafted by Ratzeburg himself. As a testament to the scope and value of the work, the frugal ministry paid to have individual copies sent to every forest official in Prussia. Ratzeburg's *Die Forst-Insecten* (*The Forest Insects*) would stand as the most extensive and detailed work of its kind for a century, and even today, his beautiful etchings of insects are remarkable for their fine accuracy.

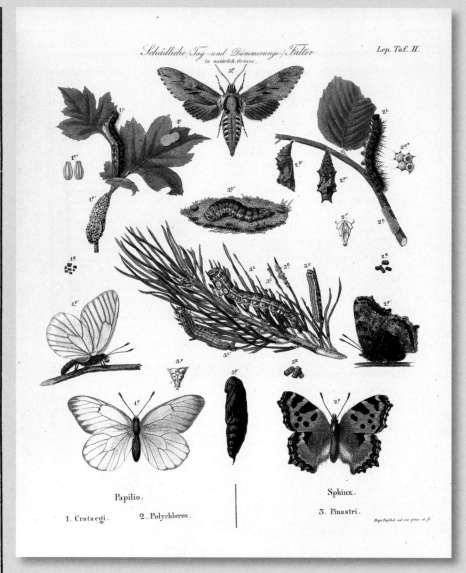

The three volumes Ratzeburg produced on forest insects were filled with detailed observations on injurious insects, but made all the more useful by the detailed lithographs depicting the insects, their life stages, and the sometimes characteristic damage they produced, such as with the depictions of three butterflies shown here from volume 2: the pine hawk moth (*Sphinx pinastri*, top), and the black-veined white (*Aporia crataegi*, lower left), and blackleg tortoiseshell (*Nymphalis polychloros*, lower right).

discovered in the mountains of Colorado in the early nineteenth century, this beetle is native to Mexico and the United States but it is now a pest throughout the world wherever potatoes, tomatoes, and eggplants are grown. During the Cold War, the CIA was falsely accused of using these beetles as a form of biological weapon meant to undermine Soviet agriculture. Little did the Central Committee of the Soviet Union realize that the beetles required no help from any government in spreading and making a plague of themselves. Today, this species is becoming even more troublesome owing to its increased resistance to pesticides, and so sustainable practices have the greatest hope of achieving "détente" between the beetles and ourselves.

WEEVILS

One of the most successful of all insect groups is the weevil (superfamily Curculionoidea), a lineage of specialized beetles famed for their elongate snouts but also infamous for the many injuries they wreak upon plants. There are already around sixty thousand species of weevils that have been documented from around the world, and new species turn up on even the most cursory of entomological expeditions. Weevils of one kind or another have evolved to feed on virtually every part of a given plant, specializing to feed as adults and larvae on roots, stems, leaves, flowers, seeds, and everything in between. This wide breadth of feeding is largely due to their snouts. Despite misconceptions, the long, slender snouts of weevils are not for sucking fluids; they actually have the usual complement of jaws at their apex, merely in reduced form. The snout permits the weevil to not only feed on otherwise inaccessible plant

Numbering over sixty thousand species worldwide, weevils (family Curculionoidea) are among the most injurious of beetles, and their characteristic anatomy permits different species to feed on virtually every part of a plant. From Ratzeburg, *Die Forst-Insecten*, volume 1.

parts, but also to chew deep into specific plant tissues or into the soil, making holes in which to place their eggs. Weevils, like most beetles, have less-than-impressive ovipositors, and the snout permits them to access spaces for their eggs that would otherwise be out of reach. The hatching larvae are then, ideally, placed to feed within the roots, stems, or other parts of the plant, leading to considerable damage, particularly when populations are large.

The galleries made by bark beetles (family Scolytidae), although seriously deleterious to trees, can nonetheless be stunning to behold. Bark beetles are nothing more than specialized weevils that have lost their characteristic snouts during the course of evolution. From Ratzeburg, *Die Forst-Insecten*, volume 1.

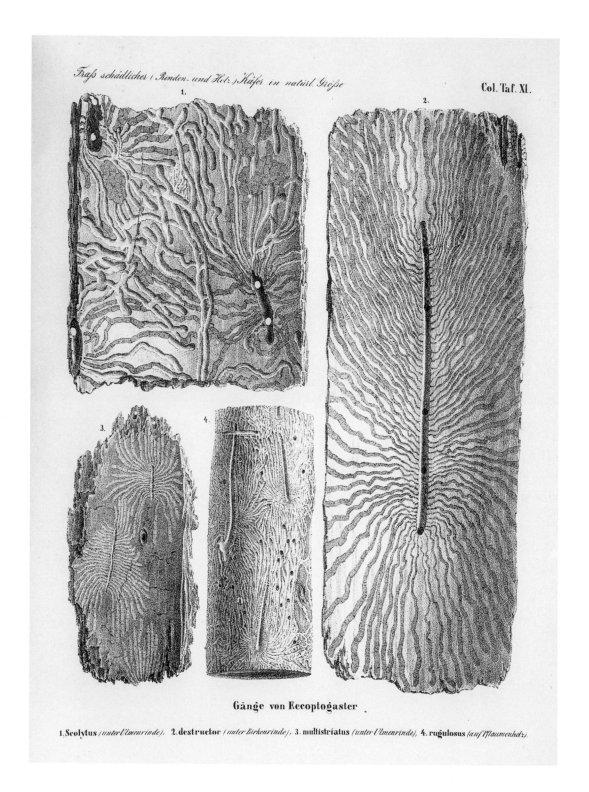

The cotton boll weevil (*Anthonomus grandis*) was originally native to central Mexico but was introduced into the United States in the 1890s, and by the roaring 1920s had ravaged the entirety of the South. Today, it remains the primary pest of cotton. Species of the weevil genus *Sitophilus* are devastating to many of our most critical crops, feeding on and developing within the grains of rice, wheat, and corn. Not all weevils compete for our foods, and some, like the bright red *Merhynchites bicolor*, or rose weevil, drill through the buds and petals of flower gardens, rendering them horticultural nightmares. Others, like *Ips calligraphus*, are difficult to recognize as weevils owing to the secondary loss (the reversion to an ancestral state) of their snouts, but they remain equally destructive. Commonly referred to as bark beetles—obscuring their actual status as modified weevils—these insects infest many of the hardwoods we are so fond of using for timber. *Ips calligraphus* is so named for the fine "calligraphy" these beetles etch through the wood as their larvae burrow, creating remarkable patterns but rendering the wood useless. Bark beetles in all of their variety represent some of the greatest threats to the forest industry, particularly the invasive species that lack the natural checks and balances native species have evolved as a control against their populations running amuck.

THERE ARE TENS OF THOUSANDS more species of parasitic and herbivorous insects that do not attack us or feed on our crops. Accordingly, they are not pestiferous to us. These insects are pests to those species they impact, but their pestilence usually goes on without our taking

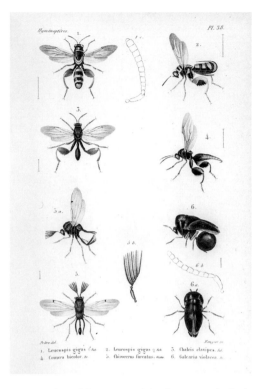

any notice. Most parasitic insects victimize other insects, and although they are technically parasites, we consider several of them as beneficial since we can use their powers to our advantage—usually as a natural control over the populations of those species that *do* impact us. For example, parasitic wasps are fearsome to those insects that they attack, but they can be used to our advantage in biological control programs. By way of illustration, the minute wasps of the genus *Aphytis* are parasitic upon mealybugs and scale insects that feed on citrus, olive, and other orchard trees. The wasp injects its eggs into the host's body, and the developing larvae consume the victim from within. One species' demon is another's savior.

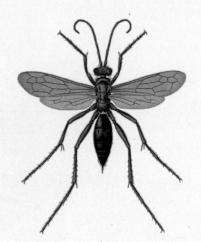

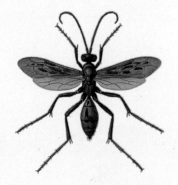

7

It Takes a
VILLAGE

> ## *"No man is an island."*
>
> —John Donne
> *Devotions upon Emergent Occasions,* Meditation XVII, 1624

Humans are social animals—at least most of us are—and it is only natural that we should have a particular affinity for those other species that exhibit similar societal instincts. We see in such animals ourselves and parallels of our own evolution. Social interactions come in a wide gradation of forms, from degrees of parental investment to large communities teeming with thousands, if not millions, of individuals. Outside of humans, almost all instances of truly complex animal societies are found among arthropods, and the majority of these are spread across the insects.

A society, of course, consists of individuals working together. The simplest social expression may be that of extended care on the part of a mother tending her brood. The insect world teems with protective mothers, ranging from earwigs to leaf beetles, and many of their behaviors are not all that different from those of birds tending their eggs or feeding their chicks. Gregarious associations, such as large aggregations of springtails or even the coordinated swarms of locusts, also represent a simple form of social behavior. In some species, insects of the same generation will come together within a common structure, such as a branching burrow underground or a thicket of spun silk in trees. Within these collective nests, the community garners the advantages of group protection, but otherwise each mother raises her own offspring independently of the others. These types of communal societies are found among tent caterpillars, some bees and wasps, and beetles.

The ultimate expression of sociality is one in which overlapping generations of females come together within a shared nest and collaborate in the care of a brood, even though the offspring come from only one or a few of the total females involved. This form of social behavior is called *eusocial*, a term coined in 1966 by American bee biologist Suzanne Batra (b. 1937) that literally means "truly social" (the prefix *eu* means "true" and is derived from the ancient Greek for "well" or "good"). Within a eusocial society some females forego their own reproduction in order to help rear the offspring of another related female or subset of females. These nonreproducing females are known as *workers*, while those that lay eggs are the queens, and these are distinct castes within the society. In the most primitive eusocial societies, the

Stylops
melittæ.

Vespa arborea
et son nid.

Nomada
ruficornis.

Formica rufa
et son nid.

Cilissa
hæmorrhoïdalis.

Eumenes et
son nid.

Andrena
nitida.

Andrena
Trimmerana.

Larve et nid
d'Andrena.

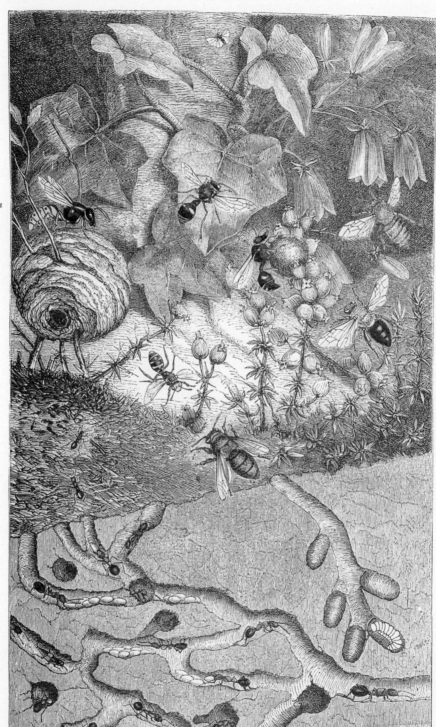

HYMÉNOPTÈRES. — Pl. XI

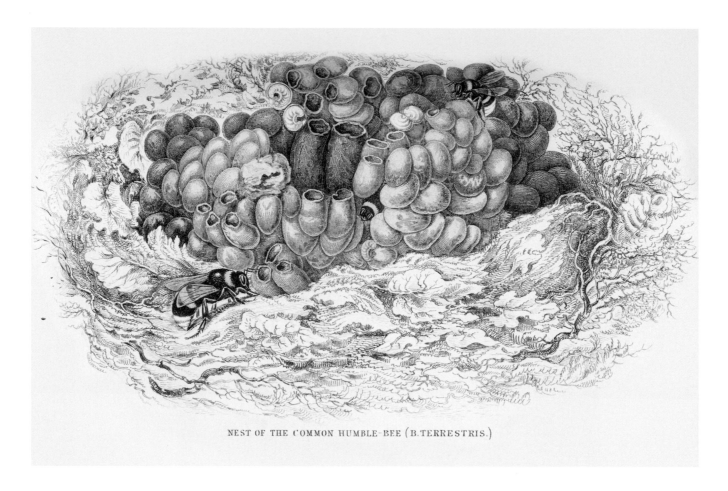

NEST OF THE COMMON HUMBLE-BEE (B. TERRESTRIS.)

The nest of the buff-tailed bumble bee (*Bombus terrestris*) consists of a series of simple pots loosely clustered together, some of which are used to store food, while others are the chambers in which larvae develop. From William Jardine, ed., *Bees. Comprehending the Uses and Economical Management of the Honey-Bee of Britain and Other Countries . . .* (ca. 1846).

workers are capable of laying their own eggs but do not do so, opting not to mate and instead work solely in aid of the queen, who is either a sister or their mother. Should the queen be injured or die, any one of the workers might then succeed her as a new queen. The caste distinction is therefore one of behavior, and there is a flexibility to the societal structure. Bumble bee societies are based on this model.

Some eusocial societies, however, have caste systems that are more rigidly set in place, with there being considerable anatomical differences between the sterile workers and the queen caste. In this these societies it is not possible for a worker to replace the latter. In fact, some of the most ubiquitous and ecologically dominant of all insects are such highly eusocial species, specifically the triumvirate of termites, ants, and certain species of bees, including honey bees. While all ants and termites are highly eusocial, among bees, social behavior is the exception rather than the rule. Most of the twenty thousand species of bees are solitary, and those that form characteristic eusocial societies represent perhaps no more than 5 percent of this diversity. The eusocial societies of these three insect lineages form a virtual hegemony over our world. They are,

INNUMERABLE INSECTS

however, not the only eusocial groups; there are some eusocial aphids and thrips, and there is even a primitive eusocial species of ambrosia beetle that lives in galleries (tunnels) in the heartwood of eucalyptus trees in southeastern Australia. Outside of the insects, eusociality is rare. It is found in some spiders and snapping shrimps, but in only two other animals; the naked mole rat of the Horn of Africa and southern Africa's Damara mole rat are the only eusocial vertebrates. Some argue that subsets of human society meet the criteria for eusocial behavior, so we might include ourselves in this distinguished company.

For most of human history, the majority of people lived under the rule of a leader who was typically male—a chieftain, a king, or an emperor—one whose will, whether it was just, wise, or even deranged, would determine the fates of all others. Communities of social insects were miniaturized versions of our own civilization in the minds of early naturalists, and it is reasonable that they assumed the toiling laborers of insects were male and that the monarch over these workers must be a king.

In 1586, Spanish apiculturist and author Luis Méndez de Torres first speculated that in bee colonies, the insect king was in fact a queen. Two decades later, the father of modern beekeeping, English vicar Charles Butler (1560–1647) published his seminal work on the honey bee, entitled *The Feminine Monarchie* (1609) (see pages 163–165). Jan Swammerdam (see pages 82–83) would confirm the female gender of the bee monarch through his microscopic study of apian dissections in the 1670s, demonstrating that the "king" bee had ovaries and therefore must be female. The workers, too, proved to be female, showing that bee

1. Vespa Crabro ♀ 2. Vespa Crabro ♀ 3. Vespa Crabro ♂ 1.a. Aile ployée comme elle l'est dans le repos. 1.a. Aile déployée comme elle l'est dans le vol. 4. Polistes Gallica ♀ 5. Polistes Gallica ♂ 6. Polistes Gallica ♂ 4.a. Aile déployée comme elle l'est dans le vol.

LEFT: The three castes of two highly eusocial wasps: the European hornet (*Vespa crabro*) and the European paper wasp (*Polistes gallicus*). From Amédée Louis Michel Lepeletier, comte de Saint Fargeau, *Histoire naturelle des insects* (1836–1846).

ABOVE: The title page to François Huber's *Nouvelles observations sur les abeilles* (1792), whereby he presented an account of his studies on the natural history of the honey bee (*Apis mellifera*) although he was completely blind.

societies are dominated and run by females, while males serve only to fertilize the queen. Despite finally giving the queen proper credit for her gender, a prior notion that she never mated still persisted. Swammerdam insisted that the male impregnated the queen by some means of seminal spirit, which he called the *aura seminalis*, but was incapable of actually copulating. It took the keen observations of the Swiss naturalist François Huber (1750–1831) to put this pernicious rumor to bed in his book *Nouvelles observations sur les abeilles* (*New Observations on Bees*) (1792). Huber's "observations" are particularly remarkable when one considers that he was totally blind. Through careful experiments outlined by Huber and executed for him by his wife, Marie-Aimée Lullin (1751–1822), and his manservant,

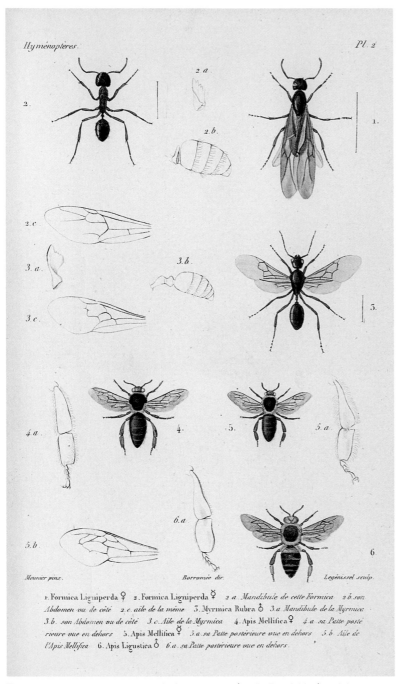

Hyménoptères. Pl. 2

Meunier pinx. Borromée dir. Legénissel sculp.

1. Formica Ligniperda ♀ 2. Formica Ligniperda ♂ 2.a. Mandibule de cette Formica 2.b. son
Abdomen vu de côté 2.c. aile de la même 3. Myrmica Rubra ♂ 3.a. Mandibule de la Myrmica
3.b. son Abdomen vu de côté 3.c. Aile de la Myrmica 4. Apis Mellifica ♀ 4.a. sa Patte posté-
rieure vue en dehors 5. Apis Mellifica ♀ 5.a. sa Patte postérieure vue en dehors 5.b. Aile de
l'Apis Mellifica 6. Apis Ligustica ♂ 6.a. sa Patte postérieure vue en dehors.

The two most iconic groups of social insects—ants (family Formicidae) and the European honey bee (*Apis mellifera*)—and their three castes: queens, sterile female workers, and males (dubbed "drones" among honey bees). From Lepeletier, *Histoire naturelle des insects.*

François Burnens, Huber confirmed that a single queen reigns over the hive, that she lays all of the eggs, and that she most certainly indeed does mate with a male. Huber's book would become the standard reference on honey bee natural history and beekeeping for a generation, and the glass-paneled observation hive he devised revolutionized apiculture.

The males of eusocial bees are known as *drones*. Butler correctly realized that the drones were male, but he assumed they mated with the workers. The drones of honey bees are unique among bees in that they die after copulation; the male organ and viscera are ripped off as the drone disengages from the queen. Fortunately the males of other bee species do not suffer such fates. In termite colonies, the reproductive male (there is only one) at least gets the royal title of *king*, although his only functions in termite society are to act as consort to the queen and release pheromones that help control the other castes in the colony (the queen does this as well). In particular, if a queen dies, then the king emits pheromones that induce the development of replacement queens. Male ants are not so fortunate as to receive a specialized name, perhaps because they do not live long after completing their singular duty to their monarch.

Insectan caste systems are not always binary, consisting of only workers and queens. Some insect societies have a third caste, the soldier caste, which serves the function of protecting the colony. Soldier castes can be found in aphids, thrips, some ants, and termites (see pages 70 and 74). Soldiers are specialized females that, like the workers, do not reproduce but are anatomically modified for defense. Soldiers have evolved any number

of medieval means by which to engage and defeat invaders. At their simplest, many have massive heads and muscles supporting elongate snapping jaws, but others are far more creative. The soldiers of nasute termites (from the subfamily Nasutitermitinae), for example, have heads that are modified into something resembling a squeeze bottle, complete with a forward-directed spout known as a *nasus* (from the Latin for "nose," and by extension, a nozzle or spout). Such soldiers spray an aerosol chemical from the spout, either as a repellant or as a glue that ensnares the attackers, which are usually ants. Soldiers are often so highly specialized as to no longer be capable of feeding themselves, relying instead on workers to nourish them.

The first animals to evolve complex societies were the termites, having done so by the late Jurassic, or at least 145 million years ago, a time in which *Stegosaurus*, *Apatosaurus*, and *Allosaurus* roamed over Colorado and Wyoming, pterodactyls soared overhead, and birdlike *Archaeopteryx* lived in Germany. The societies of ants and bees similarly appeared alongside dinosaurs, out-surviving the latter with the exception of dinosaurs' feathered descendants, birds. By the time our species appeared approximately 300,000 years ago, the civilizations and cities of termites, ants, and bees had surrounded the globe and survived cataclysms of global intensity. Despite the success and hardiness of these societies, it is sobering to watch how vulnerable they have been to the effects of human-induced climate change and habitat destruction. For example, bumble bees, which are some of our most vital pollinators, are disappearing from many places where they were once abundant.

INSECT ARCHITECTURE

A prerequisite for being social is, of course, a common structure within which to live. However, not all animal architecture is associated with social behavior. In the insect world, the most basic constructions are simple roosts in which a mother rears her offspring. By example, female earwigs will occupy small spaces, ranging from simple burrows in soil to crevices under bark or stones, within which she will tend to her younglings. Solitary wasps and bees dig burrows in which they place collected provisions and lay their eggs, and caddisfly larvae build cases for retreat. Protective cases among solitary insects are familiar—and frustrating—to many homeowners with yards; particularly those of us who have had to pull bags woven from plant materials and silk by bagworms—the caterpillars of moths in the family Psychidae—from our ornamentals. Nonetheless, the constructions of the eusocial insect species are particularly magnificent and have inspired imaginations since antiquity.

The most familiar eusocial construction is the hexagonal comb of a honey bee. There are seven species of honey bees, all of which construct waxen combs of six-sided cells. Within these cells the bees store honey and rear their larvae. For most honey bee species the combs are built within the confines of some cavity, such as a hollow in a tree. The combs hang vertically, and the workers walk about the outer surface, forming a constantly moving curtain of living insects that help to protect and regulate the combs. The bees are remarkably adept at maintaining a constant temperature within the hive, making certain that conditions remain ideal for

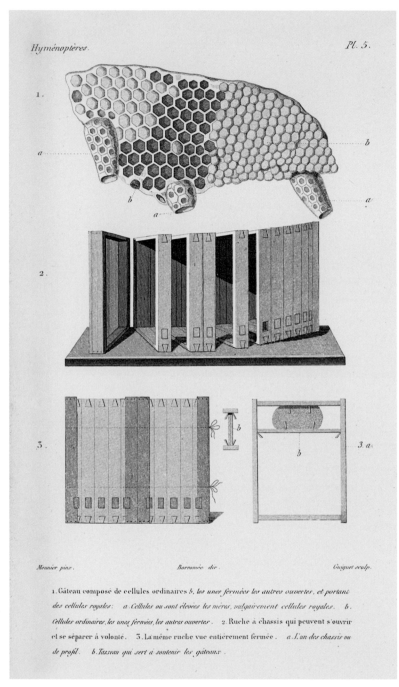

1. Gâteau composé de cellules ordinaires b, les unes fermées les autres ouvertes, et portant des cellules royales: a. Cellules ou sont élevées les mères, vulgairement cellules royales. b. Cellules ordinaires, les unes fermées, les autres ouvertes. 2. Ruche à chassis qui peuvent s'ouvrir et se séparer à volonté. 3. La même ruche vue entièrement fermée. a. l'un des chassis ou de profil. b. Tasseau qui sert à soutenir les gâteaux.

Meunier pinx. Borromée dir. Guiguet sculp.

There is perhaps no architectural feature more recognizable than the waxen hexagonal combs of honey bees (species of the genus *Apis*). The combs of the domesticated European honey bee (*Apis mellifera*) can be easily manipulated within wooden frames, making modern-day beekeeping a profitable enterprise. From Lepeletier, *Histoire naturelle des insects*.

the developing brood as well as for the preservation of the communities' stores. Bees can warm the hive by contracting the muscles that move their wings, but while holding their wings in place. This movement generates a great deal of heat as the energy is not released by flight. Bees can also fan their wings to move air and cool the enclosure during particularly hot days.

Bumble bees are also eusocial, albeit of the more primitive form, whereby workers are capable of succeeding their queen should the need arise. Bumble bee nests are also found within cavities, and the bees tend to use the abandoned burrows of rodents or birds, nestled amid or under vegetation. The bees construct waxen pots that are grouped into irregular, horizontal clumps. Some pots are used for developing larvae, while others store pollen. Other primitively eusocial bees dig multibranched burrows within the soil, such as the social species of sweat bees. Yet other lineages of primitively eusocial bees, such as allodapine bees, relatives of the more familiar carpenter bees, will excavate burrow within hollow stems.

Like their cousins the bees, stinging wasps such as paper wasps, hornets, and yellow jackets also build elaborate nests, replete with rows of cells. Some nests are dug into cavities within the ground, but the more conspicuous nests dangle from eaves, wrap around branches, or are delicately suspended by slender stalks. While some nests are open, exposing the papery combs—usually with many females covering them and at guard—others are securely encased by papery or hard mud overlays. Wasp colonies can become massive, and one interconnected series of paper wasp combs suspended from the roof of a cave in Brazil was discovered to consist of millions of individual wasps. Those species with smaller colony sizes, or even wasps who

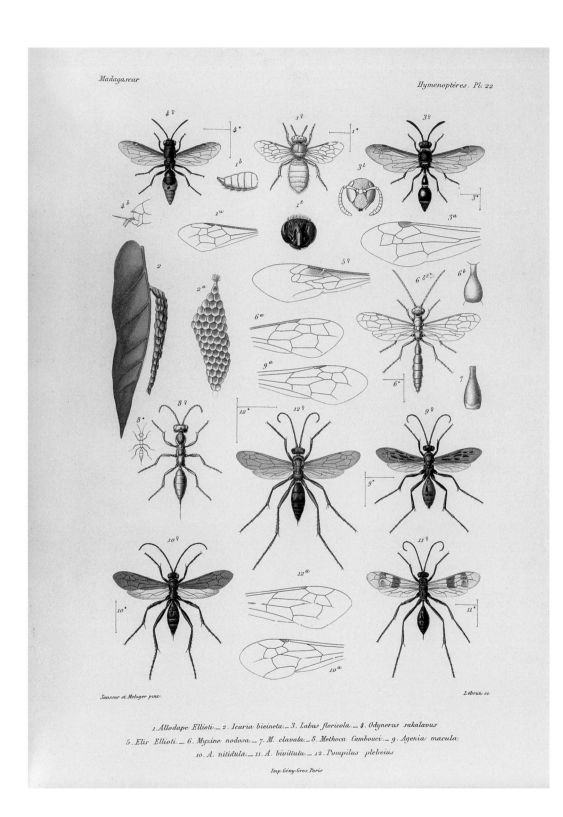

1. *Allodape Ellioti.*— 2. *Icaria bicincta.*— 3. *Labus floricola.*— 4. *Odynerus sakalavus.*
5. *Elis Ellioti.*— 6. *Myzine nodosa.*— 7. *M. clavata.*— 8. *Methoca Cambouei.*— 9. *Agenia macula.*
10. *A. nitidula.*— 11. *A. bivittata.*— 12. *Pompilus plebeius.*

Imp. Géry-Gros, Paris

Diverse stinging wasps (families Vespidae, Tiphiidae, and Pompilidae) from Madagascar are depicted in Henri de Saussure's volume *Histoire physique, naturelle et politique de Madagascar, Orthoptères* (1895). The illustration includes the delicate comb of the social paper wasp (*Ropalidia bicincta*), which is suspended by a fine petiole (leaf stalk) from the undersurface of leaves.

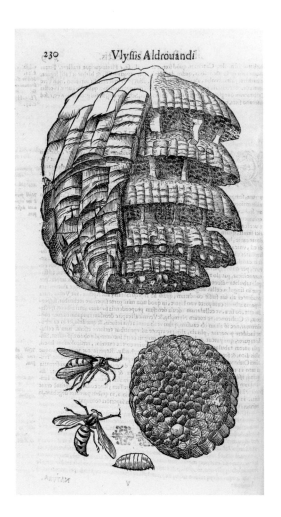

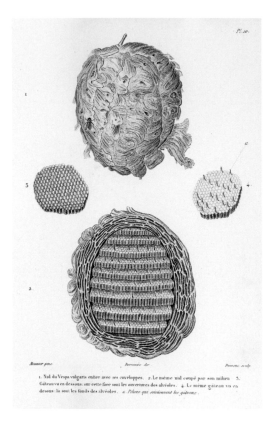

are solitary, also build delicate nests, some using leaves as anchors or curling them to form parts of the architecture itself.

ANTS AND TERMITES

Like bees, ants and termites are also excellent architects, and in many ways their constructions make honeycombs seem trivial in comparison. While many bee nests are distinctive for their uniform structure, those of ants and termites stand out for their irregularity. Most ant and termite nests are built within different substrates, such as wood or soil. They typically consist of chambers connected by networks of tunnels and have one or more openings to the outside world. Many of these nests are underground and usually go unnoticed by humans, although the galleries that are dug can be intricate.

The soil excavated by the ants building subterranean nests is brought to the surface and dumped, resulting in small mounds, much like chat piles from human mining activities. These colonies can dig quite deep, with those of some ant species extending to depths of 12 feet (3.66 meters) or more. While it may seem simple to dig tunnels and chambers, these nests are well planned. At their most complex, they include ventilation

mechanisms for circulating air and drainage tunnels for funneling water and wastes away from those chambers serving as nurseries, granaries, or gardens. As with bees hives, the temperatures within can be controlled with great precision. The mounds created by wood ants are particularly familiar sights in forests in North America and Europe. These can be massive, with the largest approaching nearly four hundred thousand workers and forming small mountains exceeding the height of an average man. There are usually small earthen craters at the cores, but otherwise the mounds are built up from twigs or needles from trees. Other ants build their nests in trees, constructing them of twigs, leaves, and other plant materials that they weave together into suitable cities for their colony.

Perhaps the most impressive and easily observed nests are those of macrotermitine termites, a lineage found only in the Old World, whose often colossal nests can define and transform vast landscapes in Africa. At their core, the principal galleries are subterranean or at the surrounding soil level, with a broad cellar from which extends small channels up to and opening on the sides of the mound. These termites cultivate fungi within specialized garden chambers that are situated above the subterranean network of galleries. The mound itself is built of clay moistened by the termites' saliva, which cements the structure. *Cemented* is an apt term, as the mounds are extremely sturdy and not easily breached. It often takes a heavy pickax wielded by a particularly strong person in order to make a significant dent. The mounds are porous and have series of chimneys that extend throughout to help regulate airflow as well as control the temperature and humidity within.

LEFT: Social insects represented by workers and a winged male of various species of Malagasy ants (family Formicidae) from A. Forel's 1891 contribution to the *Histoire physique, naturelle et politique de Madagascar.*

BOTTOM LEFT: The arboreal nest of the Malagasy acrobat ant (*Crematogaster ranavalonae*), built up of twigs and leaves and bound together in a carton composed of chewed plant material mixed with soil, which hardens into an impenetrable wall. From A. Forel, *Histoire physique, naturelle et politique de Madagascar.*

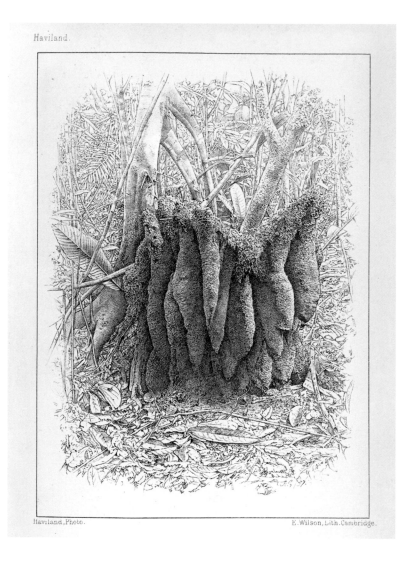

themselves. To put this achievement into perspective, consider the current tallest building in the world, the Burj Khalifa of Dubai. This impressive tower extends a staggering 2,722 feet (829.7 meters) into the sky, a little over one-half of a mile, with 163 individual stories above ground topped by a massive spire. The average height of a Western male is generally 5 feet 9 inches (1.75 meters), meaning that at our current best, humans have built a structure approximately 473 times our size. This is trivial compared to what insects can achieve. In the largest termite species, Africa's *Macrotermes bellicosus*, the average worker—the caste that labors to build their colossal structures—is 0.14 inches (3.6 millimeters) in length, and some build nests that extend 27 feet (8.2 meters) into the air. The termite mound is therefore about 2,286 times the size of the workers. This is a conservative minimum value, as many workers are even smaller—and their towers do not include spires with unusable space. Were we to build today something of equivalent proportion, the building would have to be at least 13,147 feet high, or 2.49 miles, and consist of no less than 1,314 stories!

SQUATTERS AND FARMERS

The nests of social insects house entire industries of other insects, all eager to benefit from the protective enclosure and concentration of resources residing therein. These insect squatters, called *inquilines*, include mites, true bugs, and a spectacularly diverse fauna of specialized rove beetles. Inquilines use all kinds of means to gain access to nests and remain undetected once inside. Some, like termite bugs, are flat

An exquisitely rendered lithograph of a nest of the Bornean termite *Dicuspiditermes nemorosus*, a species first discovered by George Haviland, who made a detailed account of their elaborate nests. From "Observations on Termites . . . ," *The Journal of the Linnean Society of London. Zoology.* 1898.

While some macrotermitine nests really are mound-shaped, others extend upward like blades, broad but thin. The blade-shaped nests are built such that their broad surface is oriented to the sun, catching the rays of first light to help warm the colony after a cold night. Looking across an African savannah, one can find the landscape studded with dozens of such colonies. The heights attained by these nests are impressive, and are large enough that elephants will use older mounds to scratch

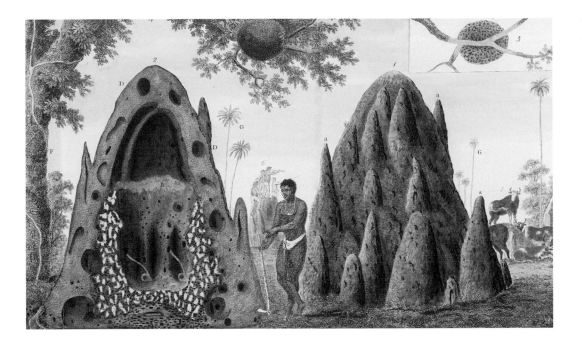

The remarkable architectural achievements of the mound-building termites of western Africa *Macrotermes bellicosus* were initially made known to European scholars though an eloquent letter from English naturalist Henry Smeathman to the famed explorer Sir Joseph Banks, who published the missive *Some Account of the Termites Which Are Found in Africa and Other Hot Climates* in 1781.

with textured backs meant to mimic the walls of termite tunnels, thereby camouflaging themselves by pressing tightly against the tunnel walls. Rove beetles not only at times mimic their hosts—such as those who resemble ants—but are also excellent chemists, secreting scents identical to those of the ants and termites with whom they live. They will even copy the behaviors of their hosts, all so they might move about the colony without raising alarm.

While we like to think ourselves clever for having developed crop species and domesticated livestock, social insects evolved agriculture and animal husbandry eons before we did so in the Neolithic. Ants, termites, and beetles have each evolved agricultural systems, cultivating crops of fungi from which they derive their nourishment. Unlike us, for millions of years these insects have practiced sustainable agriculture, while we struggle to adopt such methods in the cultivation of our crops. There are, however, some forms of insect agriculture that

do cause damage to the environs while they go about their cultivation.

Ambrosia beetles live in galleries dug through living trees, and they inoculate the walls of their tunnels with a fungus that infests the surrounding wood. As the fungus grows, the beetles feed upon it. Newly dispersing beetles then take samplings of the fungi with them when they found new galleries. The infamous mountain pine beetle (*Dendroctonus ponderosae*) presently devastating forests in Canada and the western United States, is an ambrosia beetle that introduces a blue stain fungus, *Grosmannia clavigera*, to pine trees. The fungus not only serves as a source of food for the beetle but also inhibits the natural defenses of the trees, such that they do not exude resin. The burrowing beetle larvae ultimately circumnavigate the tree, cutting off its internal water flow, and together the beetles and fungi leave their host dead.

In a manner more similar to human farmers, fungus-growing termites and ants

LIFE AND DEATH IN ARABIA FELIX

While Carl Linnaeus's name is synonymous with biological classification, his contributions went well beyond his writings. He was also a gifted professor, giving popular lectures at Uppsala University and organizing botanical excursions that attracted many. Some of Linnaeus's most promising students undertook voyages of exploration in order to bring botanical and other biological specimens back to Uppsala, so that a fuller picture of God's grand design might be understood. These adventurous students became known as Linnaeus's "apostles," and as journeys to exotic locales in the eighteenth century were often fraught with peril, it is perhaps unsurprising that not all survived their ordeals. One of these intrepid young men was Peter Forsskål (1732–1763), a free-thinking Swede who had earlier written the tract *Tankar om borgerliga friheten* (*Thoughts on Civil Liberty*) (1759), which included, among other things, heretical notions such as freedom of speech; it was a virtual blueprint of the United States' Bill of Rights, which would appear several decades later.

In 1760, Forsskål was assigned to join an expedition, launched by the Danish king Frederick V (r. 1746–1766), to Arabia Felix, the southwestern portion of the Arabian Peninsula that today encompasses southern Saudi Arabia and

A map of Arabia Felix by Carsten Niebuhr, the frontispiece to Peter Forsskål's posthumously published work *Flora Aegyptiaco-Arabica* (1775). Forsskål, the devoted student of Linnaeus, did not survive the ordeals of his expedition, and it was left to Carsten Niebuhr to publish his friend's copious manuscript notes in several volumes.

Yemen. Arabia Felix included the fabled kingdom of Sheba, and one goal of the expedition was to bring back ancient copies of biblical scriptures that were presumed to be there for the taking. Aside from Forsskål, the group consisted of the Danish philologist Frederik C. von Haven (1728–1763), German artist Georg W. Bauernfeind (1728–1763), Danish physician Christian C. Kramer (1732–1763), Lars Berggren as man-servant, and Carsten Niebuhr (1733–1815), a German of humble background relative to his compatriots but who was a skilled mathematician and cartographer.

The team left from Copenhagen in January 1761, venturing first to Constantinople and Alexandria, then Cairo, and ultimately arriving in Arabia in 1762. The greatest danger they had endured en route was one another—tensions were high among the multinational crewmembers, and at times the atmosphere even became rife with fears of suspected plots of subterfuge. The danger from marauding tribes and deceitful scoundrels as well as the hardship of travel in a hot and arid land eventually melded most of them together as dear friends. By Cairo, all but von Haven had adopted Arab dress and methods of living, knowing that becoming one with their environment and building compassionate friendships with their hosts was critical to the survival of all.

Throughout their journey, Forsskål made collections of plants and animals, preparing copious notes to be shared with Linnaeus upon his return. They were also to serve as the foundation

for a grand treatment of the Arabian and Egyptian biotas. Unfortunately, the expedition was plagued by many misfortunes. The group finally reached Yemen on December 29, 1762, but sadly, five months later, von Haven succumbed to malaria. He was followed in death by the hopeful Forsskål in July 1763, who also had contracted the disease. Niebuhr and the others buried him outside of a small montane town near Sana'a where he had passed. The remaining explorers made their way back to the coast, each falling ill. They eventually found passage on an English vessel bound for India, but while traversing the Indian Ocean, both Bauernfeind and Berggren perished of the disease, their bodies committed to

The title page to Peter Forsskål's posthumously published work on the animals discovered during his travels through Egypt and Arabia, *Descriptiones Animalium, Avium, Amphibiorum, Piscium, Insectorum, Vermium* (1775).

the depths. In Bombay, Kramer died, and so by February 1764, Niebuhr was the only one who remained.

Niebuhr slowly made his way back to Europe, traveling by ship to Oman and then to Persia, along the way visiting the ruins of ancient Persepolis—one of the first Europeans to see the city and, in fact, the first to prepare detailed accounts of its monuments and cuneiform writing. By way of today's Iraq, Syria, and Turkey, Niebuhr finally reached Constantinople once again in January 1767, and by November of that year he arrived safely in Copenhagen, where the whole expedition had begun six years earlier. He wrote an account of the expedition, and so as to not see the labors of his dear friend Forsskål

The title page to the atlas volume of *Descriptiones*, containing the various images of the plants and animals discovered during Forsskål's exploration of Egypt and Arabia.

perish, he published what remained of Forsskål's monographs on the flora and fauna of the Red Sea environs of Egypt and Arabia.

Forsskål discussed twenty-five insect species, including one he called *Gryllus gregarius*, and that we today know as the voracious desert locust (*Schistocerca gregaria*), the scourge of biblical plagues. He also described and depicted a soldier and worker of the subterranean termite *Reticulitermes lucifugus* (called *Termes arda* by Forsskål) as well as one of their constructed tunnels; the species is notorious for its damage to human structures throughout the Middle East and Europe. These are among the earliest images of the castes of termites. Forsskål's account also included one mosquito, *Culex molestus* (today known as *Culex pipiens* form *molestus*), so called because of the incessant botheration it makes of itself. While it is not a species that transmits malaria, it is chilling to think of how its brethren helped bring to ruin the journey of Linnaeus's pupil and his companions.

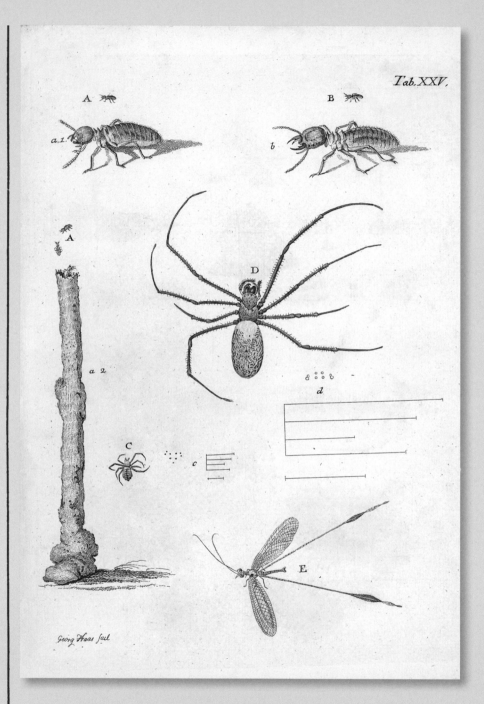

Forsskål's work included the first figures of the social castes of termites, showing workers and soldiers of the subterranean termite *Reticulitermes lucifugus*, as well as portions of their nest constructions. This illustration also included other arthropods he discovered, such as the spider *Argiope sector* and the thread-winged lacewing *Halter halterata*.

cultivate actual gardens, grown within specialized chambers deep within their nests. While fungus-growing ants are restricted to the New World, farming termites are only found in the Old World, so the two groups do not ever overlap. Fungus-growing termites usually cultivate their crops on beds of dead plant tissue or animal feces. The fungus produces nodules that are then collected and consumed by the termites. New queens who found new colonies must locate a starting sample of the fungus in the surrounding environment. This is easily done by collecting spores that are emitted from mushrooms sprouting from the sides of older termite mounds.

The most adept insect farmers, however, are ants. Fungus-growing ants have perfected gardening and have been at this activity for at least the last fifty million years. Unlike the termites, ants harvest clippings of leaves upon which to grow their fungus, and queens founding new colonies carry with them a culture of the fungi used to develop a new garden. Like human farmers, the insects face challenges with maintaining a suitable climate and avoiding crop pests, the latter being other fungi or bacteria that may devastate their gardens. To avoid introducing any unexpected "pests" into their gardens, the ants groom themselves and clean their gardens constantly, and some cultivate specific bacteria and yeasts that act as antibiotics, functioning like "weed killers," to keep the gardens healthy.

Other groups of ants have also evolved to tend plant-sucking aphids or treehoppers, collecting "honeydew" from them. Aphids suck sugary fluids from their plant hosts, consuming massive volumes from the plant in order to gain sufficient nutrition. This heavy flow through their bodies produces considerable fluid wastes;

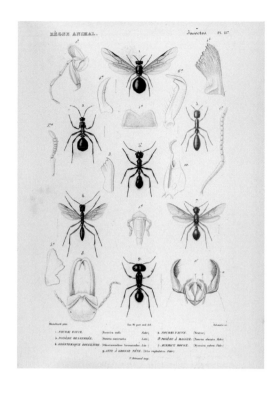

A diversity of ants (family Formicidae)—queen, workers, and males. Ants are among the most familiar of social insects, living in highly integrated societies throughout the world. From Georges Cuvier, *Le règne animal distribué d'après son organisation* (1836–1849).

they excrete droplets of this honeydew, which is rich in sugars, much like nectar, and it is therefore desirable to the ants. The ants have evolved to become ranchers, looking over a herd of aphids like tiny cattle. Some ants will even "milk" the aphids like dairy cows, stimulating the aphid to secrete drops of honeydew on command through a stroke of the ant's antennae. The aphids are protected by the ants, and the ants feed on the honeydew, representing an ideal mutualism. Like human ranchers, should a "field" become used up, the ants will carry their herd to a new location where "grazing" is more suitable. The ants even collect the aphids' eggs and bring them within their nests during winter months, protecting them from the harsh cold. They then carry the aphid nymphs out to feed once spring arrives.

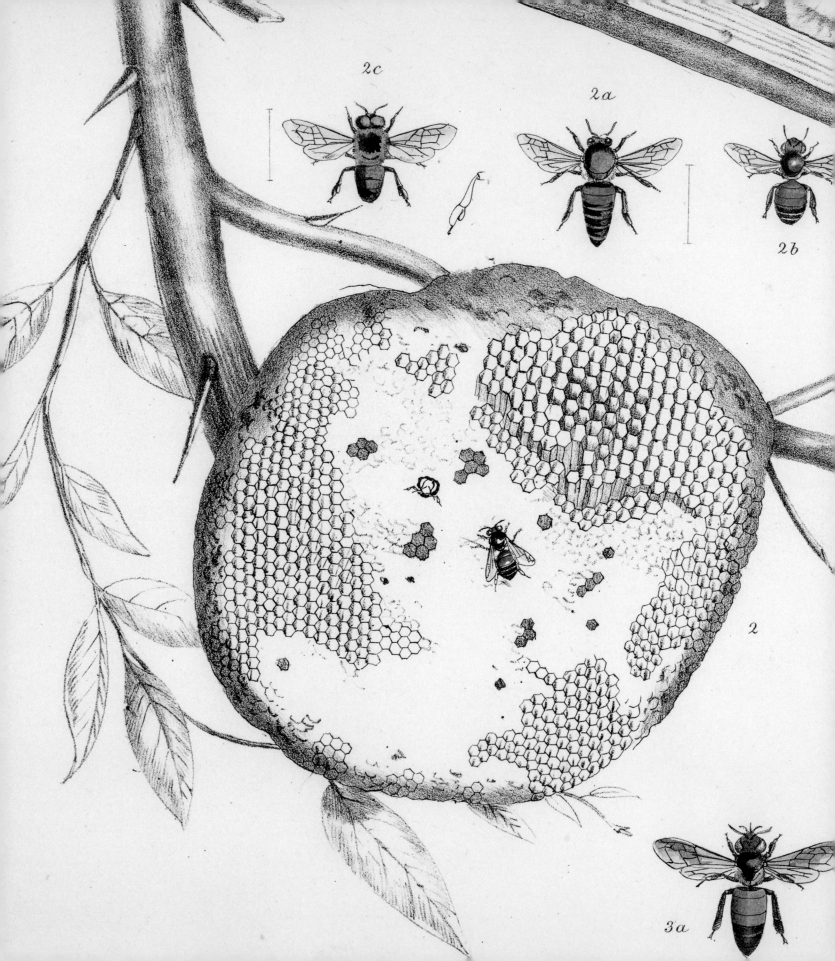

2c

2a

2b

2

3a

The Language of
INSECTS

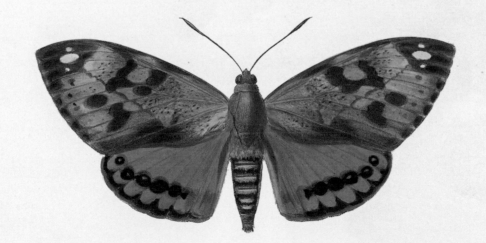

"The limits of my language mean the limits of my world."

—Ludwig Wittgenstein

Tractatus Logico-Philosophicus, 1922

"Bzzz."

—Honey bee

———⊰✦⊱———

The American poet A. R. Ammons (1926–2001) wrote, "Two things are dead giveaways in nature: one is moving, making a motion, and the other is making a sound. Because these two are so risky, wild nature is mostly still and quiet." But life—and "wild nature"—are about risk. Whether we notice it or not, all around us species constantly take risks by both moving and making sounds. A crescendo of communication surrounds us, and while it is true that there are times when we might be stunned by the "deafening" silence of a forest like Ammons describes, there are many occasions on which we may feel deluged by the noise of abundant life—from the songs of birds to the symphonies of crickets. Nature is often neither still nor quiet. Yet, our noisy human world has left too many of us tone-deaf, so much so that when we find ourselves in the great outdoors we may fail to take notice of the variety of calls that envelope us. Each sound and each movement that alerts a predator is indeed risky, but wild nature must risk all in order to truly thrive. Only by doing so can animals—including insects—complete their lives: find

food, locate and choose a mate, and keep their species thriving.

Our lives revolve around communication. We talk to our loved ones, to our coworkers, sometimes to ourselves, and even to our pets. Right now you are reading a silent form of communication involving an agreed-upon set of abstract scrawls to represent the sounds of words that would otherwise be spoken. Our other senses are also involved in communication: smells tell us of delicious meals, warn us of dangers, and fill us with memories; touch can similarly provide us with a flood of information. Our natural and cultural habit of gathering and sharing information is one of the defining traits of our civilizations and species.

Every insect species communicates in one form or another, and any nice summer's evening attests to this profusion, with its background chorus of chirping crickets and roaring cicadas, and the gentle flashes of fireflies. The concert of sights and sounds goes well beyond these familiar signals—beetles stridulate, roaches hiss, stoneflies drum, moths send ultrasonic bursts, treehoppers buzz twigs,

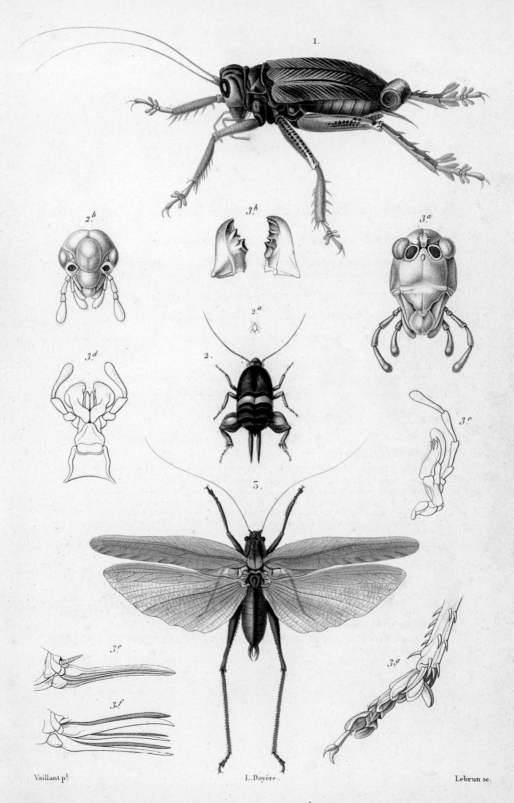

Vaillant p.! L. Doyère. Lebrun se.

1 . *GRILLON MONSTRUEUX* .(Gryllus monstruosus.) 2 . *MYRMÉCOPHILE DES FOURMILIERES* .(Blata acervorum.)

3 *LA GRANDE SAUTERELLE* . (Locusta viridissima.)

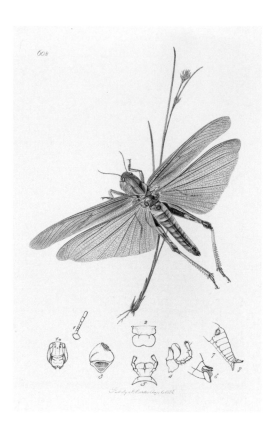

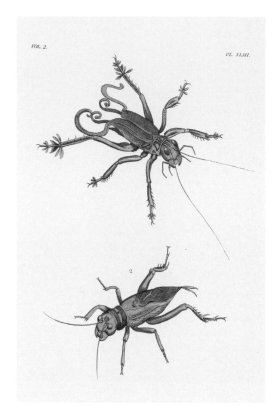

CHEMICAL SIGNALS

and any number of others dance. In fact, insects communicate via every modality imaginable—including some that we were scarcely aware of until recent decades. The most basic signal-receiver systems are those between male and female, parent and offspring, and prey and predator. Males and females must find each other within a varied and changing environment, often filled with hazards. Females signal to their broods when danger is near, and countless species warn potential attackers of their noxiousness through bright and distinctive palettes of color. Whether we "hear" it or not, there is a virtual cacophony of communication underway at all times in the insect world.

The most prevalent means of communication among insects is via chemical cues. Pheromones are used to bring males and females together, facilitating propagation of their species. The feathered antennae of most moths are greatly attuned to specific chemical signatures. In fact, there are some male moths that are so sensitive to the chemical signature of the female that they can hone in on a single molecule emitted from a source miles away. The many branches and sometimes broad shapes of these antennae allow the flying male to have the greatest amount of air flow and circulation over the numerous microscopic receptors, of which there can be many tens of thousands.

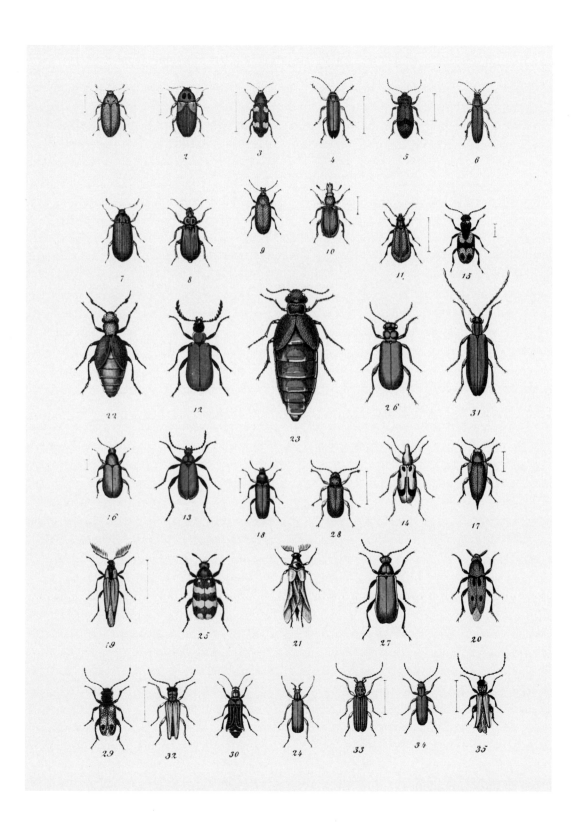

A splash of colorful beetles and some examples of aposematic coloration. The large beetle at center (*Meloe variegatus*) and the black beetle at its far left (*Meloe proscarabaeus*) are blister beetles, the males of which secrete a defensive chemical called *cantharidin*, which they offer to the female as a nuptial gift at mating. The female covers her eggs with cantharidin as a protection against predators. Interestingly, the black-headed cardinal beetle (*Pyrochroa coccinea*) between the two blister beetles uses its red color to warn predators that it, too, is toxic, but it must collect its chemical defense by licking cantharidin off the backs of blister beetles. From Jules Rothschild, ed., *Musée entomologique illustré: histoire naturelle des Coléoptères* (1876).

Social insects use alarm pheromones to alert related individuals of danger. Such chemical signals are often employed to alert a colony of some invader, and these alarms can cause huge numbers of worker ants or bees to flow from their nests, either rearing to defend their nestmates, or simply to flee. Chemical signals may also be sent to individuals of a different species. Stink bugs, stick insects, and many other insects have glands that produce repugnant—and sometimes powerfully pungent or even caustic and harmful—fluids that are meant to repel an attacker. Blister beetles (see illustration on previous page) are so named because their defensive secretion, cantharidin, is particularly powerful and can cause chemical burns. Toxic species often advertise this aspect of themselves through some form of coloration, called *aposematic coloration*. Among blister beetles, for example, some may be black with prominent red, orange, or yellow bands or spots, signaling "do not touch." Others, however, can be entirely black or blue and yet just as capable of inflicting a painful burn.

MOVEMENT AND LIGHT, VIBRATION AND SOUND

Because humans are such visual creatures, we are drawn to anything that may catch our eye, like behavioral displays and vibrant washes of color—whether or not the information conveyed is intended for us. The warning coloration of the aforementioned blister beetles, as well as those of harmful or toxic species ranging from wasps to monarch butterflies, certainly communicate loudly, and can do so

even if the insect is at rest. Insect movement also conveys considerable meaning, and perhaps the most common visual repertoires are courtship displays, which are performed across the full spectrum of hexapod evolution, from springtails to bark lice to butterflies. Nuptial dances, consisting of choreographed and stereotypical movements, sometimes coupled with species-specific patterns of coloration, not only permit individuals to recognize whether or not they are of the same species, but they also allow females to be choosy. Depending on the vigor of the displays, a female will select among potential mates, and this finickiness can sometimes lead to the evolution of exaggerated traits among males as they compete for the favors of their beloved. Even the primitive springtails, bristletails, and silverfish—which do not copulate—perform ritualized dances with females that ultimately lead to her accepting a spermatophore. Most of these visual signals are made while the insects are in close proximity, owing to varying degrees of visual acuity for certain insect groups and sometimes the incorporation of tactile stimulatory elements to the dance. Otherwise, the males' pirouettes and turns might go unseen. But this does not mean that all visual expressions are restricted to the myopic.

Fireflies, a worldwide group of beetles, are the insect world's great telegraphers, with those that are luminescent sending characteristic flashes of light after dusk. Each species produces its own pattern of flashes, much like a glowing Morse code. The light is produced in special photic organs located in the beetle's abdomen, the result of a chemical reaction that, depending on the species, appears as pink, yellow, or the more-familiar pale-green light. The duration, location, and even the

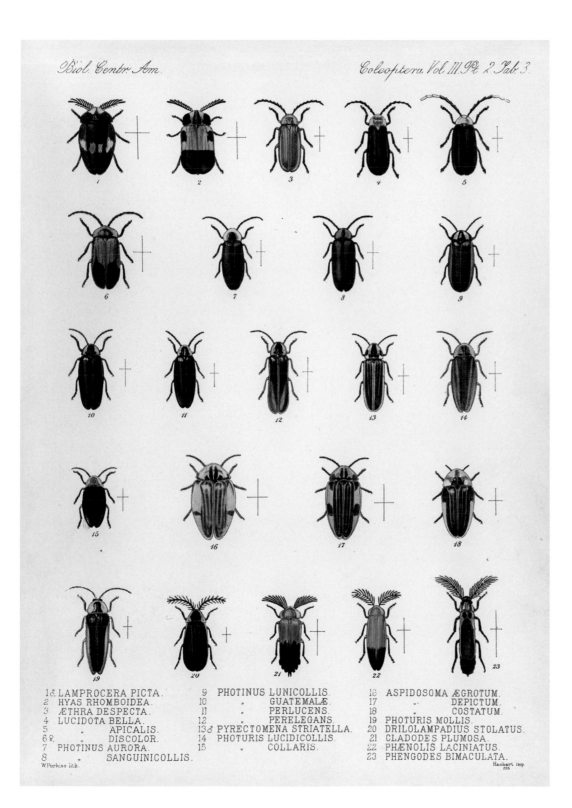

1 LAMPROCERA PICTA.
2 HYAS RHOMBOIDEA.
3 ÆTHRA DESPECTA.
4 LUCIDOTA BELLA.
5 „ APICALIS.
6 ♀. „ DISCOLOR.
7 PHOTINUS AURORA.
8 „ SANGUINICOLLIS.

9 PHOTINUS LUNICOLLIS.
10 „ GUATEMALÆ.
11 „ PERLUCENS.
12 „ PERELEGANS.
13 ♂ PYRECTOMENA STRIATELLA.
14 PHOTURIS LUCIDICOLLIS.
15 „ COLLARIS.

16 ASPIDOSOMA ÆGROTUM.
17 „ DEPICTUM.
18 „ COSTATUM.
19 PHOTURIS MOLLIS.
20 DRILOLAMPADIUS STOLATUS.
21 CLADODES PLUMOSA.
22 PHÆNOLIS LACINIATUS.
23 PHENGODES BIMACULATA.

W. Purkiss lith.

Hanhart imp.
226

The beetles commonly known as fireflies (family Lampyridae) comprise approximately two thousand species, and while not all produce light, the flashes from those that do are distinctive to their individual species. From *Biologia Centrali-Americana. Insecta. Coleoptera.* (1880–1911).

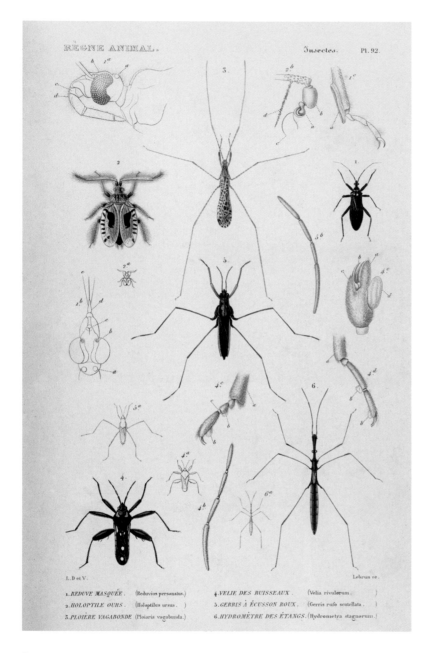

Bugs produce varied communications, and water striders such as *Limnoporus rufoscutellata* (with its long legs, center), can produce ripples on the surface of the water that serve as calls to their mates or to ward off other individuals. Circling the water strider, clockwise from upper left: feather-legged bug (*Holoptilus ursus*), thread-legged bug (*Empicoris vagabunda*), masked hunter bug (*Reduvius personatus*), water measurer bug (*Hydrometra stagnorum*), and riffle bug (*Velia rivulorum*). From Cuvier, *Le règne animal distribué d'après son organisation*.

visual shape of the flashes are sufficiently specific as to permit the proper pairing of males and females.

Other forms of communication are heard and felt. Outside of insects, we are all familiar with the sensitivity of spiders to the vibrations of their webs, which inform them of the arrival of an ensnared meal. The uses of similar surface vibrations is numerous among insects. Nymphs of the treehopper *Umbonia crassicornis*, or thorn bug, feed in small aggregations, usually through punctures made by the mother into a plant stem, while she sits not too far off. Upon the approach of a predator, such as a wasp, fly, or beetle, the nymphs produce vibrational calls that travel through the stem of the plant. The calls become synchronized as more and more alarmed nymphs join in the plea for help, and these vibrations are felt by the nearby mother who comes to their aid, beating away the attacker with her toughened wings and legs.

Water striders, those slender-legged bugs that skate along the edges of calm ponds, are general predators who will snatch helpless arthropods that accidentally drop to the water's surface. One genus, *Halobates*, can quite remarkably stride over open-ocean water. Living on the surface of water possesses several challenges, not the least of which is avoiding drowning. Like the treehoppers, however, water striders communicate through vibrations, a form of ripple communication, with different frequencies conveying differences in intent. The most common of these is a ripple to let nearby striders know of an individual's presence, each replying to the other with a similar ripple as a way of asking them to back off. If a male strider sends a ripple but receives no reply from the other strider, then he knows it to be a female who is

open to mating. He will then sing to her with a different form of ripple as a means of courtship. If she is not impressed, she signifies with a ripple of her own letting him down. If she is taken by his charm, then she will orient herself such that he can join her on the water.

The more famous vibrations are the many trills, tweets, chirps, clicks, and clacks of the "singing" insects—the very melodies that led English poet John Keats (1795–1821) to write that, "the Poetry of earth is never dead." The acoustic sounds of insects are never really "sung," as none produces sounds vocally. Instead, insects are fiddlers and drummers, rubbing wings, legs, abdomens, or even mandibles together to create the choruses with which we are so familiar. These may be solo acts or generated by entire orchestras. Acoustic calls are most famous among the orthopteran insects, such as those of crickets, grasshoppers, and katydids. Most of these calls are made by the males singing for their mates, each sending forth long-distance arias. Crickets and katydids do this by rubbing together specialized files on their wings, the sound amplified by membranous areas outlined by veins, called *mirrors*. By contrast, those grasshoppers that call, and not all do, generate their sound by rubbing a scraper on their hind legs against a thickened file on the wing. In all of these, the sounds produced are unique to each species, and the trained ear can identify what species are present simply from the calls, without ever seeing the insect itself. So specific are the calls that specialists might first realize that a new species is present upon hearing its song—before the animal itself has been captured! Some mole crickets—whose forelegs, which are used for burrowing, resemble those

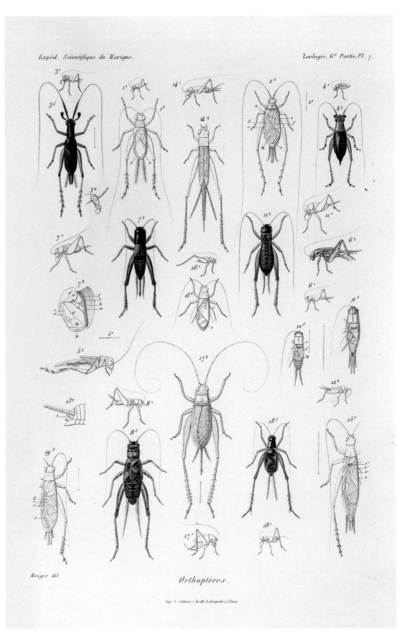

Our summer evenings are awash with the loud song of crickets (family Gryllidae)—such as these Mesoamerican, Caribbean, and southwestern US species. Colored crickets, clockwise from top left: *Phyllopalpus caeruleus, Phyllopalpus brunnerianus, Anurogryllus abortivus, Prosthacusta circumcincta, Gryllodes sigillatus,* and *Anurogryllus toltecus.* From Henri de Saussure, *Études sur les Myriapodes et les insects* (1870).

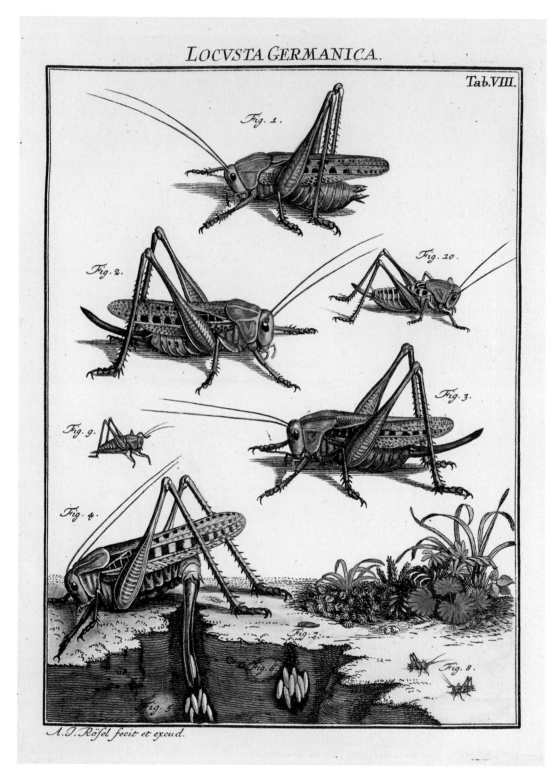

As correctly figured by Rösel von Rosenhof, grasshoppers dig shallow burrows into which they extend their abdomen in order to lay a clutch of eggs. The eggs are then covered over while the embryos inside develop, and eventually emerge as nymphs. From Rösel von Rosenhof, *De natuurlyke historie der insecten.*

of tiny moles—build small amphitheaters at the openings of their tunnels in order to better project their calls. Another subterranean group, related to grasshoppers but entirely wingless, are the Australian sandgropers, family Cylindrachetidae. Sandgropers have specialized mandibles with scrapers and files, and they generate their calls by rubbing these together.

Long before the evolution of birds and their melodious calls, ancient forests were filled with the cacophony of insect songs. Remains of a katydid from 165 million years ago, complete with the scraper and file of the wings, were used to reconstruct the sound produced, revealing this ancient acoustician to produce a pure-tone call. We are well familiar with pure tones, as these comprise music. The ancient katydid did not call out with a nonmusical buzz or clack, but with music—a Jurassic-age love song.

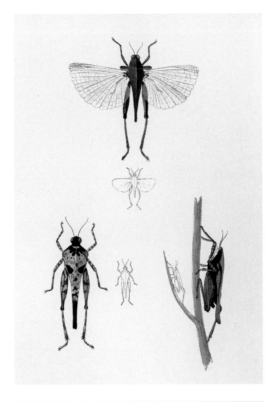

LEFT: The North American pygmy grasshoppers *Tetrix ornata* and *Tettigidea lateralis*. From Thomas Say, *American Entomology* (1828).

BOTTOM LEFT: The miniatures of Rösel von Rosenhof are stunning for their level of accurate detail and for capturing of the insects in life, such that a reader might easily imagine the chirping of these crickets. From August Johann Rösel von Rosenhof, *De natuurlyke historie der insecten* (1764–1768).

BOTTOM RIGHT: Sandgropers (family Cylindrachetidae) are a lineage of greatly modified grasshoppers found only in Argentina, New Guinea, and Australia. Species such as the Australian *Cylindracheta spegazzinii*, figured here, use stridulatory files on their mandibles to produce their subterranean calls. From Ermanno Giglio-Tos, "Sulla posizione sistematica del gen. *Cylindracheta* Kirby," *Annali del Museo civico di storia naturale di Genova* (1914).

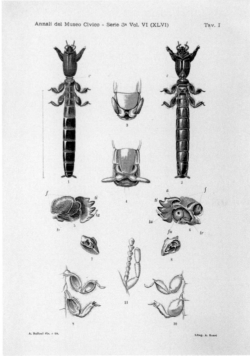

Males of the European mole cricket (*Gryllotalpa gryllotalpa*), use their molelike forelegs to dig burrows in the soil that function as amphitheaters to amplify their mating calls. From Julius T. C. Ratzeburg, *Die Forst-Insecten* (1844).

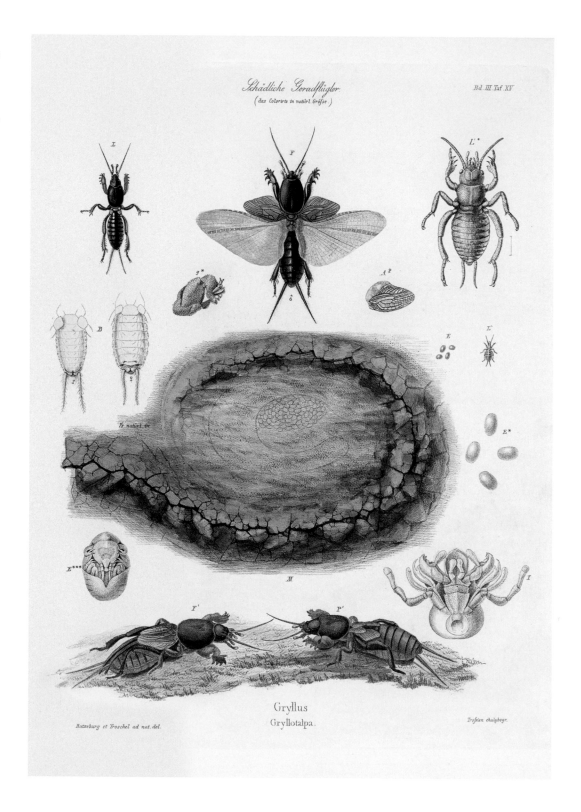

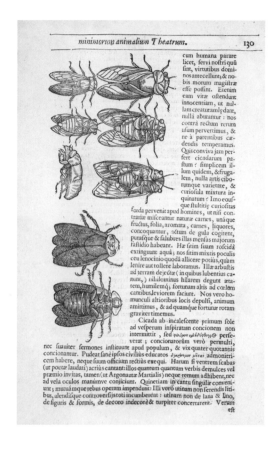

minimorum animalium Theatrum. 130

FAR LEFT: Woodcuts depicting different views of European cicadas from Thomas Moffet's *Insectorum sive Minimorum Aniamalium Theatrum* (1634).

NEAR LEFT: The drowning calls of cicadas, such as the little-owl cicada of Madagascar (*Pycna strIx*, top) and the common European cicada (*Lyristes plebejus*, bottom), are common sounds during evenings after males and females emerge and begin the hunt to find one another. From Cuvier, *Le règne animal distribué d'après son organisation*.

The noisiest calls, of course, are those of cicadas. The roar of chorusing cicadas can be deafening, quite literally. The cumulative cater-wauling of cicadas in treetops can quickly exceed 100 decibels, a level equivalent to that of some jets at takeoff. Noises over 90 decibels can damage hearing, and at 110 decibels we experience noticeable pain. In fact, male cicadas are capable of disengaging their own "ears" during such choruses in order to avoid damaging their hearing. These impressive sounds are produced by plates (called *tymbal plates*, which are located on the sides of the abdomen) that are vibrated rapidly. Adjacent to the plates are large air sacs that serve to amplify the sound produced, and bordering the tymbals are the cicada's ears, or *tympana*. The tympana act much like our eardrums and permit the insects to hear (see also page 62). As in the previous examples, the calls are specific to each species. Not all cicada sounds, however, are meant as courtship songs, and these insects will produce tones for other purposes, such as shrill shrieks to startle predators.

Although insect sounds are made by drumming or scraping, there is one creature famous for its hiss. The Madagascar hissing cockroach, *Gromphadorhina portentosa*, is a large, wingless roach popular as a pet and in zoological exhibits. These harmless herbivores push air through special holes in their abdomen, creating the hissing sound for which they are famed. When the roach is disturbed it will emit this hiss, but males will also hiss

Cicadas amid their hemipteran relatives: in the center, the large *Diceroprocta ruatana*; and below it, *Dorisiana amoena*. From *Biologia Centrali-Americana. Insecta. Rhynchota. Hemiptera-Homoptera.* (1881–1909).

1 CLADYPHA INTERLITA.	7 DICTYOPHARA HERBIDA.	13 TYMPANOTERPES RUATANA.
2 DICTYOPHARA FEROCULA.	8 ” FLORENS.	14 DORACHOSA EXPLICATA.
3 ” CURVICEPS.	9 ” ORBICULATA.	15 FIDICINA AMŒNA.
4 ” NODIVENA.	10 DICTYOPHAROIDES TENUIROSTRIS.	16 ” CACHLA.
5 ” BRACHYRHINA.	11 CLADYPHA RUFIVENA.	17 CICADA OLEACEA
6 ” OBTUSIFRONS.	12 ” BUGABENSIS.	18 HYPÆPA DIVERSA.

W. Purkiss lith.

Hanhart imp.

to attract a female or to convey aggression toward competing males.

Any long-distance signal runs the risk of being intercepted, and it is not uncommon that some unwanted party may be "listening" in on a conversation. Certain predators and parasites have evolved to detect signals such as this. A mating call for one species can turn into a "dinner bell" to the right kind of predator. For example, species of the firefly genus *Photuris* are predators whose females have evolved to send out light displays that mimic those of other fireflies (see pages 148–149), thus luring in unsuspecting males of the other species, which they then devour. Similarly, the calls of male crickets are also heard by parasitic flies via their attuned ears. Ormiine tachinid flies listen in to the reproductive songs of crickets, follow the sound back to the singer, and then lay live larvae—rather than eggs—nearby. The fly's larvae burrow into the body of the cricket, feeding within its body before becoming pupae.

Making a noise or emitting light certainly carries with it considerable risk, as birds and bats are also attracted to certain insect calls. Sometimes no communication is intended by a caller, and yet its signal is discerned by an animal who then reacts accordingly. Bats are famed for their echolocation, producing ultrasonic bursts as a natural form of sonar. With this sonar they develop an acoustic map that enables them to locate and hone in on an insect in flight, for those that are insectivorous. Of course, it is preferential to the bat if an insect is unaware that it is being tracked. Fortuitously, many groups of insects have evolved to hear these ultrasonic sounds and can understand precisely what such signals foretell. Moths, lacewings, and even praying mantises can hear ultrasonic sounds, giving them a fighting

The hissing roaches of Madagascar (genus *Gromphadorhina*), at left (colored) and center, produce their distinctive sounds by forcing air through the spiracles of their abdomen. Other Malagasy roaches (colored), at right from top to bottom: *Ateloblatta cambouini*, *Ateloblatta malagassa*, and *Thliptoblatta obtrita* (two views). From Henri de Saussure, *Histoire physique, naturelle et politique de Madagascar, Orthoptères* (1895).

chance when it comes to facing such a fearsome predator. In moths, the ears are located on the sides of the abdomen, while in green lacewings they are on the base of the wings, and in mantises there is a single ear centered on its chest. A moth or lacewing in flight that

1 CLANIS IMPERIALIS.
2 CHŒROCAMPA GODMANI.

3 CALLIOMMA NOMIUS.
4 AMPHONYX RIVULARIS.
5 PERIGONIA LUSCA.

6 PERIGONIA RESTITUTA.
7 CASTNIA CLITARCHA.

W. Purkiss lith.

Hanhart imp.
334

Excellent "ears"—used to detect the ultrasonic bursts of rapidly approaching bats—have evolved numerous times among moths, such as in the several species of hawk moths (family Sphingidae) seen here (except for the castniid moth, *Athis clitarcha,* at bottom). From *Biologia Centrali-Americana. Insecta. Lepidoptera-Heterocera.* (1881–1900).

detects the sonic burst of a bat will dive from the air, often moving in an irregular pattern so as to make itself more difficult to trace. There are even species of moths that can apparently "talk back" to the bat, producing their own ultrasonic clicks. In some species the clicks are meant to convey that the moths are toxic, either truthfully or as a form of deception. In the Southeast Asian hawk moth *Theretra nessus*, such sounds are made by rasping the genitalia against the abdomen. The tiger moth *Bertholdia trigona* generates ultrasonic clicks with tymbal plates, similar to those of cicadas, and the signal produced actually jams the bat's sonar.

THE DANCE OF THE HONEY BEES

The ultimate form of communication, however, is that of language. Language is set apart from other forms of communication in its use of arbitrary symbols in a structured form to convey ideas. We use sounds and symbols, placed together in specific patterns, to convey ideas. Thus, the letters printed on this page serve to represent sounds, and when placed together in a specific order they denote words, which when again arranged according to a set of rules form utterances that then pass along meaning.

Since antiquity we've known of a peculiar behavior among honey bees, where returning foragers will "dance." Aristotle recorded the behavior over twenty-three hundred years ago, and through the ages writers have ascribed varied meanings to the action, including simply thinking the bees were so overjoyed at returning home they performed a little jig. In fact, the dance and its many nuanced components serve as a set of organized symbols, a language,

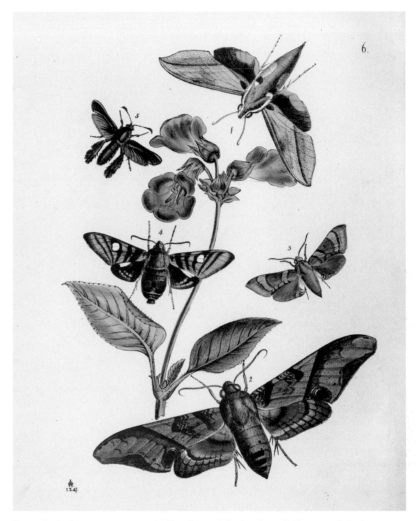

A species in the same genus as the Southeast Asian hawk moth *Theretra clotho* (top right) is capable of not only detecting but actually producing ultrasonic bursts. Other moths (clockwise): *Agnosia orneus*, *Amplypterus panopus*, *Hayesiana triopus*, and *Lenyra ashtaroth*. From John O. Westwood, *The Cabinet of Oriental Entomology* (1848).

through which one bee can inform others of the direction, distance, and quality of a particular resource, often of nectar and pollen but even of potential new nest sites. This remarkable reality was discovered through a series of intricate experiments by the German behavioral entomologist Karl von Frisch (1886–1982). The discovery was so considerable that it won von Frisch the Nobel Prize in Physiology or

The combs of honey bees also serve as the dance floors for their distinctive system of communication. The combs of dwarf and giant honey bees (*Apis dorsata* and *Apis florea*) in Southeast Asia are built in the open, hanging from branches, and the worker bees dance on the upper surface of the hive in order to "tell" their nestmates where to find resources. The large carpenter bee, *Xylocopa chloroptera* (upper right), is also depicted along with its nest composed of linear brood chambers in branches. From Horne and Smith, *Transactions of the Zoological Society of London* (1870).

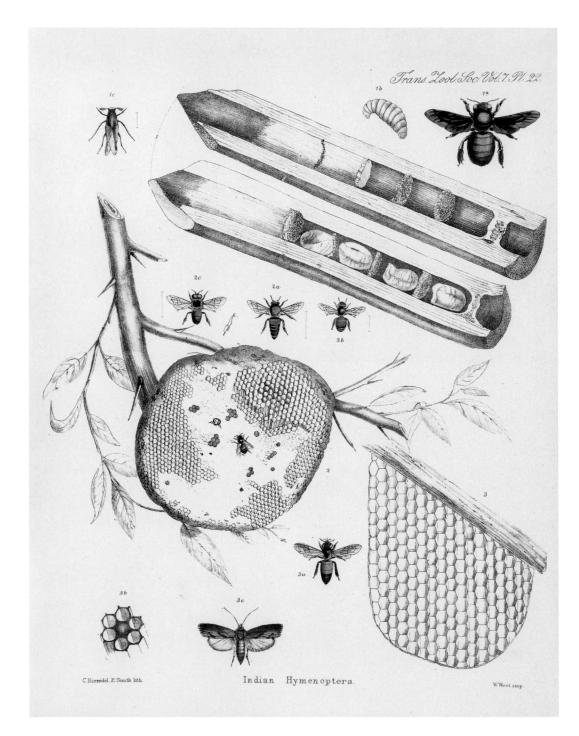

Trans. Zool. Soc. Vol. 7. Pl. 22.

C. Horne del. E. Smith lith.

Indian Hymenoptera.

W. West imp.

Medicine in 1973, a prize he shared with Austrian zoologist Konrad Lorenz (1903–1989) and Dutch biologist Nikolaas Tinbergen (1907–1988) "for their discoveries concerning organization and elicitation of individual and social behavior patterns"; von Frisch is the only entomologist to have ever won the award.

At its simplest, a laden forager "speaks" to her nestmates through a series of movements called the *waggle dance*. The bee dances on the vertical comb in the hive in a figure-eight fashion, waggling her abdomen during the middle part of the eight before circling back to do so again, each return cycle alternating between left or right turns. The bee does not waggle during the return runs, only doing so during the middle part of the dance. In addition, she is very specific in the direction in which she orients herself for the waggle run of the dance. It is this orientation that conveys the direction to the source. The world outside is a horizontal landscape, and the bees are dancing on a vertical surface, which means they require an abstract point of reference that they can then convert and use out of the hive. This point of reference is the sun, and a waggle run that is pointed directly up means that the direction is toward the sun. Any deviation, either left or right, from direct up indicates the same degree of deviation outside and relative to the sun. The length of the waggle run correlates to a specific distance from the hive, while the vigor of the performance indicates the relative quality of the food. All of this is taking place within the confines of a dark and crowded hive, and the bees being recruited therefore crowd close to the dancer. Their antennae are placed in close proximity to her, and the Johnston's organ—that specialized sensory structure that helps to define all insects (see page 8) detects the frequency of vibrations as well as the

orientation of the dancer's body relative to gravity. Collectively, these various elements give sufficient precision for a recruited worker to decide whether or not the food is good enough to visit, and, if so, to depart from the hive in the proper compass direction relative to the sun and fly the necessary distance to find it. There may also be odor cues, such as the scent of the flowers that were visited, that further aid the recruit upon its arrival at the correct location. The language is actually more varied and nuanced than this. For example, should a resource be close enough, then the bee abandons the figure-eight form and does a round dance.

An iconic honey bee (*Apis mellifera*) skep, or basket, hive from the frontispiece of Moffet's *Insectorum sive Minimorum Animalium Theatrum*.

Just as with a human language where there are regional dialects, the same is found among honey bees. Subtle variations are known among distant populations, such as the duration and number of waggle runs correlating to different distances. Thus, a follower from one region "listening" to a dancer from another region will arrive at the wrong location—perhaps going too far or not far enough. They understand the language but don't quite get the exact meaning. The same is true for all seven species of honey bees, each of which has its own variant of the waggle dance.

Linguists and semioticians forever debate what constitutes language, a concept easily understood but difficult to define. What criteria must be fulfilled in order to satisfy the high standards of a communicative form becoming so labeled? The great founder of semiology, Swiss linguist Ferdinand de Saussure (1857–1913), considered language to require a signifier ("sound-image") and a signified ("concept"), components both achieved by honey bees. (Interestingly, Saussure's father was the celebrated entomological taxonomist Henri de Saussure [1829–1905], renowned worldwide for his extensive monographs on Orthoptera and Hymenoptera. One has to wonder whether the communicative calls of the many crickets and katydids his father studied might have stimulated the junior Saussure toward his calling in linguistics.) The symbols and affiliated notions are then arranged according to syntax to form language. Do honey bees have syntax? Yes, since the dance proceeds in an organized and structured fashion, with the particular signs conveyed in an order. For example, waggling does not occur during the return loops, and waggling out of place would lead to confusion, just as writing the words of this paragraph in random order would lose their meaning. A titan among modern linguists, Noam Chomsky (b. 1928) once noted that language was a set of sentences of finite length and constructed of a finite set of elements, and these convey either a finite or infinite range of ideas. Our language is considered "open," as our range and creativity permit us to generate a seemingly endless possibility of expressions. As far as we know, honey bees are fairly limited in the variety of information conveyed, their language therefore being "closed." Bees don't muse about the beauty of a tree or the comforting feel of warm sunshine, nor do they debate whether the squawking of *Homo sapiens* constitutes a language or not (that we know of, at least). Other schools of thought argue that true language is not innate, i.e., it is not an intrinsic behavior genetically conveyed like most insect communication systems, and yet today's biolinguists have uncovered that our own foundational capacity for language is ingrained and heritable. Thus, our languages and those of the honey bees seem to sit on a spectrum, distinguished more by a mere degree of complexity and range. For the bees, their dances speak volumes.

The debate over how narrowly or broadly the term *language* should be used will continue to occupy linguists and philosophers for generations, but no matter how you slice it, an abstract language evolved first among insects. Honey bees have been using a language for at least thirty-five million years, and although the range of ideas that can be expressed is limited, it is nonetheless perhaps one of the most remarkable forms of communication across animals.

FEMININE WIT AND INDUSTRY

Aristotle remained one of the primary sources for information on natural history through the early seventeenth century. Apiculture was already ancient by Aristotle's age, and the Greek scholar was keeping with convention when he wrote that the leader of a honey bee's hive was the "king." The mere inclusion of this idea in Aristotle's *Historia animalium* (see page 15) consecrated the concept in the minds of later naturalists. The work of one radical English vicar and beekeeper, however, would overturn this received wisdom, rightly revealing a hive to be a feminine monarchy. Charles Butler was born to an impoverished family in Buckinghamshire in 1560, but his humble origin did not hold him back. In his late teens he was admitted to Magdalen Hall at Oxford, working to support his studies, which in time likely included teaching courses of his own. After ten years of hard effort, Butler completed an arts degree in 1587. Trained in the ministry, following graduation he worked at Magdalen as a Bible clerk until 1593, when he became rector of Nately Scures in Hampshire.

Aside from his ministry, Butler was a logician, grammarian, phonetician, musician, and, most notably, a beekeeper. After moving a couple of times, in 1600, Butler settled down as vicar of the village of Wootton St. Lawrence, remaining there until his passing in 1647. In 1609, Butler published *The Feminine Monarchie*, the first comprehensive tract on beekeeping in English. The book was of considerable practical use, with instructions on capturing swarms, building hives, and managing the various enemies of the colony. In addition, he wrote of the importance of the bees to gardens and fruit pollination, and even how to use the tone of the bees' buzzing to predict when a colony was about to abscond and swarm. As a musician, he was so inspired by the sounds of the hive that he even composed a four-part madrigal titled *Melissomelos*, a transliteration of the tones he perceived the bees to be making (see page 165).

Butler demonstrated that the workers produce their wax from the under-

ABOVE LEFT: The title page to the 1634 edition of Charles Butler's *The Feminine Monarchie* (1609), in which he employed the phonetic alphabet he developed as a grammarian and phonetician.

ABOVE RIGHT: The frontispiece of *The Feminine Monarchie*, with its stylized honey bee comb. Butler first disseminated the correct notion that the ruler of the hive was a queen, here, depicted with a crown at the top of the hive and surrounded by a retinue of workers and princes (drones).

Butler was so moved by the honey bees he tended and studied that he was inspired to compose a madrigal based on the sounds of the hive. The madrigal, the *Melissomelos* (opposite), was performed at the dedication of a stained glass window (right) honoring Butler in the parish over which he presided at Wootton St. Lawrence in Hampshire, nearly 350 years after the publication of *The Feminine Monarchie*. (Parts of the musical notations were printed upside down so two or four singers facing each other could share the book while singing.)

side of the abdomen—from structures we today call *wax mirrors* but which are specialized glands—rather than collect it from mysterious sources in the environment. Most importantly, Butler popularized the seemingly heretical notion that the "king" of the hive was, in actuality, a queen, that the drones were the males of the species, and that the workers—whom he praised for their wit and industry (the *solertia et labore* motto on his book's frontispiece illustration of a stylized hive, see page 163)—were themselves female. He did not have much empirical evidence for this, but such proof would be forthcoming by the end of the century, when Jan Swammerdam dissected a queen and discovered ovaries therein. Likely unbeknownst to Butler, a Spaniard, Luis Méndez de Torres (see page 129), had also advocated this idea in 1586, but it was Butler's popular treatise that widely disseminated the feminine rule of bees.

Butler's *The Feminine Monarchie* ordained him as the "Father of English Beekeeping." It is perhaps, however, his 1634 edition that is the most fascinating. As a phonetician and grammarian, Butler pushed for an overhaul of the English language, publishing *The English Grammar* in 1633, in which he invented an entirely new phonetic alphabet. The revised edition of *The Feminine Monarchie* that appeared the following year was printed in Butler's new phonetic system. To commemorate the coronation of Queen Elizabeth II (b. 1926) in 1953, a new stained-glass window, opposite, was installed

in the Wootton St. Lawrence church. The window, opposite, depicts Butler holding *The Feminine Monarchie*, a hexagonal comb surrounding his head and shoulders, much like a halo, with bees arranged in the same formation as in the illustration from the book's frontispiece. Quite appropriately, the choir performed *Melissomelos* at the window's dedication. It may finally be time for Butler to gain a new title as England's patron saint of apiculture.

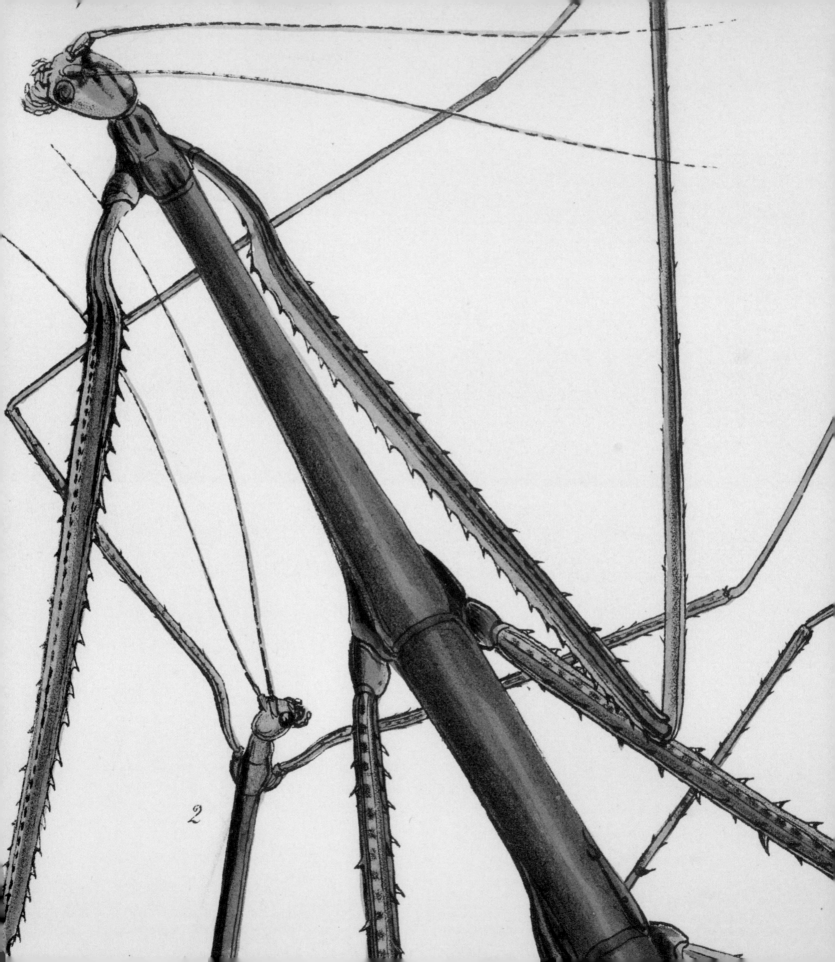

2

9

HIDING
in Plain Sight

"Conceal me what I am, and be my aid
For such disguise as haply shall become
the form of my intent."

—William Shakespeare
Twelfth Night, Act 1, Scene 2, ca. 1601

PAGE 166: Detail of the stick insect *Bacteria virgea*, from John O. Westwood, *The Cabinet of Oriental Entomology* (1848) (also see page 172).

OPPOSITE: The Indonesian stick insect *Phasma gigas*, illustrated here, can grow up to 9 inches (23 centimeters) in length. While this is impressive, it falls short of the longest record among Phasmatodea, currently held by *Phryganistria chinensis* of southern China, a species that can extend to 2 feet (61 centimeters). From Georges Cuvier, *Le règne animal distribué d'après son organisation* (1836–1849).

The ability to go about undetected is greatly advantageous, whether employed as a form of protection or as a means of stealthily approaching prey. A concealed individual avoids detection, but this is not the same as merely hiding. A truly cloaked individual is not restricted to a single location or cloistered within the confines of a crevice or roost that obscures a plain view of the animal. Instead, through camouflage, mimesis, or mimicry, animals can go about their lives, often in plain sight, yet completely and utterly hidden from others. In any form of disguise, one organism assumes the appearance, behavior, sound, or odor of some model, typically a plant or animal but also sometimes inanimate objects like stones or soil. Even the simplest forms of concealment are considerably complicated. The evolution of such disguises require changes in behavior and anatomy as well as less obviously discerned alterations to the physiology and biochemistry of the mimic. If successfully achieved, to disguise oneself is a powerful asset, and insects are among the best at such deception.

All forms of deception involve various players in order to pull off the act. Foremost is the animal that is hiding, usually dubbed as the mimic, and then there is the species or object it is attempting to resemble, termed the model. The goal is such that by assuming the appearance of the model, the mimic either avoids detection by or confuses a predator, who is appropriately duped. In entomology, camouflage covers a wide range of diverse evolutionary tactics but is usually considered to apply to any use of coloration, materials, anatomy, or behavior to achieve disguise. Most of these fall under what entomologists refer to as crypsis, which simply refers to forms of camouflage that make the insect difficult to see against a particular background.

CAMOUFLAGE

At its simplest, particular colors or patterns permit the insect to seamlessly blend into its surrounding environment. This is commonplace among the animal kingdom, and most insects are suitably patterned. For example, the average desert locust has a pale color suited to its environment, and many grasshoppers

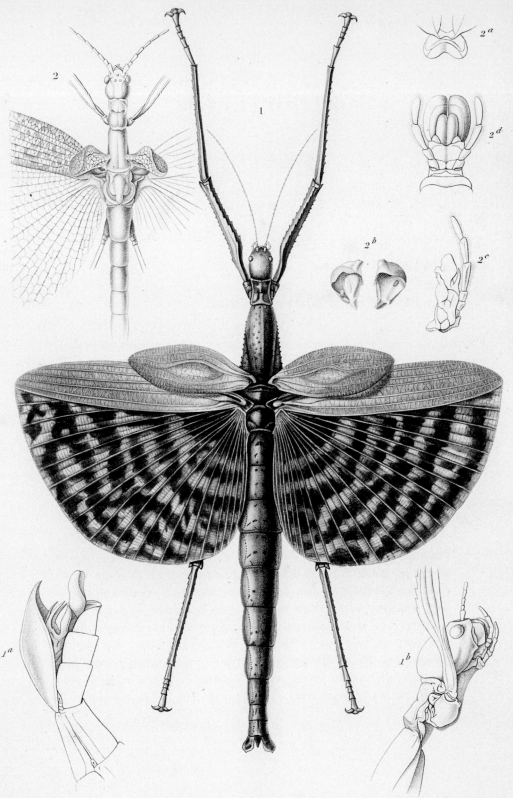

2 _a_

2 _d_

2 _b_

2 _c_

1 _a_

1 _b_

F. Doyère pinx. L. Doyère Lebrun sc.

1. *LE PHASME GÉANT*. 2. *LE PHASME PHTYSIQUE*.

(Phasma Gigas.) (Phasma phtysicum.)

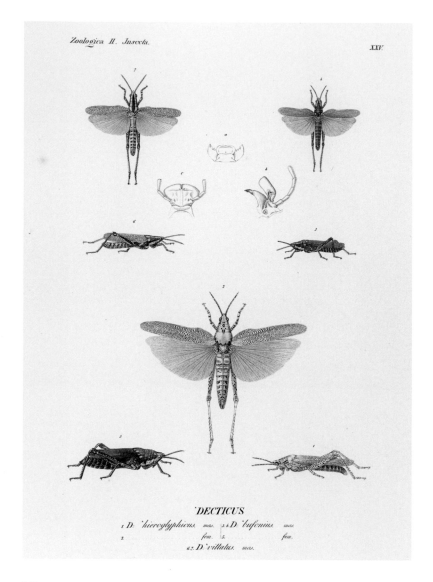

'DECTICUS'

1 D. 'hieroglyphicus. mas. 2 & 4 D. 'bufonius. mas.
3. fem. 5. fem.
6.7. D. 'vittatus. mas.

Different subspecies of the African gaudy grasshopper (*Poekilocerus bufonius*), whose general coloration and frequently fine mottled spots render it difficult to observe when set among rocky or sandy soil. From Christian Gottfried Ehrenberg, *Symbolae Physicae* (1828–1845).

materials they stand out and are fairly obvious to behold. This is not the same as constructing a nest, which, depending on the form and materials, can also blend well into a setting. Instead, camouflage utilizing exogenous materials is built directly onto the insect's body. It is a remarkably complex feat, and for insects some of the best examples are found among true bugs, bark lice, and lacewings. Nymphal assassin bugs attach plant materials to glandular setae on their bodies, and those in our homes even collect dust or small household debris as part of their camouflage. Bark lice similarly attach debris or even their own feces to glandular setae using silk.

Perhaps most remarkable are the larvae of green lacewings. As larvae, green lacewings are voracious predators of small arthropods, such as aphids or scale insects, making them particularly useful biological control agents whenever such plant-feeding insects make pests of themselves. Most lacewing larvae have specialized knobs and setae on their sides and backs that are used to hold objects in place to cover them. Different species use different materials, but many cover themselves with packets of plant fragments. The larva collects individual pieces and gradually places them onto its back, building up the packet until its body is completely concealed from above, with little more than perhaps its head exposed. The camouflage acts not only as a form of protection for the lacewing, but for certain species it also gives them an advantage when edging up on their prey. Some lacewing larvae will even use the emptied exoskeletons of their prey as material with which to cover themselves, thereby taking on the scent of their chosen victims as part of their disguises. Dressed as a "wolf in sheep's clothing," a larva

living on sandy soil will have mottled patterns rendering them difficult to detect. This simple means of hiding in plain sight is why we can be simultaneously surrounded by insects and yet scarcely ever see them.

A more complex and far less common form of camouflage is the actual construction of a disguise from materials available in the environment. Insects that do this are not otherwise disguised, and without the camouflaging

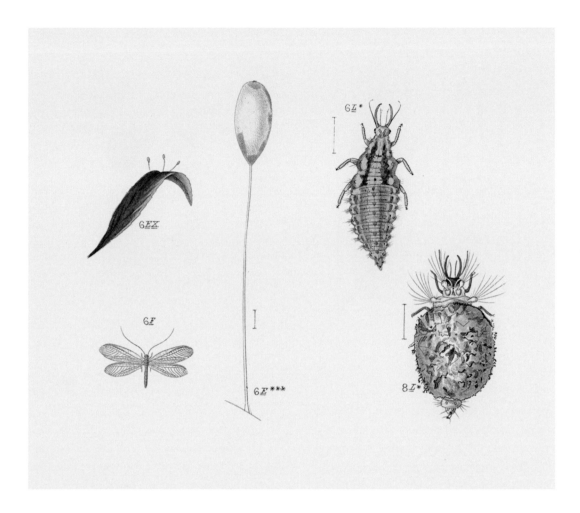

The larvae of green lacewings are famous for building disguises of debris, ranging from plant materials to the carcasses of their prey. Such camouflage permits them to avoid detection by predators and approach their own prey more easily. Shown here are lacewings in various stages of development. Clockwise from top left: a leaf with stalked eggs, a detail of an egg on its stalk, a larva without its camouflage, a larva with a camouflage package of plant debris on its back, and an adult. (Not shown: the pupa and each of the various larval stages.) From Julius T. C. Ratzeburg, *Die Forst-Insecten* (1844).

is able to get close to its potential prey, usually undetected until it is too late for some hapless aphid or scale insect. Insects appear to have been the first animals to achieve such complex forms of disguise, as there are fossils of such lacewing larvae, some complete with their disguise still on their backs, from as long ago as 125 million years.

MIMESIS

An improvement beyond simple camouflage is achieved through *mimesis*. Mimesis is where the very form of the insect has evolved such that it outright resembles the shape of the model that is being imitated, usually a plant or other object. Such animals need not seek protective materials from their surroundings in order to build a disguise, as their own bodies are the disguise. We have all been duped by such insects. Stick insects or caterpillars mimetic with twigs, leaf insects nestled among foliage, or thorn bugs sitting along the stems of prickly bushes challenge us to find them even on intense inspection.

Mimetic species are known to have existed 150 million years ago, demonstrating the

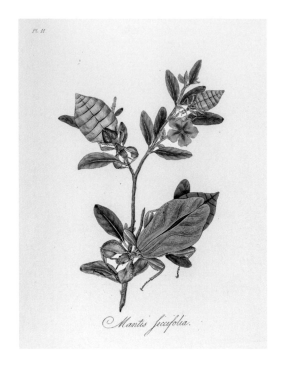

considerable antiquity of their mode of life. With this kind of longevity, they must be doing something right. The masters of mimesis, however, are the stick and leaf insects (see pages 63–66). This group of insects has gone all-in when it comes to deception—a commitment that runs through nearly every life stage. Most stick insects, as their name implies, resemble twigs, branches, or sticks of some kind, having the slender forms and colors necessary to pull off such mimesis. Their legs are typically long and slender, also resembling sticks, but rather than use their legs to stand, the insect often presses itself against the plant, pulling its legs alongside its body, stretching them in front and behind. Broader species resembling leaves often sit or even dangle amid foliage, perfectly disappearing from view among the "other" leaves. Some species change colors during different stages of life, and in each stage they are better colored in order to blend in with their

host plant at the time—going so far as to match the stages in which leaves discolor and die.

Yet other stick insects correspond perfectly with certain mosses and may be mottled to resemble lichens, all depending on their particular habitat. During the day, these insects do little, often remaining motionless. Nearly all, however, exhibit some form of cryptic behavior, and they will even gently sway side to side, attempting to imitate the action of the breeze on the actual twigs, thereby enhancing their disguise. If startled or detected, most will go cataleptic, freezing and dropping to the ground where, lying motionless, they usually blend in with the other plant litter on the forest floor. Should this fail to deter an attacker, then all stick insects have a repugnant gland at the front of their thorax from which they can exude a noxious chemical that can be quite effective as a last resort. The chemical spray of some species in the genus *Anisomorpha* can potentially

INNUMERABLE INSECTS

induce blindness should the insect success-fully squirt it into the eyes of its foe. There are a few species of stick insects that are not cryptically colored at all, but instead they sport bright colors and patterns. These insects don't need to hide, because they have these partic-ularly powerful chemical defenses and choose to advertise this fact as a warning through their coloration. Thus, if you can easily see the stick insect, it is best not to bother it.

As if this suite of camouflaging color, behavior, and mimetic form were not enough, mimesis even extends to the eggs of stick and leaf insects. Instead of cream-colored ovate, spherical, or sausage-shaped eggs—the most common color and shapes of insect eggs—the eggs of stick and leaf insects actually resem-ble the seeds of particular plants. The mimetic form of the eggs is remarkable and so specific that one can usually identify the species of insect simply from the egg alone. Some adult females will lay individual eggs, usually flicking them from the tip of her short ovipositor, scat-tering her offspring amid the leaf litter on the ground. Others may glue their eggs to leaves or branches. In species of the western North American genus *Timema*, the female goes so far as to ingest soil that is then coated over the eggs as they are laid. In certain stick insects—such as Macleay's Spectre, *Extatosoma tiaratum*, a giant spiny stick insect from Australia that can reach up to 8 inches (20.3 centimeters) in length and is usually heavier than a hamster—the eggs have a knoblike structure at one end called the *capitulum*. The eggs are tossed to the forest floor by the female, where foraging ants of the genus *Leptomyrmex* find and collect them, bringing them back to their nests. The ants will consume the capitulum while leav-ing the rest of the egg unharmed, and in this

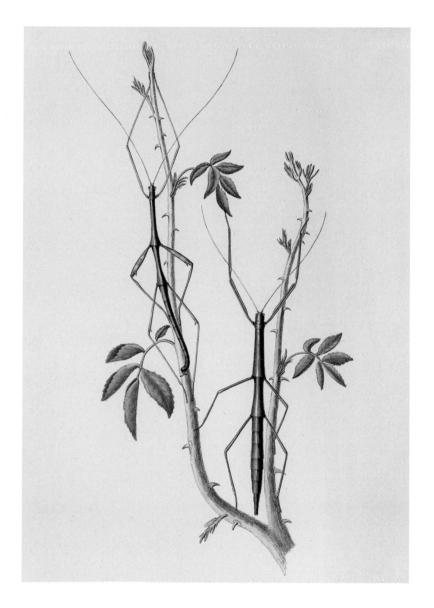

way the egg is afforded the general protection of the colony, while the ants get nourished—a spectacular mutualism. Upon hatching, the first-stage nymph has a form and coloration that generally resembles that of the ant species. Uncharacteristic for a stick insect, and even departing from what the animal will do during the remainder of its life, the nymph is agile and quick, rapidly exiting the colony before being

A male (left) and female of the common walkingstick of North America (*Diapheromera femorata*), painted against twigs to highlight their resemblance with their surroundings. From Thomas Say, *American Entomology* (1828).

mimesis. Thorn bugs (opposite) come in a variety of shapes, giving the viewer the impression that they are nothing more than a prickly part of the plant upon which they peacefully suck fluids. Meanwhile, flower mantises have forms that are mimetic of the flowers upon which they patiently await their prey, snatching floral visitors who fail to notice their presence. One of the most remarkable is *Hymenopus coronatus*, the orchid mantis. This mantis, from the rain forests of Southeast Asia, has flat extensions on its legs that resemble petals and an overall pink-and-white coloration similar to that of several orchids in the region. The resemblance is so striking and so complete that the mantis need not rest on the orchid in order to attract prey. Orchid-visiting pollinators actually approach the mantis itself, thinking it to be the flower, and are greeted with an alarming surprise upon getting too close.

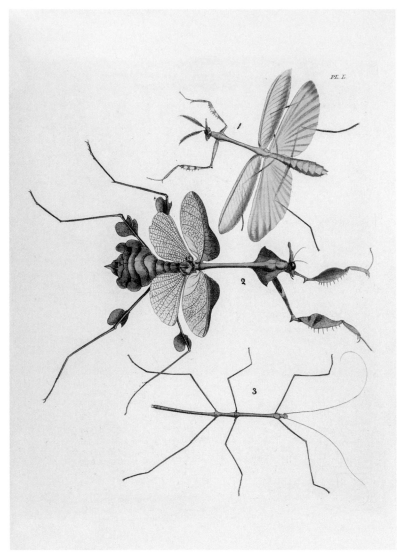

Mimicry can be used by predators just as much as it is by prey. As ambush predators, praying mantises employ numerous forms of camouflage and mimicry in order to steal closer to their victims. From top to bottom: the mantis *Empusa pennicornis*, the Indian rose mantis (*Gongylus gongylodes*), and the common walkingstick (*Diapheromera femorata*); unlike the aforementioned mantises, the stick insect is not a predator. From Dru Drury, *Illustrations of Exotic Entomology* (1837).

Butterflies, moths, and katydids also widely exhibit leaf mimesis, usually with their forewings broadened to resemble the shape of a specific leaf, with colors ranging from green to brown so that they may appear fresh or dried, depending on the habitat. Others have mixed colors, with an overall green surface and patches of brown near the tip, suggesting the form of a leaf that has begun the process of decay. In some katydids, the mimetic form is enhanced by a strong fold line running along the length of the wing, resembling the midrib of the leaf (see page 176). In others, the margins of the wing toward the apex may even be scalloped, looking as if some herbivore has recently taken a bite from the leaf!

While most katydids resemble leaves or other plants, there are some who have evolved a different approach and are mimetic of other animals, particularly of models that most

detected and moving up into the surrounding forest, where upon their next molt they begin to take on more of the stick insect form.

Although stick insects go to extremes with their disguises, many other insects also exhibit

predators might choose to avoid. For example, spider wasps are large, robust wasps feared for their powerful stings, which are considered to be among the most painful of any wasp. Many of the spider wasps have an overall jet black color, with contrasting orange wings and sometimes orange tips to the antennae. The pattern of color is a form of warning coloration (called *aposematism*) and is a well-understood advertisement that these wasps are to be reckoned with. Perhaps not surprisingly then, several other groups have evolved a similar pattern of coloration in the hopes of conveying the same warning signal to any predator that might glance their way. Thus, there are large katydids, similar in size to some of the large spider wasps, that are black with narrow, orange wings. They even go so far as to have the tip halves of their antennae similarly orange, just like the wasps. To a quick glance, they certainly look like a spider wasp at rest. While the katydid is no real threat to anything other than the plant it will consume, the wasp is definitely venomous. Nonetheless, the katydid gains some degree of protection from vertebrate predators who have learned through unpleasant encounters with the spider wasps to avoid that particular color pattern.

This kind of disguise is considered outright mimicry, and more specifically a strategy known as *Batesian mimicry*. Batesian mimicry is named for English naturalist Henry Walter Bates (1825–1892), who first described the phenomenon from butterflies he observed during an eleven-year sojourn in Brazil. In Batesian mimicry, the model species is unpalatable to predators, either possessing some toxicity or being capable of aggressive defense, like the aforementioned wasps. The model species advertises its danger through aposematic coloration, usually bright or

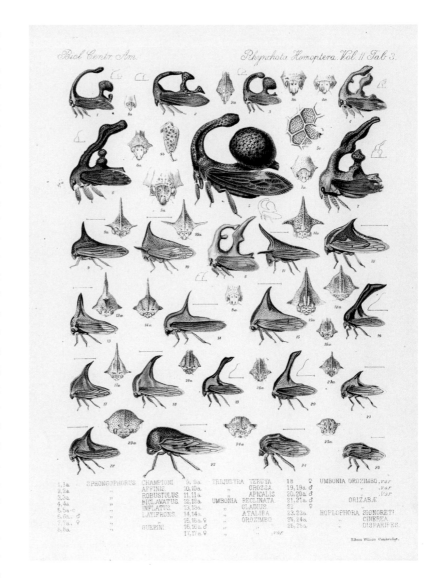

distinctive patterns that are easily learned by predators such that they avoid individuals with such markings. The mimic, however, is perfectly delectable and lacks its own toxic defenses. By assuming the same pattern as the unpalatable model, though, the mimic dupes the predator, who fails to distinguish the mimic from its toxic archetype. These associations can be large, with many species converging on the same color pattern and widely

Thorn bugs (family Membracidae) come in as many shapes and varieties as there are thorns on the plants in which they hide, such as this array of species from Central America. From *Biologia Centrali-Americana. Insecta. Rhynchota. Hemiptera-Homoptera.* (1881–1909).

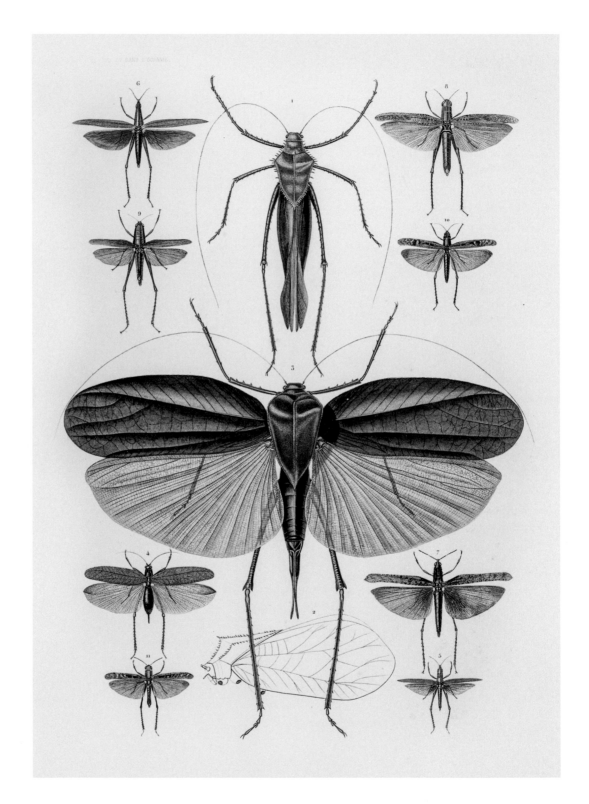

Katydids can often have large wings that resemble leaves, such as the sizable *Siliquofera grandis* of New Guinea (center). From Jules-Sébastien-César Dumont d'Urville, *Voyage au pôle Sud et dans l'Océanie sur les corvettes* l'Astrolabe *et* la Zélée (1842–1854).

benefiting from the protection it bestows. Clearwing moths will sometimes evolve color patterns similar to those of stinging social wasps, while the larva of the hawkmoth *Hemeroplanes triptolemus* is colored so as to perfectly match the head of a small snake, complete with an expanded end that looks like a serpent's head and blackened patches fringed by white spots to look like dark eyes with areas of reflected light. Add to this a cryptic behavior of short forward thrusts and the mimicry is complete, convincing birds to avoid a possible strike from this "dangerous" serpent.

Sometimes both the mimic and the model, however, have their own chemical defenses and neither is palatable to a predator. Yet, despite each having its own defense, they mimic each other in advertising colors. Such mimicry functions differently from Batesian mimicry and is called *Müllerian mimicry*, again named for its discoverer, the German biologist Johann F. T. "Fritz" Müller (1821–1897), who, like Bates, spent many years living and observing nature in Brazil. In such mimicry complexes, the convergence on a common warning coloration provides a predator with a single pattern to learn, rather than many. Müller demonstrated this through a detailed study of butterflies in the genus *Heliconius*. Despite the fame of heliconiine mimicry among evolutionary biologists, perhaps the most familiar species involved in Müllerian mimicry are the monarch and viceroy butterflies, *Danaus plexippus* and *Limenitis archippus* respectively. Like Müller's heliconiine butterflies, the monarch and viceroy have converged on a common warning pattern, with their bird predators learning to avoid both as each butterfly species is noxious. For a long while, entomologists incorrectly believed viceroys were not noxious to birds. In fact, the viceroy

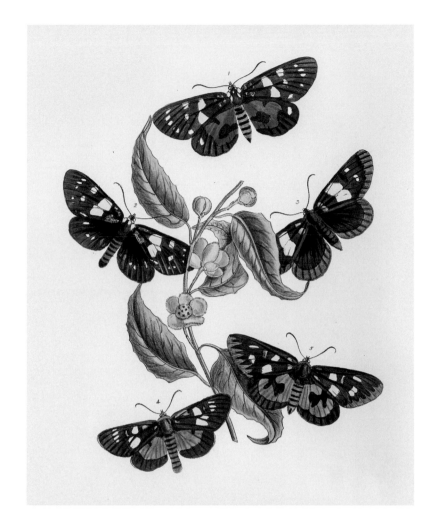

and monarch together were mistakenly considered as a textbook example of Batesian mimicry before it was recently discovered that viceroys are themselves unpalatable to birds. Thus, monarchs and viceroys represent a case of Müllerian mimicry. Rather than duping a would-be predator, the viceroy is in fact legitimately advertising itself as an unsuitable meal.

Day-flying moths of the family Noctuidae, shown with unrelated species exhibiting similar patterns of coloration as well as related species with disparate colors. Clockwise from top: *Episteme westwoodi*, *Exsula victrix*, *Exsula dentatrix*, *Scrobigera amatrix*, and *Episteme bellatrix*. From Westwood, *Cabinet of Oriental Entomology.*

WHEN WE PRACTICE TO DECEIVE

Henry Walter Bates was born in Leicester, England, in 1825, and received the usual education of someone from his middle-class background. At thirteen he became an apprentice to a manufacturer of hosiery. During his spare time, however, he explored the forests and collected insects. Bates eventually met fellow nature-lover Alfred Russel Wallace (1823–1913), who was teaching at the nearby Leicester Collegiate School, and together the two men would collect and reflect. Both dreamed of being explorers and read William H. Edwards's (1822–1909) *A Voyage up the River Amazon* (1847), which piqued their interest in doing the same.

Intent on making a contribution toward explaining biological diversity, the two devised a plan to explore the Amazon themselves, which involved shipping back specimens to be auctioned off to support their efforts. They even gathered particular wish lists from museums and sponsors. Together they sailed from England in April 1848, reaching the ports of southern Brazil just before June. They set themselves to collecting, at first together, but then each went in a different direction, covering different territories. Wallace headed back in 1852, but the ship caught fire and his invaluable collections were lost. He and the others aboard spent ten days adrift in a small boat before being rescued. Undeterred, Wallace headed next to the Malay Archipelago in 1854, not returning to England until 1862. While on these islands between the Pacific and Indian Oceans, he arrived at the same conclusions as Darwin regarding the origin of species. Wallace wrote to Darwin about his idea, and the two

Portrait of Henry Walter Bates, ca. 1880.

coauthored the first paper on evolution, which they did just prior to the release of the latter's explosive book.

Meanwhile, Bates had greater success in Brazil than his compatriot, shipping back crates of specimens representing nearly fifteen thousand species, more than half of which were new to science. Bates continued collecting and making observations in Brazil, only returning home eleven years later when his health became compromised. He lived the remainder of his life in London, passing away there in 1892.

Bates wrote of his life in the jungle in *The Naturalist on the River Amazons*, a book he was encouraged to prepare by Darwin, who praised it highly when it appeared in 1863. Bates was a strong proponent for Darwin's theory of evolution, his vast experience with species in the tropics having given him empirical evidence as to its veracity. Most importantly, the mechanism of evolution by natural selection explained perfectly a phenomenon he had uncovered while in Brazil. Bates had found complexes of butterflies whereby different species had virtually identical patterns of coloration. Sometimes the similarities were so strong that even under close inspection one could be fooled. He had discovered that some species advertised themselves to predators, signaling their toxicity as a defense, while hypothesizing that the others lacked such defenses but had safety conferred upon them owing to their resemblance with the other. He realized that natural selection resulting from the differential survival of color variants could, over time,

produce mimics—species that were fully tasty to a hungry bird but colorfully disguised to prevent their easy distinction by a predator, or even some entomologists! Today, this kind of disguise is known as Batesian mimicry.

Bates published his hypothesis of mimicry in butterflies in 1861, and today, this mechanism of "false-advertising" coloration as an antipredator defense is known to be widespread across the animal kingdom. Given that insects are so ancient, so varied, and such champions of evolutionary success, it is perhaps not surprising that they have been a frequent source for informing us of evolution's underlying principles, even when the very process itself is meant to deceive.

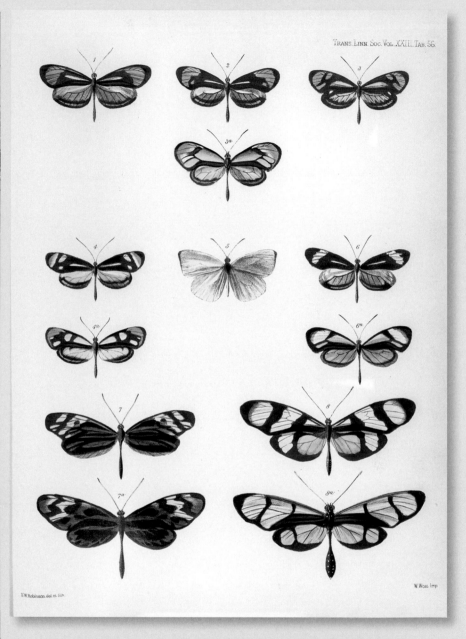

TRANS. LINN. SOC. VOL. XXIII. TAB. 56.

During his exploration through the Amazonian region, Henry Bates was taken with the convergent patterns of coloration among unrelated butterflies within a common area, and he explored how such patterns could have evolved. For example, the pair at lower left are tiger mimic white (*Dismorphia amphione*, second from bottom) and disturbed tigerwing (*Mechanitis polymnia*, bottom), while the pair at lower right are clearwing white (*Patia orise*, second from bottom) and giant glasswing (*Methona confusa*, bottom). From his paper "Contributions to an Insect Fauna of the Amazon Valley," in the *Transactions of the Linnean Society* (1862).

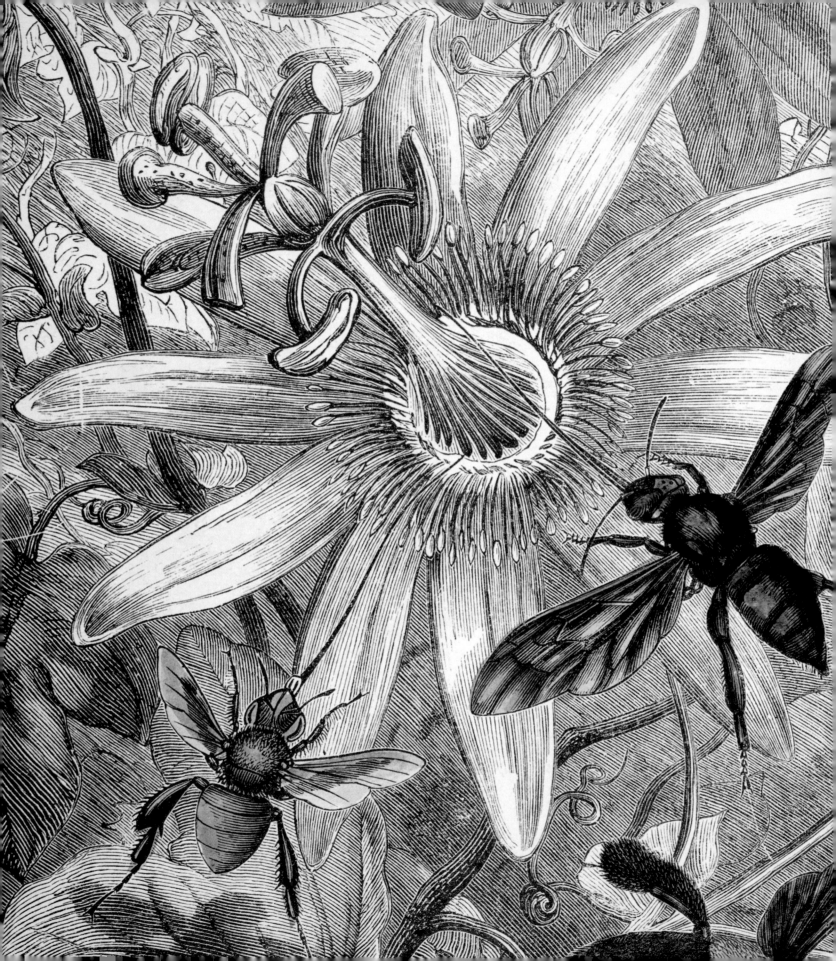

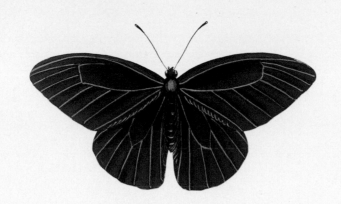

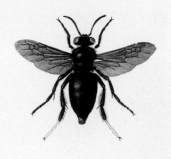

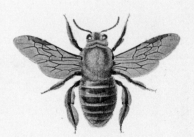

—• 10 •—

The World
ABLOOM

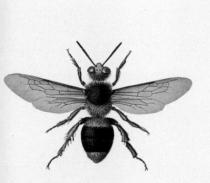

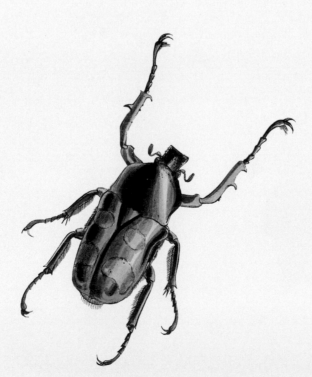

> *"To make a prairie it takes a clover and one bee,—*
> *One clover, and a bee,*
> *And revery."*
>
> —Emily Dickinson
> *Complete Poems*, 1924

Visit any meadow in bloom and you will invariably find butterflies flitting about and bees abuzz. There is perhaps no more familiar or intimate relationship in the biological world than that between insects and plants. Long before there were flowers, insects spent eons perfecting ways in which to feed on plant tissues—everything from the roots to the shoots, the seeds to the leaves. Plants evolved mechanisms by which to deter these herbivores—noxious chemicals, sticky resins, tougher and more abrasive tissues, even mimicry—and insects responded in kind. The numerous varieties of mouthpart specializations among insects reflect this evolutionary back and forth. Around 140 million years ago, the first flowers appeared, and although it would take another 50 million years before they would begin to achieve considerable dominance, eventually flowering plants would become ubiquitous. The ecological rise of flowering plants was partly fueled by their marriage to insects, and many groups of insects owe *their* own success to their floral hosts.

Flowers come in all shapes, colors, and sizes; they beautify our deserts, prairies, forests, and even tundras. We grow flowering plants for food, medicine, clothing, and simply for enjoyment. Horticultural societies abound for fanciers of nearly all flower varieties, from roses and violets to peonies and begonias. For all this variety, pleasure, profit, and sustenance, we owe thanks to the simple act of pollination. Pollination is the process by which pollen—the grains of which encapsulate the male gametes of the plant—is transferred to a flower's stigma, the female reproductive organ. Some plants rely upon the wind or gravity to achieve pollination. Many flowering plant species, however, employ an animal vector to transport the pollen from one plant to the other. The action of this animal vector is usually inadvertent from the animal's perspective. An insect, for example, may visit one plant, and get pollen stuck to its body as it navigates about within the flower. Then, upon the insect's arrival at the next plant, some of the transported pollen is incidentally transferred to its intended destination. Although some flowers are capable of pollinating themselves, having both male and female parts on the same plant, they may still rely upon an animal to move the pollen to the stigma.

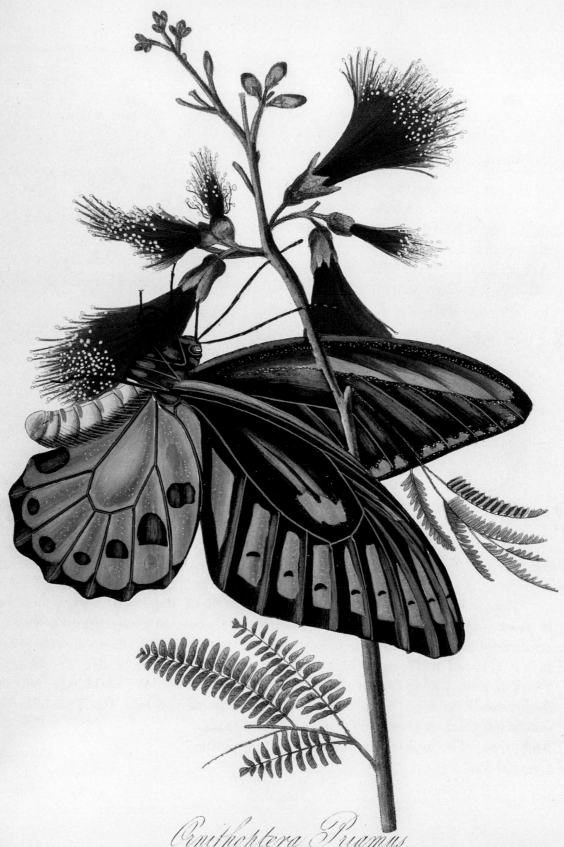

Ornithoptera Priamus.

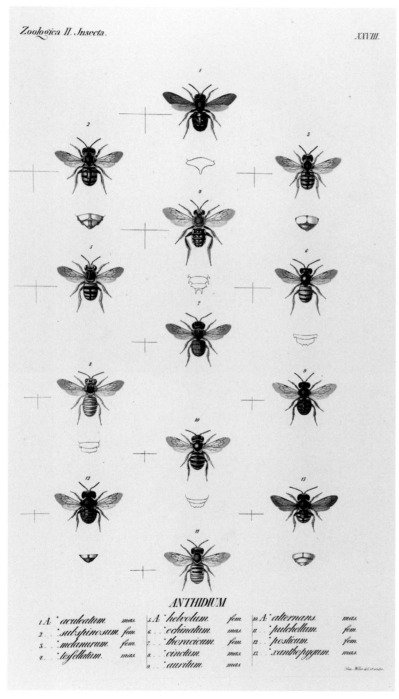

ANTHIDIUM

1. A.	aculeatum.	mas.	5. A.	helvolum.	fem.	10. A.	alternans.	mas.
2.	subspinosum.	fem.	6.	echinatum.	mas.	11.	pulchellum.	fem.
3.	melanurum.	fem.	7.	thoracicum.	fem.	12.	posticum.	fem.
4.	tessellatum.	mas.	8.	cinctum.	mas.	13.	xanthopygum.	mas.
			9.	auritum.	mas.			

A diversity of pollinating carder bees (family Megachilidae), males of which can be quite territorial. Carder bee nests are lined by a "froth" of plant hairs that females scrape from leaves. From Christian Gottfried Ehrenberg, *Symbolae Physicae* (1828–1845).

How critical is animal pollination? Of the approximately 300,000 species of flowering plants, about 90 percent of them utilize animal vectors. Of the 200,000 species of animals that serve as pollinators, about 1,000 of these are birds, and bats, and other mammals. The remaining 199,000 species of pollinators are insects. Pollinators are responsible for 35 percent of global food production, with 75 percent of our most important food crops relying entirely on such pollination. Every third bite of food you take is owed to the action of some pollinator. An oft-quoted (and apocryphal) prediction attributed to Albert Einstein (1879–1955) claims that the human race would have but four years to live after the disappearance of bees. While Einstein likely never said anything of the sort, there is considerable merit in the sentiment. In fact, the origin of this saying stems from Maurice Maeterlinck (1862–1949), an acclaimed Belgian playwright and controversial "entomologist" who somewhat notoriously plagiarized a famous work on termites in 1926. Maeterlinck did write several philosophical essays on entomological subjects, one of which, *Le Vie des Abeilles* (*The Life of the Bees*) (1901), emphasized the ecological important of bees. In the essay, he lauded "the venerable ancestor to whom we probably owe most of our flowers and fruits (for it is actually estimated that more than a hundred thousand varieties of plants would disappear if the bees did not visit them), and possibly even our civilisation, for in these mysteries all things intertwine." Such a statement is not hyperbolic, and without pollinators our world would indeed wither and die.

NECTAR, FRAGRANCE, AND WARMTH

Insects are not altruistic. They do not engage in this service for the benefit of the flower, although the success of the plant will mean the continued availability of the resources the insects seek, and thus perpetuate their own survival as well as that of the host plant. Insects principally visit flowers for some food reward, typically nectar, a sugary fluid secreted by many flowers in order to attract potential pollinators. We, too, consume nectar, but in its more processed form as honey. Honey bees collect nectar and pollen from flowers, mix it with their own enzymes, and concentrate it through evaporation, transforming it into the sweet substance we crave so eagerly as to support a multibillion dollar global industry. The Food and Agriculture Organization of the United Nations reported that in 2013 the United States alone imported about $500 million worth of honey, and this is the result of merely one product from one insect species. Considering more broadly the impact of honey bee pollination as it relates to our insatiable diet of fruits and vegetables, this singular species contributes $15 billion dollars to the American economy, according to the United States Department of Agriculture. All of this from the action of one insect pollinator—and we have not even mentioned the full host of other insect pollinators: butterflies, moths, flies, beetles, wasps, and even tiny, unseen thrips. If insects disappeared, then nearly all pollination would cease and our world would wither. Keep this in mind the next time you wonder whether or not insects are vital to our health and security.

Nectar is not the sole reason an insect may visit a flower. Some insects visit to

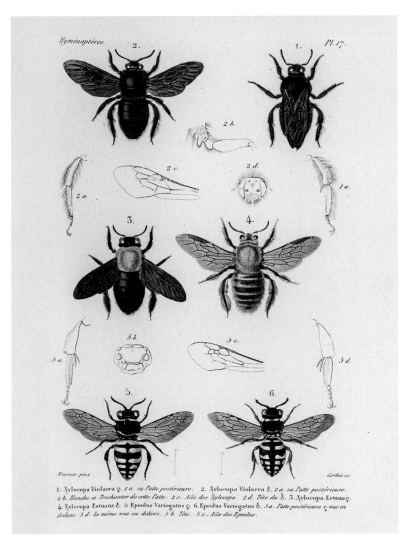

While most bees are pollinators, such as the large carpenter bees (genus *Xylocopa*) depicted here (top and center rows), hundreds of bees are cuckoos, such as the male and female of *Epeolus variegatus* (bottom row), which invade and lay eggs in the nests of pollen-collecting bees. From Amédée Louis Michel Lepeletier, comte de Saint Fargeau, *Histoire naturelle des insects* (1836–1846).

collect floral oils and fragrances, while others consume the pollen itself. One particularly interesting insect-floral association is demonstrated by the orchid and its bees. Orchid bees as a group encompasses approximately 250 species of fairly robust and often brightly metallic colored bees found

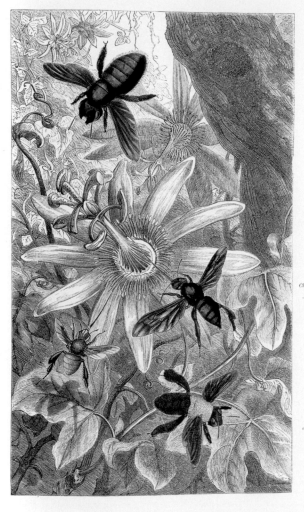

MUSÉE ENTOMOLOGIQUE

Xylocopa morio.

Chrysantheda frontalis.

Euglossa Romandi.

Centris denudans.

HYMÉNOPTÈRES. — Pl. VII

Many bees are generalists, visiting a wide variety of different flowers for pollen and nectar, while others are narrowly specialized to visit particular genera or species of flowers. Carpenter bees (top) are generalists; while orchid bees (center) visit orchids to collect fragrant oils used in attracting a mate; and oil-collecting bees (bottom) have particular combs on their fore- and midlegs to scrape plant oils from their floral hosts, which they then mix with pollen to feed their larvae. From Rothschild, ed., *Musée entomologique illustré.*

throughout tropical South America and Central America. Male orchid bees visit orchids (which have no nectar) to collect fragrant compounds secreted by the flowers. As the male bee goes about his task, the orchid attaches a purse of pollen to his back; the pollen is distributed to other flowers as the bee goes from orchid to orchid. The male bee packs the fragrant compounds into a specialized gland within his hind legs, and then he synthesizes the compounds into a pheromone to attract females. The orchids are pollinated and the male orchid bee gets the sweet perfume he requires in order to find a mate.

Much farther north, some arctic flowers that bloom during the region's short, cool summers concentrate the rays of the sun to heat their organs, and pollinators such as flower flies, dagger flies, and even mosquitos (yes, mosquitos can be pollinators!) visit these flowers in order to take advantage of the warmth. Flowers can also serve as a secure place in which to roost for the night, and there are many insects that can be found sleeping within the protective folds of petals. The benefits of flowers to insects are therefore manifold.

The pollinators most familiar to us are bees, butterflies, and moths. Among these, butterflies perhaps have historically grabbed the most attention—their large, colorful wings and bobbing flight as they flit from flower to flower have long made them the favorites of naturalists. It is no surprise that sublime paintings of butterflies on their host plants have dominated the pages of historical works, such as the sumptuous monographs of Edward Donovan (see pages 188–189) or many other naturalists. Among the bees, however, we tend to overlook the majority of these preeminent pollinators. While we love

INNUMERABLE INSECTS

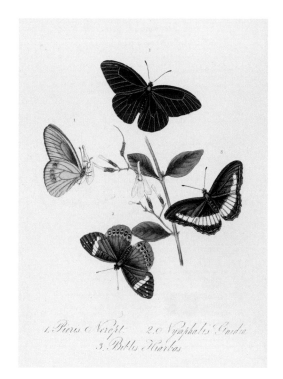

Butterfly pollinators are famous for their showy colors, which can be dramatically different depending upon the side of the insect viewed. Here, amid some of Edward Donovan's Indian butterflies from his *Natural History of the Insects of India*, this is exemplified by the wings of the orange albatross butterfly (*Appias nero*), whose wings are bright yellow on their underside (left) and reddish orange when viewed from above (top).

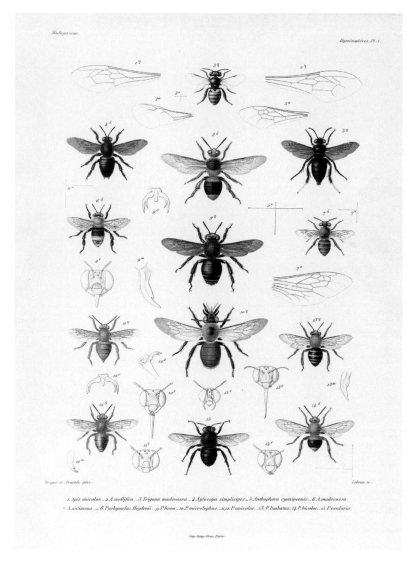

Bees are preeminent pollinators, with over twenty thousand species found worldwide, and here represented by a diversity of Malagasy bees from Henri de Saussure's volume on ants, bees, and wasps from *Histoire physique, naturelle et politique de Madagascar* (1890).

to sing the praises of honey bees and bumble bees, they are merely a small fraction of more than twenty thousand species of bees throughout the world, most of which are solitary. These include digger bees, sweat bees, carpenter bees, fire bees, nocturnal bees, and countless others that have not been so fortunate as to receive a common label. In North America alone there are nearly 4,400 species of bees, of which the common honey bee is just one, and it is not native; it was brought by English colonists to the nascent Virginia Colony in 1622. The thousands of native North

American bee pollinators are just as important as the imported honey bee, and some species are even more effective than honey bees, owing to their evolution with the native flora. For example, solitary orchard bees and leafcutter bees can dramatically increase yields, with entire industries now centered around such species.

While butterflies and bees are crucial to flower fertilization, critical pollinators are also

THE ARMCHAIR ENTOMOLOGIST

Edward Donovan was the epitome of an eighteenth-century armchair naturalist, and aside from excursions to Wales or the English countryside, he remained well ensconced at home in London. Born in Ireland in 1768, he became an insatiable collector, purchasing specimens at auction that were being brought back from abroad. Donovan eventually built up a considerable private collection, which he opened to the public in 1807 as the London Museum and Institute of Natural History. Eager to share his knowledge on natural history, particularly exotic species, Donovan published and illustrated various books on botanicals, birds, fishes, and, most notably, insects. Donovan's association with several learned societies of the day gave him access to even more material, including extensive reference libraries to consult, and he was supported for a time in his efforts by Sir Joseph Banks (1743–1820), the famed explorer, botanist, and patron of many naturalists for nearly half a century. Donovan published three particularly important books on insects: *An Epitome of the Natural History of the Insects of China* (1798) and similarly titled works on the insects of India (1800) and New Holland (Australia) (1805).

Since Donovan relied on others for much of his knowledge of foreign insects, errors crept into his books, such as depictions of a butterfly species from the West Indies that he incorrectly attributed to India. Nonetheless, while most monographs concerned themselves with accounts of European insects, Donovan's books were a refreshing departure. His devotion to his craft was total—he wrote, drafted, engraved, and ultimately colored all of

Papilio Ulysses.

Once threatened, the blue emperor swallowtail butterfly (*Papilio ulysses*) is now thriving across northeastern Australia and the islands of Southeast Asia owing to conservation efforts. While the underside of its large wings—wingspan approximately 4.1 inches (10.4 centimeters)—are brown, concealing the insect when at rest, the upper surface is a broad splash of vivid blue. From Donovan, *Natural History of the Insects of India*.

Saturnia Atlas.

Idea Agelia.

them by hand. His artistic talents were considerable, and he often undertook commissions, particularly for floral paintings.

Like many whose obsessions are left unchecked, however, Donovan eventually fell on hard times. His purchases of specimens became quite costly, and he quarreled with publishers whom he felt had dealt with him wrongly—he sold them 50 percent of the rights to his books, but they retained a far greater portion than this. Add to this an economic depression brought on by the government's campaigns against Napoleon, and by 1817, Donovan had to close his museum. Heartbreakingly, in 1818, he was forced into the sale of his treasured collection at auction. Once a frequent buyer at

auction, Donovon was now the seller. In 1833, he penned a plea to readers for help in suing his publishers, but no one came to his aid. Even in financial despair, Donovan kept publishing, eventually leaving his family destitute when he died in debt in 1837. After his death, John O. Westwood (see pages 50–53) revised Donovan's books on Indian and Chinese insects. Owing to the use of thicker layers, albumin glazes, and metallic paints, the newly reproduced plates were more vibrant than Donovan's originals. These volumes are among the most beautiful and artistic renderings of butterflies, moths, and other exotic insects of the period. It is sad to think that today, when Donovan's books turn up at auction, they fetch many thousands of dol-

ABOVE LEFT: The great Atlas moth (*Attacus atlas*), is one of the largest of all Lepidoptera (moths and butterflies), with a wingspan slightly over 9.8 inches (25 centimeters), and can be found commonly across the Malay Archipelago and elsewhere in the tropical forests of Southeast Asia. From Donovan, *Natural History of the Insects of China* (1838).

ABOVE RIGHT: The fantastical Southeast Asian rice paper butterfly (*Idea idea*) originally described by Linnaeus. These large pollinators are difficult to miss with their stark black-and-white color and wingspans up to 5.2 inches (13.3 centimeters). From Donovan, *Natural History of the Insects of India*.

lars—even single paintings by him can go for such prices—and yet his work failed to bring him sufficient support in life as to attend to his family's needs and further his entomological passions.

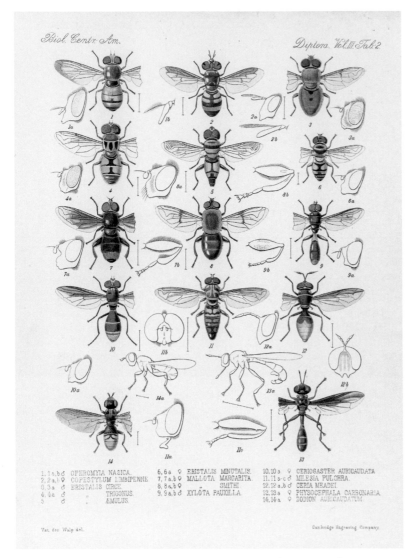

Although bees and butterflies get all the attention, true flies (order Diptera), such as this diversity of flower flies (family Syrphidae), include some of the most important pollinators. From *Biologia Centrali-Americana. Insecta. Diptera.* (1886–1903).

Beetles, such as these colorful scarabs (family Scarabaeidae) from John O. Westwood's *The Cabinet of Oriental Entomology* (1848), are often excellent pollinators of flowering plants.

to be found among flies, beetles, and thrips; for certain flower species, these insects are infinitely more vital. In fact, flies are perhaps second only to bees as vital pollinators, and quite spectacularly, the largest flowers in the world are pollinated by flies and beetles, not butterflies or bees. The two most massive flowers are both native to Sumatra and, when in bloom, smell of rotting flesh. The so-called corpse flower, or *Rafflesia arnoldii*, can measure 3.28 feet (1 meter) in diameter and weigh nearly 25 pounds (11.34 kilograms). The unrelated titan arum, *Amorphophallus titanum*, produces a phallus-shaped inflorescence, or cluster of flower structures, that can reach to 10 feet (3 meters) in height, which blooms for the first time after approximately a decade of growth. The stench of these flowers attracts the flies and beetles that are the principal pollinators for the plants.

Sometimes plants certainly get one over on insects. Producing nectar and other rewards for insects can come at some price to the flower, as these activities require water and sugars that

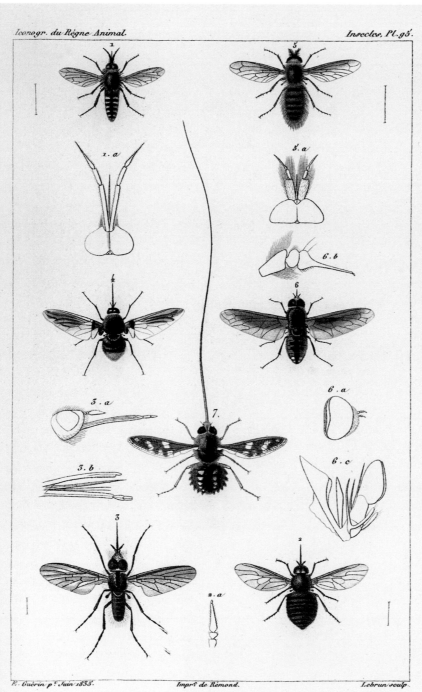

E. Guérin p.t Juin 1833. Impr.e de Rémond. Lebrun sculp.

1. Toxophora *americana* Serv. 2. Usia *ænea*, Lat. 3. Phthiria *pulicaria*, Meig. 4. Bombylius *tricolor*, Guér. 5. Ploas *lusitanica*, Guér. 6. Anthrax *aurantiaca*, Guér. 7. Nemestrina *longi= rostris*, Wied.

True flies include some of the more spectacular of specialized pollinators, such as *Moegistorhynchus longirostris* at center, a fly whose proboscis is the longest relative to its body size among insects. This tangle-veined fly is an important pollinator that has coevolved alongside long tubed flowers in western South Africa. From Félix-Edouard Guérin-Méneville, *Iconographie du règne animal de G. Cuvier* (1829–1844).

could otherwise be used to make more seeds; many plants have evolved sneaky ways of getting around this problem. Some orchids have flowers that superficially resemble the patterns of female bees or wasps and remarkably produce chemical scents that mimic the odors of such females. For example, species of the orchid genus *Chiloglottis* produce pheromones similar to those of a group of stinging wasps in the family Tiphiidae. Male tiphiids approach the flowers, whose shape and patterns similarly mimic female wasps, and attempt to mate. The landing of the male on the orchid flower triggers the plant to glue a packet of pollen to the wasp's back or head, and the pollen is then picked up by the next flower the male attempts to mate with. In this way the flowers are pollinated while the male wasps are duped.

The head and extended tongue of the four-spotted moth (*Tyta luctuosa*) with various pollinia of the pyramidal orchid (*Anacamptis pyramidalis*) attached. From Charles Darwin, *The Various Contrivances by Which Orchids Are Fertilised by Insects* (1895 [1862]).

Fig. 4.

SPECIALIZATION

Some insects are generalist pollinators, visiting a wide range of flower species as they seek nectar and pollen, the honey bee being a paramount example of such indifference. Others are specialized to feed on only a subset of certain flowers, either within a particular genus or even family of plants. More specialized yet are those insects that can survive only through visits to a single plant species, and often the plant is similarly reliant on this one insect for its own persistence. The specialization between flower and insect can be great. A famous example is Morgan's sphinx moth, *Xanthopan morganii*, and its eastern African and Malagasy orchid, *Angraecum sesquipedale*. Charles Darwin spent time researching insect pollination for his 1862 book, *Fertilisation of Orchids*. He received flowers of *A. sesquipedale* from a horticulturist and was surprised to note that the peculiar nectary (the gland that secretes nectar) of the flower was nearly 1 foot (30 centimeters) in length. Darwin concluded that there must exist a specialized moth with a greatly elongate proboscis capable of reaching into the nectary. Darwin's collaborator in publishing a sound mechanism for evolutionary processes, the explorer Alfred Russel Wallace (see page 178), later wrote in 1867 that specimens of *X. morganii* had elongate mouthparts and were perhaps the visitors of these flowers, refining Darwin's prediction that in Madagascar there must be a form of this moth species capable of reaching so deep into the nectary. Indeed, such a form was discovered in 1903, and it was described as the subspecies *X. morganii praedicta*, corroborating the hypotheses put forward by Darwin and Wallace about forty years prior.

The specialized relationship between an insect pollinator and its flower can be far more extreme than merely having correspondingly long tongues and nectaries. Some insects have coevolved with their floral hosts, the two becoming so specialized for one another that when one diverges into two new species, so too does the other. Textbook examples of coevolving pollinators are fig wasps and yucca moths, and the figs and yucca plants for which each is named. Figs are critical sources of food, and in some forests they can comprise up to 70 percent of the diet for the associated animals, be they birds, monkeys, or even humans. An immature fig fruit has a small opening that serves as the tunnel through which a mated female fig wasp, who is often scarcely larger than the head of pin, will crawl. The space is narrow and her body is slender, frequently with a rather peculiarly flattened and elongate head. Despite her adaptive size, she will usually have her wings torn from her sides as she attempts to make her way inside the fruit. Once inside, she lays her eggs and simultaneously deposits the pollen she had picked up from the original fig plant where she was born. The fig's flowers are minute and line the inner chamber within the immature fruit. Trapped within the fruit, the fig wasp mother dies. Her offspring emerge as larvae and are provided safety and nourishment by the fig fruit, which, now pollinated, matures. After pupating, male fig wasps, many of which are neotenic (see page 90) and therefore flightless and more worm-like than recognizable as wasps—mate with the emerging females. As his final act, a male will bore a hole through the mature fig fruit, eventually reaching the outside, where he will die. The new females use the tunnel dug by the male

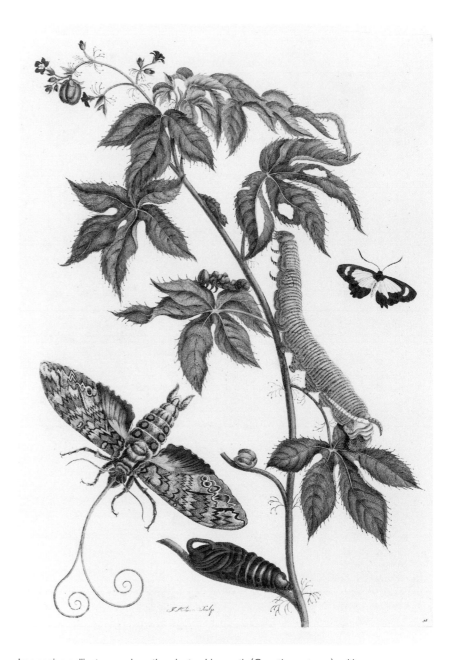

Impressive pollinators such as the giant sphinx moth (*Cocytius antaeus*), with a wingspan up to 7 inches (17.8 centimeters), have elongate proboscides to enter the deep tubular flowers which they pollinate, including the rare ghost orchid (*Epipogium aphyllum*). From Maria Sibylla Merian, *Over de voortteeling wonderbaerlyke veranderingen der Surinaemsche insecten* (1719 Dutch edition of *Metamorphosis Insectorum Surinamensium*, 1705).

writer Herodotus (ca. 484–425 BCE) reported in his book, *The Histories*, how the Babylonians, who cultivated figs, understood that the fruits would not ripen unless they were first entered by a miniscule "fly" and that mature figs had the insects within them. The wasps were so small that in the absence of optics with which to magnify them, it is easy to see how they might be confused as gnats or other flies. While they could not have imagined the real complexity of the relationship or the underlying mechanism of what was going on, the growers of Babylon were keen observers and knew that ripened fruits were only achieved by the entry of the insect.

Yucca moths are the obligate pollinators of yuccas, as well as herbivores that partially devour them. Pollinating yucca moths are perhaps the only example of a pollinator in which the animal vector *intentionally*, rather than inadvertently, pollinates the plant. The adult moth has modifications of its proboscis that permits it to collect yucca pollen. The moth then bores a hole into the flower's ovary and stuffs the packet of pollen into the stigma, thereby pollinating the plant. She will also deposit her eggs within. The moth larvae feed exclusively on yucca seeds; on cursory inspection this would appear to be disadvantageous to the plant, as the latter obviously needs the seeds in order to reproduce. The larvae, however, feed only on a sufficient number of seeds to complete their development, but never all of them, leaving behind a shared portion for the plant. In this way, the moth and yucca share in the harvest, and neither can survive without the other.

The intimate association of insects and flowers is a common theme in illuminated entomological texts, as exemplified here in the finely colored title page from the third volume of August Johann Rösel von Rosenhof's *Der Insecten-Belustigung* (1746–1761).

as a means of escape, picking up pollen as they go and then departing to perpetuate the cycle.

Figs and fig wasps have been at this for about seventy million years, and we can find fossils of fig wasps, complete with the fig pollen they are carrying, preserved with lifelike fidelity in ancient amber. The fig–fig wasp mutualism is complex and varied across the hundreds of species involved, but what is perhaps truly remarkable is that we seem to have had a rudimentary appreciation of this method of pollination for thousands of years. The ancient Greek

We have long held flowers in high esteem, and gardens, floral folios, and flower societies attest to this adoration. Many of the illuminated entomological texts of past centuries revolved around this fondness, showcasing the largest and most spectacular of insects in association with flowers, ranging from Maria Sibylla Merian's engravings of metamorphosis (see pages 94–96) to Edward Donovan's butterflies of India and China (see pages 188–189). Libraries and galleries are filled with such art, the peaceful joining of insects and their pollinators. If you will, pollination represents a form of détente in the otherwise ancient battle between plants and their dominant herbivores—insects. Through pollination, plants and insects become collaborators rather than combatants, and as this relationship blossomed, so too did our world.

There remains much to discover about the intimate entanglement of flowers and insects. While certain aspects of such discovery may appear esoteric—of interest to no one other than singularly obsessed horticulturists or bespectacled entomologists—they all have far-reaching ramifications. Our very lives may depend on discovering, learning about, and conserving insects as "invisible" as thrips or as conspicuous as gently humming bumble bees. The avenues of discovery are as innumerable as insects themselves. Even the seemingly common and well-trodden faunas of our own backyards are filled with novel and important discoveries to be made, from new species to new revelations into insect songs, dances, rituals, and rites. Insects are significant, and it is only appropriate that some of us devote our lives to more fully understanding theirs.

The number of biodiversity entomologists who undertake this work is few, and the task before us great. Many of the spellbinding discoveries and scientific artwork of the past were expertly executed by amateurs, the "citizen scientists" of their day—informed clergy, passionate medical doctors, artists, and explorers. The awe-inspiring achievements of insects, past and present, readily enliven a passion for engaged research, and such study is not the privileged reserve of only a few in lofty towers of ivory.

Insects are not merely innumerable, for their diversity is disproportionately large when compared to those other lineages of life around us. As J. B. S. Haldane (see page xiii) rightly intimated to his august companion the archbishop of Canterbury, insects are inordinate—inordinate in the legions of individuals that surround us, inordinate in the endless variety of species, and inordinate in the myriad manners by which they live out their lives and underpin, or undermine, those of other organisms, ourselves most of all. Inordinate, however, does not mean incomprehensible, intractable, or impossible. Inordinate instead should inspire, invigorate, enthrall, enliven, and call for eager engagement. We can all be entomologists, for in our capacities to learn and create we too are inordinate.

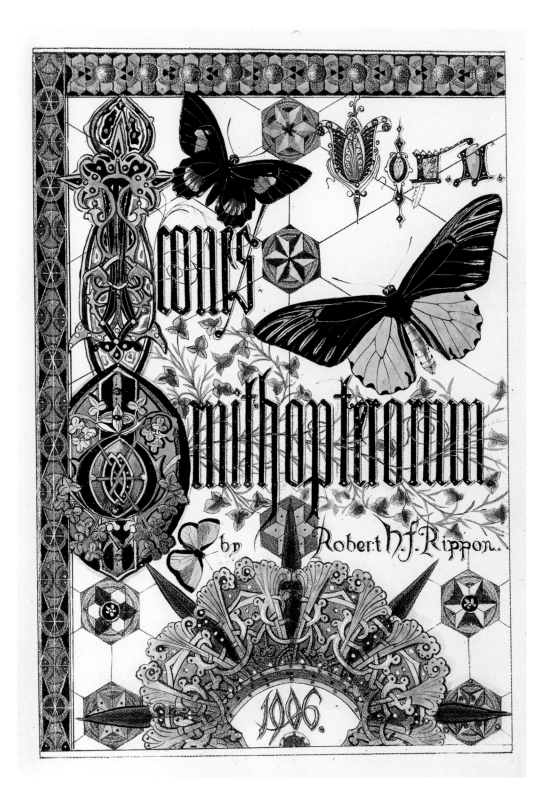

The resplendently ornate title page to Robert H. F. Rippon's *Icones Ornithopterorum* (1898–[1907]), a three-volume work that covered everything known of the great birdwing butterflies and their relatives. Rippon, a student of the great polyhistor John O. Westwood, provided all of his own illustrations, including this title page.

"There is grandeur in this view of life, with its several powers, having been originally breathed by the Creator into a few forms or into one; and that, whilst this planet has gone cycling on according to the fixed law of gravity, from so simple a beginning endless forms most beautiful and most wonderful have been, and are being, evolved."

—Charles R. Darwin
On the Origin of Species, 1859

ACKNOWLEDGMENTS

For Mnemosyne:
a Bee, a Bloom, a Breeze

A work such as this attempts to thread a fine needle, representing two seemingly different books interwoven into one. On the one hand it tries to provide a narrative of insect diversity and evolution, an evolutionary history of 400 million years on six legs. On the other, it chronicles, albeit with great lacunae included, humankind's past exploration of insects, highlighting some of the now rare tomes that represent both artistic as well as scientific achievements. A wiser author would see these as disparate and unmixable tales, and the reader is left to judge the mongrel hybrid produced of this forced union.

Although it may be my words that appear on the pages bound herein, a work such as this is truly a collaborative endeavor, both directly and indirectly. At the American Museum of Natural History, Tom Baione, Harold Boeschenstein Director, Department of Library Services, was a cheerful and wealthy store of wisdom and assistance throughout. He and Mai Reitmeyer, senior research services librarian, were as patient as Job while I feverishly poured over the fine works under their care, and they tolerated my many large requests. I am further grateful to Tom for composing the beautiful foreword that graces the start of this volume. David Grimaldi, curator and professor, Division of Invertebrate Zoology, generously suggested I should make this undertaking, and for the joyful labor I cannot be too grateful. Dave, Tom, Mai, and Valerie Krishna, professor emerita of English at the City College of New York, offered many constructive suggestions, and any lapses that remain are my fault alone. They and my other dear friends at the Museum have represented a tremendous source of support, devoting time and energy beyond measure. Like Aeneas recalling the siege of Troy, they may each claim "quorum pars magna fui"! Although no longer with us, distinguished entomologists Kumar Krishna and Charles Michener seemed to have been with me throughout, and fond memories of either pouring over rare volumes with each or visiting antiquarian book stores in London with the former and Valerie dispelled frustrations whenever they arose.

Also of particular note at the American Museum of Natural History in the office of Global Business Development are Sharon Stulberg, senior director; Elizabeth Hormann, former assistant director; Joanna Hostert, marketing manager, and Courtney Edwards, business manager, with additional support from Jill Hamilton. Roderick Mickens, senior photographer in the Museum's photography studio, dedicated countless hours to the photography for this book with assistance from Barbara

OPPOSITE: The gilt cover of E. F. *Stavely's British Insects* (1871).

199

Rhodes, conservation librarian. At Sterling Publishing, I am grateful to Barbara M. Berger, executive editor, for encouragement, listening to my entomological musings, and forgiving those unexpected challenges that stumble any writer. Also at Sterling I would like to thank Scott Russo, associate art director, for his stunning cover and his interior art direction; as well as Jo Obarowski, creative director; and Ellen Hudson, production manager. At Tandem Books, special thanks to Ashley Prine for the beautiful interior design and to Katherine Furman for her proficient copyediting. For their tolerance of my absences while I hid myself away to read and write, I am thankful to my students and colleagues at the University of Kansas, Zachary H. Falin, senior collection manager, Division of Entomology, Biodiversity Institute; Jennifer C. Thomas, associate collection manager, Division of Entomology, Biodiversity Institute; and Victor H. Gonzalez, director, Human Anatomy Laboratories, Undergraduate Biology Program, all of whom leapt to pick up matters when I was otherwise occupied.

I am grateful to the many writers and artists who preceded my own entomology, and left behind such grand and sumptuously illustrated works. They universally inspired and entertained, and left me awestruck over their genius, skill, passion, and bravery, all in the name of the mighty majority. If it were not for their many labors, there would have been no tales to tell.

Lastly, no prose is sufficient to thank my family for their forbearance, confidence, and love. Supporting my obsessions and frequent absenteeism have been my parents, A. Gayle and Donna Engel, without whom none of this would have been possible, quite literally. My siblings, Elisabeth and Jeffrey, have endured my prattling on over dusty books and all things "buggy"; while my nieces and nephews—Grace, Kate, Leo, and Isaac—and extended family have been a constant source of joy, rejuvenating the soul on weary days. Foremost of all, I am thankful to my wife, Kellie. During late nights and long days she assisted in tracking down obscure historical sources, read and edited text, and kept spirits high when faculties and energy were stretched to their most thin. It is fair to say that without her constant faith and aid, my efforts would have been in vain. To her, and my whole family, I am most deeply appreciative, and before them I am always humbled.

　　　　　　　　　　　　　　ACKNOWLEDGMENTS

SUGGESTED READING

Buchmann, Stephen L., and Gary P. Nabhan. *The Forgotten Pollinators*. Washington, DC: Island Press, 1996.

Dethier, Vincent G. *Crickets and Katydids, Concerts and Solos*. Cambridge, MA: Harvard University Press, 1992.

Eisner, Thomas. *For Love of Insects*. Cambridge, MA: Belknap Press, 2003.

Grimaldi, David, and Michael S. Engel. *Evolution of the Insects*. Cambridge, UK: Cambridge University Press, 2005.

Hoyt, Erich, and Ted Schultz. *Insect Lives: Stories of Mystery and Romance from a Hidden World*. New York: John Wiley & Sons, 1999.

Marshall, Stephen A. *Insects: Their Natural History and Diversity—With a Photographic Guide to Insects of Eastern North America*. Richmond Hill, ON: Firefly Books, 2006.

Seeley, Thomas D. *Following the Wild Bees: The Craft and Science of Bee Hunting*. Princeton, NJ: Princeton University Press, 2016.

Shaw, Scott R. *Planet of the Bugs: Evolution and the Rise of Insects*. Chicago: University of Chicago Press, 2014.

Wilson, Edward O. *The Diversity of Life*. Cambridge, MA: Belknap Press, 1994.

Zinsser, H. *Rats, Lice and History: A Chronicle of Pestilence and Plagues*. Boston: Little, Brown, 1935.

WORKS FEATURED

Aldrovandi, Ulisse. *De Animalibus Insectis: Libri Septem cum Singulorum Iconibus ad Vivum Expressis.* Bologna: Apud Clementem Ferronium, 1638 (1602).

Audouin, Jean Victor. *Histoire naturelle des insectes, traitant de leur organisation et de leurs moeurs en general.* Paris: F. D. Pillot, 1834.

Bates, Henry W. "Contributions to an Insect Fauna of the Amazon Valley. Lepidoptera: Heliconidae." *Transactions of the Linnean Society of London,* vol. 23. London: Taylor and Francis, 1862 (1791–1875).

Biologia Centrali-Americana. Insecta. Coleoptera. London: Published for the editors by R. H. Porter, 1880–1911.

Biologia Centrali-Americana. Insecta. Diptera. London: Published for the editors by R. H. Porter, 1886–1903.

Biologia Centrali-Americana. Insecta. Lepidoptera-Heterocera [. . .] London: Published for the editors by R. H. Porter, 1881–1900.

Biologia Centrali-Americana. Insecta. Neuroptera. Ephemeridae. London: Published for the editors by Dulau, 1892–1908.

Biologia Centrali-Americana. Insecta. Orthoptera. London: Published for the editors by R. H. Porter, 1893–1909.

Biologia Centrali-Americana. Insecta. Rhynchota. Hemiptera-Homoptera. London: Published for the editors by Dulau, 1881–1909.

Butler, Charles. *The Feminine Monarchie, or the Historie of Bees. Shewing Their Admirable Nature, and Properties; Their Generation, and Colonies, Their Government, Loyaltie, Art, Industrie, Enimies, Warres, Magnanimitie, &c. Together with the Right Ordering of Them from Time to Time: and the Sweet Profit Arising Thereof.* Oxford: Printed by William Turner, for the author, 1634 (1609).

Curtis, John. *British Entomology; Being Illustrations and Descriptions of the Genera of Insects Found in Great Britain and Ireland: Containing Coloured Figures from Nature of the Most Rare and Beautiful Species, and in Many Instances of the Plants upon Which They Are Found.* London: Printed for the author and sold by E. Ellis, 1823–1840.

Cuvier, Georges. *Le règne animal distribué d'après son organisation: pour servir de base à l'histoire naturelle des animaux et d'introduction à l'anatomie comparée.* Paris: Fortin, Masson et cie, 1836–1849.

Darwin, Charles. *The Various Contrivances by Which Orchids Are Fertilised by Insects.* New York: D. Appleton, 1895 (1862).

Denny, Henry. *Monographia Anoplurorum Britanniae; or, An Essay on the British Species of Parasitic Insects Belonging to the Order of Anoplura of Leach, with the Modern Divisions of the Genera According to the Views of Leach, Nitzsch, and Burmeister, with Highly Magnified Figures of Each Species.* London: H. G. Bohn, 1842.

Donavan, Edward. *Natural History of the Insects of China.* London: R. Havell and H. G. Bohn, 1838.

———. *Natural History of the Insects of India*. London: R. Havell and H. G. Bohn, 1838.

Drury, Dru. *Illustrations of Exotic Entomology, Containing Upwards of Six Hundred and Fifty Figures and Descriptions of Foreign Insects, Interspersed with Remarks and Reflections on Their Nature and Properties*. London: H. G. Bohn, 1837.

Dumont d'Urville, Jules-Sébastien-César. *Voyage au pôle Sud et et dans l'Océanie sur les corvettes l'Astrolabe et la Zélée, exécuté par ordre du roi pendant les années 1837–1838–1839–1840, sous le commandement de m. J. Dumont d'Urville, capitaine de vaisseau, publié par ordonnance de Sa Majesté sous la direction supérieure de m. Jacquinot, capitaine de vaisseau, commandant de la Zélée* [. . .] Paris: Gide, 1842–1854.

Ehrenberg, Christian Gottfried. *Symbolae Physicae, seu, Icones et Descriptiones Corporum Naturalium Novorum aut Minus Cognitorum, Quae ex Itineribus per Libyam, Aegyptum, Nubiam, Dongalam, Syriam, Arabiam et Habessiniam* [. . .] Berlin: Mittlero, 1828–1845.

Forel, Auguste. *Histoire physique, naturelle et politique de Madagascar, Hymenoptères. Les Formicides*. Paris: Imprimerie nationale, 1891.

Forsskål, Peter. *Descriptiones Animalium, Avium, Amphibiorum, Piscium, Insectorum, Vermium; Quae in Itinere Orientali Observavit Petrus Forskål*. Copenhagen: Mölleri, 1775.

———. *Flora Aegyptiaco-Arabica: Sive Descriptiones Plantarum, quas per Egyptum Inferiorem et Arabiam Felicem Detexit, Illustravit Petrus Forskål . . . Post Mortem Auctoris Edidit Carsten Niebuhr. Accedit Tabula Arabiae Felicis Geographico-Botanica*. Copenhagen: Mölleri, 1775.

Gerstaecker, Carl Eduard Adolph. *Baron Carl Claus von der Decken's Reisen in Ost-Afrika in den Jahren 1859 bis 1865. Dritter Band. Wissenschaftlich Ergebnisse. Gliederthiere (Insekten, Arachniden, Myriapoden und Isopoden)*. Leipzig and Heidelberg: C. F. Winter, 1873 (1869–1879).

Giglio-Tos, Ermanno. "Sulla posizione sistematica del gen. *Cylindracheta* Kirby." *Annali del Museo civico di storia naturale di Genova*. Genoa: Tip. del R. Istituto Sordo-Muti, 1914 (1870–1914).

Guérin-Méneville, Félix-Edouard. *Iconographie du règne animal de G. Cuvier; ou, Représentation d'après nature de l'une des espèces les plus remarquables, et souvent non encore figurées, de chaque genre d'animaux: avec un texte descriptif mis au courant de la science: ouvrage pouvant servir d'atlas à tous les traités de zoologie*. Paris: J. B. Baillière, 1829–1844.

Haeckel, Ernst. *Generelle Morphologie der Organismen: Allgemeine Grundzüge der organischen Formen-Wissenschaft, mechanisch begründet durch die von Charles Darwin reformirte Descendenz-Theorie*. Berlin: G. Reimer, 1866.

Haviland, George D. "Observations on Termites; with Descriptions of New Species." *The Journal of the Linnean Society of London. Zoology*, vol. 26. London: Academic Press, 1898.

Hoefnagel, Jacob. *Diversae Insectarum Volatilium Icones*. [Amsterdam?]: N. I. Visscher, 1630.

Hooke, Robert. *Micrographia: or, Some Physiological Descriptions of Minute Bodies Made by Magnifying Glasses. With Observations and Inquiries Thereupon*. London: Printed for J. Allestry, printer to the Royal Society, 1667.

Horne, Charles, and Frederick Smith. "Notes on the Habits of Some Hymenopterous Insects from the North-West Provinces of India. With an Appendix, Containing Description of Some New Species of Apidae and Vespidae Collected by Mr. Horne." *Transactions of the Zoological Society of London*, vol. 7. London: Longmans, Green, Reader and Dyer, 1870.

Huber, François. *Nouvelles observations sur les abeilles adressées à M. Charles Bonnet*. Paris: J. J. Paschoud, 1814 (1792).

Jardine, William, ed., *Bees. Comprehending the Uses and Economical Management of the Honey-Bee of Britain and Other Countries, Together with Descriptions of the Known Wild Species*. London: H. G. Bohn, [1846?].

Lepeletier, Amédée Louis Michel, comte de Saint Fargeau. *Histoire naturelle des insectes. Hyménoptères*. Paris, Librairie encyclopédique de Roret, 1836–1846.

Kirby, W. F. *European Butterflies and Moths*. London: Cassell, 1889 (1882).

Linnaeus, Carl. *Systema Naturae per Regna Tria Naturae, Secundum Classes, Ordines, Genera, Species, cum Characteribus, Differentiis, Synonymis, Locis*. Stockholm: Impensis L. Salvii, 1758.

Lubbock, John. *Monograph of the Collembola and Thysanura*. London: Printed for the Ray Society, 1873.

Merian, Maria Sibylla. *Histoire des insectes de l'Europe*. Amsterdam: Jean Frederic Bernard, 1730.

———. *Over de voortteeling wonderbaerlyke veranderingen der Surinaemsche insecten*. Amsterdam: Joannes Oosterwyk, 1719.

Moffet, Thomas. *Insectorum sive Minimorum Animalium Theatrum*. London: T. Cotes, 1634.

Olivier, M. *Encyclopédie méthodique. Histoire naturelle*. Vol. 4–10, *Insectes*. Paris: Panckoucke, 1811 (1789–1828).

Panzer, Georg Wolfgang Franz. *Deutschlands Insectenfaune*. Nürnberg: Felseckerschen Buchhandlung, 1795.

Parkinson, John. "Description of the *Phasma dilatatum*." *Transactions of the Linnean Society*, vol. 4. London: [The Society], 1798 (1791–1875).

Ratzeburg, Julius T. C. *Die Forst-Insecten oder Abbildung und Beschreibung der in den Wäldern Preussens und der Nachbarstaaten als schädlich oder nützlich bekannt gewordenen Insecten; in systematischer Folge und mit besonderer Rücksicht auf die Vertilgung der Schädlichen*. Berlin, Nicolai'sche buchhandlung, 1839–1844.

Ray, John. *Historia Insectorum*. London: Impensis A. & J. Churchill, 1710.

Rippon, Robert H. F. *Icones Ornithopterorum: A Monograph of the Papilionine Tribe Troides of Hubner, or Ornithoptera (Bird-Wing Butterflies) of Boisduval*. London: R. H. F. Rippon, 1898–[1907?].

Rösel von Rosenhof, August Johann. *Der monatlich-herausgegebenen Insecten-Belustigung erster [-vierter] Theil: in welchem die in sechs Classen eingetheilte Papilionen mit ihrem Ursprung, Verwandlung und allen wunderbaren Eigenschaften, aus eigener Erfahrung beschrieben, . . . nach dem Leben abgebildet, vorgestellet warden*. Nuremberg: Röselischen Erben, 1746–1761.

———. *De natuurlyke historie der insecten; voorzien met naar 't leven getekende en gekoleurde plaaten*. Amsterdam: C. H. Bohn and H. de Wit, 1764–1768.

Rothschild, Jules, ed. *Musée entomologique illustré: histoire naturelle iconographique des insects*. Paris: J. Rothschild, 1876 (–1878).

Saussure, Henri de. *Études sur les myriapodes et les insects*. Paris: Imprimerie impériale, 1870.

———. *Histoire physique, naturelle et politique de Madagascar, Hymenoptères*. Paris: Imprimerie nationale, [1890?].

———. *Histoire physique, naturelle et politique de Madagascar, Orthoptères*. Paris: Imprimerie nationale, 1895.

Say, Thomas. *American Entomology, or Descriptions of the Insects of North America*. Philadelphia: Philadelphia Museum, S. A. Mitchell, (1824–) 1828.

Smeathman, Henry. *Some Account of the Termites Which Are Found in Africa and Other Hot Climates*. London: Printed by J. Nichols, 1781.

Snodgrass, Robert Evans. *The Thorax of Insects and the Articulation of the Wings*. Proceedings of the United States National Museum, vol. xxxvi. Washington, DC: Government Printing Office, 1909.

Southall, John. *Treatise of Buggs: Shewing When and How They Were First Brought into England. How They Are Brought into and Infect Houses. Their Nature, Several Foods, Times and Manner of Spawning and Propagating in This Climate* [. . .]. London: J. Roberts, 1730.

Staveley, E. F. *British Insects: A Familiar Description of the Form, Structure, Habits, and Transformations of Insects*. London: L. Reeve, 1871.

Stelluti, Francesco. *Persio tradotto in verso sciolto e dichiarato da Francesco Stelluti*. Rome: G. Mascardi, 1630.

Swammerdam, Jan. *Historia Insectorum Generalis, in qua Quaecunque ad Insecta Eorumque Mutationes Spectant, Dilucide ex Sanioris Philosophiae & Experientiae Principiis Explicantur*. Leiden: Apud Jordanum Luchtmans, 1685 (1669).

Vincent, Levinus. *Wondertooneel der nature geopent in eene korte beschryvinge der hoofddeelen van de byzondere zeldsaamheden daar in begrepen: in orde gebragt en bewaart*. Amsterdam: F. Halma, 1706–1715.

Walckenaer, Charles Athanase. *Histoire naturelle des insectes. Aptères*. Paris, Librairie encyclopédique de Roret, 1837 (–1847).

Westwood, John O. *Arcana Entomologica; or, Illustrations of New, Rare, and Interesting Insects*. London, W. Smith, 1845.

———. *The Cabinet of Oriental Entomology; Being a Selection of Some of the Rarer and More Beautiful Species of Insects, Natives of India and the Adjacent Islands, the Greater Portion of Which Are Now for the First Time Described and Figured*. London, W. Smith, 1848.

———. *An Introduction to the Modern Classification of Insects; Founded on the Natural Habits and Corresponding Organisation of the Different Families*. London, Longman, Orme, Brown, Green, and Longmans, 1839–1840.

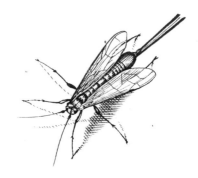

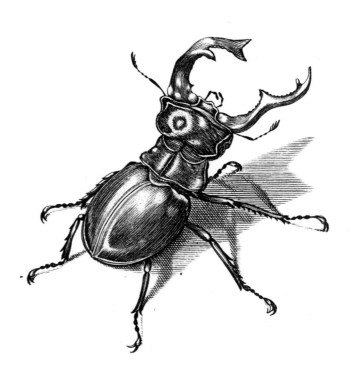

PICTURE CREDITS

All images from the American Museum of Natural History Rare
Book Collection except as follows:

BasPhoto/Bigstock.com: 164
gilmanshin/Depositphotos.com: wood background on 3, 13, 29, 45, 79, 107, 127, 145, 169, 181
Courtesy Rijksmuseum, Amsterdam: xiii, 82 left, 94
Wellcome Collection: 19, 32, 178
Courtesy of Wikimedia Commons: 20 top

INDEX

Page numbers in *italics* indicate illustrations on that specific page

Individual species and common names are listed individually

A

Acherontia lachesis, 101
Acherontia styx, 101
Acheta domesticus, 62
Acoustic calls, 151–153
Acrocinus longimanus, 87
Actias luna, 102
Actias maenas, 50
Adams, Douglas, 46
Adaptability of insects, xv
Aedes cinereus, 106, 107
African gaudy grasshopper, *170*
African trypanosomiasis, 111
Agnosia orneus, 159
Alderflies, *81*, 84
Aldrovandi, Ulisse, 17–18, 19, 20–21, *20*, 30, *97*
Allodapine bees, 132
Ambrosia beetle, 129, 137
Amegilla circulata, 9
American Entomology (Say), *93 bottom, 153 left, 173*
American lantern bug, *46*
American longhorn beetle, *88*
American Museum of Natural History, xi, xvii
Ammons, A. R., 144
Amplypterus panopus, 159
Anacamptis pyramidalis, 192
Anaplura, 72
Ancient river water bug, *16*
Angel insects, 59–60
Angraecum sesquipedale, 192
Annali del Museo civico di storia naturale di Genova (Giglio-Tos), *153 bottom right*
Anomala donovani, 16
Anopheles maculipennis, 106, 107
Anthonomus grandis, 123
Antlions, *85, 86*

Ant-loving cricket, 144, *145*
Ants
 agricultural systems of, 137–141
 architectural dwellings, 134–136
 as complex societies, 131
 depictions of, *83, 91, 135, 141, 145*
 metamorphosis of, *83*, 91
 as social insects, 128, *130,* 131, *135*
 subterranean, 126, *127*
 types of, *141*
 wood, 135
Anurogryllus abortivus, 151
Anurogryllus toltecus, 151
Aphelocheirus aestivalis, 16
Aphid wolf, 86
Aphids, *72*, 74–75, 129, 141
Apiculture, 2, 130, *132*, 162, 163
Apis dorsata, 142, 144
Apis florea, 142, 144
Apis mellifera, 130
Aporia crataegi, 120
Aposematic coloration, *147,* 148, 175
Aposematism, 175
Appias nero, 187
Aptera, 30–31
Aquatic insects, *xii,* xiii, *15,* 35, 54, *56, 57,* 59, 84, 88, 97, *100,* 101
Arabia Felix, 138–140, *138*
Arcana Entomologica; or, Illustrations of New, Rare, and Interesting Insects (Westwood), *53, 75*
Archaeognatha, 28, 32, 38–40
Architecture, insect, 131–134
Aristotle, 15, 159, 163
Arixeniidae, 61
Arthropoda, 2–6, *4,* 25
Articulated joints of arthropods, 4
Asian sandy cricket, 144, *145, 146*
Asilus crabroniformis, 99
Ateloblatta cambouini, 157

Ateloblatta malagassa, 157
Athis clitarcha, 158
Atlas moths, 102, *189*
Atlas scarab beetle, *87*
Attacus atlas, 102, *189*
Aura seminalis, 129
Aurelian Society, 103
Australian sandgropers, 153

B

Bacillus rossius, 66
Bacteria virgea, 166, 168, *172*
Banks, Joseph, 137, 188
Barbados cherry plant, *96*
Barberini, Cardinal Antonio, *xiii*
Bark beetles, *122,* 123
Bark lice, 71, 170
Barnacles, 5
Baron Carl Claus von der Decken's Reisen in Ost-Afrika (Gerstaecker), 2, *3, 9, 63 left, 91 right*
Bates, Henry Walter, 175, 178–179
Batesian mimicry, 175–177, 178–*179*
Batra, Suzanne, 126
Bats, 46, 47, 61, 99, 111, 157, 158, 159, 184
Bauernfeind, Georg W., 139
Bechstein, Johann M., 118–119
Bed bugs, 75, 111–114, *111*
Bee colonies, 129
Bee fly, *16*
Bee robber hawk moths, *101*
Beekeeping. *See* Apiculture
Bees. *See also* Bumble bees; Honey bees; Wasps
 allodapine, 132
 architectural dwellings, 131
 carder, *184*
 complex societies of, 131
 cuckoo, 93, 126, *127, 185*
 digger, 187
 depictions of, *19, 79, 91, 128, 130, 132, 142, 160, 161, 163, 184, 186, 187*

ecological importance of, 184
 fire, 187
 as generalists, *186*
 ground-nesting, solitary, 126, *127*
 metamorphosis of, 91
 nocturnal, 187
 number of species, 9
 orchid, *180,* 182, 185–186, *186*
 parasitic, 93
 as pollinators, 185–187
 as specialists, *186*
 sweat, 132, 187
 worker, *19,* 126–128
Bees. Comprehending the Uses and Economical Management of the Honey-Bee of Britain and Other Countries (Jardine), *128*
Beetles. *See also* Weevils
 African, *9*
 agricultural systems of, 137
 depictions of, *xii, xvi, 6, 7, 9, 16, 51, 78, 87, 88, 89, 109, 116, 117, 121, 147, 149, 190*
 examples of colorful, *147*
 as herbivore pests, 116–117
 mating, 99, *147*
 metamorphosis of, 86–88
 as pollinators, 190
Berggren, Lars, 139
Bertholdia trigona, 159
Biblia Naturae (Nature Bible), 83
Biologia Centrali-Americana. Insecta. Coleoptera., 9, 88 left, 89, 149
Biologia Centrali-Americana. Insecta. Diptera., 190 left
Biologia Centrali-Americana. Insecta. Lepidoptera-Heterocera., 158
Biologia Centrali-Americana. Insecta. Neuroptera. Ephemeridae., 55
Biologia Centrali-Americana. Insecta. Orthoptera., 67
Biologia Centrali-Americana. Insecta. Rhynchota. Hemiptera-Homoptera., 156, 175

Birds, 8, 9, 46, 47, 56, 128, 131, 155, 157, 177, 184
Bird grasshopper, *46*
Birdwing butterfly, *24*, *102*, 182, 183
Biston betularia, *118*
Biting midges, *106*
Bittacus italicus, *98*
Blaberus giganteus, *70*
Black beetle, *147*
Black fly, 44
Black-headed cardinal beetle, *147*
Blackleg tortoiseshell butterfly, *120*
Black-veined white butterfly, *120*
Blattaria, 66, 69
Blister beetles, *147*, 148
Blood-feeding insects, 71–72, 75, 82, 97–100, 102, 111–114
Blue emperor swallowtail butterfly, *188*
Body louse, 72, *109*, 110
Boerhaave, Herman, 83
Bombus terrestris, *128*
Bombyx mori, 102
Book louse, *58*, 71
Boreus hyemalis, *16*, *98*
Bornean termite, *124*, 126, *136*
Bot flies, 114–115
Bourignon, Antoinette, 83
Brachyptera risi, *58*
Brachytrupes membranaceus, *146*
Bristletails, 28, 30, 31, 38–40, *39*, 148
British Entomology (Curtis), *61*, *93 top*, *146 left*
British Insects (Staveley), *62*, *99 right*, *198*, 199
Bubonic plague, 108–110
Buff-tailed bumble bee, *128*
Bugs, 75. *See also* Thorn bugs; True bugs
Bumble bees, *128*, 131, 132, 187. *See also* Bees
Burnens, François, 129–130
Butler, Charles, 129, 163–165, *164*
Butterflies
 color variations of, *101*
 described, 102–103
 depictions of, *6*, *24*, *52*, *95*, *96*, *101*, *102*, *120*, *179*, *183*, *187*, *188*, *189*, *196*
 exhibiting leaf mimesis, *174*

heliconiine, 177
life stages of, *95*
mimicry in, 178–179
number of species, 9
as pollinators, 186

C

Cabinet of Oriental Entomology, The (Westwood), *50*, *51–53*, *63 right*, *64*, *74 85 right*, *99 left*, *101*, *159*, *166*, 168, 170, *172 left*, *177*, *190 right*
Caddisflies, *15*, 100–102, *100*
Calopsyra octomaculata, *63*
Calopteryx virgo, *15*
Camouflage, 168–170
Campodea staphylinus, 28, *29*, 31
Canine lice, *71*
Cantharidin, *147*, 148
Caravaggio, 94
Carder bees, *184*
Caribbean crickets, 151
Carpenter bees, 132, *160*, *185*, *186*, 187
Carroll, Lewis, 28
Caste systems in eusocial societies, *58*, 70, 74, 127–129, *129*, *130*, 140
Castniid moth, *158*
Caterpillars, 78, 102, 126, 131, 174
Centipedes, 5
Central American giant cave cockroach, *44*, *70*
Cerci, 34, 38
Cesi, Frederico A., 19
Ceylon tree nymph butterflies, *101*
Chagas disease, 110–111
Chalcid wasps, *123*
Chalcosoma atlas, *87*
Chaoborus crystallinus, 106, *107*
Chauliodes pectinicornis, *81*, *85*
chelicerae, *5*, 6
Chelicerata, 4, *5*, 6
Chemical signals, insect, 146–148, *147*
Childeric I, king of Francia, xiv
Chironomid midges, 106, *107*
Chironomus plumosus, 106, *107*
Chomsky, Noam, 162
Cicadas, *xv*, *73*, 74–75, *155*, *156*
Cicindela hybrida, *16*
Cimex lectularius, *111*

Classifications
 by Aldrovandi, 17–18
 arrangement of species, 14
 binomial nomenclature, 14
 evolutionary relationships of insects, 25
 families, 25
 first use of species in, 22
 iconography of, *23*
 Linnaean hierarchy, 12–14
 of natural world, 12–14
 Renaissance, 17–19
 species, 22
 taxonomic orders, 25
Clearwing moths, 177
Clearwing white butterfly, *179*
Clothes moths, 102
Coat of arms, *xiii*, xiv
Cockroach, *42*, 44, *70*. *See also* Roaches
Cocytius antaeus, *193*
Coevolving pollinators, 192–193
Coleoptera, 86–88
Collembola, 28, 32, 34–38
Colorado potato beetle, 117–121
Common green birdwing butterfly, *24*
Common walkingstick, *173*, *174*
Communal societies, 126–129
Communication, insect
 by acoustic sounds, 151–153
 chemical cues, 146–148
 courtship displays, 148
 described, 144–146
 echolocation and, 157
 by hissing, 155–157
 by light, 148–150
 by movement, 148
 pheromones, 146
 by surface vibrations, 150
 ultrasonic sounds, 157–159
 by water ripples, *150*
Concealment, insect. *See* Camouflage
Cook, J., 114
Copepods, 5
Corpse flower, *190*
Corydalus cornutus, *84*
Cotton boll weevil, 123
Courtship displays, 148, 150–151, *154*
Crab louse, *109*

Crabs, 2, 4, 5
Crampton, Guy C., 60
Crematogaster ranavalonae, *135*
Crickets. *See also* Katydids
 acoustic calls of, 151, *153*
 ant-loving, *144*
 depictions of, *21*, *62*, *145*, *146*, *151*, *153 bottom left*, *154*
 described, 62
Crustacea, 5
Crypsis, 168
Cryptocercus, 69
Cuckoo bees, 93, 126, *127*, 185
Cuckoo wasps, *92*
Culex pipiens, *99*, 106, *107*
Cylindracheta spegazzinii, *153*
Cyrtacanthacrus tatarica, *46*

D

Dagger flies, 186
Damselflies, *15*, *49*, *54*, 56–57
Danaus plexippus, 177
Darwin, Charles R., 22–25, 32, 50, 113, 178, 192
Day-flying moths, 177
De Animalibus Insectis Libri Septem (*On Insects, Seven Books*) (Aldrovandi), 17–18, *20*, *21*, *97 bottom*, *134 left*
De natuurlyke historie der insecten (von Rosenhof), *xii*, *xvi*, *5*, *54*, *57*, *69*, *78*, *86 right*, *87 top*, *100*, *108 left*, *115*, *152*, *153 bottom left*
De Saussure, Ferdinand, 162
De Saussure, Henri, 162
Death's head hawk moths, *101*
Deidamia morpho, *96*
Denny, Henry, 112–113
Dermaptera, 60–61
Der monatlich-herausgegebenen Insecten-Belustigung (von Rosenhof), *194*
Descriptiones Animalium, Avium, Amphibiorum, Piscium, Insectorum, Vermium (Forsskål), *138*, *139–140*
Desert locusts, 116, 168
Devonian period, 25
Diapheromera femorata, *173*
Diapriid wasp, *16*
Diceroprocta ruatana, *156*
Dicladocerus westwoodii, *16*

Dicuspiditermes nemorosus, 126, 127, *136*
Dicyrtoma fusca, *35*
Dicyrtomina ornata, *34*
Die Forst-Insecten (Ratzeburg), *116 left*, *117*, *118*, *119*, *120*, *121*, *122*, *154*, 170, *171*
Digger bees, 187
Dioscorides, 15
Diplura, 28, 32
Diptera, 44, 98–100
Dismorphia amphione, *179*
Disraeli, Benjamin, 50
Disturbed tigerwing, *179*
Diversae Insectarum Volatilium Icones (Hoefnagel), *xiv*
Dobsonflies, 81, *84*
Donovan, Edward, 186, 188–189
Dorisiana amoena, *156*
Down-looker snipe flies, *99*
Dragonflies, *xii*, xiii, *15*, *49*, 54, *54*, 56–57, *56*
Dragonfly naiads, 57
Dragons, 20–21
Drebbel, Cornelis, 19
Drones, 21, 80, 82, *130*, 165
Dryococelus australis, 65
Dwarf honey bee, *142*, 144, *160*

E
Ears, insect, 157–159, *158*
Earwigflies, 97
Earwigs, 60–*61*, 62, *63 left*, 126, 131
Echolocation, 157
Ectobius lapponicus, 62
Einstein, Albert, 184
Elenchus tenuicornis, *90*
Elongate-bodied springtail, *36*
Elytra, 87, *88*
Embia mauritanica, 58
Embiodea, 59–60
Empicoris vagabunda, *150*
Empusa pennicornis, *174*
Encyclopédie méthodique. Histoire naturelle. Insectes. (Olivier), *84 right*, *86 left*, *104*, 106, *109*
English Grammar, The (Butler), 165
Ensign scale insect, *16*
Entognatha, 7, 28, 30, 31, 34–38
Entomological interventions, civilizations and, xiii

Entomological Society of London, 51
Epeolus variegatus, *185*
Ephemeroptera, 54–56
Epipogium aphyllum, *193*
Episteme bellatrix, *177*
Episteme westwoodi, *177*
Ericacceae, 74
Etomology, 2, 15–17
Études sur les Myriapodes et les insects (Saussure), *xvii*, 151
Etymologiae (Isidore), 16–17
Eulaema cingulata, *78*
Eulophine parasitoid wasp, *16*
Euptilon ornatum, *85*
European Butterflies and Moths (W. D. Kirby), *x*, xi
European cicada, *155*
European paper wasp, *129*
European praying mantis, *69*
European scorpionfly, *97*
European stick insect, *66*
European wasps, *134*
Eusocial societies, 126–129, 131–134
Eversible vesicles, 31
Evolution
 of bark beetles, *122*
 bees and, 187
 biological traits in, 12
 camouflage and, 168
 classification and, 22, 25
 Darwinian, 32, 178
 of fleas, 98
 of flight, 46–49, 54
 of humans, insects and, xiv
 by natural selection, 178
 in optics, 19
 ovipositor influencing insect, 7
 parallels with humans, 126
 of stick insects, 63
 of true lice, 72
 Wallace on, 178
 of wasps, 92
Exogenous materials, camouflage using, 170
Exoskeletons of arthropods, 4–5
Exsula dentatrix, *177*
Exsula victrix, *177*
Extatosoma tiaratum, 173

F
Fairy wasps, *93*
Farming termites, 141
Feather-legged bug, *150*
Feather-wing beetle, 88
Feminine Monarchie, The (Butler), 129, *163*
Fidicina mannifera, *xv*
Fig wasps, 193–194
Fig–fig wasp mutualism, 193–194
Fire bees, 187
Firebrats, 38
Fireflies, 88, 148–150, 157
Fish, 9, 55, 57
Fishflies, *81*, 84, *85*
Fleas, 97–99, 108–111, *108*, *109*
Flies
 Johnston's organ, 8
 life stages of, 100
 parasitic, 99–100
 as pollinators, 190
Flightless insects, 28–31, 32–33, 193
Flora Aegyptiaco-Arabica (Forsskål), *138*
Flower flies, 186, *190*
Flower mantises, 174
Flowering plants, ecological rise of, 182
Flying insects. *See* Winged insects
Food and Agriculture Organization (United Nations), 185
Forcepflies, 97
Forest entomology, 118–120
Forewings
 of African common milkweed locust, 44, *45*
 of beetles, 87–*88*
 of butterflies, 174
 of crickets, 62
 of earwigs, 60–61
 exhibiting leaf mimesis, 174
 of fairy wasps, *93*
 of grasshoppers, crickets, and katydids, 62, 174
 of mayflies, 54–55
 of moths, 174
 of termites, 69
 of true bugs, 75
 of true insects, 7
 of twisted-wings, 90

Forficula auricularia, *61*, 62
Formicidae, *130*, *135*. *See also* Ants
Forsskål, Peter, 138, 139–140
Four-spotted moth, *192*
Frederick V, king of Denmark, 138
Fruit flies, 100
Fulgora laternaria, *xv*, 46
Fungi, 34, 35, 59, 72, 88, 100, 134, 137, 141
Fungus-growing termites, 134, 137, 141
Furculum, 36

G
Galileo Galilei, 19
Gall tissues, 74
Generalist pollinators, 186, 192
Generelle Morphologie der Organismen (Haeckel), *10*, 12, *23*
Geometrid moths, *118*
Ghost insects, 62–66
Ghost orchid, *193*
Giant glasswing butterfly, *179*
Giant honey bee, *160*
Giant sphinx moth, *193*
Gibbon, Edward, 110
Globular springtail, 28, *29*, 35
Golden egg bugs, 75
Goliath beetle, *87*, 88
Goliathus goliatus, *87*
Gongylus gongylodes, *174*
Grasshoppers. *See also* Locusts
 acoustic calls of, 151
 burrows of, *152*
 defined, 115
 described, 62
 disguising, 168–170
 depictions of, *xii*, *21*, *46*, *62*, *63 left*, *115*, *116*, *145*, *152*, *153*, *170*
Great green bush katydid, 144, *145*
Green lacewings, 157–159, *170*–*171*
Gregory XIII (pope), 20
Gromphadorhina portentosa, *155*
Ground-nesting, solitary bees, 126, *127*
Gryllodes sigillatus, 151
Gryllotalpa gryllotalpa, *154*

H

Haldane, J. B. S., xiii, 87, 195
Halictophagus curtisii, 90
Halter halterata, 140
Halteres, 98. *See also* Hind
 wings
Hangingflies, *98*
Harlequin beetle, *87*
Haviland, George, *136*
Hawkmoth, *50*, *158*, 177
Hayesiana triopus, *159*
Head louse, 72
Heel walkers, 60
Heliconiine butterflies, 177
Hellgrammites, *84*
Hemeroplanes triptolemus, 177
Hemimeridae, 61
Hemimetabolous
 metamorphosis, 78–81
Hemiptera, *73*, 74–75
Herodotus, 194
Heteropteryx dilatata, *65*
Hexagenia limbata, *49*
Hexapoda, 6–7, *30*
Hexapods, wingless, 28–31
Hidden insects
 by camouflage, 168–170
 by mimesis, 171–177
 by mimicry, 168, 175–177
Hind wings
 of beetles, 87–88
 of earwigs, 60–61
 fanlike, 60
 halteres, 98
 of mayflies, 54–55
 of southern African
 milkweed locust, *44*
 of stoneflies, 57
 of termites, 69
 of true flies, 98
 of true insects, 7
 of twisted-wings, 90
Histoire des insectes de l'Europe
 (Merian), *76*, *78*, *96*, *98*, *80*,
 95
Histoire naturelle des insectes.
 Aptères. (Walckenaer), *26*, *28*,
 29, *37*, *39*
Histoire naturelle des insects
 (Audouin), *8*, *42*, *44*, *70*
Histoire naturelle des insects
 (Lepeletier), *92 left*, *123*, *129*
 left, *130*, *132*, *134 right*, *185*

Histoire physique, naturelle
 et politique de Madagascar,
 Hymenoptères. (Forel), *135*
Histoire physique, naturelle
 et politique de Madagascar,
 Orthoptères. (Saussure), *68*, *71*
 left, *133*, *157*, *187 right*
Historia animalium (Aristotle),
 15, 163
Historia Insectorum Generalis
 (Swammerdam), *82*, *83*, *106*
Historia Insectorum (Ray), *22*
Hollick, A. T., 33
Holometabolous insects, 78–81,
 84, *85*, 95, 97
Holoptilus ursus, *150*
Honey bees. *See also* Bees
 caste system of, 129–*130*
 combs, 131–*132*, *142*, 144,
 160
 communication forms of,
 159–162
 dancing, 159–162
 exploitation of, 2
 nectar, 185
 as pollinators, 187, 192
 skep, *161*
 triumvirate of, *19*
 waggle dance, 161–162
Hooke, Robert, 22, *97*, *108*
Hope, Frederick W., 50–51
Hornet robber flies, *99*
Hornets, 132. *See also* Wasps
House cricket, *62*
House fleas, *108*
House flies, 98–99
House mosquito, *99*
Huber, François, 129–130
Human louse, *108*, *113*
Hydrometra stagnorum, *150*
Hymenoptera, 91–93, 126,
 127
Hymenopus coronatus, 174

I

Ice crawlers, 60
Ichneumonid wasps, *8*, 93
Icones Ornithopterorum (Rippon),
 24, *102*, *196*
Iconographie du règne animal de G.
 Cuvier (Guérin-Méneville), *49*,
 73, *88 right*, *98*, *191*
Idea iasonia, *101*

Idea idea, *189*
Illnesses, insects curing, 15–16
Illustrations of Exotic Entomology
 (Drury), *46 right*, *56*, *85 left*, *87*
 bottom right, *146*, *right*, *174*
Imaginal discs, 81
Indian rose mantis, *174*
Indonesian stick insect, 168, *169*
Inquilines, 136–137
Insect agriculture, 137–141
Insect architecture, 131–134
Insect diversity
 Aldrovandi on, *21*
 aquatic, *xii*, *xiii*, *15*
 beetles, 86
 depiction of, *xii*, *xiv*
 in Holometabolous insects,
 81
 life stages of, *15*
 origin of wings and, 75
 population estimates, xv
Insectorum sive Minimorum
 Animalium Theatrum (Moffet),
 18–19, *155 top*, *161*
Introduction to the Modern
 Classification of Insects, An
 (Westwood), *16*
Ips calligraphus, 123
Isidore of Seville, 16–17, 80
Isoptera, 66, 69–71

J

Janssen, Zacharias, 19
Japyx solifugus, *34*
Jet propulsion system, 57
Johnston, Christopher, 8
Johnston's organ, 7–8, 161
Journal of the Linnean Society of
 London. Zoology., The, *124*, *126*,
 136
Julius III (pope), 20
Jumping bristletails, *38*
June bugs, 88
Justinian I, Emperor of the
 Byzatine Empire, 110
Justinian plague, 108–110

K

Katydids. *See also* Crickets
 acoustic calls of, 151, 153
 described, 62
 depictions of, *21*, *62*, *63 right*,
 145, *176*

 exhibiting leaf mimesis,
 174–175, *176*
Keats, John, 151
Kissing bugs, 75, 110–111
Kramer, Christian C., 139
Krill, 5

L

Labium, 7, 57
Laboratory fruit flies, 100
Lace palm bugs, 75
Lacewings, *81*, 85–86, 157–159,
 170, *171*. *See also* Mantises
Ladybugs, *xii*, *xiii*, 88
Lake flies, *106*
Language, 159, 162. *See also*
 Communication, insect
Lantern bugs, *46*, *73*, 74–75
Larvae, *78*, 80, 100, 170–171
Leaf beetles, *89*, 116, *117*, 126
Leaf insects, 62–66, *64*,
 172–173
Leaf mimesis, 174–175, *176*
Lenyra ashtaroth, *159*
Lepidocyrtus curvicollis, 28, *29*
Lepidoptera, 100–103
Lepisma saccharina, *40*
Leptinotarsa decemlineata, 117–121
Le règne animal distribué d'après
 son organization (Cuvier), *46*
 left, *58*, *66*, *72*, *81*, *84 top*, *90*
 left, *106*, *107*, *111*, *141*, *144*,
 145, *150*, *155 bottom*, *168*, *169*
Lertha extensa, *98*
Leucophlebia lineata, *50*
Libellula depressa, *15*
Lice, 71–75, 97–98, 112–113,
 170
Life cycles of insects, 69, 82, 95,
 119. *See also* Metamorphosis
Limenitis archippus, 177
Limnoporus rufosculellata, *150*
Linnaean hierarchy, 12–*14*
Linnaeus, Carl, 12–14, 22, 31,
 138, 182
Little-owl cicadas, *155*
Lobsters, 2, 4, 5
Locusta migratoria, 116, *146*
Locusts, 44, 62, 115–121, 126,
 168. *See also* Grasshoppers
Longhorn beetle, *77*, *78*
Lord Howe Island stick insect, 65
Lorenz, Konrad, 161

Lubbock, John, *32–33*
Lucanid stag beetle, *78*
Lullin, Marie-Aimée, 129–130
Luna moths, 102
Lyristes plebejus, 155

M

Macleay's Spectre, 173
Macrodontia cervicornis, 78, 87
Macroterminite termites, 135–136
Madagascar hissing cockroach, 155, *157*
Maeterlinck, Maurice, 184
Magee, John G., 46
Magellan birdwing, *102*
Maggots, 100
Malagasy acrobat ant, *135*
Malagasy ants, *135*
Malagasy bees, *187*
Malaysian jungle nymph, *65*
Malaysian moon moth, *50*
Malpighi, Marcello, 82
Malpighia glabra, 96
Mammals, 9, 61, 112, 114, 184
Mandibles
 of bristletails, *38*, 40
 creating sound with, 151, *153*
 Crustacea, 6
 of damselflies, 57
 Hexapoda, 6
 hierarchical organization of, *4*
 of lacewings, 85
 of lice, 72
 Myriapoda, 6
 of sandgropers, 153
 of silverfish, 40–41
 of termites, 70
 of true insects, 7, 22
 of twisted-wings, 90
 unjointed, 7
 vestigial, 90
Mantises. *See also* Lacewings;
 Praying mantises; Stick insects
 camouflage and, *174*
 described, 66–69
 depictions of, *xvii, 67, 68, 69, 81, 85, 174*
 ears of, 157
 life cycle of, *69*
 mating, 69
 predatory, *68*
Mantispa styriaca, 81

Mantodea, 66–69
Marine caddisflies, 101
Marrel, Jacob, 94
Marsh grasshopper, *62*
Marsh horse flies, *99*
Masked hunter bug, *150*
Mating, 56, *57*, 69, 99, *147*, 150–151
Mating calls, *154*, 157
Mating fleas, *109*
Maxillae, 7, 85
Mayflies, *15, 49,* 54–56
Mechanitis polymnia, 179
Mecoptera, 97–98
Medical remedies of insects, 15–16
Medicinale anglicum (*Bald's Leechbook*), xvi
Megaloptera, 81
Melissographia (broadsheet), *19*
Melissomelos (madrigal), 163, 164, *165*
Meloe proscarabaeus, 147
Meloe variegatus, 147
Méndez de Torres, Luis, 129, 165
Merhynchites bicolor, 123
Merian, Maria Sibylla, 80, *94–96*
Mesoamerican crickets, *151*
Metamorphosis
 Coleoptera, 86–88
 Diptera, 98–100
 defined, 78–80
 depictions of by Maria Sibylla Merian, *78, 80, 95*
 depictions of by Jan Swammerdam, *83*
 of dobsonflies, 81
 Hymenoptera, 91–93
 lacewings, 81
 Lepidoptera, 100–103
 Mecoptera, 97–98
 Megaloptera, 81
 moth, *76, 78, 80*
 Neuroptera, 81
 Raphidipotera, 81
 Siphonaptera, 97–98
 snakeflies, 81
 Strepsiptera, 90–91
 Trichoptera, *100–102*
Metamorphosis Insectorum Surinamensium (*Transformation of the Suriname Insects*), 95, *193*
Methona confusa, 179

Micrographia (Hooke), 22, *97 top, 108 right*
Microscopes, 19–22
Midges, 98, *106*
Migratory locusts, 116, *146*
Millipedes, 2, *3*, 5
Mimesis, 171–177
Mimicry, 168, 175–177
Minute thrips, *62*
Minute wasps, 123
Mirrors, 151
Mites, 136–137
Model, 168
Moegistorhynchus longirostris, 191
Moffet, Thomas, 18–19
Mole crickets, 151–153, *154*
Monarch butterflies, 177
Monograph of the Collembola and Thysanura (Lubbock), *31, 32–33, 34, 35, 36, 38, 40, 41*
Monographia Anoplurorum Britanniae (Denny), *71 right, 112, 113*
Morgan's sphinx moth, 192
Morpho deidamia, 96
Mosquitos, 98, *99*, 106, *107*, 186
Moths
 adult, *76*, 78
 caterpillars, 102
 clothes, 102
 depictions of, *50, 74, 76, 80, 95, 101, 118, 120, 158, 159, 177, 189, 192, 193*
 ears of, 157–159
 exhibiting leaf mimesis, 174
 geometrid, *118*
 larva, *76*, 78
 life stages of, *95*
 mimesis and, 177
 producing ultrasonic bursts, *159*
 pupa, *76*, 78
 ultrasonic sounds and, *158*
Mountain pine beetle, 137
Movement, insect, 148
Müller, Johann F. T., 177
Müllerian mimicry, 177
Musca domestica, 98–99
Musée entomologique illustré: histoire naturelle iconographique des insects (Rothschild), *15,* 126, *127, 147, 180,* 182, *186*

Myiasis, 114–115
Mymar pulchellum, 93
Myriapoda, 5–6
Myrmecophilus acervorum, 144, 145

N

Naiads, *15,* 54–59, *56, 57*
Nannochoristid scorpionflies, 97
Napoléon, Emperor of France, xiv, 110
Natural History of the Insects of China (Donavan), 44, *45, 189 left*
Natural History of the Insects of India (Donavan), *87 bottom left, 92 right, 172 right,* 182, *183, 187 left,* 188, *189 right*
Naturalis historia (Pliny the Elder), 16
Nectar, 85, 93, 101, 102, 141, 159, 185, 186, 190, 192
Neopterous, 57
Neotenic, 90
Neurobasis chinensis, 49
Neuroptera, 55, 81, *85, 86, 98*
Nicoletia silverfish, 28, *29*
Niebuhr, Carsten, 139–140
Nits, 72
Nocturnal bees, 187
Nonpareil liquor, *114*
North American pygmy grasshoppers, *153*
Northern dune tiger beetle, *16*
Northern jungle queen butterfly, *52,* 53
Notoptera, 60
Nuptial dances, 148
Nymphal assassin bugs, 170
Nymphalis polychloros, 120
Nymphs, 59, 61, *69,* 78, 150, *152,* 173

O

Ocelli, 40
Odonata, 54, *56*
Oothecae, 67, 69
Optical microscopes, 19–22
Orange albatross butterfly, *187*
Orchesella villosa, 36
Orchid bees, 77, 78, *180,* 182, 185–*186*
Orchid mantises, 174

Oriental rat flea, 111
Ornithoptera priamus, *24*, 182, *183*
Orthezia urticae, *16*
Over de voortteeling en wonderbaerlyke veranderingen der Surinaemsche insecten (Merian), *xv*, 12, *13*, 78, *79*, *96*, *193*
Ovipositors, 7, *8*, 84, 92–93, 121
Owlflies, *85*, *86*

P

Paleopterous insects, 54. *See also* Winged insects
Palpares libelluloides, *85*
Paper wasps, *129*, 132, *133*
Papilio ulysses, *188*
Parasanaa donovani, *63*
Parasitic insects, *8*, *16*, 61, 71, 72, 75, 90–93, *90*, 94, *95*, *97*, 99, *104*, *106–114*, 123. *See also* Bed bugs, Fleas, Lice, Twisted-wing Parasite
Patia orise, *179*
Pauropods, 5–6
Pediculus humanus, *108*, *109*, 110
Peppered moths, *118*
Perla marginata, *58*
Phantom midges, 106, *107*
Phasma gigas, 168, *169*
Phasmatodea, 62–66
Pheromones, 146, 148
Phryganea grandis, *15*
Phryganistria chinensis, 65, 168, *169*
Phthiria fulva, *16*
Phyllium donovani, *172*
Phyllium siccifolium, *66*, *172*
Phyllopalpus brunnerianus, *151*
Phyllopalpus caeruleus, *151*
Piaget, Édouard, 113
Pincer diplurans, *34*
Pine hawk moth, *120*
Plagues, 98, 108, 110–111, 115, 140
Plant-feeding wasps, *119*
Planthoppers, *73*, 74–75
Plant-sucking aphids, 141
Platymischus dilatatus, *16*
Plecoptera, 57–59
Pliny the Elder, 16
Poekilocerus bufonius, *170*
Polistes gallicus, *129*

Pollen, 72, 85, 93, 132, 159, *182*, 185, 186, 192 194
Pollinating insects, 93, 100, 174, *183*, *184–185*, *186–187*, *189*, *190*, *191*, 192–194
Pollination, 163, 182–185, 192, 194, 195
Potter wasps, 126, *127*
Praying mantises, 66–69, 157–159, *174*. *See also* Mantises; Stick insects
Predatory mantises, *68*
Prosthacusta circumcincta, *151*
Protura, 28, 32, 34
Pseudapis amoenula, *9*
Psocodea, 71–72
Psocus bipunctatus, *58*
Pterosaurs, 46–47
Pterygota, 44
Pthirus pubis, *109*
Pubic louse, 72
Pulex irritans, *97*, *108*
Pupa, 80
Pycna strix, *155*
Pyrochroa coccinea, *147*

Q

Queen bees, 82, 127–130, *163*, 165

R

Raphidia ophiopsis, *81*
Raphidioptera, 81, 84–85
Rat fleas, 108–110
Ratzeburg, Julius T. C., *116*, 118–120
Ray, John, 22
Reduvius personatus, *150*
Reticulitermes lucifugus, *58*
Rhagio scolopaceus, *99*
Rhynchophorus palmarum, *78*
Rhyniella praecursor, 38
Rhyothemis variegata, *49*
Rickettsia prowazekii, 110
Riffle bug, *150*
Rippon, Robert H. F., *196*
Roaches, *62*, 66–69, *71*. *See also* Central American giant cave cockroach; Cockroach; Wood roaches
Robust wasps, *175*
Rock crawlers, 60
Roly polies, 5

Ropalidia bicincta, *133*
Rose weevils, 123
Rove beetles, 136–137
Rutidoderes squarrosus, *46*

S

Sabertooth longhorn beetle, *87*
Sanaa imperialis, *63*
Sandgropers, *153*
Sargus cuprarius, *99*
Sawflies, 92, *119*
Scale insects, *72*, 74–75
Scambophyllum sanguinolentum, *63*
Scarab beetle, *16*, *190*
Scharfenberg, Georg L., 118–119
Schistocerca gregaria, 116
Schizodactylus monstrosus, 144, *145*, *146*
Scorpionflies, *86*, 97–98, *98*
Screwworm flies, 100, 114–115
Scrobigera amatrix, *177*
Scydosella musawasensis, 88
Seed beetles, *89*
Seed bugs, 75
Segond, Paul F., xvi
Sensory structures of arthropods, 5
Sericulture, 2, 102
Sermatophore, 31, 38
Serromyia femorata, *106*
Setae, 5, 35, 72, *93*, 101, 170
Shield bugs, 75
Shrimp, 2, 5, 129
Sialis lutaria, *81*
Siliquofera grandis, *176*
Silk farming. *See* Sericulture
Silk moths, exploitation of, 2
Silkworm moths, 102
Silverfish, 28, *29*, 30–31, 38–*41*, 148
Silvestri, Filippo, 59
"Singing" insects, 144, *145*, 151. *See also* Crickets; Grasshoppers; Katydids
Siphonaptera, 97–98
Skep, honey bee, *161*
Sleeping sickness, 111
Snakeflies, *81*, 84–85
Snodgrass, Robert E., 44–46
Snow scorpionflies, 97
Snowfleas, *16*, 97, *98*
Social paper wasps, *133*

Some Account of the Termites Which Are Found in Africa and Other Hot Climates (Smeathman), *137*
Soldier flies, *99*
Soldier termites, 70
Soldiers, 130–131
Southeast Asian hawk moth, 159
Southeast Asian rice paper butterfly, *189*
Southeast Asian walking-leaf, *66*
Southhall, John, 114
Specialized pollinators, 192 194
Species
adaptability of, xv
artistic representation in science and books, xvii
defined, 22
locations of, xv–xvi
population estimates, xv
rapid generation of, xvi–xvii
Spermatophores, 31, 35, 38, 148
Sphecid wasp, 93
Sphecius grandis, *93*
Sphinx pinastri, *120*
Spider wasps, *9*, 175
Spiders, 2, *3*, *5*, 129, *140*, 150
Spongillaflies, 86
Spontaneous generation, 82
Spoon-winged lacewings, *98*
Springtails, 28, *29*, *33*–38, 126, 148
Stag beetles, *xii*, *xiii*, *51*
Stalk-eyed flies, *99*
Staphylococcus aureus (MRSA), xvi
Stelluti, Francesco, 19–22
Stephanid wasps, *8*
Stethophyma grossum, *62*
Stichophthalma camadeva, *53*
Stick insects, 63–66, 148, 168, *169*, 172–174. *See also* Mantises; Praying mantises
Stinging wasps, 132, *133*
Stink bugs, 75, 148
Stizoides unicinctus, *93*
Stoneflies, 57–59
Stratiomys chameleon, *99*
Strepsiptera, 90–91
Stylops aterrimus, *16*
Stylops dalii, *90*
Subterranean ants, 126, *127*
Sucking lice, 72, *112*
Swammerdam, Jan, 80–81, 82–83, 106, 129, 165

Sweat bees, 132, 187
Symbolae Physicae (Ehrenberg), *184*
Sympetrum sanguineum, 15
Symphylans, 5–6
Systema Naturae (Linnaeus), *14*

T

Tabanus autumnalis, 99
Tanypus varius, 106
Taxonomic orders, 25
Termite colonies, 130
Termites
 agricultural systems of, 137
 architectural dwellings, 134–136, *140*
 castes of, *58*
 as complex societies, 131
 depictions of, *58, 124, 136, 137, 140*
 farming, 141
 macroterminite, 135–136
 mound-building, *137*
 nest construction, *140*
 number of species, 9
 social castes of, 70, 74, 130, *140*
 as social insects, 66, 69–71
 queens, 70
 soldiers, 70, 131
Tetrix ornata, 153
Tettigidea lateralis, 153
Tettigonia viridissima, 62, 144, *145*
Theretra clotho, 159
Theretra nessus, 159
Thévenot, Melchisédech, 82
Thliptoblatta obtrita, 157
Thorax
 Archaeognatha, 40
 Cicindelidae, *7*
 Coreidae, *75*
 of death's head hawk moths, *101*
 diagrammatic segment of, *47*
 Hexapoda, 6–7
 Notoptera, 60
 of spiders, *5*
 of stick insects, 172
 of wasps, 92
Thorax of Insects and the Articulation of the Wings, The (Snodgrass), *47*

Thorn bugs, 150, 171, 174, *175*
Thread-legged bug, *150*
Thread-winged lacewings, *85,* 140
Thrips, *62, 72–74,* 129
Thysanoptera, 72–74
Thysanura, 32
Ticks, East African, 2, *3*
Tiger beetle, *7*
Tiger mimic white butterflies, *179*
Tiger moth, 159
Tinbergen, Nikolaas, 161
Tineola bisselliella, 102
Titan arum, 190
Tobacco crickets, *146*
Tobacco hornworms, 102
Tomato hornworms, 102
Tracheae, 6
Transactions of the Zoological Society of London, 65, *142,* 144, *160, 179*
Treatise of Buggs, A (Southall), *114*
Treehoppers, 141, 150
Triatomines, 110–111
Trichoptera, 100–102
Tropical lantern bugs, *xv*
Tropical weevil, *77, 78*
Tropidacris cristata, 115
True bugs, 74–75, 136–137, 170
True flies, 98, *190, 191*
True insects, 7–8, 28, 32, 38–40
True lice, 71–72
Trypanosoma cruzi, 110
Turbulent flow, 48
Tuxen, Søren L., 34
Twisted-wing parasite, *16, 90*
Tymbal plates, 155
Tympana, 62, 155
Typhus, 108, 110, 113
Tyta luctuosa, 192

U

Ultrasonic sounds, 157–159
Urban VIII (pope), 19, 22

V

Van Leeuwenhoek, Antonie, 19
Van Sommelsdijck, Cornelius van Aerssen, 94

Various Contrivances by Which Orchids Are Fertilised by Insects, The (Darwin), *192*
Velia rivulorum, 150
Vella americana, 85
Vespula vulgaris, 134
Viceroy butterflies, 177
Victoria, Queen of England, 32
Vincent, Levinus, *2*
Von Frisch, Karl, 159–161
Von Haven, Frederik C., 139
Von Rosenhof, Rösel, *152, 153*
Voyage au pôle Sud et et dans l'Océanie sur les corvettes l'Astrolabe et la Zélée (Dumont d'Urville), *116 right, 176*

W

Waggle dance, 161–162
Walking-leaf insect, *66*
Walkingstick, *173, 174*
Wallace, Alfred Russel, 178, 192
Wasp colonies, 132–134
Wasps. *See also* Bees
 architectural dwellings, 131
 castes, *129*
 depictions of, *xii, 6, 8, 9, 16, 91, 92, 93, 119, 123, 127, 129, 133, 134*
 eulophine parasitoid, *16*
 life stages of, *119*
 metamorphosis of, 91
 ovipositor of, 92–93
 parasitic, *8,* 93, 94, 123
 plant-feeding, *119*
 Stephanid, *8*
 stinging, 132, *133*
Water measurer bug, *150*
Water striders, 75, *150–151*
Wax mirrors, 165
Webspinners, *58,* 59
Weevils, *9,* 88, 121–123
Western cicada killer, *93*
Westwood, John O., *50,* 51–53, 113, 189, *196*
Whiteflies, *72,* 74–75
Winged insects
 angel insects, 59
 classifying, 49–54
 introduction to, 44–47
 primitive, *49*
 sexual maturation of, 49
 stonefly, *58*

Wingless hexapods, 28–31. *See also* Collembola; Diplura; Entognatha; Protura; springtails
Wingless insects, 38–41. *See also* Archaeognatha; bristletails; silverfish; Zygentoma
Wings
 of beetles, 87–88
 of butterflies, 102
 of Central American giant cave cockroach, *70*
 diagrammatic segment of, *47*
 evolution of, 47–54
 of lacewings, *85*
 mechanics of, 47–48
 of moths, 102
 paleopterous, 54
 as passive structure, 48
 turbulent flow, 48
 variety of, 49
Wondertooneel der nature (Vincent), *xviii,* 2
Wood ants, 135
Wood roaches, 69, 70. *See also* Roaches
Wood wasps, 92
Worker bees, *19,* 126–128

X

X. morganii praedicta, 192
Xanthopan morganii, 192
Xenos vesparum, 90
Xylocopa chloroptera, 160

Y

Yellowjackets, 126, *127,* 132, *134. See also* Wasps
Yersinia pestis, 111
Yucca moths, 193, 194

Z

Zinsser, Hans, 108
Zoraptera, 59–60
Zygentoma, 28, 32, 38, *40,* 41

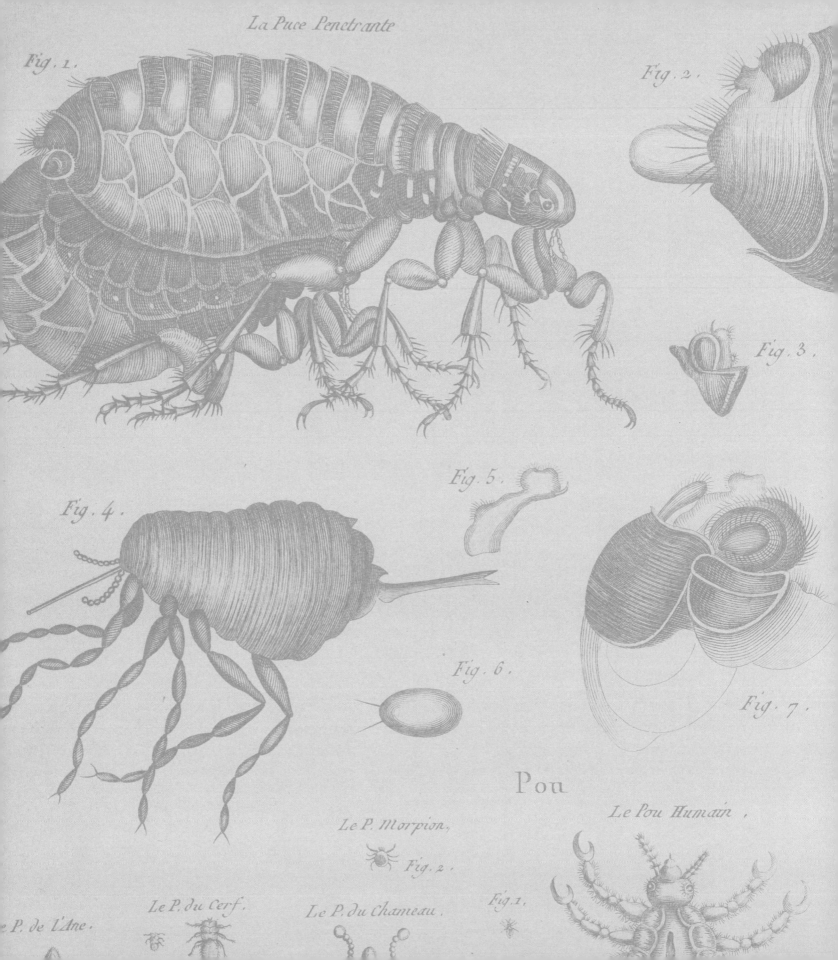

La Puce Penetrante

Fig. 1.

Fig. 2.

Fig. 3.

Fig. 4.

Fig. 5.

Fig. 6.

Fig. 7.

Pou

Le Pou Humain.

Le P. Morpion.

Fig. 2.

Le P. du Cerf.

Le P. du Chameau.

Fig. 1.

Le P. de l'Âne.